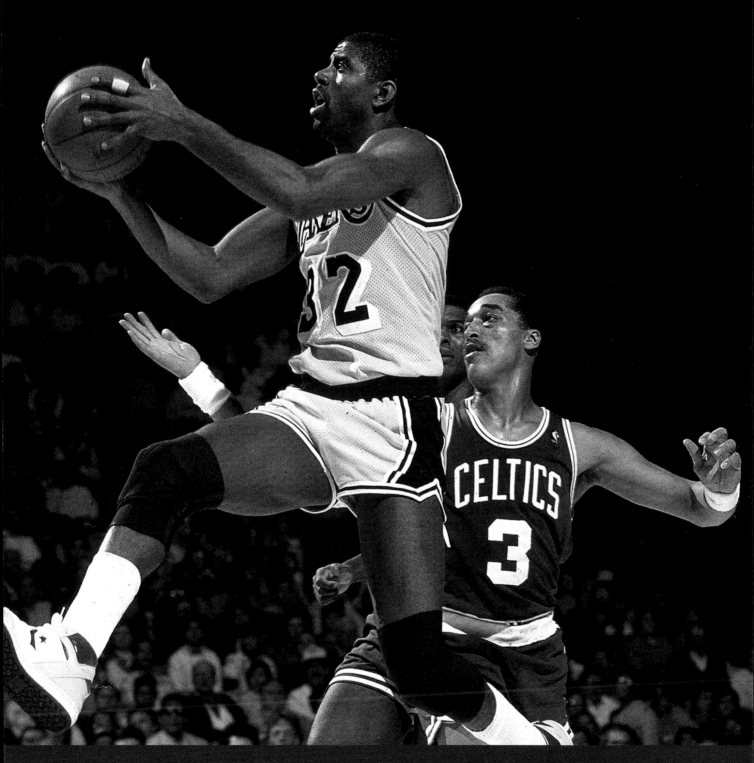

Sports Illustrated

THE GREATEST SHOW ON EARTH

A HISTORY OF THE LOS ANGELES LAKERS' WINNING TRADITION

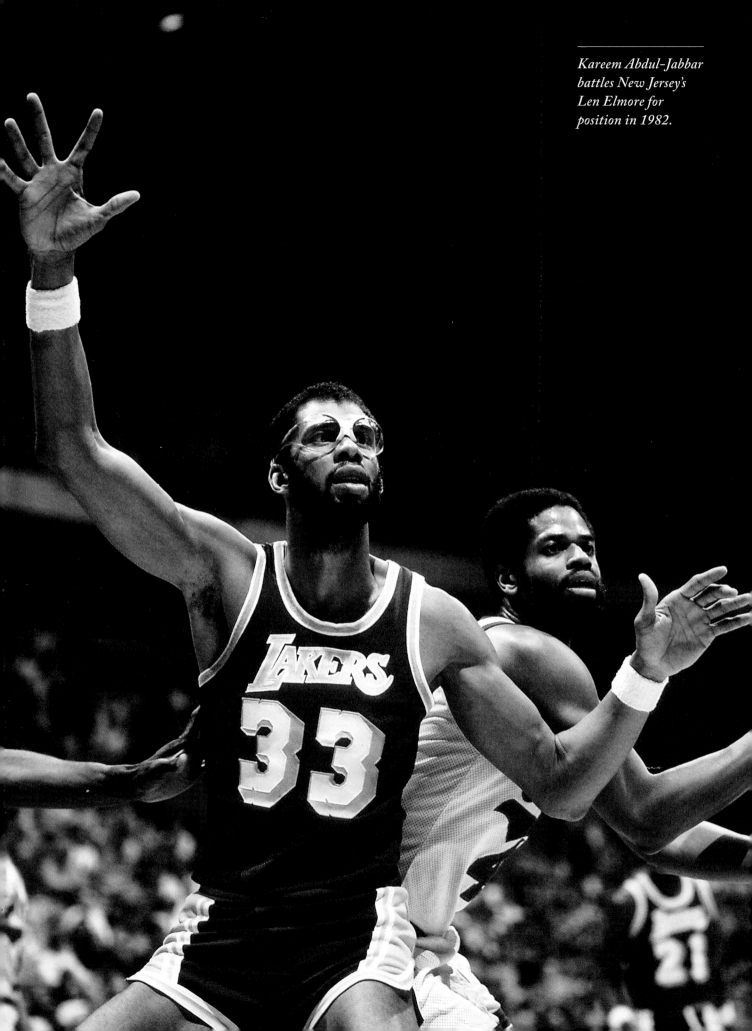

*Kareem Abdul-Jabbar
battles New Jersey's
Len Elmore for
position in 1982.*

CONTENTS

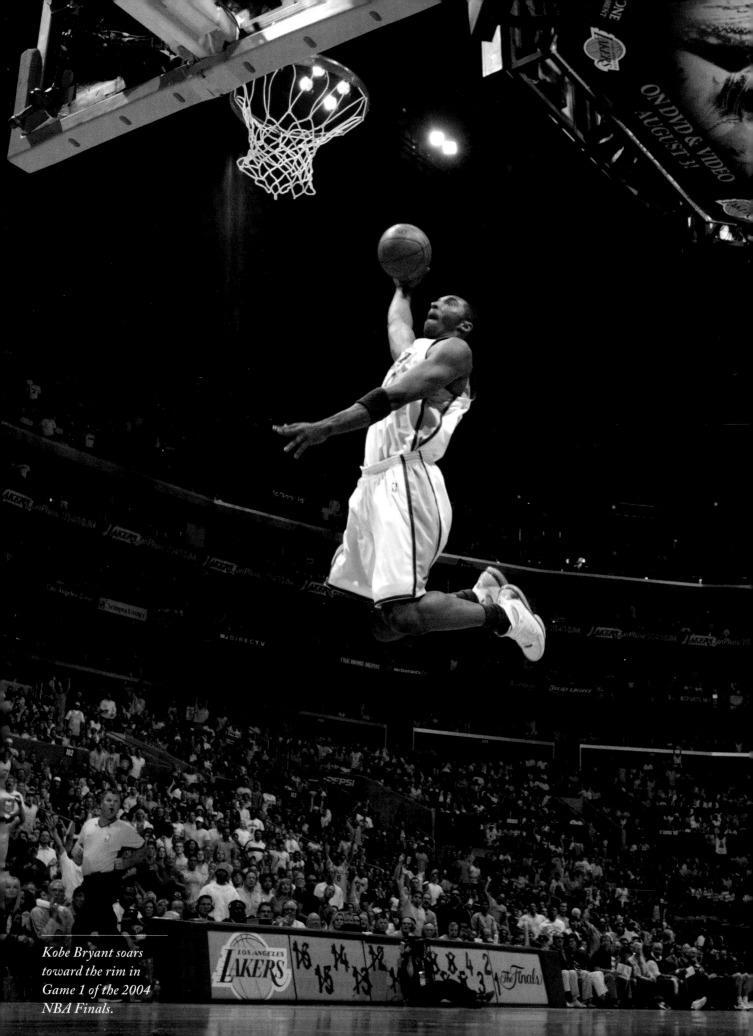

Kobe Bryant soars toward the rim in Game 1 of the 2004 NBA Finals.

INTRODUCTION

BY HOWARD BECK

THE BEVERLY HILTON IS A POSH, RITZY LANDMARK NESTLED IN THE HEART OF BEVERLY HILLS, A MAGNET FOR movie stars and awards shows and celebrity soirees. It's the kind of place you might spot George Clooney or Angelina Jolie on a given evening. It is *not* the sort of place frequented by khaki-panted sportswriters—or by basketball coaches, for that matter.

But Phil Jackson was no ordinary coach, and the team he'd just joined was no ordinary franchise. So there I was on June 16, 1999, milling about an ornate ballroom packed with hundreds of fellow media members from across the country, all assembled for a press conference that felt more like a coronation.

Basketball royalty dotted the room. Magic Johnson. Jerry West. And a young NBA prince, Kobe Bryant, there to welcome his new mentor.

First lesson you learn covering the Los Angeles Lakers: The glory and the glamour go hand in hand, always. "Showtime" isn't just some cool slogan from the 1980s—it's an ethos that guides and defines the franchise, across the decades, across the generations. The Lakers don't just win (an NBA-leading 17 championships), they do it with style, with flair, with personality. And often, with drama. Oh, do they do drama.

I covered the Lakers on a daily basis from 1997 to 2004 (otherwise known as "the Shaq and Kobe era"), as the beat writer for the *Los Angeles Daily News*, and have continued to chronicle them from afar ever since, as an NBA reporter for the *New York Times*, Bleacher Report and *Sports Illustrated*. No team in that time has consistently generated as many thrills, chills,

championships and plot twists—or shepherded as many basketball legends.

Kobe Bryant. Shaquille O'Neal. Pau Gasol. LeBron James. Anthony Davis. And more recently (for better or worse), Russell Westbrook. You'd be hard-pressed to find an era when the Lakers *didn't* have at least one NBA luminary on the roster. And when the current headliners move on, you can bet another wave will be coming behind them. They almost always do. Indeed, it's what the Lakers—heck, what everyone who's ever worked for the Lakers—absolutely *expect*. It's the lone NBA franchise that basically views superstars and championships as a birthright, and somehow doesn't even sound ridiculous believing it.

Lakers exceptionalism is real and undeniable and, frankly, pretty well earned. Only the rival Boston Celtics can boast as many titles as the Lakers. But the Celtics hung most of those banners back in the 1950s and '60s—before free

agency existed, before the NBA-ABA merger, before the league had fully integrated. But in the modern era? The Lakers reign supreme, racking up 11 Larry O'Brien trophies since 1980—more than the Chicago Bulls (six), more than the San Antonio Spurs (five), more than the Golden State Warriors (four) and nearly three times more than the Celtics (four).

Partisans in other NBA towns might resent the Lakers' success and their excess and their soaring self-importance…but they grudgingly respect the results, the legacy. It's been that way for at least 40 years, going back to the Showtime era. To Magic and Kareem. But especially Magic.

When we talk about the Lakers' glitz and glamour, their uniquely Hollywood aura, we're really talking about Magic. Sure, the Lakers were winners from the moment they touched down in L.A. in 1960, helmed by Jerry West (a.k.a. Mr. Clutch) and Elgin Baylor, the league's first high-flyer, progenitor of Dr. J and Michael Jordan. Wilt Chamberlain landed in 1968—the first superstar to force his way to L.A.—and helped secure the city's first NBA title, in 1972. But it's the Showtime Lakers who made championship parades a habit (with five in a nine-year span), and it's Magic who embodies everything we think about when we think about the Lakers: the charisma, the charm, the pretty passes, the joyful gait, the movie-star smile. And yeah, the winning.

It's an image that enchanted a young Kobe Bryant, growing up in Italy and later the Philadelphia suburbs, one he wanted to emulate from his earliest days. And so when the time came to turn pro in 1996, Bryant maneuvered his way to L.A (through much backdoor politicking and manipulation by his representatives). O'Neal, a consummate showman himself—a part-time rapper and actor and gifted pitchman—chose the Lakers that same summer. Almost instantly, the

Lakers were contenders again, as if it were fated. Manifest destiny.

I joined the Lakers beat a year later, almost by accident, having no idea what I'd stumbled into. I can tell you this: It was never boring. Shaq tortured opposing centers, dunked harder than any human in history, gave himself clever nicknames, mocked rivals with glee and flashed a disarming smile just often enough to remind you: It's all just showbiz. Kobe channeled his idol Michael Jordan, alternately dissecting defenses and soaring over them, dazzling us all with his ferocity, his footwork, his creativity and his relentless drive. When they weren't raising trophies, Shaq and Kobe were sniping and snarling and trying to drive each other out of town. (See, drama. Always drama.) When they were in sync, they were brilliant, a uniquely devastating one-two punch that, as Shaq would often tell us, ranked as the greatest center-guard duo in NBA history. Their feuds were just as spectacular, just as legendary. Phil Jackson alternately played mediator and provocateur, lending another complex layer to this Hollywood saga.

You'll find some of those tales in the chapters that follow, tucked into the witty works of Jack McCallum, who documents both the highs ("The Shaq Factor") and the lows ("The End") of the Shaq-Kobe era; while Phil Taylor captures Shaq at his most joyful ("Big Time"). Years after the partnership disintegrated, Bryant's single-minded drive powered the Lakers back to glory, as expertly chronicled by Chris Ballard ("Satisfaction"). Frank Deford, as poetic a sportswriter as has ever lived, lends his graceful prose to the effortless artistry of Elgin Baylor ("A Tiger Who Can Beat Anything") and the enduring legend of Wilt Chamberlain at 50 ("Doing Just Fine, My Man"). Jerry West, as driven and anguished as the Lakers' chief architect as

he was as a player, is expertly profiled by the great Gary Smith ("Basketball Was the Easy Part"). And of course, there's Magic, the irrepressible virtuoso, driving the Lakers to the title as a rookie ("Arms and the Man," by John Papanek) and later conquering the hated Celtics ("Finally, A Happy Laker Ending," by Alexander Wolff).

In my own time on the NBA beat, I've been privileged to cover some of the most transcendent talents to grace the court—from Shaq and Kobe to Allen Iverson to Tim Duncan, to Dirk Nowitzki, to Kevin Garnett, to LeBron James, to Kevin Durant, to Stephen Curry. The great ones don't just dazzle and entertain and win, they make you *feel* something, like you've been witness to something special. Every superstar has a story to tell, a journey that shaped him, all the trials and tribulations and setbacks and doubts that shape a professional career. You can find similar themes linking the legends of every era, regardless of team or city or uniform. It's just that, the Lakers' trials and tribulations somehow always seem bigger, more spectacular, more dramatic, as if their annual story arcs were indeed scripted in a Hollywood studio. At their best or at their worst, they're always compelling.

Which is why when Commissioner David Stern was asked once, back in the waning days of the Kobe-Shaq era, who would be the ideal Finals matchup, Stern answered simply: "The Lakers against the Lakers." •

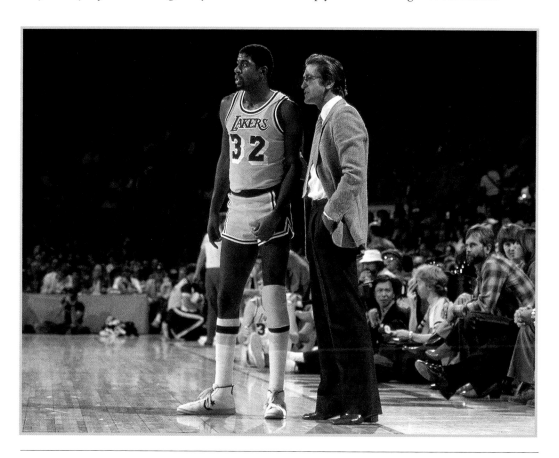

Earvin (Magic) Johnson and Pat Riley brought "Showtime" to Los Angeles—and changed the NBA forever.

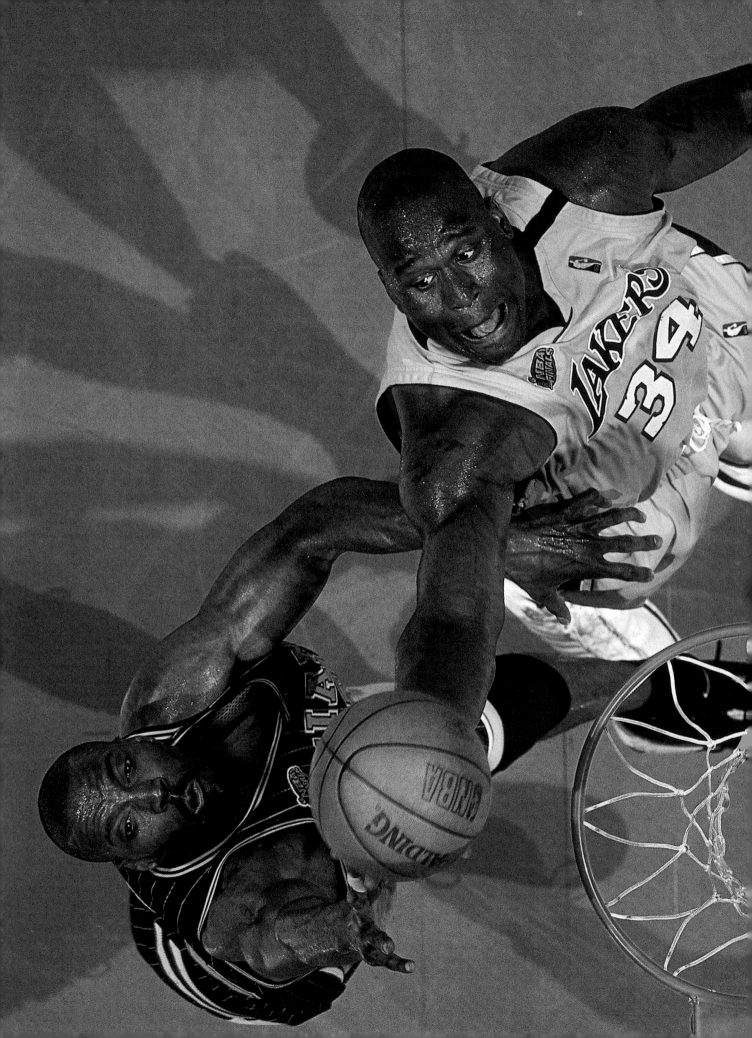

Shaquille O'Neal grabs a rebound over Indiana's Dale Davis during Game 2 of the 2000 NBA Finals.

THE PLAYERS

A succession of stars helped turn the Lakers into one of the NBA's premier franchises. These are the 11 men whose banners hang in the rafters of Crypto Arena

KOBE BRYANT

- » Guard 1996–2016
- » Five-time NBA champion
- » Eighteen-time NBA All-Star

Inarguably the most beloved Laker of his generation, wunderkind Kobe Bryant was acquired by L.A. on draft night in 1996. That same summer, the franchise signed Shaquille O'Neal, and the dynamic duo soon formed the nucleus of a team that claimed three straight NBA championships. After O'Neal was traded to Miami in 2004, the Lakers retooled around Bryant, and the guard led them to two more titles in 2009 and 2010. The franchise leader in career points, games, minutes, field goals, three-pointers and steals, Bryant's impact on the Lakers, the city of Los Angeles and the NBA itself is hard to overstate. When the team retired his jersey numbers in 2017, Earvin (Magic) Johnson made his opinion known, saying Bryant was "the greatest who's ever worn the purple and gold."

Bryant soars against the 76ers in 2000.

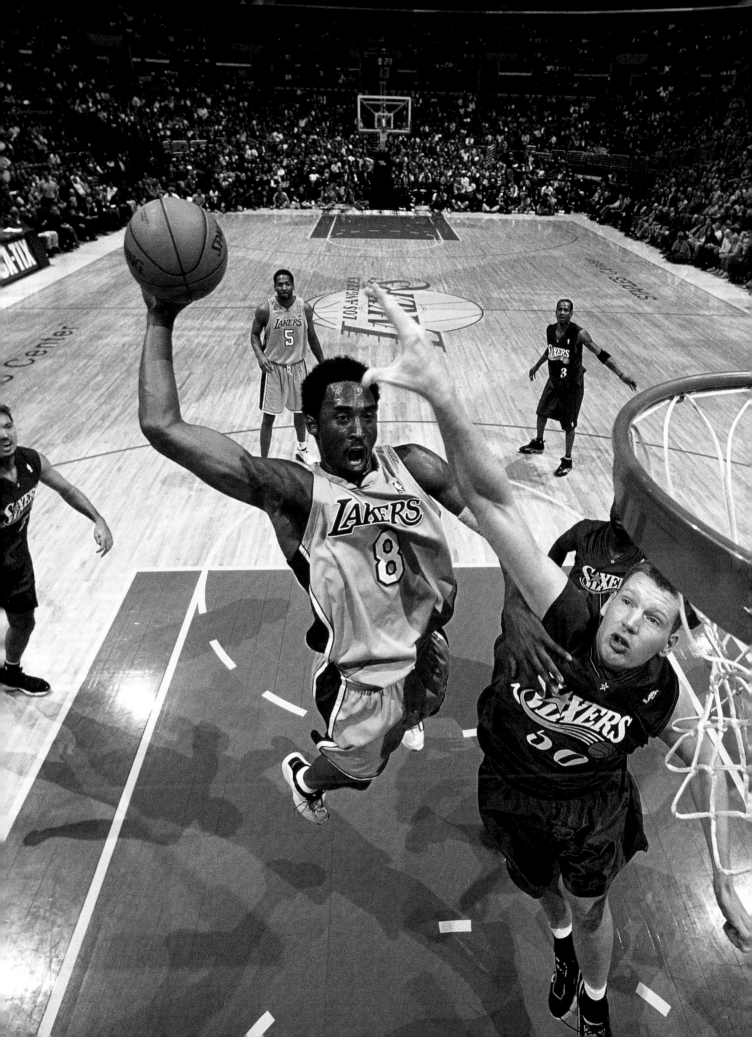

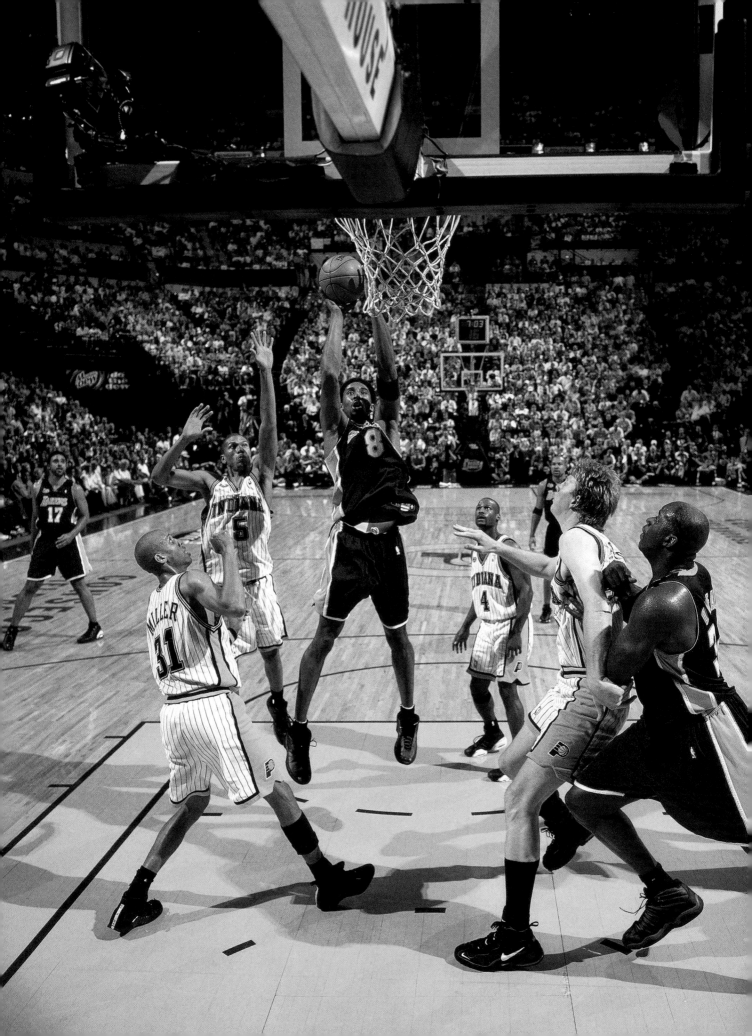

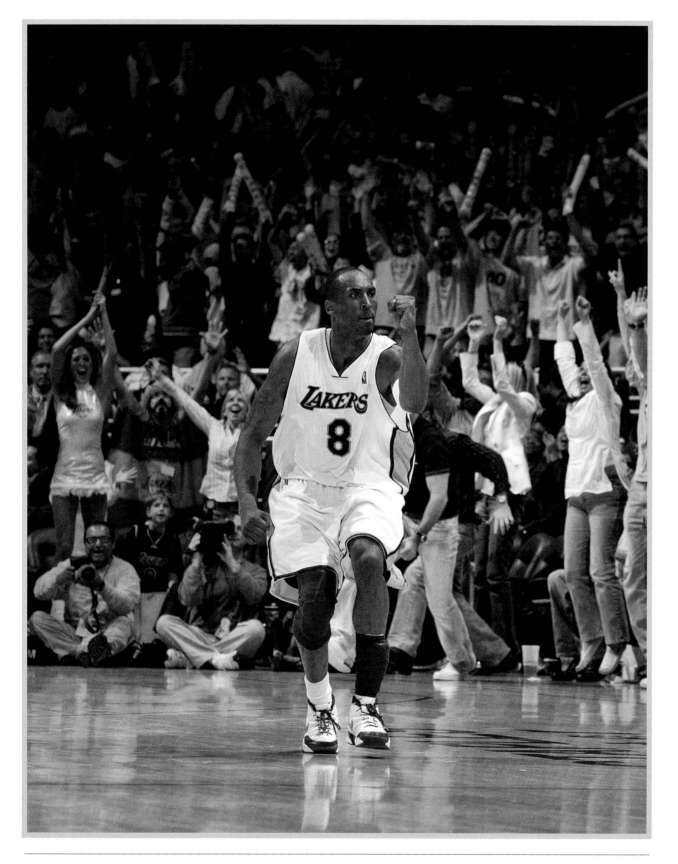

Opposite: Bryant shoots against the Pacers in Game 4 of the NBA Finals in 2000. Above: Bryant celebrates a victory against Phoenix in the playoffs in 2006.

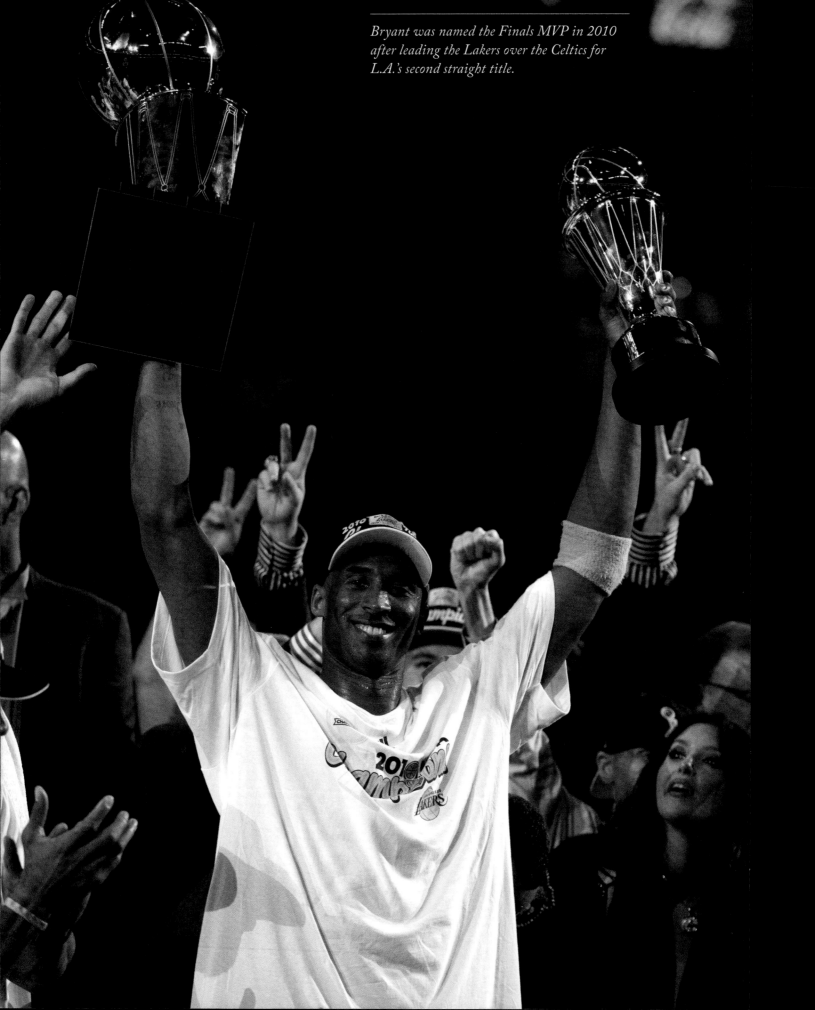

Bryant was named the Finals MVP in 2010 after leading the Lakers over the Celtics for L.A.'s second straight title.

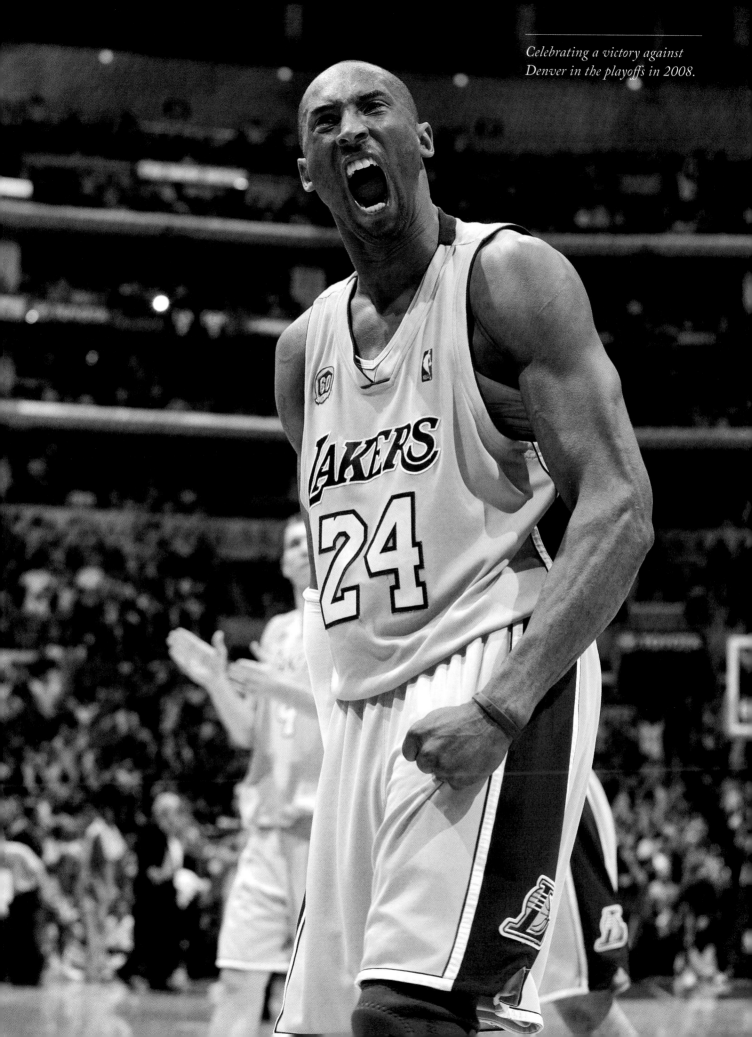

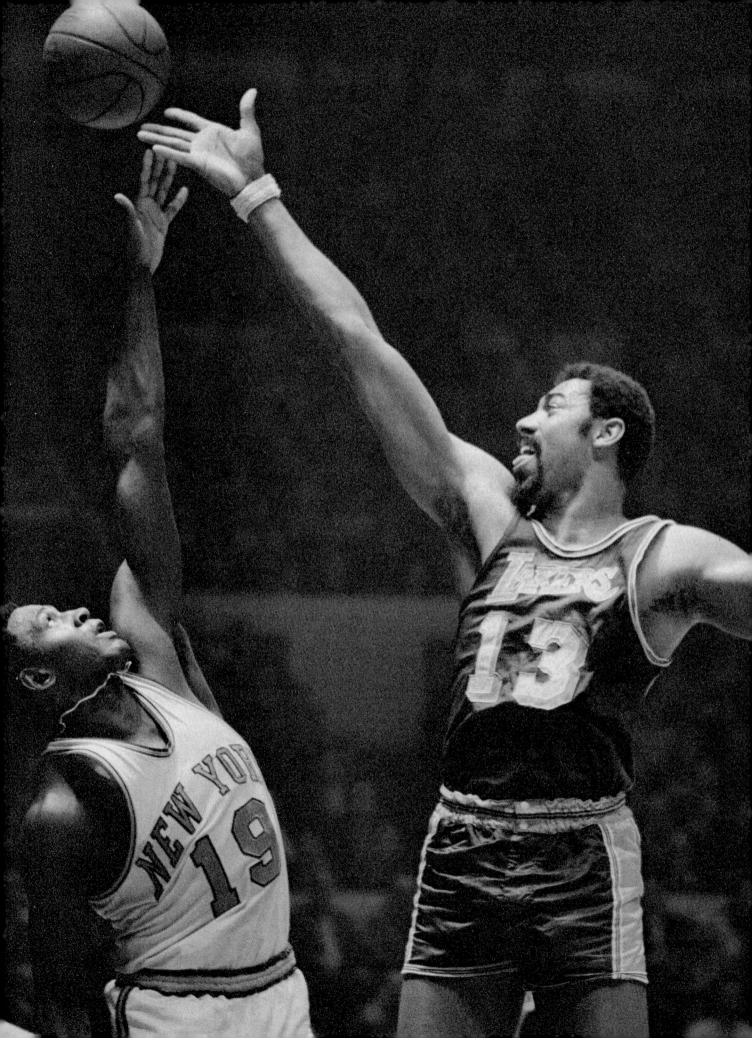

WILT CHAMBERLAIN

» Center 1968–1973

» NBA Finals MVP (1972)

» Four-time NBA MVP

Wilt Chamberlain's statistical achievements nearly defy comprehension: famously scoring 100 points in a single game; averaging 50 points per game in 1961–62; and seven times averaging at least 30 points and 20 rebounds in a single season. Wilt the Stilt was already a legend and a champion when he arrived in L.A. in 1968, and he teamed with Jerry West and Elgin Baylor to lead the Lakers to back-to-back NBA Finals. Both trips, however, were losing efforts, and by 1971–72, many questioned whether Chamberlain would ever win again. But that season, despite Baylor's retirement, Chamberlain and the Lakers won an NBA-record 33 straight games during the regular season and defeated the Knicks in the Finals to bring Los Angeles its first NBA championship.

Even Hall of Fame players such as New York's Willis Reed were physically overmatched against Chamberlain.

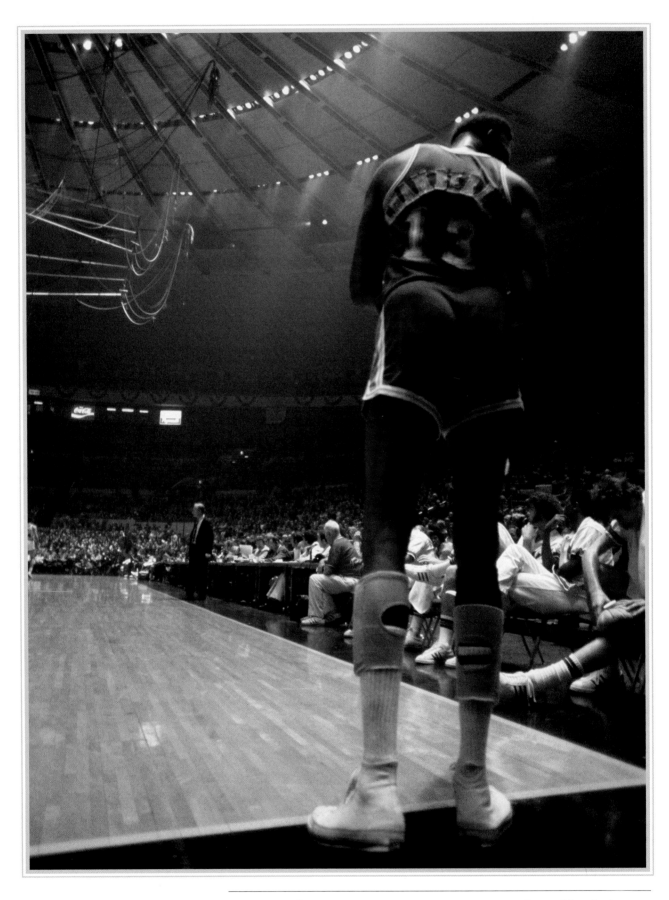

Opposite: Chamberlain rises over Knick Jerry Lucas. Above: Chamberlain surveys the court at Madison Square Garden in 1972.

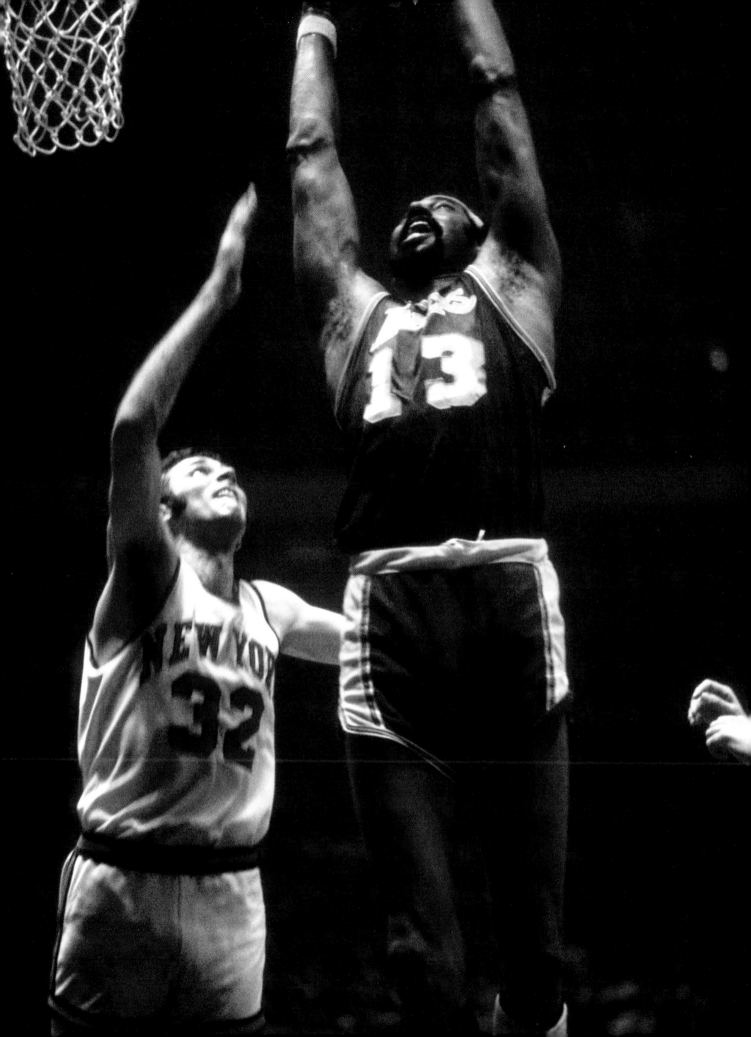

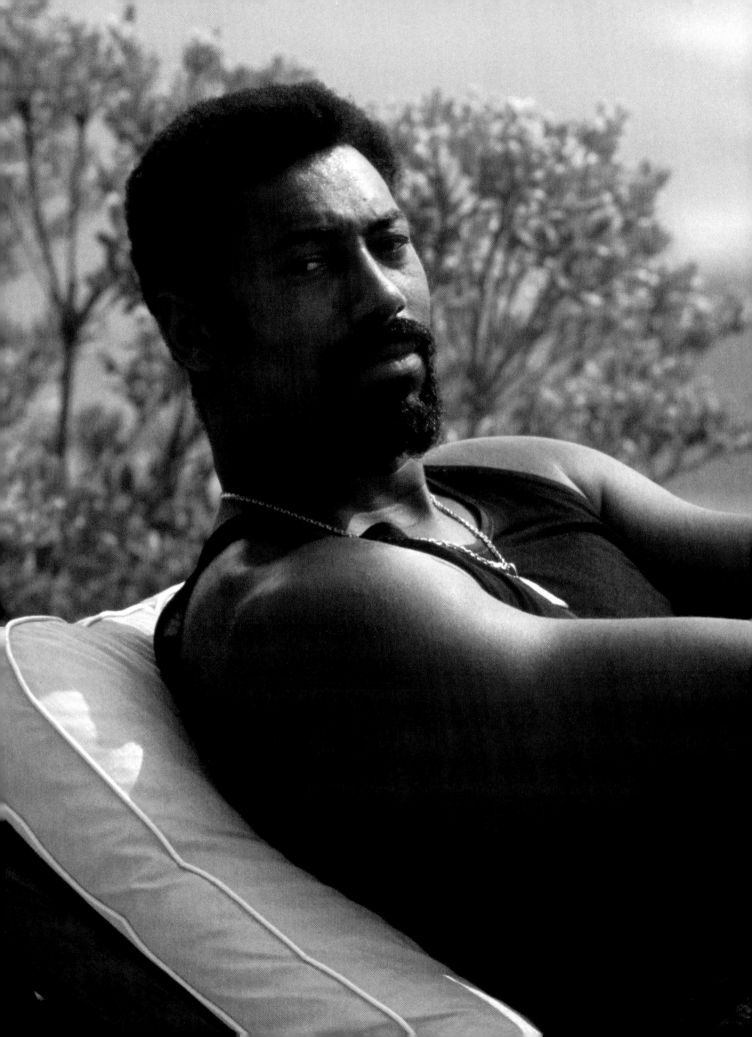

ELGIN BAYLOR

» Forward 1958–1972

» Eleven-time All-Star

» Ten-time All-NBA First Team

One of the greatest all-around performers in league history, Elgin Baylor spent his entire playing career with the Lakers. Selected with the first pick in the 1958 NBA Draft, Baylor was an immediate sensation, winning the league's Rookie Of The Year Award and leading his team to the NBA Finals, where they fell to the Boston Celtics and launched a rivalry that continues to this day. In addition to being credited with modernizing the league's style of play with his incredible athleticism, Baylor was also an advocate for Black players of his era, once refusing to play a game in West Virginia after the team's hotel refused to accept him and two of his teammates. When pushed to play, Baylor said, "I'm a human being. I'm not an animal put in a cage and let out for the show. They won't treat me like an animal."

Baylor followed the team from Minnesota to L.A.

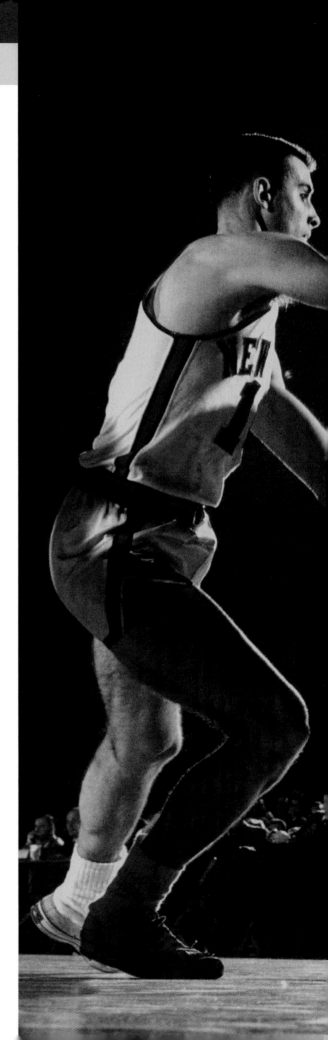

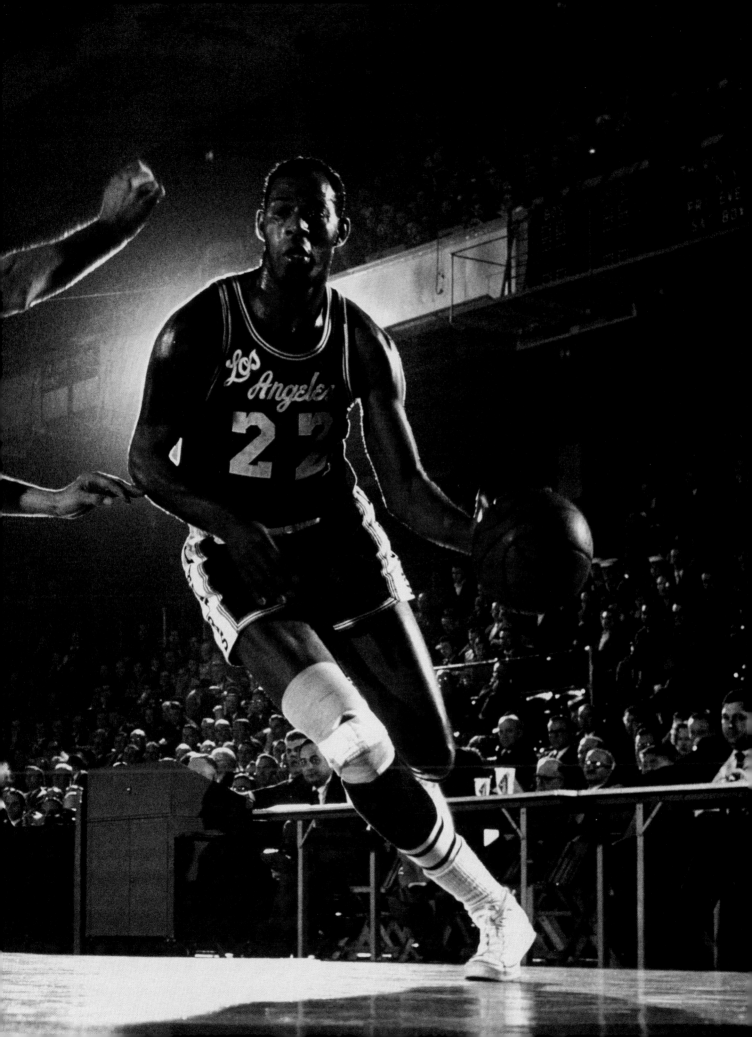

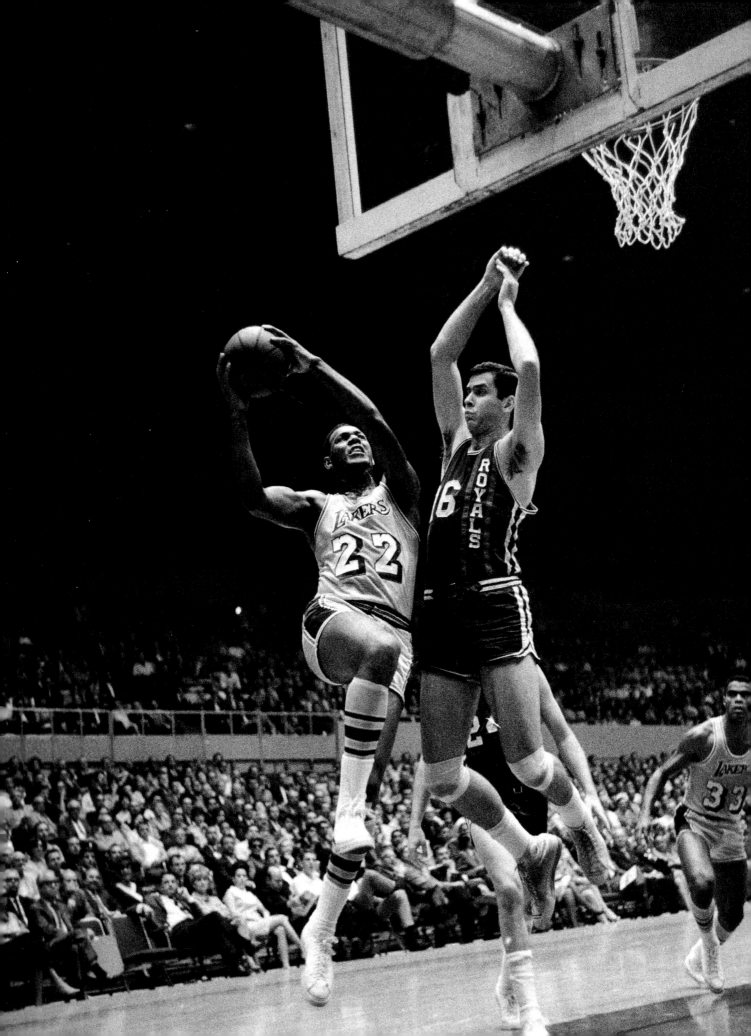

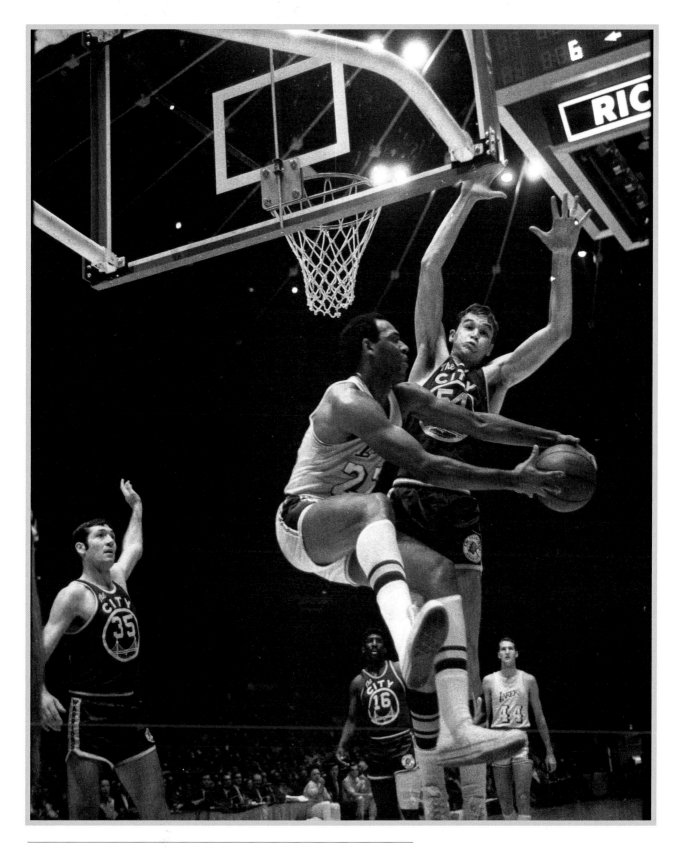

Opposite: Baylor drives to the basket against Cincinnati's Jerry Lucas in 1967. Above: The Lakers forward is credited with bringing a new level of athleticism and creativity to the NBA.

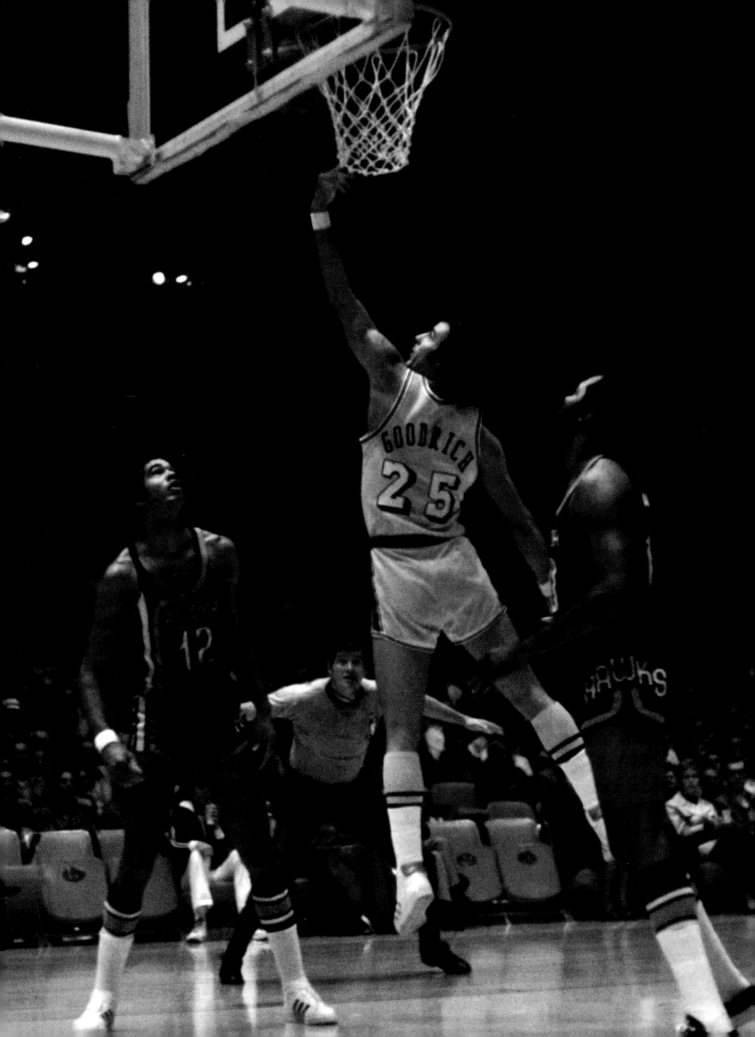

GAIL GOODRICH

» Guard 1965–1968, 1970–1976

» NBA champion (1972)

» Five-time NBA All-Star

Believed by some to be neither tall nor strong enough for the NBA, Gail Goodrich won two NCAA championships at UCLA playing for John Wooden. After three up-and-down seasons in L.A., Goodrich joined the Phoenix Suns for two years before being traded back to the Lakers. In 1971–72, Goodrich was the leading scorer on a Lakers team that won 33 straight games and the NBA championship. Despite playing alongside more heralded teammates such as Jerry West and Wilt Chamberlain, Goodrich was L.A.'s leading scorer in four consecutive seasons. He was inducted into the Basketball Hall of Fame in 1996.

Goodrich was the leading scorer on one of the greatest regular-season teams in league history.

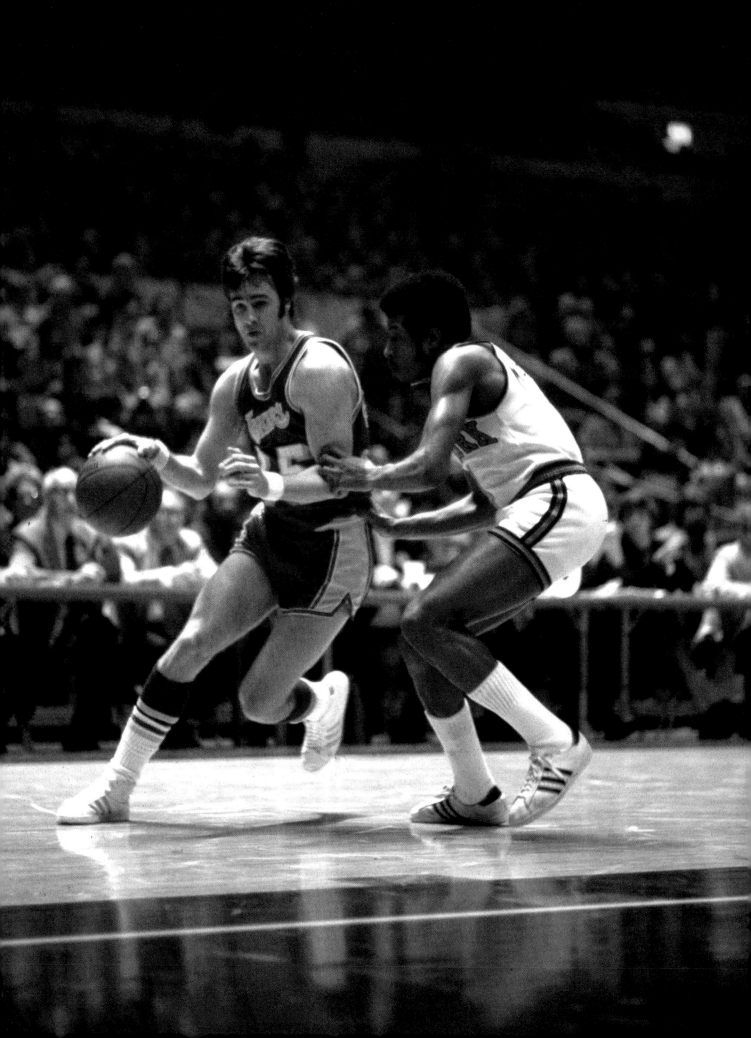

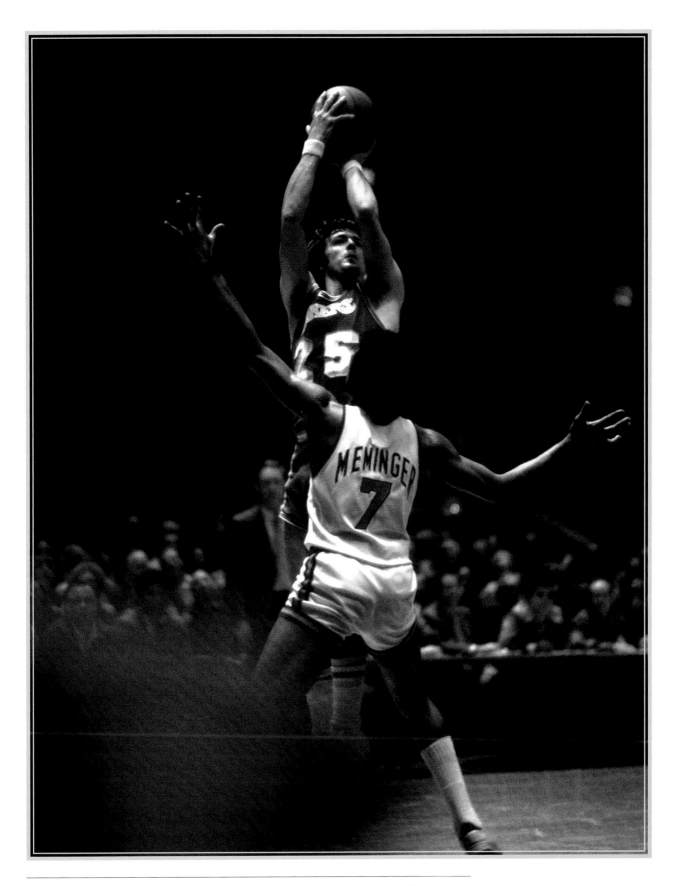

Goodrich drives (opposite) and fires (above) against New York's Dean Meminger in 1972, the year the Lakers set an NBA record with 33 straight victories.

EARVIN (MAGIC) JOHNSON

» **Point Guard 1979–1991, 1996**

» **Five-time NBA champion**

» **Three-time NBA MVP**

Basketball had never seen a player quite like Earvin (Magic) Johnson. Exceptionally tall for a point guard at 6'9", Johnson was the first overall selection in the 1979 NBA Draft. That season he won the league's Rookie of the Year Award and guided the Lakers to the NBA title, the first of five he'd win in L.A. His flamboyant and electrifying style on and off the court ushered in the era of "Showtime" in Los Angeles and changed the NBA forever. Johnson retired in 1991 after contracting HIV, but has continued to be an ambassador for the game of basketball ever since.

At 6'9", Johnson revolutionized the point guard position.

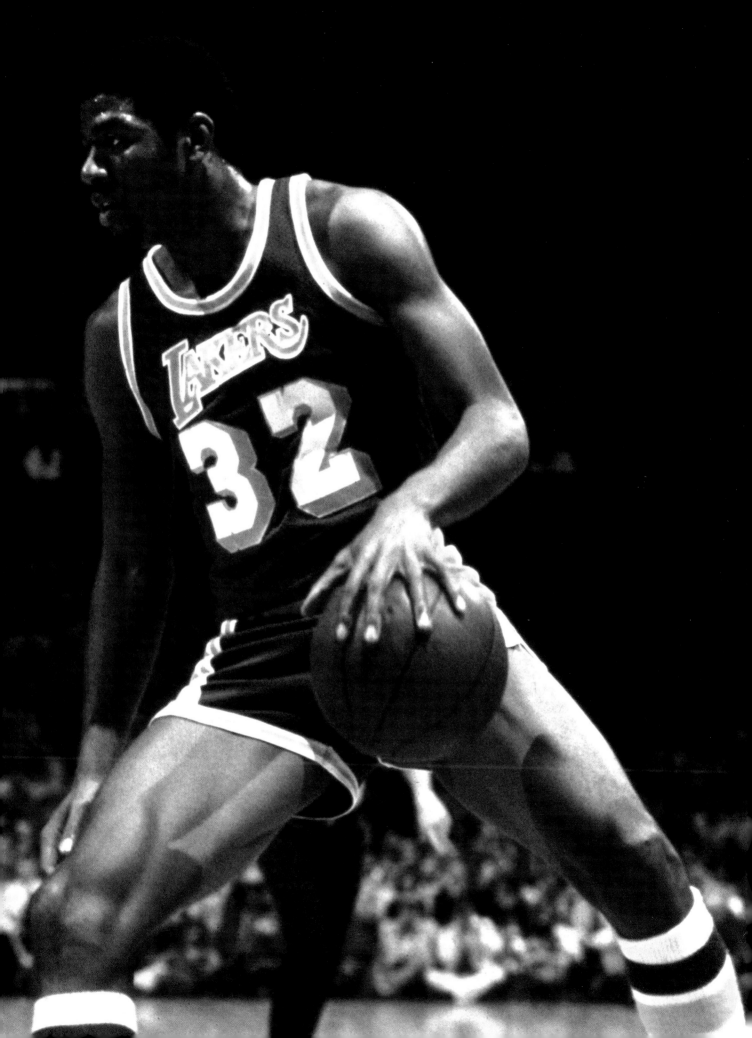

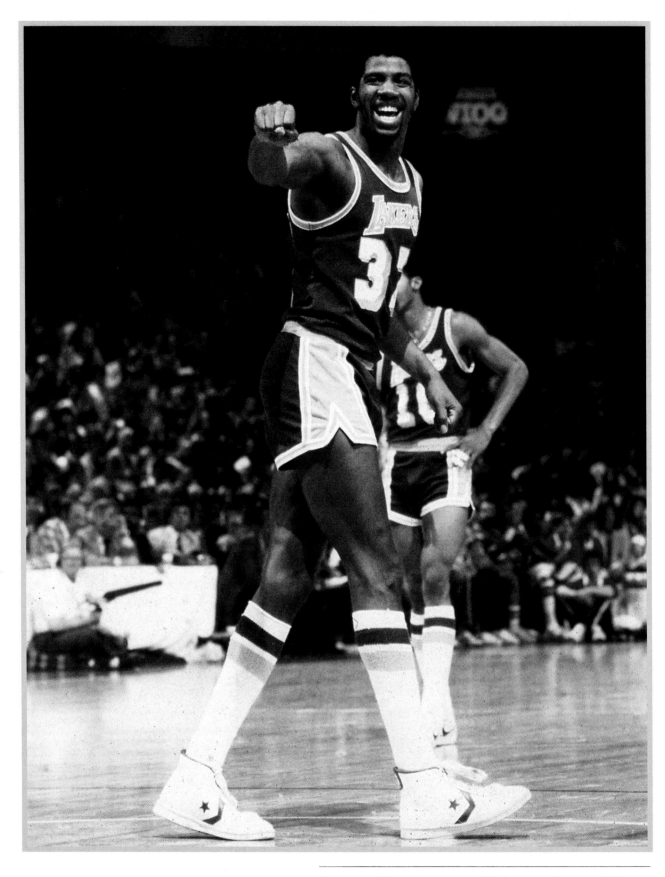

Opposite: Johnson scores over the 76ers in Game 6 of the
1980 NBA Finals. Above: His talent, charisma and
movie-star smile were a perfect match for Los Angeles.

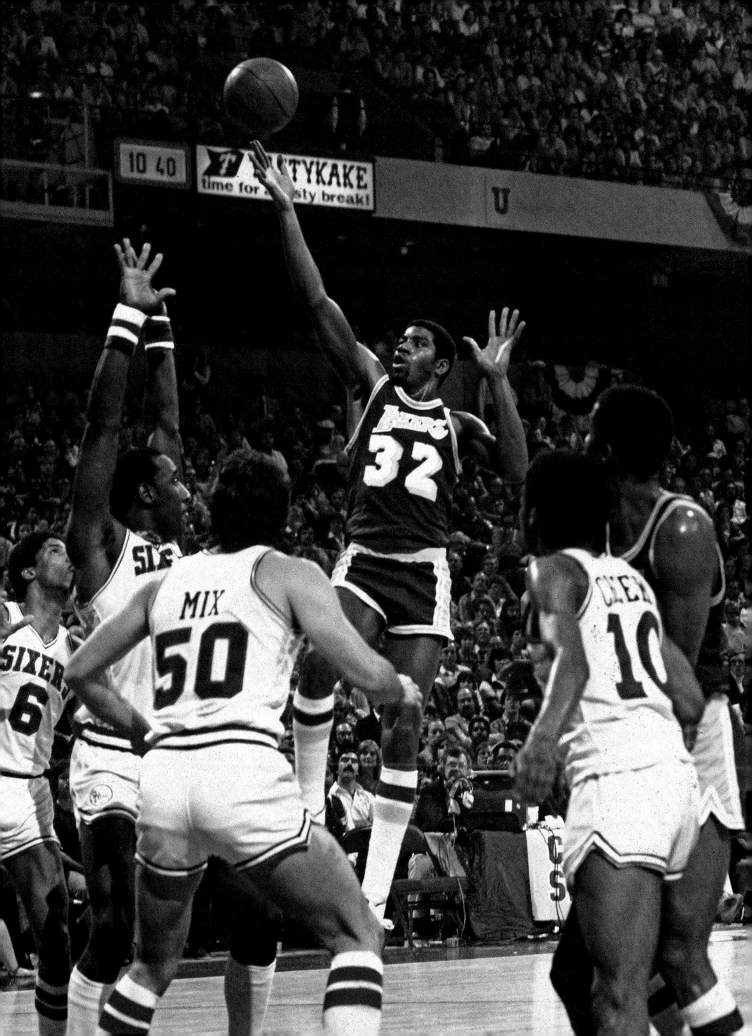

KAREEM ABDUL-JABBAR

- » Center 1975–1989
- » Six-time NBA champion
- » Six-time NBA MVP

Like Wilt Chamberlain in the previous decade, Kareem Abdul-Jabbar was already an NBA champion by the time he was traded to the Lakers, in 1975. He brought his sky hook and interior dominance with him from Milwaukee, winning the NBA MVP Award in his first season in L.A., and once Earvin (Magic) Johnson joined the team in 1979, the "Showtime" era had begun. Perhaps the most accomplished player in league history, Abdul-Jabbar remains the NBA's all-time leading scorer and was a 19-time All-Star, a two-time NBA Finals MVP and a 10-time All-NBA First Team selection. He was inducted into the Basketball Hall of Fame in 1995.

Abdul-Jabbar towered over opponents during his 14 seasons in L.A.

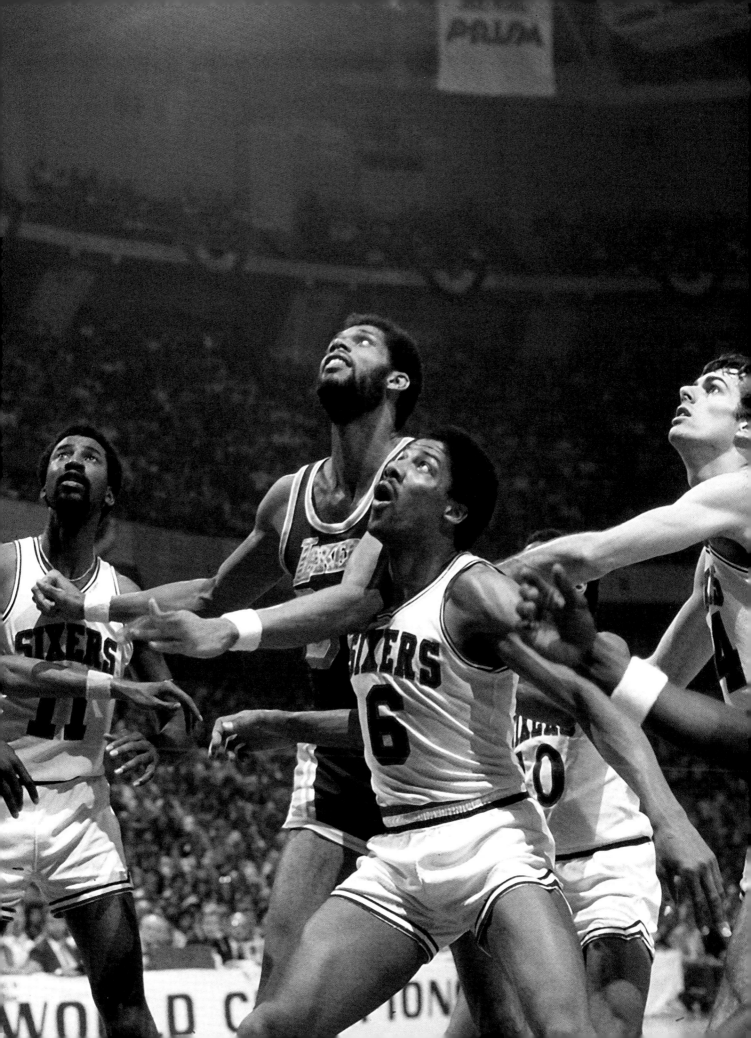

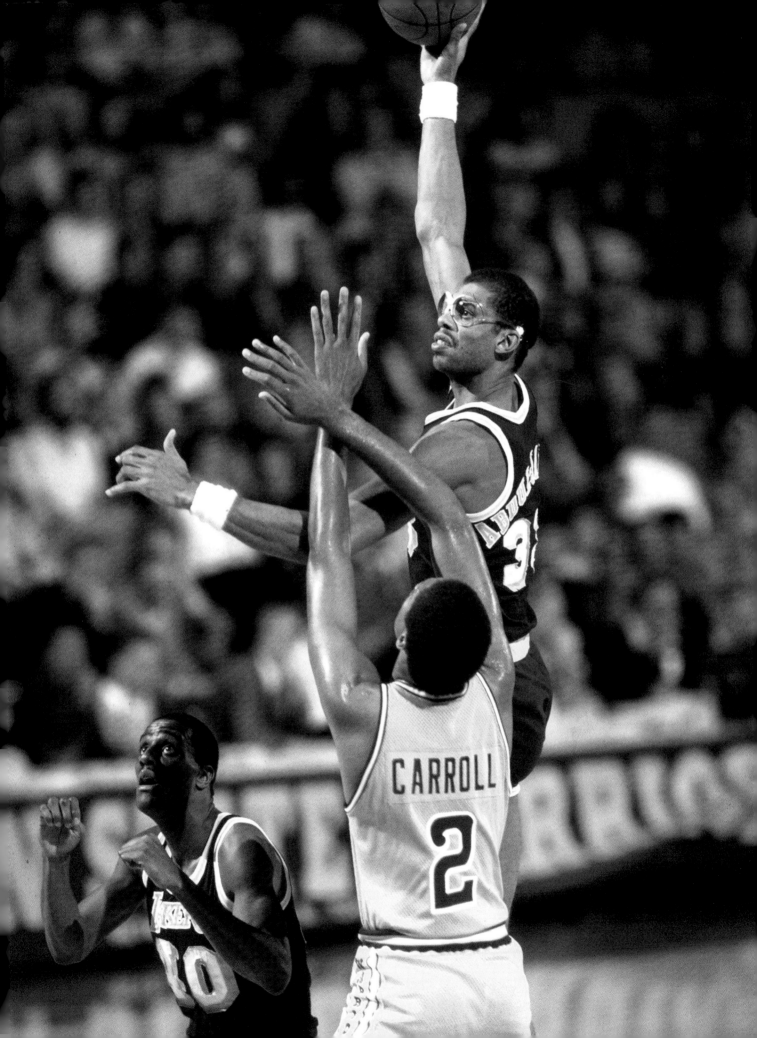

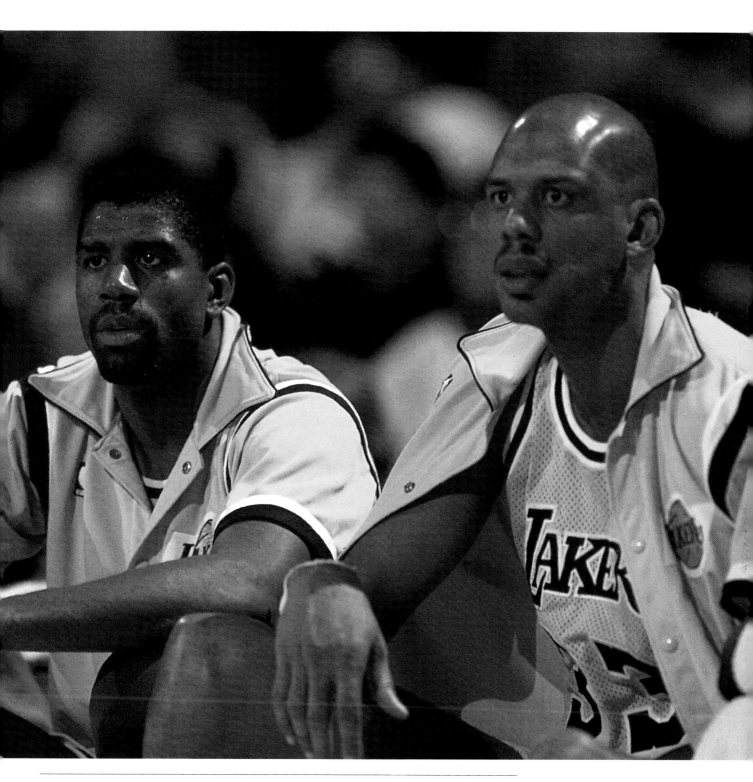

Opposite: Abdul-Jabbar's sky hook is one of the most identifiable shots in NBA history.
Above: The center and Earvin (Magic) Johnson won five NBA championships together in the 1980s.

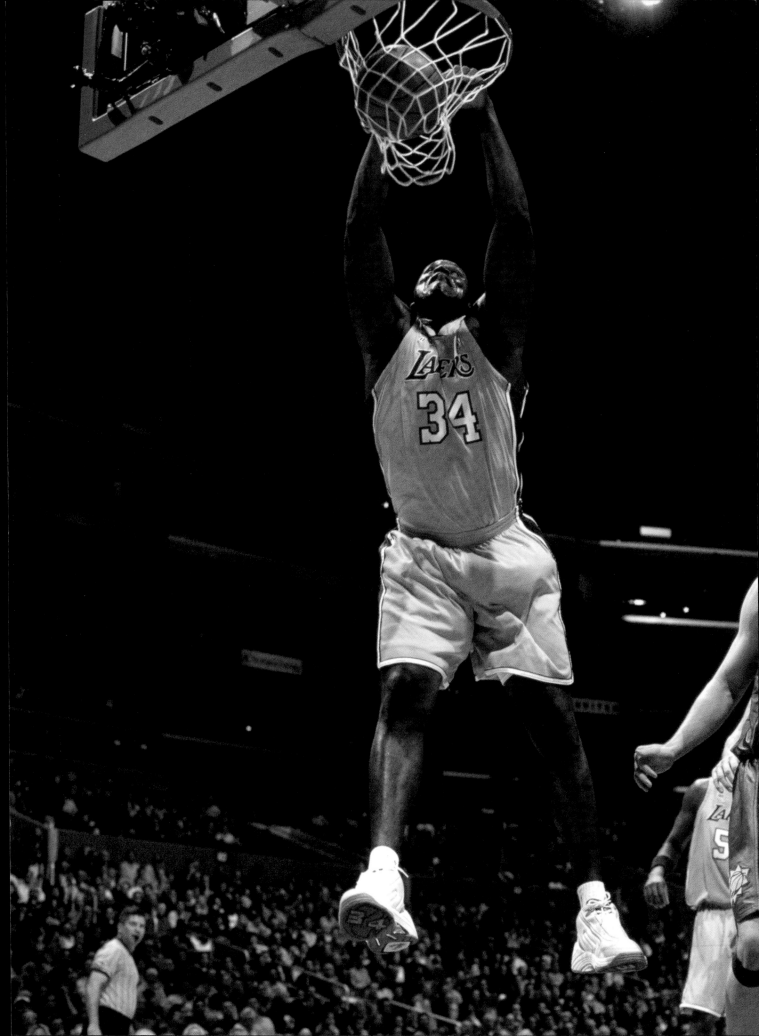

SHAQUILLE O'NEAL

- » Center 1996–2004
- » Four-time NBA champion
- » Three-time NBA Finals MVP

Another in a long line of dominant Lakers big men, Shaquille O'Neal was signed as a free agent in 1996, the same summer the team acquired a teenager named Kobe Bryant. It took four seasons and the arrival of head coach Phil Jackson to fully unlock the duo's potential, but the result was three consecutive NBA championships from 2000 to 2002. A larger-than-life character on the court and off, O'Neal was a fan favorite who retired as a 15-time All-Star, an eight-time All-NBA First Team selection and a two-time scoring champion. He was inducted into the Basketball Hall of Fame in 2016.

O'Neal scored more than 17,000 points as a Laker, many of them on dunks.

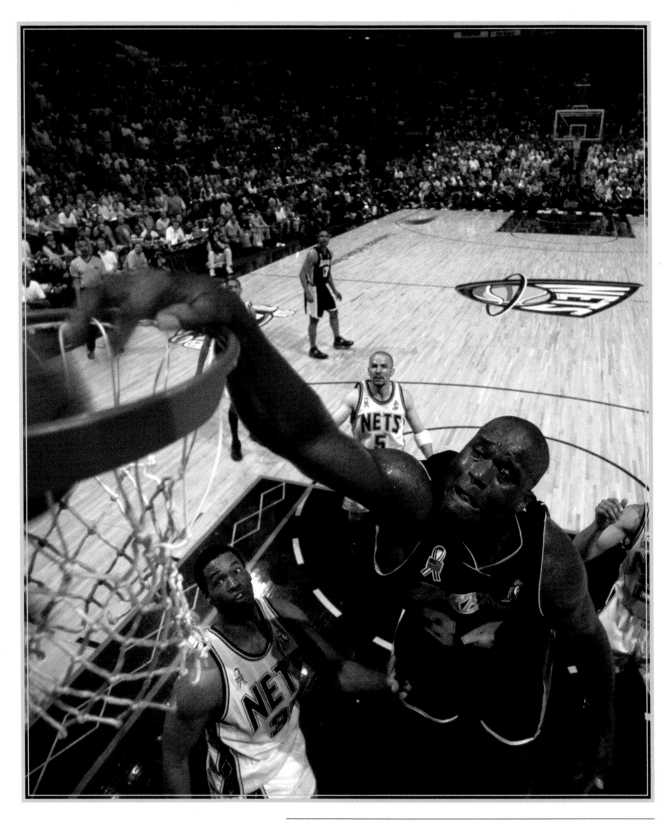

Opposite: O'Neal physically dominating opponents was a regular sight during his years in L.A. Above: O'Neal slams one home against New Jersey during the 2002 NBA Finals.

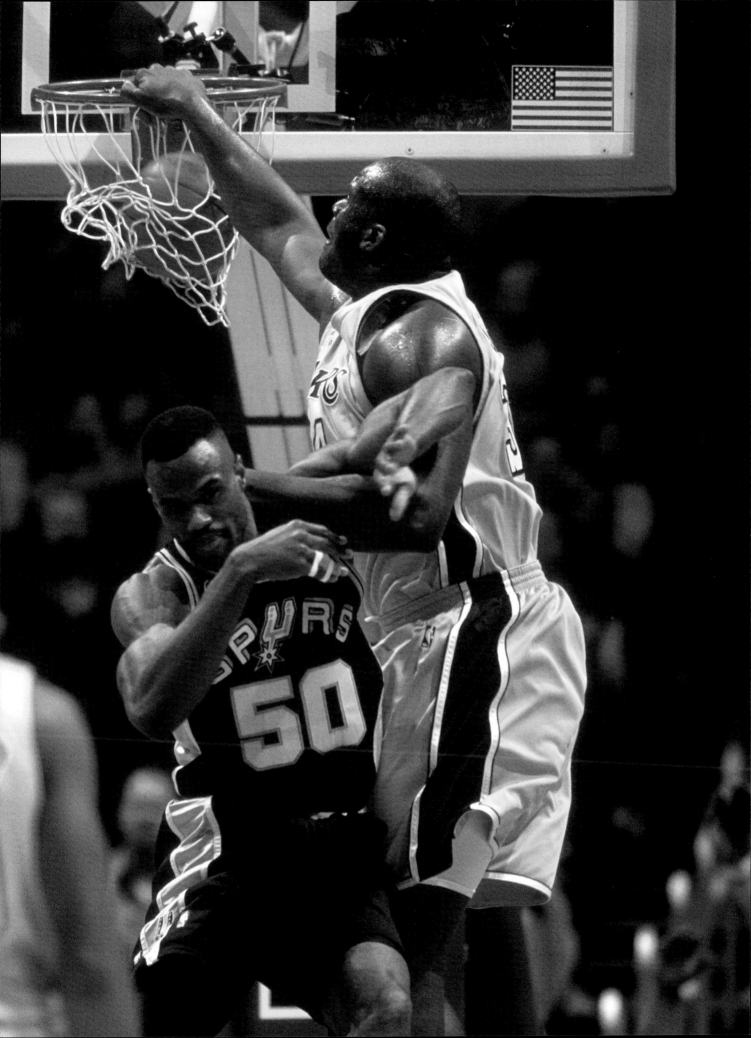

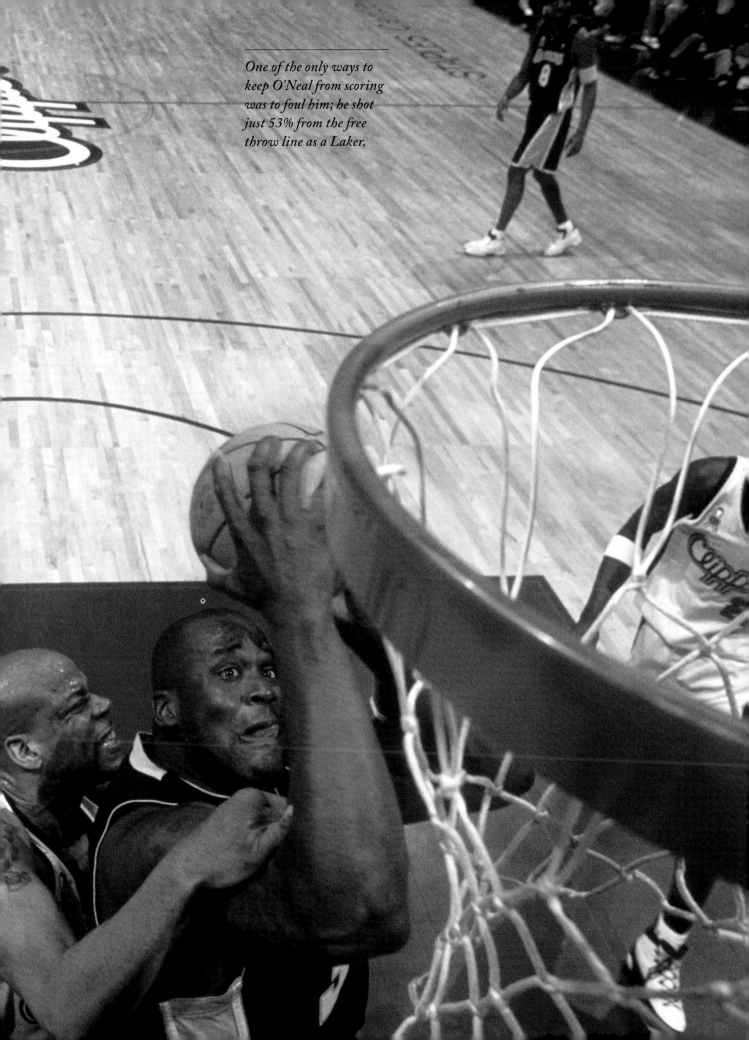

One of the only ways to keep O'Neal from scoring was to foul him; he shot just 53% from the free throw line as a Laker.

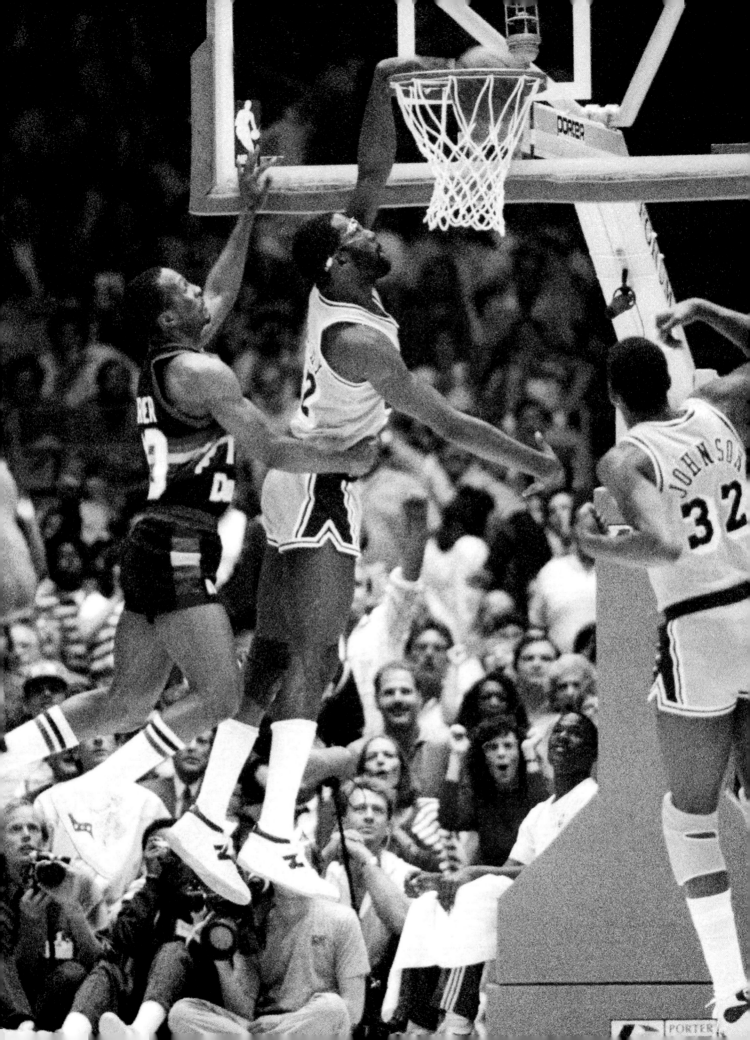

JAMES WORTHY

» **Forward 1982–1994**

» **Three-time NBA champion**

» **NBA Finals MVP (1988)**

A consensus All-American and NCAA champion at the University of North Carolina, James Worthy would have begun his NBA career as the featured attraction on most NBA teams. But on a Lakers team already featuring the "Showtime" tandem of Earvin (Magic) Johnson and Kareem Abdul-Jabbar, Worthy had to settle for being an integral part of the NBA's most exciting offense. A frequent beneficiary of Johnson's passes on L.A.'s fast breaks, Worthy was named to seven consecutive All-Star teams and played a key role in the Lakers-Celtics rivalry throughout the 1980s. In the Lakers' final championship season of the decade, Worthy was named the Finals MVP after posting a triple-double in Game 7 against the Detroit Pistons.

Worthy was often the finisher on a Lakers fast break.

Opposite: Worthy, sans his usual goggles, scores over Washington's Greg Ballard in 1983. Above: The small forward won three titles with the Lakers, two of them against Larry Bird's Celtics, in 1985 and '87.

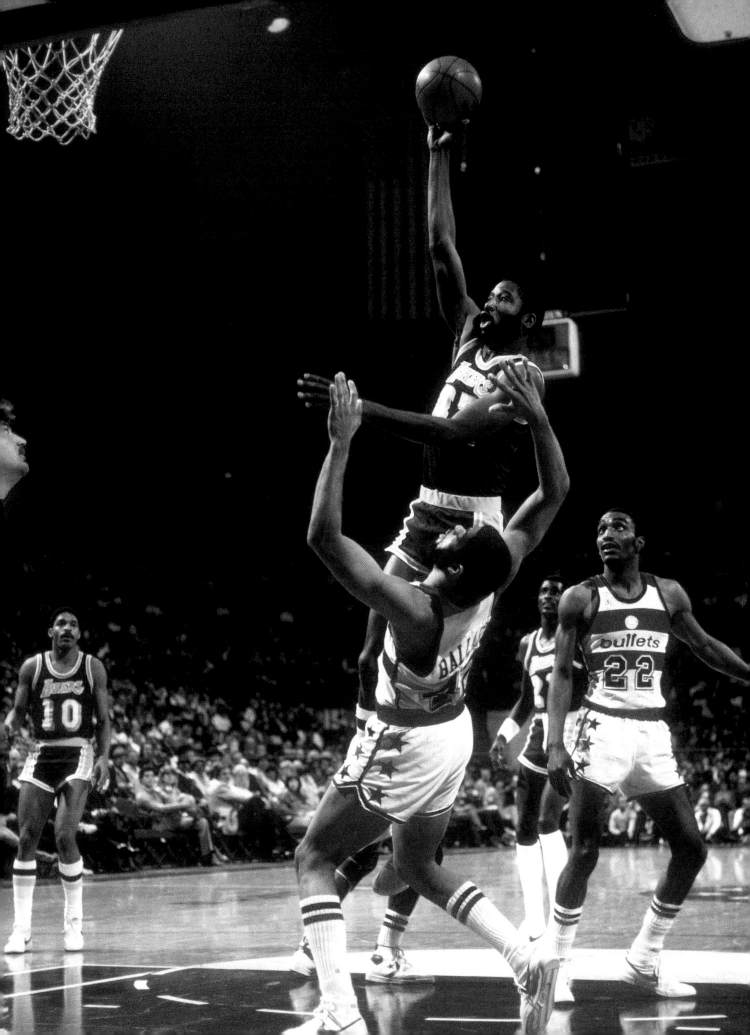

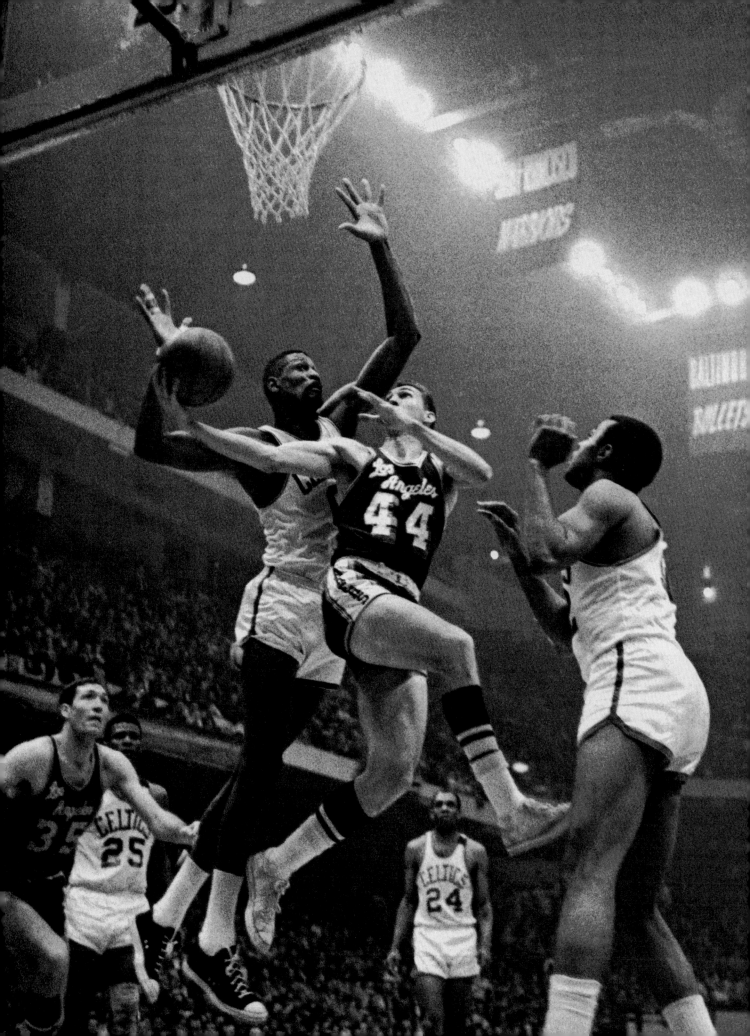

JERRY WEST

» **Guard 1960–1974**

» **NBA champion (1972)**

» **NBA Finals MVP (1969)**

Though widely regarded as one of the greatest players in NBA history, Jerry West's on-court career is often remembered more for its challenges than its triumphs. One of the most hard-nosed competitors of his era, West joined the Lakers in their first season after moving to Los Angeles. Unfortunately, his arrival coincided with the Celtics' ongoing dynasty, and Boston defeated L.A. six times in the NBA Finals between 1962 and 1969. In that final matchup, West averaged nearly 38 points per game and was named the series MVP, becoming the only player from the losing team ever to win the award. West and the Lakers finally won the championship in 1972, the only title of the guard's career. He was inducted into the Basketball Hall of Fame in 1979.

West's quest for a championship was most often thwarted by Bill Russell and the Celtics.

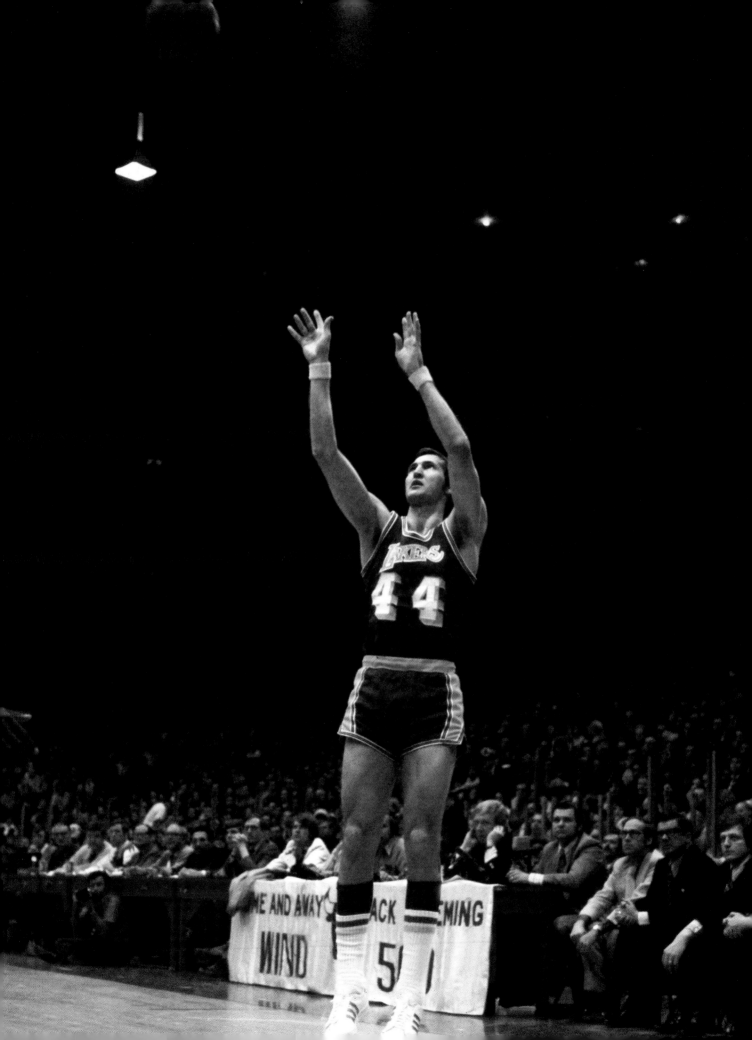

Opposite: West takes a jumper against Chicago in 1972. Above: West's connection to the Lakers continued after his playing days, first as a coach and later as the general manager.

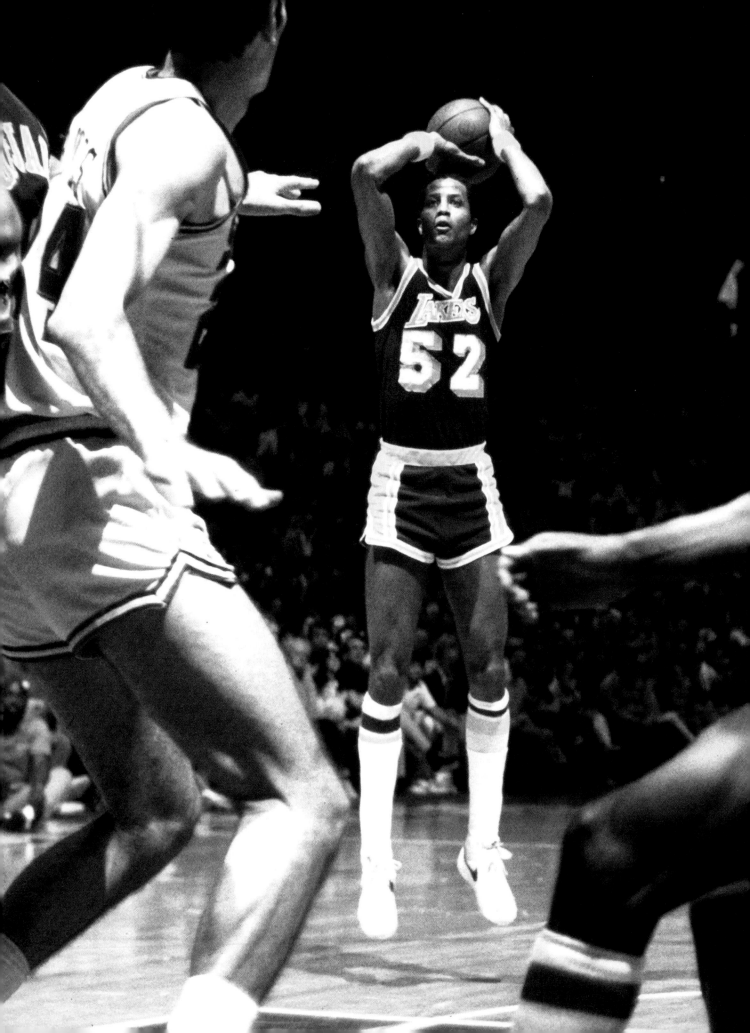

JAMAAL WILKES

- » **Forward 1977–1985**
- » **Four-time NBA champion**
- » **Three-time NBA All-Star**

Jamaal Wilkes won the NBA Rookie of the Year Award and an NBA title in 1974-75 with the Golden State Warriors, and after two more seasons in Northern California he signed with the Lakers in 1977. The lanky and smooth forward nicknamed "Silk" was an ideal fit alongside Earvin (Magic) Johnson and Kareem Abdul-Jabbar, and he helped L.A. win titles in both 1980 and 1982, and was an injured member of the 1985 champions. Perhaps Wilkes's greatest performance came in the clinching Game 6 of the 1980 NBA Finals, when he scored a career-high 37 points against the Sixers; it was somewhat overshadowed by the rookie Johnson's 42-point night as Abdul-Jabbar's replacement at center.

Wilkes won two NCAA championships at UCLA, then four more titles in the NBA.

FRANCIS (CHICK) HEARN

» Broadcaster 1961–2002

For generations of fans, Francis (Chick) Hearn will forever be the voice of the Lakers. Born and raised in Illinois, Hearn became the play-by-play man for the Lakers in 1961 and at one point broadcast 3,338 consecutive games. Known for his staccato style and credited with introducing phrases such as "slam dunk" and "no harm, no foul," Hearn was the first broadcaster ever inducted into the Basketball Hall of Fame in 2003. He passed away in 2002 at the age of 85.

Hearn's career spanned generations, from Elgin Baylor and Jerry West to Kobe Bryant and Shaquille O'Neal.

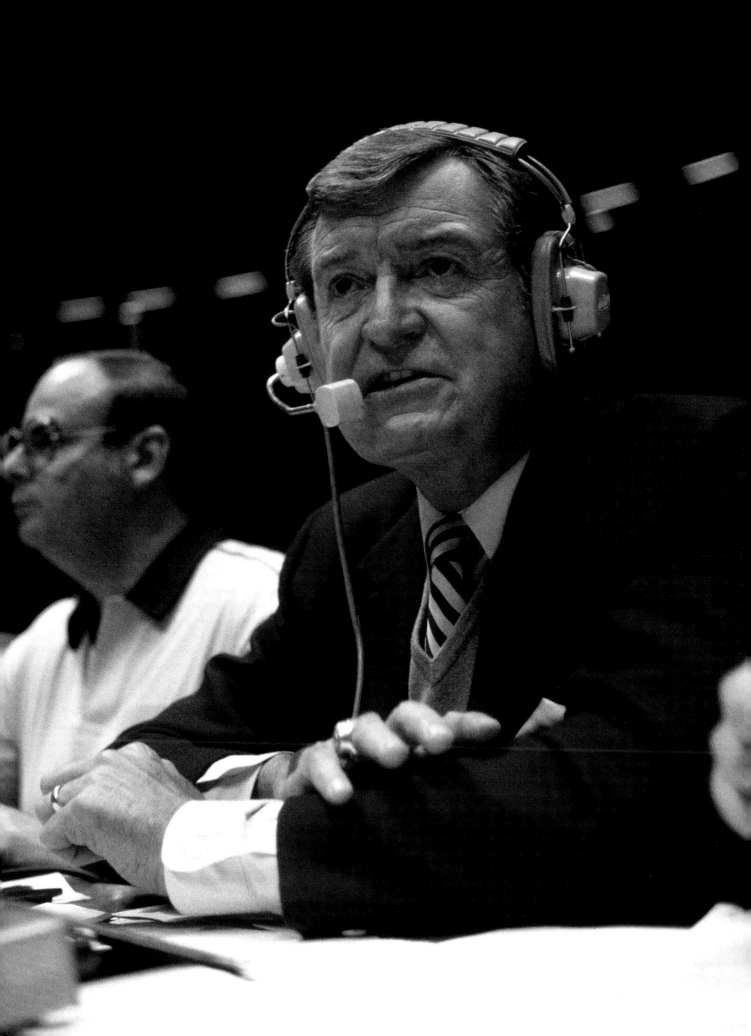

Kareem Abdul-Jabbar walks alone at the Great Western Forum in 1989.

THE STORIES

The Lakers' history is a rich one, filled with great characters and memorable games. SPORTS ILLUSTRATED has written about it extensively over the years

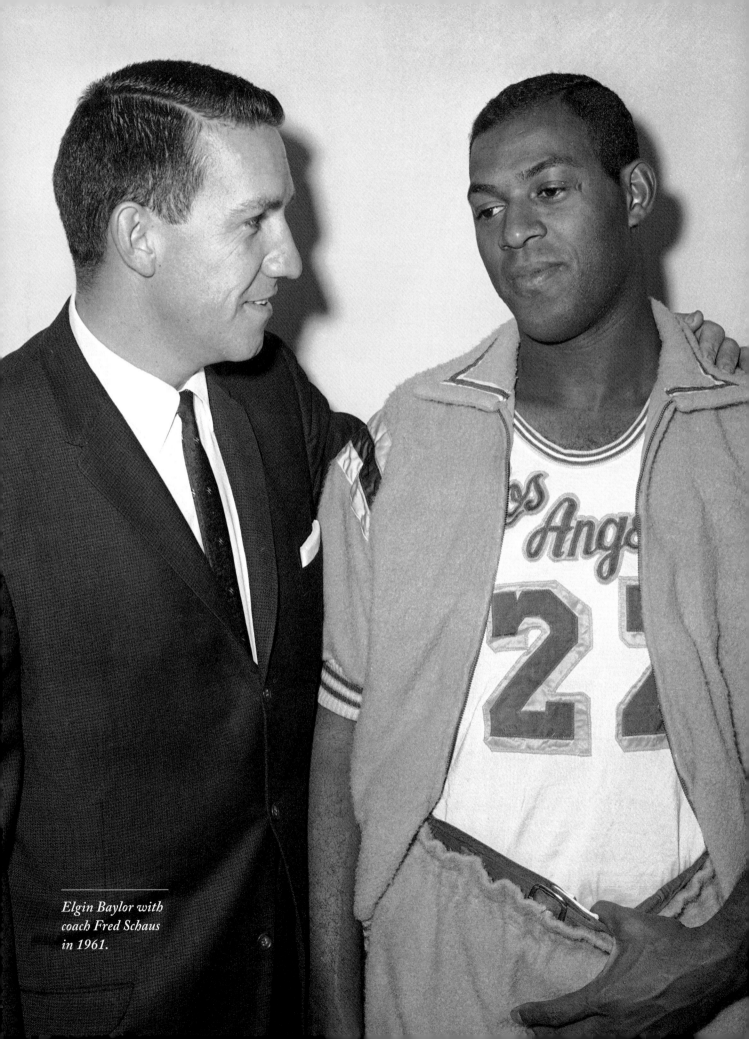

Elgin Baylor with coach Fred Schaus in 1961.

A TIGER WHO CAN BEAT ANYTHING

BY FRANK DEFORD

ELG IS...WELL, I GUESS THE BEST WAY TO PUT IT IS THAT ELG IS THE KIND OF GUY THAT WHEN HE'S NOT around, you know he's not around. —Jerry West.

Elgin Baylor is back, his knees restyled and his magnetic quality reconstituted, so that he is again the player of basketball legend, of his own elegant moves, all smoothness, all power. He is one of a kind; were Elgin Baylor an animal, he would be a satin tiger.

On and off the court, he glides with a regal mien, carrying himself with such élan that it often has been said of him that he must surely descend from the giant black royalty of some Nubian empire.

He dresses, always richly and impeccably, in the soft, tame shades, for he is one of those few who are able to accept simple quality as sufficiently ostentatious by itself.

He is aware of his own great talent and thus is immune to flattery. For he is, above all, a proud man, and one who is determined to secure the dignity of Elgin Baylor as he respects that of others.

Here he is in a game. No matter how the action swirls, his demeanor does not change. There is no apparent emotion and never a word. And afterward he sits, silent among the strangers in the locker room, unmoved by the commotion and the acclaim pressing in on him. Then a shower, and next—with tailor's hands—buttoning a fresh shirt, sliding into custom-made pants and coat. A measured spicing with a brisk new aroma, a fastidious brush at one errant strand of hair, and the leavetaking, again with the regal air. Finally, to the Jaguar and the drive with his wife Ruby to their new home high in the Beverly Hills—Los Angeles spread out below the smog, and Catalina Island 23 miles beyond the telescope in the upstairs front window.

That is the public Elgin Baylor. Now meet Elg—as in those often-heard expressions, "Not

again, Elg!" "I give up, Elg!" and "Shut up,
Elg!" With his Laker teammates Baylor is a
cackling mother hen, an impossible bore, a
show-off, a know-it-all, a needler, a wise guy,
a con man, a put-on, a gamesman, a big-
mouth, an unstoppable mouth and a general
all-round self-proclaimed authority on every-
thing that walks, crawls, flies or just exists.

And he is positively charming. The Lakers
love him. It is unlikely that any athlete has
ever been held in such personal and profes-
sional awe as Baylor is by his teammates.

There are a few outsiders who also are
aware of the Baylor phenomenon. Bill Russell
is one. Last fall, at the San Diego airport
before an exhibition against the Celtics,
the Lakers were discussing their new team
blazers. Among those who cared, the vote
was seven for light blue, Elg for dark blue.
This is a pretty even matchup for a Laker
argument. "Mighty democratic of you,
Mr. Baylor," Russell said, "to let these gen-
tlemen discuss the situation with you." The
Lakers were all fitted for their dark-blue
blazers the next week.

But Elg does not require issues that arise
naturally. He is best at manufacturing his
own. At any time, out of the blue, he may
inquire: "In a race, could a bear beat a leopard?"
or "How many seats in a Boeing 707?" These
are not rhetorical questions. He wants an
argument, but he has his own answers ready,
and they are guaranteed to be outrageous
and arbitrary.

Here he is, in the privacy of the Lakers,
coming through the locker room and talking
as usual. He has a new nickname for someone,
criticism for the alleged tackiness of someone
else's wardrobe ("That's a nice checked coat: I
didn't know Purina was making clothes"), at
least one outrageous new theory, suggestions
on the relative abilities of various animals,
an updated critique on airplane safety and
assorted comments—all opinionated—on

those discussions already in progress ("That
broad? Why, she's older than baseball," has
ended many movie conversations).

Momentarily, he will switch from his
usual, well-mannered speech into an obvious
"he do" Negro dialect. It is as if sometimes
he even puts himself on. At practice, which
he still loves, he cavorts throughout. "Hey,
I got a turkey!" he laughs as soon as he gets
a little man guarding him. One move, rock,
back, fake, rock, up, zoom for the basket.
And badger, roar, scream, fat-mouth, annoy
until back in the locker room. He will still
be talking when he leaves. "One time," says
Walt Hazzard, his friend and teammate,
"he ran his mouth without stopping, five
and a half hours, nonstop, mouth and plane,
Boston to L.A."

"I've roomed with Elg a lot of times,"
Rudy La Russo says, "and he literally talks you
to sleep. You know, he may even talk all night,
because he is going as soon as you wake up.
He talks in Technicolor. He's just one of the
world's great conversationalists." Lou Mohs,
the Lakers' general manager, is on record that
were he stranded on a desert island and had a
choice he would select Baylor for company. It
just seems that however much the invective,
however repetitive the rhetoric or however
aggravating its tenor, Baylor never really irri-
tates the Lakers. It is a phenomenon at least
equal to his court achievements.

Most of last year, of course, it was
different and not much fun. He played when
he could, but it was not Elgin Baylor. His
right knee was a flame with calcium deposits,
but still it was forced to cover for the left,
which was split in two and held together
by tendons reattached through bone holes.
Through almost all of the season he was
a tattered mediocrity, struggling to shoot,
shamed by opponents who scrambled to end
up opposite him. Baylor was scared to move,
afraid that the next time he cut, a knee would

go and it would all end there in a pitiful, writhing heap.

His knees have bothered him for several seasons now. "I wake up and the way they feel I can tell if it is a rainy day," he says. After the '64 season, Dr. Robert Kerlan, the renowned orthopedic, Koufaxedic surgeon, took charge of Baylor to try to strengthen the worn-out knees. "Baylor missed one day that whole summer," Frank O'Neill, the therapist and Laker trainer, says. "And just like Elg, all he wanted that day was to take his little boy to the zoo."

His conscientiousness was rewarded, and Baylor's knees endured the entire '65 season until the first playoff game against Baltimore. Baylor came down for a jump shot. "Something pulled," he remembers. "I didn't know what it was. I forgot about the ball as soon as I felt it. But I could run. I went up and down the court a few times, but it hurt so much and I didn't know what it was, so I decided I better get out."

How he ran a single step no one knows. It seemed impossible, because somehow the top third of the left patella had broken

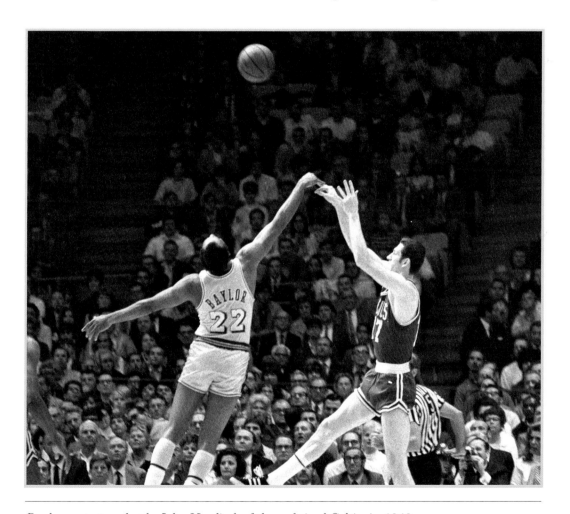

Baylor contests a shot by John Havlicek of the archrival Celtics in 1969.

completely off from the rest of the kneecap. Kerlan operated the very next day, put the knee back together, sewed Baylor up and told him they all hoped he would play again someday.

———————————

This time, the summer of '65, it was not to strengthen a knee; it was, almost, to have one or not. The problem, O'Neill emphasizes, was as much mental rehabilitation as physical. "I'd never broken anything before," Baylor says, "so at first I just didn't know what to think, whether to be scared or what. Dr. Kerlan kept assuring me, but as soon as I'd get some confidence something would go wrong again. Finally I just accepted the fact that I would never play again. I just worried about being a normal person—could I fish or play golf, just

find out right now. I told him that he either had to go out and test it and find out, or otherwise he might as well come over and rest with me."

Baylor took the gamble, and for the balance of the regular season and the playoffs he averaged almost double what he had before—more than 25 points and 14 rebounds a game. "It was an amazing recovery, certainly," Dr. Kerlan says, "but only if you consider it as simply overcoming an injury. The man is often the most important thing, and in view of the sort of man that Elgin is, then maybe we should have even expected it." Baylor has maintained his brilliant spring performance in exhibitions this fall. "I would have to guess," Dr. Kerlan says, grinning, "that Elgin is just not ready to come over and rest with me."

Neither Baylor's wit nor his inherent qualities of leadership were obvious when he joined the Minneapolis Lakers in 1958. But there was not even passing doubt about his basketball ability.

move around ever again? I thought that way. And then, just about then, it all got better." He was in the starting lineup when the season began last October.

It was, however, a sad false promise. Baylor was so unsure and so bad that he overcompensated for the left knee. The right one—still full of calcium—could not accept the stress. Late in November, Kerlan had to put a cast on the *right* leg. Baylor was out for a month, and when he came back he was out of shape, unimproved and more timid.

Finally Kerlan called Baylor to his office one day. "It was about a month before the season ended," the doctor says. "I sat him down and told him it was *now*—he had to

And as Elgin Baylor came back, so too did Elg. By the playoffs he was his gracious old abrasive self again. He rounded up his teammates for a tour of the St. Louis zoo and also thoughtfully provided them with a complete, if rather captious, commentary on all zoo facilities and every animal—bird, mammal and reptile—therein. Another day, as he led the Lakers through dinner conversation at their motel, he suddenly turned to La Russo and, as if it were the most appropriate thing in the world to ask, loudly demanded: "Who'd win in a fight, a lion or a tiger?"

La Russo, taken aback, answered haltingly: "A lion, I guess, Elg."

Baylor, aghast, frowned at La Russo for such abject stupidity. He moved to his dialect

for effect. "A tiger beat anything," was all he said, though with such finality that it hushed the room and sent napkins crashing to the floor. Presently, as Baylor looked on with satisfaction, the entire Laker quarter was filled with earnest speculation on the combat ability of lions, tigers, panthers, elephants and those other creatures that Baylor would interject in lulls in the debate. He also made the final decisions.

On the Lakers his word is, in fact, law—though it is more often of an ex post facto nature. The other Lakers shrug a lot; Baylor is resident arbiter and verbal rule book. Darrall Imhoff introduced cribbage to the Lakers last year. Within 24 hours Baylor was not only adjudicating disputes but was also informing Imhoff how cribbage was traditionally played on the Lakers.

On a plane trip last year Forward Bob Boozer was playing a contemplative game called Categories (or Guggenheim) with Merv Harris, the *Los Angeles Herald-Examiner* basketball writer. In Categories, players must list the names of countries, authors, etc. that begin with certain selected letters. La Russo asked to join. Baylor put down the *Wall Street Journal* and announced that he would join. He lost the first game despite having demanded a time extension. Beginners get more time—new rule. In the next game, under the category of rivers starting with the letter T, Baylor wrote:

"Tanganyika River."

"Tanganyika River!" Boozer screamed in anguish. "Where's that?"

"What you mean, where's that?" Baylor answered coyly. "Buffalo, Noo York." The answer was accepted. He won that game and those that followed.

"We call him the King of Gamesmanship," Hazzard says. Baylor can be so competitive in these games that his famous head twitch—which occurs so often on the court—will show

itself in the heat of cardplaying. And because of his running dialogue, all Laker games are more spirited than classic; losers must suffer the most interesting abuse. "So you see," Baylor says, "that's the idea—don't lose."

Neither Baylor's wit nor his inherent qualities of leadership were obvious when he joined the Minneapolis Lakers in 1958. But there was not even passing doubt about his basketball ability. He had led a mediocre Seattle University team to runner-up in the NCAA the year before, and he promptly became the Lakers' star. For much of the season, though, he remained quiet and diffident, was genuinely terrified of flying and often complained of feeling sick.

Then in January the Lakers went to Charleston, W. Va. for a game with Cincinnati. The hotel clerk, a mousy chap, looked at Baylor, immaculate as always, and at the two other Negroes on the team. "We can't take those three. We run a respectable hotel," is what the little man said. Baylor stiffened. He decided simply that he would not play.

But he made no fuss. The papers did not even know. Some of his teammates called him selfish. As the team walked out of the locker room, one Laker spoke over his shoulder: "Nine of us go out to play; nine of us split the playoff money." Baylor heard, as he was supposed to. He made no reply, and he did not move.

Hot Rod Hundley, a teammate who was from Charleston, came back to implore Baylor. He went through the litany: We Need You; For The Team; Please; This Won't Accomplish Anything Anyway. Baylor listened, and only at the end did he speak. "Rod," he said, "I'm a human being. I'm not an animal put in a cage and let out for the show. They won't treat me like an animal."

For the first time Hundley, the white kid from Charleston, understood the great pride

that lives in Elgin Baylor. "Baby," he said, "don't play."

The Lakers lost that night but made the playoffs, and Baylor even carried them to the finals before Boston beat them. "By the end of the year," Hundley says, "we couldn't shut Elg up." They split the playoff money 10 ways.

Baylor is from Washington, D.C., so he was hardly introduced to discrimination in Charleston, W. Va. In fact, he never even played basketball until he was about 14 because until that time the city playgrounds were not open to Negroes. He was the third son—his brothers are 6 feet 9 and 6 feet 6—of John and Uzziel Baylor. When he was told that he had a new son, John Baylor glanced at his watch to mark the time. Luckily for Elgin, it was not a Timex. Soon everybody called him "Rabbit" anyway.

As a senior at Spingarn High, an all-Negro school, Baylor was honored as the first of his race ever to make the All-Metropolitan team. (He still holds the District record of 68 points.) There were objections at the time that he was 19, a year overage. This has led to some extraordinary estimates of his age, but unless he attended Randall Junior High at the age of 20, he is now only 32.

"He never shot much unless we needed the points," his coach, Dave Brown, says. "And even back then he was never excitable. In one big game, they got four quick fouls on him. I moved him outside and he made 44 points."

Baylor was even less excitable in the classroom. Several colleges were prepared to abrogate their racial policies to accept him, but he could not qualify and finally chose a football scholarship at the tiny College of Idaho. Seattle

Coach Alex Hannum, Baylor, Jerry West and Bob Pettit at the NBA All-Star Game in 1965.

spirited him out of Idaho the next year, and when his eligibility ran out Minneapolis Owner Bob Short signed him for $20,000. That same day Short refused an offer to sell the franchise, because the bidding fell short of the $250,000 that he was asking. Seven years and 17,000 Baylor points later, Short sold the Lakers for $5,175,000.

Since he came into the NBA, Baylor has been outscored only by Wilt Chamberlain, and Wilt leads everybody in history. Baylor has a career average of 29 points and 14.7 rebounds a game and, while he is naturally famous for his scoring feats, the rebounds seem to please him more. At 6 feet 5 he is the smallest man among 18 players in NBA history to average 10 or more rebounds a game.

Baylor has seen a number of changes take place in the league, in styles and attitudes, since he started playing. On the light side, he says, "There's too many country boys in their bully-woolly suits and Buster Browns in the NBA now. Their idea of a real good time is a James Bond movie and then 16 hours of sleep."

Some things, perhaps, have not yet changed sufficiently. Last January he was in a hotel room in Boston, running the Lakers because Coach Fred Schaus was in St. Louis at the All-Star game. It was the first one to which Baylor had not been invited. All the great years did not make up for one season as a cripple. In St. Louis, Schaus and Mohs were discussing this. Finally Schaus called Baylor to say it had been arranged that he could sit on the bench as an honorary All-Star. However late a gesture, it was a rare tribute. Baylor told Schaus he would call him back.

He did not think about it for long, though, for Dick Barnett, Baylor's old team-mate, was not in St. Louis either. At that time, Barnett was the third leading scorer in the NBA. A white player had been picked instead because, some said, there were not

enough white faces on the All-Stars. Baby, don't play. Baylor called Schaus back and said he would stay in Boston.

When the Lakers returned to Los Angeles Ruby Baylor was there to meet her husband, and together they went over and thanked Fred Schaus. Schaus watched the Baylors walk away, and he remembers the feeling he had, because he says he has never been so touched or so proud of the man.

The Baylors went home. They have two little children—Alan, 6, and Alison, 2—and two very big German shepherds, Brutus and Caesar. The home on the hill is beautiful. "When you're a Negro lucky enough to be in my position." Baylor says, "how you show yourself is important for all Negroes. I think that every day I serve by showing that I can conduct myself as well as anyone.

"We all work hard to get into this league, because it is one chance we have. And besides, we have to be that much better to beat out a white player. And then everyone asks where the white players are. I've seen so many of them come into this league, and they've had great talent. But they didn't last—they married some money or got a good outside job, things that don't happen to us." He leaned forward. "You give us a chance in other things, and you'll get your white ballplayers back right away."

A long way from the Baylors' house at another time, when Fred Schaus was scouting in North Carolina, somebody asked him if he thought Baylor was the finest ballplayer ever. Schaus smiled and thought. Finally he gave the motel table a little slap. "Yeah," he said, "if there were money on the table, I'd take Elg over anybody."

Somebody else there agreed, but said, really, if there were money involved, Baylor would win at any game, whatever it was. Whatever. Schaus smiled again. "Yeah," he said. "That too." A tiger beat anything. •

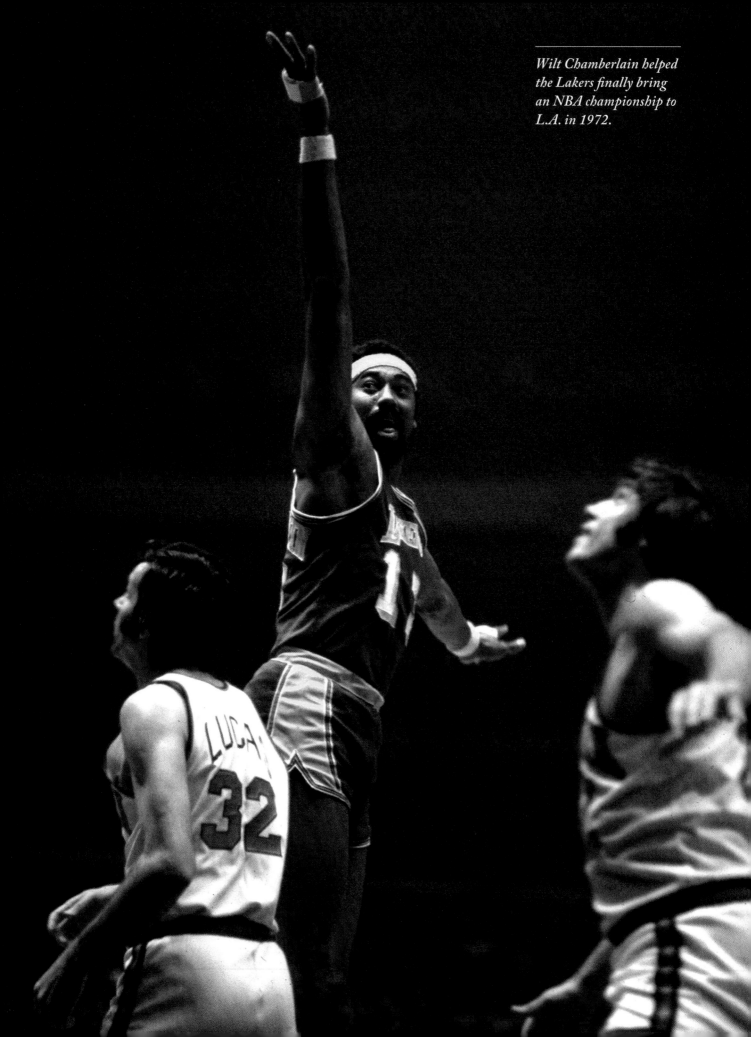

Wilt Chamberlain helped the Lakers finally bring an NBA championship to L.A. in 1972.

SWISH AND THEY'RE IN

Flashing lots of hot hands—and a single sore one—
Los Angeles goes all the way BY PETER CARRY

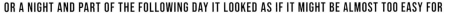

FOR A NIGHT AND PART OF THE FOLLOWING DAY IT LOOKED AS IF IT MIGHT BE ALMOST TOO EASY FOR Los Angeles. After 11 seasons of succumbing to fate and their opponents' heroics, the Lakers last Friday seemed to have their first NBA championship locked up. In their steamy dressing room at Madison Square Garden they celebrated the gritty overtime defeat of the New York Knickerbockers which gave them a 3–1 lead in the final round. It was the Lakers' third straight win, each one of them a show of power and proficiency. And Los Angeles' prospects could not have looked brighter.

The only important injury victim of the series, New York wheelhorse Dave DeBusschere, was still hampered by a pulled muscle in his right side, and the teams were heading West the next morning to get ready for what even the Knicks appeared to believe would be the finale at The Forum. "The patient is critical and about to die," conceded New York's Walt Frazier.

But only minutes after they arrived in Los Angeles the Knicks were given one last flicker of hope, and the Lakers, whose mood had been so buoyant, were wondering if that old playoff voodoo had struck again. Wilt Chamberlain was hurt and might not be able to play the next game or, perhaps, any more in the series.

Chamberlain, who brilliantly led Los Angeles to the brink of success, had complained mildly of soreness in his right wrist after the Lakers' third win. During the plane ride home he participated, as usual, in a raucous hearts game. He was in fine fettle, even though he mentioned that his now-swollen wrist, injured in a first-quarter fall, ached whenever he dealt. After the plane landed, Wilt left with team physician Robert K. Kerlan for Centinela Valley Community Hospital in Inglewood, where X rays were taken. Dr. Kerlan announced that there was no fracture, but the sprain was severe—so severe that it was "very, very doubtful" Wilt would play the next game.

He played. Did *he* play! He added insult to injury. Following a shot of Celestone, an anti-inflammatory agent, and a night of treating his wrist alternately with ice packs and baths in the

whirlpool built into his new $1.5 million Bel Air showplace, Chamberlain arrived at The Forum for Sunday's game with the swelling significantly reduced. "We brought a ball into the locker room," said Dr. Kerlan, "and as soon as I saw him palm it, catch it and throw it, I knew enough flexibility had been restored so he could play. But, believe me, this was a serious injury and an unexpectedly fast recovery. We weren't trying to fool anybody. If we had been, we would've held Wilt in the dressing room instead of sending him out with the rest of the team to warm up."

Wearing the padded hand wraps interior linemen use, Chamberlain played his best game of a super series. He scored 24 points. He had 29 rebounds. On defense, he harassed Knick shooters far outside, yet still scrambled

as most other players put in layups—but that outside shooting detracts from other aspects of the game. Players shooting from behind screens far from the basket are rarely fouled and are not usually in position for offensive rebounds. New York was decisively out-rebounded in this series, and the Lakers' edge in foul shots made was large enough to account for the total point margin of their four victories.

The Knicks' dilemma was not eased by DeBusschere's injury. He hurt his side late in the second period of the second game, which the Lakers won 106–92, and spent the last half sitting on the bench as Los Angeles turned a one-point halftime lead into a 20-point bulge in the third period. During the spurt, DeBusschere's man, Happy Hairston,

It was a title destined to belong to Los Angeles from the outset.

back to block inside shots. In the end, he shut up—perhaps forever—those critics who for years claimed that he was a quitter, that he could not win important games. He was, padded hands down, the most valuable player as Los Angeles took its first championship by winning the fifth game 114–100.

It was a title destined to belong to Los Angeles from the outset. Even in their first-game victory, the Knicks' unenviable position was evident. New York won 114–92 by making 72% of its first-half shots, many of them 20-footers or longer. The smaller Knicks were forced to operate almost exclusively from way outside due to Chamberlain's towering presence in the middle. There is a basketball axiom that says no team can win consistently when it relies on outside shots. In New York's case it is not so much that long shots are harder to make—the Knick starters hit 20-foot bombs as easily

scored 12 points. When the series shifted to New York three days later, DeBusschere started and played strongly enough in the first half to keep Hairston in check and to pull down nine rebounds. However, he missed all six of his shots, and the Lakers led by five points. DeBusschere declined to play in the second half. "I didn't feel I was helping the team," he said. His replacement, Phil Jackson, did not help much either as Los Angeles ran off to a 22-point lead, eventually winning 107–96.

DeBusschere's absence in the third period—the one which turned the series in Los Angeles' favor—infected New York with an odd malaise that even the usually poised Frazier could not cure. All teams go into cold shooting streaks, but during the Lakers' surge the Knicks succumbed to what may have been a playoff first. They went cold *passing*. And when they were not throwing

*Jerry West shoots
against the Knicks in
the 1972 NBA Finals.*

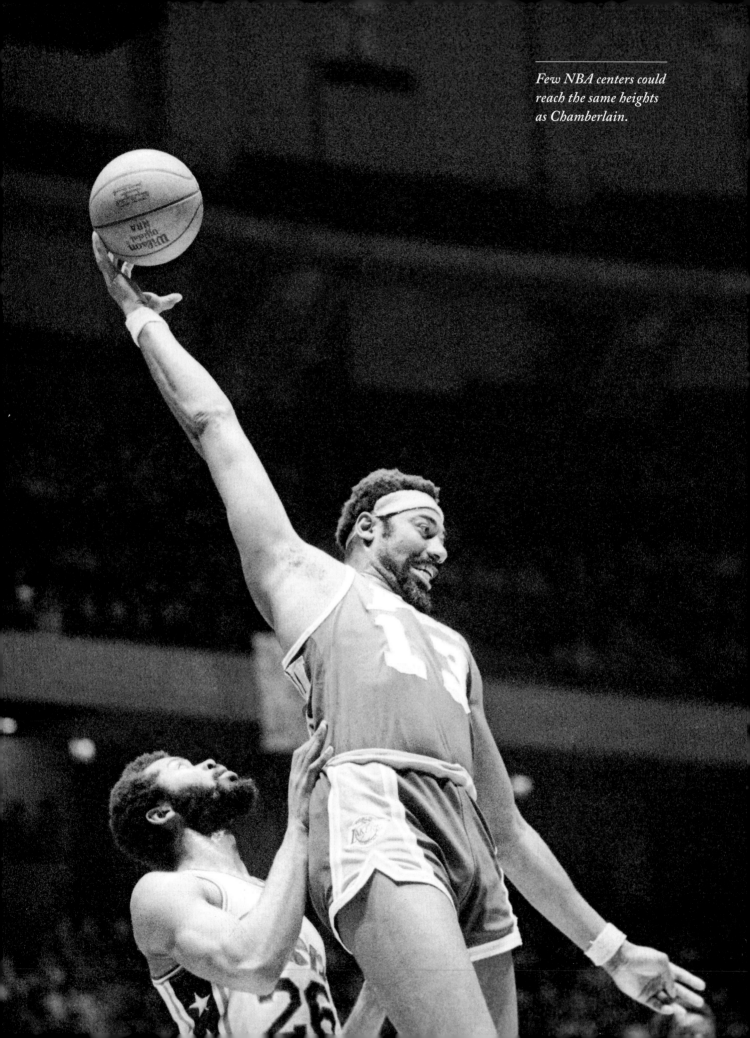

passes directly into eager Los Angeles hands, they were shooting rushed, unfamiliar shots or watching helplessly as their field-goal tries came zooming right back at them, courtesy of smashing blocks by Chamberlain.

Wilt's most important block came in the fourth game, the series' best, which Los Angeles won in overtime 116–111. Chamberlain, who has yet to foul out of a game in 13 NBA seasons, committed his fifth personal near the end of regulation time. The Lakers scored the first overtime basket after Wilt controlled the tip-off (Los Angeles won all but four of the 21 quarter-opening taps during the series, another edge it had on New York). Knick Center Jerry Lucas then drove past Chamberlain and lofted a short pop from the middle of the foul lane. Risking his sixth foul, Wilt spun and reached over Lucas' back, gently flicking the ball down. The Knicks recovered the ball, but in the next few seconds it was tipped loose by Jerry West, recaptured by the Knicks, and then Chamberlain blocked another shot. By the time New York could reorganize its offense, the 24-second clock had run out. The Lakers took possession, and Jim McMillian scored to give Los Angeles a four-point lead. New York's Bill Bradley hit a couple of jumpers to tie it up, but the Knicks were goners.

The futility of New York's position was not lost on the Lakers. After their second

West's championship triumph in '72 was the only one of his playing career.

win, McMillian agreed to a tennis match in Los Angeles scheduled for the day when a less confident man might have figured he would be in New York preparing for the sixth game. West, meanwhile, was relaxing in his Manhattan hotel room, assuring callers that his team would certainly win in five games and explaining that he had suffered insomnia after the second Laker victory. He had lain awake trying to figure out how he should act when he finally won a championship after so many near misses. "I don't yell much, and I'm not much of a drinker," he said. "Really, I can't figure out much that I'll be able to do except maybe smile a lot." When they did win, the Lakers were subdued. They drank their victory champagne out of wine glasses instead of pouring it over each other, while West smiled as predicted and delivered what were in effect a couple of toasts.

"When we went to training camp last fall," said West, "I thought we'd win our division, but never get past Chicago or Milwaukee into the finals. We were a team with a lot of lacks, but [Coach Bill] Sharman fit us together perfectly. He told us he thought that if we played the way he wanted us to that we could beat anyone. He got us to believe that right away, and he did it without raising his voice once all year. The most violent thing I remember he did was one time he threw down a pile of towels. As for Wilt, he was simply the guy that got us here."

He certainly did. At last. •

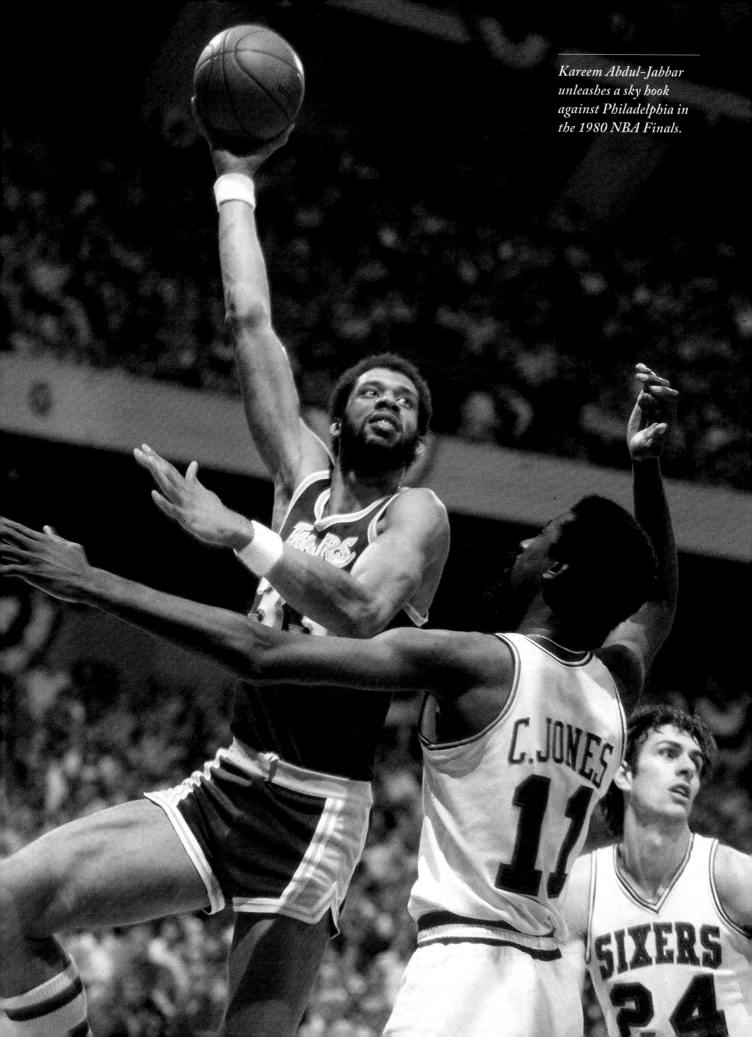

EXCERPTED FROM Sports Illustrated | MARCH 31, 1980

A DIFFERENT DRUMMER

After years of moody introspection, Kareem Abdul-Jabbar is coming out of his shell. But whether at home, as here, or on a basketball court or in a roller disco, he still steps to the music he hears BY JOHN PAPANEK

T HAPPENED ON A PERFECTLY BEAUTIFUL SOUTHERN CALIFORNIA AFTERNOON FOLLOWING NINE STRAIGHT DAYS OF devastating mid-February rains. Nearly 16,000 Los Angelenos went indoors—and on a Sunday, no less—to watch a basketball game. Moreover, it was a game between the Lakers and the Houston Rockets, which lets you know straight off that it wasn't a particularly big one, except that playoff time was near and it had been many years since the Lakers were fun to watch.

The P.A. announcer for The Forum, Larry McKay, was informing the crowd that the great Laker center, Kareem Abdul-Jabbar, had called in sick with migraines.

No one booed. In other years the fans would have hooted the roof off the Fabulous Forum and a dozen beach-bound Mercedes would have piled up at a parking-lot exit. Some sportswriters, with wicked glee, would have seized the opportunity to blast a favorite target for showing once more that he cared for nothing and no one except himself. And at least one would have begun typing: "The Lakers' 16-game home winning streak came to a s-Kareeming halt yesterday because Kareem Abdul-Jabbar rolled over in bed and said, 'Not today. I have a headache.'"

But no one wrote anything of the sort. On this Sunday afternoon the working-stiff Lakers, without their leader, slopped through two and a half periods, somehow staying barely ahead of Houston. Then a second remarkable thing happened. The crowd suddenly went berserk. Standing ovation. Players on the floor froze in mid-fast break. Abdul-Jabbar had arrived. He had tried to sneak to the bench inconspicuously, an attempt foredoomed by his 7'2" height. (Officially he is 7'2"; his lady friend Cheryl Pistono says he is closer to 7'5".)

Abdul-Jabbar entered the game immediately and swatted five Rocket shots out of the air. He rebounded ferociously, passed with èlan and hit six of the seven shots he took, two of them "sky hooks" over Moses Malone, who a year earlier had seemed ready to end Abdul-Jabbar's 10-year reign as the most dominant player in the sport. Of course the Lakers won. The score was 110–102.

"I knew it was too good to be true," moaned Houston Coach Del Harris. "Bringing in Kareem is like wheeling out nuclear weapons."

"Is Kareem better than Malone?" the Rockets' Rick Barry was asked. "What kind of ridiculous question is that?" Barry said. "Kareem is probably the best athlete in the world."

The fans at The Forum wouldn't have disagreed. Their Lakers were about to overtake Seattle, and they were considered the No. 1 contender to unseat the defending champions because, at 32, Abdul-Jabbar was playing like a kid again, having his finest season in five as a Laker. He was playing with vitality and emotion, leading fast breaks, dunking with authority, slapping palms and occasionally—you could be sure because he had finally gotten rid of those infernal goggles after four years—smiling. And he had not missed a single game.

In the Lakers' dressing room Abdul-Jabbar sat in front of his locker. Usually he is in the shower before the press arrives, dresses before he is totally dry and dashes out, saying as little as possible, as though he has a bus to catch. This day he sat there, and the media people approached him as they always do—verrry carefully.

Someone asked him how he felt, and he began to answer. In an instant he was mobbed.

"I haven't had a migraine bad enough to make me miss a game in two years," he was saying. "They're a mystery of medical science. No one knows what causes them. The pain was so bad this morning, I was crying. I couldn't move. I had to lie in a dark room in total silence. You know what it felt like? It felt like the Alien was inside my head, trying to get out my eyes."

The image was clear enough even to those who had not seen the movie *Alien*.

He was asked why, with all the pain, had he bothered with such an unimportant game? Abdul-Jabbar seemed to expect the question. If anything about him has been constant throughout his career, it has been his pride. "These guys are my teammates," he said. "But they are also my friends. They needed me."

Those familiar with Abdul-Jabbar knew there had been migraines before, usually in times of extreme tension. There had been bad ones in 1973, while he was playing for Milwaukee. They developed after seven people—a friend and six relatives of Abdul-Jabbar's Muslim mentor, Khalifa Hamaass Abdul Khaalis, members of a group called the Hanafi—were murdered, allegedly by rival Black Muslims, in a Washington, D.C. house that Kareem had purchased for them. Abdul-Jabbar was thought to be a target as well, and he was accompanied by a bodyguard for several weeks. The immobilizing headaches came on again in 1977, after Khaalis and his Hanafi group sought revenge by invading three Washington buildings, including the national headquarters of B'nai B'rith. They held 132 hostages for 38 hours, leaving seven wounded and one dead. Khaalis went to jail, and the Jewish Defense League threatened to kidnap Abdul-Jabbar. This latest series of headaches—and more would follow—seemed to coincide with Abdul-Jabbar's pending divorce suit.

There are those who have always believed that a man who can dunk a basketball without leaving his feet should be the NBA's Most Valuable Player by default. Because size seems to be the primary requisite for getting the award—centers have won it 19 times in the 24 years it has been given, including Abdul-Jabbar in 1971, '72, '74, '76 and '77—the distinction isn't esteemed as highly as MVP honors in other sports. Maybe that is why smaller players—Cousy, Robertson, West, Baylor, Frazier, Erving,

Havlicek, et al.—are accorded greater devotion than the giants who have played the game—Russell, Chamberlain, Abdul-Jabbar, Walton. They are *expected* to dominate.

Bill Russell, of course, was the perennial champion, the quintessentially unselfish team player/philosopher with the twinkly eyes and the thunderous laugh. Dominant though he was, you had to love Russell. Wilt Chamberlain, of imposing size and strength, once scored 100 points in a single game and averaged 50.4 in one season. But he was a colossus who evoked little affection. Bill Walton, one of the best all-round centers in history, has been beset by injuries; giants aren't supposed to be fragile.

And then there is Abdul-Jabbar, the first, the only player to incorporate every desirable element of the modern game into his own. He has the speed and grace of Baylor, the skill and finesse of West, the size and very nearly the strength of Chamberlain. He is a superb shot-blocker and a better passer than some think; he has seldom had teammates worth passing to. And he has been amazingly consistent, averaging nearly 30 points and 14 rebounds a game during his career. He has constantly been harassed by defenses, often by two opponents. Perhaps he has made what he does look too easy. He is not often "spectacular." But it is astounding how often he gets a "quiet" 32 points.

"He's always been my idol," says San Diego's Walton. "To me, he's the greatest."

"He does things to you that make you ask, 'Damn, now how could a man his size have done something like that?'" says Milwaukee's Bob Lanier.

A good bet to top off this, his 11th season, with his second championship ring, Abdul-Jabbar is also likely to accomplish what only one other professional athlete in any sport has done before him—win his sixth Most Valuable Player award. (Gordie Howe had six

in hockey.) In pro basketball Russell won five and Chamberlain four.

Abdul-Jabbar's athletic competence is not limited to basketball. He is a powerful runner, swimmer, bicycle racer and tennis player. He worked out last summer catching passes at the Minnesota Vikings' training camp with his friend Ahmad Rashad, and he practiced a form of kung fu for several years with the late Bruce Lee. Moreover, he is a terror on wheels at Flipper's Roller Boogie Palace in Hollywood, which he often goes to after Laker games. On a recent night he skated past two girls and heard one squeal to the other, "It's Wilt Chamberlain!"

Which brings up the perennial question: who ranks first among the great centers—Chamberlain, Russell or Abdul-Jabbar? Modesty prevents Kareem from saying what he truly believes—that it is he. "Kareem is a *player*," says West, his former coach, although he had become angry with Abdul-Jabbar at times when Kareem seemed to be playing less than inspired ball. "A great, great, great basketball *player*. My goodness, he does more things than anyone who has ever played this game. Wilt was a force. He could totally dominate a game. Take it. Make it his. People have thought that Kareem should be able to do that too. No. That would not make him a *player* of this game. Russell was a *player*. The greatest. But he was playing a different game than they're playing now. You can't compare the two of them."

What Russell had, of course—what great players must have in order to win—were other *players* around him. Abdul-Jabbar has not always had that luxury, and it rankles him that this has never seemed to matter to the press or the fans. "It's the misunderstanding most people have about basketball," he says, "that one man can make a team. One man can be a crucial ingredient on a team, but one man cannot make a team. In the past I have

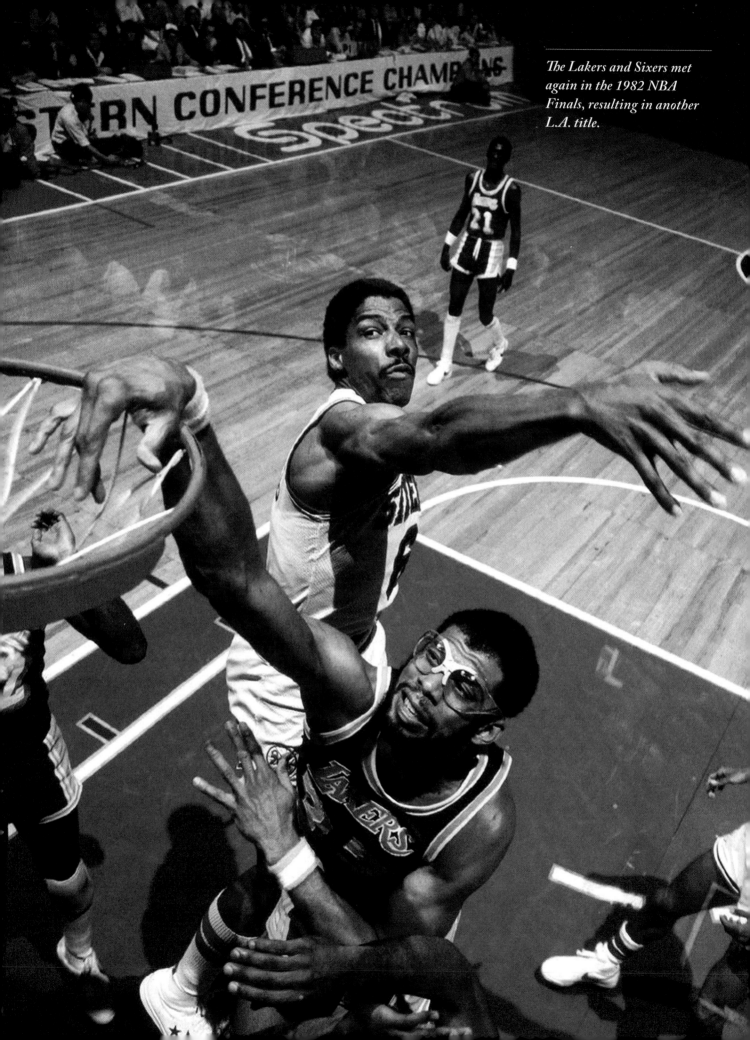

The Lakers and Sixers met again in the 1982 NBA Finals, resulting in another L.A. title.

played on only three good teams—in '71 when we won the championship, '74 when we lost to Boston in the finals and '77 here in Los Angeles. It was only when Milwaukee picked up Oscar Robertson and Bob Boozer that we became a good team. When I came to Los Angeles in 1975, the Lakers had to give up three excellent young players to get me. Those guys—Brian Winters, Dave Meyers and Junior Bridgeman—made Milwaukee a good team. I probably had my best year, and the Lakers finished next to last. In '77 we had the best team in the league, but we lost Kermit Washington and Lucius Allen just before the playoffs, and Portland beat us four straight.

"We were playing, more or less, with four guards and me. Don Ford was out-rebounded by Maurice Lucas something like 45–12. Yet everything written said that Walton had outplayed me. Walton played a great series. I played a great series. The Trail Blazers played a great series. The Lakers played a poor one. The press tried to make it seem like I was embarrassed. Walton made one dunk shot on me, and that was supposed to have signaled the end of Abdul-Jabbar being the best."

The press has apparently changed its mind—Abdul-Jabbar is the best again—because so many things have happened to make the Lakers fun once more. "I view that with total cynicism," Abdul-Jabbar says of the press turnaround.

First there was the arrival of the superb rookie point guard, effervescent Magic Johnson. He was going to be everybody's little brother, spark new life into the dour Kareem. Then came a new coach, Jack McKinney, to replace the problematical perfectionist, West. After McKinney suffered a serious injury in a freak bicycling accident 13 games into the season, *another* new coach, a bright Shakespearean scholar from LaSalle College in Philadelphia, Paul Westhead, took over.

Presiding over all was a new owner, millionaire playboy-mathematician Dr. Jerry Buss, who had pumped new life into the town by actually promoting the Lakers, and into the team by rewriting contracts, throwing lavish postgame parties stocked with *Playboy* Playmates and Bo Derek imitations, and flooding the locker room with the likes of James Caan, Sean Connery and O.J. Simpson.

Said Connery to Kareem after witnessing his first pro basketball game, "Metaphysically as well as literally, you stand head and shoulders above the rest of the gentlemen."

Every one of the Laker changes has worked like Magic, who has, says Abdul-Jabbar, "incredible talents that he brings to the game. He creates things for us the way nobody ever has for this team." Just as important have been Jim Chones, Mark Landsberger and Spencer Haywood, three strong and talented rebounders who came along this season to remove much of the inside burden from Abdul-Jabbar and enable Forward Jamaal Wilkes to play like an All-Star.

"Early in the season," says Westhead, "everything was Magic this and Magic that. People sort of forgot about Kareem. In a way that was good, because, before long, everybody realized that Magic or no Magic, this team is nothing without Kareem. I mean nothing."

So many good things happening all at once sounds like some kind of Tinseltown fairy tale. But it so happens that at this moment Abdul-Jabbar is undergoing a rebirth, fighting his way out of the shell he has kept himself in for the past 15 years. It isn't easy. There has been racial hatred and distrust; violence perpetrated against his close friends and violence perpetrated by himself; a bad marriage; and now a messy divorce.

Abdul-Jabbar lives in a 10-room Bel Air house just down the road from Caan and

O.J. and near the jazz musician and composer Quincy Jones. It is decorated with several of Abdul-Jabbar's valuable Oriental rugs and pieces of Islamic art he purchased in Africa and the Middle East.

The other day Abdul-Jabbar rather coldly told a visitor he had invited over to wait in the living room until he had finished dinner.

"Kareem!" came a loud, scolding female voice from the kitchen. "Tell him to come in here and sit with you!"

Whispers followed.

"Well, if you're going to be that way, I'll just have my dinner in the living room," she yelled, and came to the door, apologizing.

Cheryl Pistono is funny, friendly, delightfully smart-alecky, wise beyond her 23 years. Like Kareem, she has an uncommon odyssey behind her; somehow it fits that they should have ended up in the same place. She left a working-class family in LaSalle, Ill. at 16 to live with relatives on the Coast, went to Beverly Hills High School and got "into the high life. Hanging out at Hugh Hefner's, weekends in Las Vegas, stuff like that," she says. Like Kareem, she had been a disgruntled Catholic. Only she settled on Buddhism. "Some combination," she says, laughing. "Like oil and water, right?"

Last winter, when she brought Abdul-Jabbar home to meet her family, it was a big occasion. "Everyone was very excited, even though they didn't really know who he was," she says. "The funny thing is that my father is a really big basketball fan who had always loved Kareem, but when Kareem was in his house, he refused to come home. Couldn't handle the racial thing. Now my grandmother, who's in her 80s and lives out here, really gets on him. She cuts the articles about Kareem out of the papers and sends them to him, just to needle him."

Abdul-Jabbar readily acknowledges that Cheryl has had a greater impact on his adult life than any of his teachers, coaches, owners, friends or teammates. She convinced him to seek a divorce from his wife Habiba, whom he married in 1971 but has not lived with since 1973. The divorce is now being settled in court. Cheryl attacks inconsistencies in his religious beliefs—he removes paintings and photographs of human figures from the walls, according to Islamic law, and hides them under her bed when devout Muslim friends visit, for instance—and she rails at him for choosing religious laws over conventional ones. She was horrified that he fathered two children with Habiba after their separation—they have three—and told him so.

"I met a person who had never received anything from anyone but praise," she said. "I mean, he was a god, right? No one ever told him, 'Hey, that's——. Why do you do that? That hurt that person.' People have always been afraid to tell him that they don't like him. I never praise him. Never. I'm the only person who ever told him he was full of——."

As if on cue, Abdul-Jabbar bursts from the kitchen, relaxed, beaming. "Cheryl, that was a *wonderful* dinner you prepared. Really praiseworthy."

"Kareem, you can be such a jerk…."

He laughed loud and hard until Cheryl left the room. Then he grew quiet and serious. He fingered a copy of *Heavy Metal*, his favorite science-fiction magazine. He was asked about the *Alien* metaphor. Could it be a metaphor for his life? "I suppose it could," he said. "Like there's an alien inside me trying to get out? Maybe. Maybe the alien is the real me that I have kept locked away for so long, like all my life. I've missed a lot of things, I know. I'm trying very hard to change all that."

In his mind he went back to when he was a boy growing up in the Dyckman Street housing project, a racially mixed community in the Inwood section of Manhattan. Too many bad things had happened over the past 15

years, he says, for him to remember those days with fondness. He was, after all, a different person then—Lew Alcindor, Catholic—and now he finds himself a 33-year-old Muslim. "I feel sometimes that I went right from being a kid to where I am now," he says. Cheryl maintains he is still a kid.

He has no intention of renouncing Islam and becoming Alcindor again. He is a fervent believer, if less zealous than he once was. He just wants to recross the bridges between his past and his present that got burned, and try to recapture what he calls "a sense of reality."

When he was six years old he attached himself to the first and only real hero of his life, Jackie Robinson. "Not because he was the first black baseball player in the majors," Abdul-Jabbar says, "but 'cause he was a hero. See, I understand now what was going on then in terms of what it meant socially. But at the time I didn't understand that. My parents didn't explain it to me. I didn't even *know* that he was the first black. I didn't even realize that everyone else was white. All I knew was that Jack was out there and it was like Jack against the world and Jack was going to win. Jack took no prisoners. Guys like Sal Maglie would throw at Jack, and Jack would bunt down the first-base line and try to spike the guy as he fielded the ball. Jack was serious. And that competitive intensity that he had—that I understood. But I didn't understand why it was the way it was. I loved Jack."

Because he was what he was, Alcindor soon began to learn all that he could have wanted to know about the two subjects that would dominate most of his life—basketball and racial prejudice. As a boy he could never understand why his white friends seemed to feel that there was something wrong with being black. One afternoon, when he was 12, his best friend, a white boy, and two others followed him home from school, shouting "Nigger! Black Boy!

Blackie!" at him. That was when Abdul-Jabbar began constructing the wall.

At the same time, of course, he was becoming the greatest schoolboy basketball player of all time. In the eighth grade, when he was 6'8", he had his first brush with high-pressure recruiting. Manhattan's Power Memorial Academy and Coach Jack Donohue won out, and Lew Alcindor began attracting a lot more attention than most urban black children received in the middle '60s. In his last three years at Power his teams won 78 of 79 games and three city Catholic championships. But along the way there were more of those moments that reinforced Alcindor's feeling that it was himself against the world, just like Jackie Robinson.

In his junior year Power was playing St. Helena's, an easy opponent, the night before its big game with powerful DeMatha of Hyattsville, Md. As Alcindor recalled in SI (Oct. 27, 1969): "We played rotten and I played rottener than anybody, and at halftime we were only up by six points when we should have had the game settled by then. We went down to the coach's room, and Mr. Donohue started picking us apart one by one and telling us how awful we played, and then he pointed at me and he said, 'And you! You go out there and you don't hustle. You don't move. You don't do any of the things you're supposed to do. You're acting just like a nigger!'"

After Power won that game, and the DeMatha game, Donohue tried to laugh off the incident, saying, "See? My strategy worked!" But it worked instead to help shove Lew Alcindor into what he calls his "white-hating period."

"I was 17 years old, being cheered on the basketball court but being called a 'nigger' by those same people on the street," he says. That summer riots erupted in Harlem. "I stepped off the subway right into the middle of it. It was chaos, wild, insane, and I just stood there

trembling. Cops were swinging nightsticks at everybody, bullets were flying, windows were being smashed, people were stealing and looting. All I could think of was that I wanted to stay alive, so I took off running and I didn't stop till I was at 137th and Broadway, several blocks away. And then I sat huffing and puffing and pondering about what I'd seen, and I knew what it was: rage, black rage. The poor people of Harlem felt that it was better to get hit with a nightstick than to keep on taking the white man's insults forever. Right then and there I knew who I was and who I had to be. I was going to be black rage personified, black power in the flesh."

He went to UCLA, influenced in part by a letter from a famous alumnus named

his Islamic studies, had few friends and spent most of his time alone.

"Ever since childhood I had this ability to draw into myself and be perfectly contented," he said in 1969. "I *had* to. I had always been such a minority of one. Very tall. Black. Catholic. I withdrew into myself to find myself. I made no further attempts to integrate. I was consumed and obsessed by my interest in the black man, in black power, black pride, black courage. That, for me, would suffice."

After his Rookie-of-the-Year season in 1970 with Milwaukee, Alcindor made his conversion to Islam public and changed his name to Kareem (generous) Abdul (servant of Allah) Jabbar (powerful). "I never had any real trouble passing my change off on the

Abdul-Jabbar insists that basketball was really what his life had been about all along.

He loves it and expects to play, he says, "as long as I keep my mental and physical health."

Jackie Robinson. Three NCAA championships followed, and UCLA lost just two games in all that time, one being the celebrated Astrodome matchup against Houston and Elvin Hayes. That game took place just eight days after Alcindor suffered his first serious eye injury, a scratched eyeball.

Fame at UCLA did not make life any happier for Alcindor, who had already come to think of basketball as nothing more than business, though it was important for him to be the best. He nearly left UCLA for Michigan after his sophomore year, and after his junior year he incurred a great deal of resentment when he aligned himself with Harry Edwards and called upon all black athletes to boycott the 1968 Olympics. The boycott failed to materialize, although Alcindor himself stayed away, working with black children in New York instead. By his senior year he had retreated into

public," he says now. "Because of my talent on the basketball court, people tended to avoid engaging me in any conflict if they could help it. The people in Milwaukee were good about it, they realized I wasn't some sort of idiot. The coach, Larry Costello, had some trouble. He kept stumbling—'Lew…Kareem…Lew…Kareem.' He was very self-conscious about not saying the wrong thing."

In 1971 the Bucks won the NBA championship, and Abdul-Jabbar picked up his first MVP award. They won at least 60 games in each of the next two seasons, and lost to Boston in the championship finals in 1974. But life was still dragging on Abdul-Jabbar. His friends had been murdered in 1973, his marriage had broken up, he was shuttered in Milwaukee, a town he was not enthusiastic about in the first place. "I would stay home, read, get into my music," he says. His

frustrations built so, that after suffering his second serious eye injury in a 1974 exhibition game, he slammed a basket standard in disgust and fractured his hand.

When his contract expired in 1975 he did all he could to get back to New York, to play for the Knicks, which had been his lifelong dream. When that fell through he chose Los Angeles. He still kept mostly to himself, although there were more people he could be comfortable with—Muslim friends and jazz musicians like Wayne Shorter, Herbie Hancock and Chick Corea. Generally speaking, his teammates at the time did not fit that category. "My feeling about basketball then was that I was paid to play my best and that is what I did," he says, "not to pat guys on the behind and be their friend."

The worst year of his life was 1977. In March his friend Khaalis led the Hanafi Muslim siege on the B'nai B'rith building in Washington and ended up in prison. Abdul-Jabbar became the target of kidnap and death threats. Later in the spring the Lakers, with the best record in the NBA, lost four straight playoff games to Walton and the Portland Trail Blazers. The papers suggested that Abdul-Jabbar was washed up. That fall, on opening night of the 1977–78 season in Milwaukee, of all places, Abdul-Jabbar reacted to an elbow to the solar plexus from rookie Kent Benson by throwing a brutal punch that gave Benson a concussion and broke Abdul-Jabbar's hand. Again, his own violent reaction upset Abdul-Jabbar, but not nearly so much as the reaction from the public and the league office. He was fined $5,000, while Benson was not even reprimanded.

"Everyone's attitude was that it was totally my fault," says Abdul-Jabbar. "So again it was me against the world. I can understand how the punch happened. He was a rookie, he

made a mistake. When he did that I thought of all the times I was provoked, abused, bullied, scorned, and I was not going to take one more thing. My reaction was extreme, no two ways about it, but the league's reaction was wrong. It was neither my fault nor Benson's, totally. It was the system's."

Just two months earlier Abdul-Jabbar had first met Cheryl. "I had no interest in him," she recalls, "because I never liked the people who were into the sports mentality, and despite everything else, he obviously was. He expected me to fall all over him. Women always had, but one day he brought me a rose from his garden. He was serious as hell! I thought, oh, I've got to get this person to laugh. All I could think of was to not hurt him."

Abdul-Jabbar insists that basketball was really what his life had been about all along. He loves it and expects to play, he says, "as long as I keep my mental and physical health." But in December of 1977 he was nearly ready to quit. Just a month after his hand had healed sufficiently for him to return to action, he witnessed yet another violent act when teammate Kermit Washington crushed the face of Houston's Rudy Tomjanovich with a punch. "He was miserable," says Cheryl. "I sent him air-express letters saying, 'Kareem, your career is not a jail sentence.' He felt so sorry for himself it was disgusting."

Cheryl "got serious" with him and told him what he had to do. How he had to be more than just a basketball player, he had to be a leader. How he had to stop pushing people away and start listening to what they had to say. How he had to forget about keeping his emotions inside of himself, because they would continue to come out as fits of rage. And they did. Hearing these things from her one evening, he became so enraged he broke two doors in his house off their hinges.

Gradually he has come around, has gotten less "serious." But when a person has been

locked in so long, making changes is not easy. Cheryl introduced him to roller skating. It is a staggering sight to see a man his size doing disco moves on wheels with consummate grace. But he does, and he is happy, and he actually blends into the bizarre crowd at Flipper's. Even so, sometimes he closes up. One night a young fan approached Kareem to tell him how great he was. Kareem gave a blank look and the tiniest nod, but would not speak. The fellow skated off in a huff and confronted Cheryl. "Hey," he said, "how can someone be so great on the court and such a —— off it?"

Cheryl felt terrible. "Did he nod to you?" she asked. "If he did, it came from his heart, believe me." Then she chastised Kareem.

"It bothers me that people interpret me the way that they do," Abdul-Jabbar says. "I don't mean to be intimidating. I'm about respect. I want people to respect me, that's all. It's something I get from my father. He's a cop—a big, strong man, very quiet. That intimidates people. He was my example, I'm just like Big Al, that's what I always thought.

"Now I realize what happened to me. O.K., I was big. That never bothered me. I always liked being big. But because I was a basketball star, all my life people had gone to a great amount of trouble to insulate me from things. It was necessary, it seemed then. My high school coach had to insulate me from the flesh peddlers, and there were hundreds of them in New York. At UCLA they had

Lew Alcindor with his mother and father outside of his parents' home in Hollis, N.Y., in 1969.

to insulate me from the press. In Milwaukee I signed a very large contract and they were careful not to overburden me. Beautiful. It was all so easy to accept. I liked it that way. And even the people I learned about Islam from felt that it wasn't necessary for me to learn it the way it was generally taught, because that wasn't good enough for me, so they made my environment as pure as possible. My parents were part of it, too. When I was under their guardianship they always told me to go along with the program. I bought it all because there were immediate rewards— winning basketball games. Later I won basketball games and made a lot of money. Looking back on it now, I don't think any of it did me a whole lot of good.

"I didn't realize that I was missing so much. So a lot of the things I'm going through now, the things Cheryl has spoken about, have to do with reviewing my life and picking up on things I did wrong. Now I'm dealing with my life, by myself, for the first time in my life."

Westhead, the rookie interim coach, marvels at the man he had known, by reputation, as "the aloof Kareem." "I expected there to be this so-called 'chill factor,' but there is none of that at all," he says. "Maybe it is his soft personality. The guys seem to thrive on it. It's like he's their big brother. He's got so many stories. O.K., maybe a half hour before games, everybody gets quiet and waits for Kareem to tell one of his stories. He tells these special tales about growing up in New York, characters he's met. It's story time, then everybody goes out and plays basketball."

It is true. One day Kareem is telling about how Wilt took him out to dinner when he was a senior in high school: "He had the Bentley and the racehorses and every beautiful woman in Manhattan, and he takes me to his pad and there is the finest woman I have ever seen in my life. I'm 17 and my eyes are big as apples and my jaw is hanging open...." Another day he tells about "the toughest dude who ever lived in Harlem, Sugar Stamp," so named because he used to connive to get sugar-ration stamps during World War II. "One time Sugar hit the number and two guys ambushed him, shot him three times in the stomach. Man, Sugar chased 'em both, beat one to pieces and about caught the other when he finally checked out...."

Once he told about the most amazing player he had seen, a visitor to Harlem from Philadelphia for a playground all-star game. "This dude brought his own *cheering section* from Philly, man, and I had never even heard of him. Before the game they start screaming, 'Jesus! Black Jesus! Black Jesus!' I thought, who *was* this dude? He was about 6'3", and the first play of the game he got a rebound on the defensive end of the court and started *spinning*! Man, he spun four times! Now, he's 90 feet from the hoop and this dude is spinning. Well, on the fourth spin he throws the ball in a hook motion. It bounced at midcourt and then it just rose, and there was a guy at the other end and running full speed and he caught it in stride and laid it in. *A full-court bounce pass!* After I saw that I could understand all the Black Jesus stuff. I didn't find out the dude's real name until way later. It was Earl Monroe...."

An evening at the Bel Air house with Cheryl and Kareem has grown late. Kareem has talked about a movie he has just made, a spoof on the *Airport* films, called *Airplane*, in which, wearing his famous goggles, he plays a co-pilot; a record album he is contemplating making, on which he will play conga drums along with Tito Puente's percussionist, Joe Madera; a shopping trip in Karachi, Pakistan, during which he purchased Oriental rugs and was followed around by 300 people who, because of his great height, regarded him as a rare curiosity; his father— "I escaped a lot of whippins in my time thanks to Big Al"—and the crowd at Flipper's, where, the night before, ex-football star Jimmy Brown had accidentally crashed into a girl and broken her leg.

Abruptly the conversation dries up. "Kareem!" Cheryl implores. "Tell about Magic."

"'Knee Deep,'" he says. "That's the name of a song Magic keeps playing on his box. He's kind of worn me out with that." He laughs.

"But he had all the stewardesses dancing on the plane after you beat Boston for the second time, Kareem, and he had you dancing too."

"No," he protests. "I wasn't dancing on the plane."

"Pat Riley got off the plane and told me you were in the aisle."

"Nah. Pat Riley wasn't in on it."

"He said you were standing in the aisle and...."

"I couldn't even stand up in the aisle if...."

"I don't believe you!"

"Well, maybe I did do some moves...in my seat."

He tried to be serious, but he and Cheryl laughed and laughed.

"Kareem, remember opening night in San Diego when you made that hook shot at the buzzer to win the game, and Magic leaped up on you and hugged you and everyone jumped up and down in the middle of the floor?"

"Yeah," said Abdul-Jabbar, laughing. "It was like we just won the seventh game of the championships."

"Maybe you did." ●

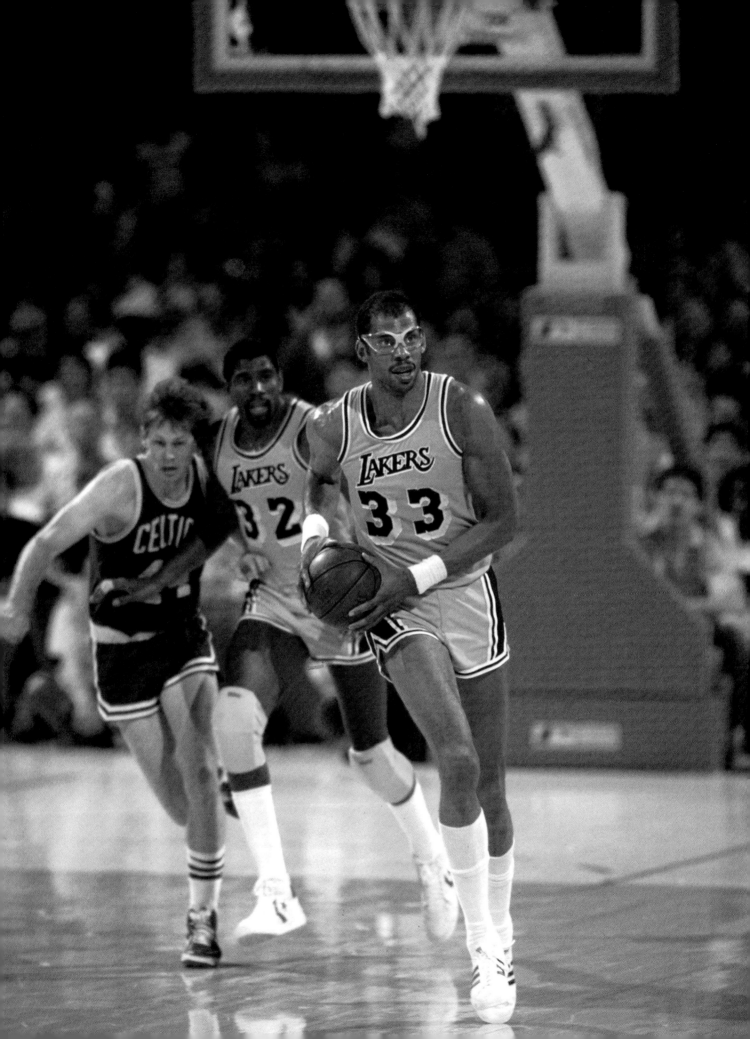

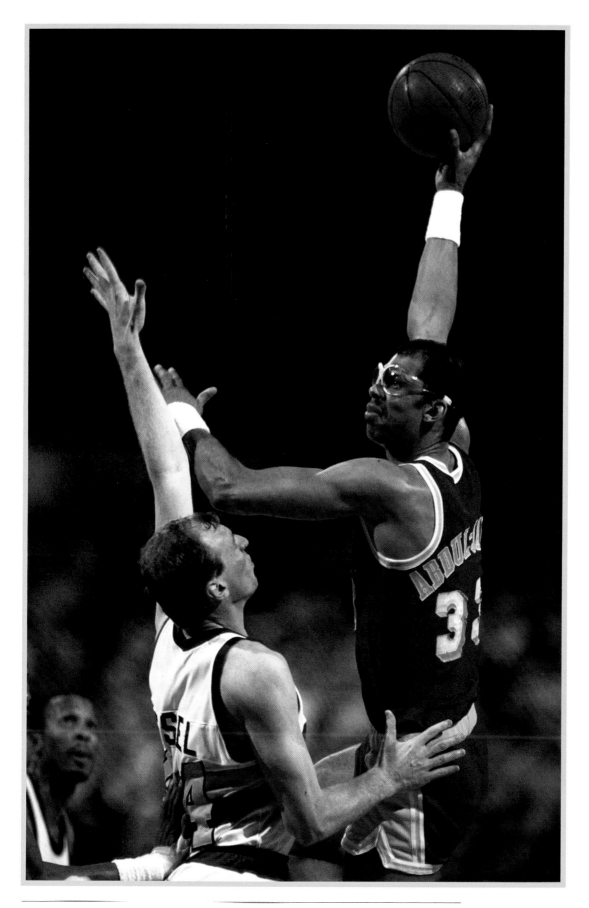

Opposite: Abdul–Jabbar looks to start the break against the Celtics during the 1985 NBA Finals. Above: Denver's Dan Issel is no match for the sky hook.

Sports Illustrated

MAY 26, 1980 $1.25

MAGIC'S MOMENT

LAKERS

ARMS AND THE MAN

With the Big Fella out, Magic Johnson was the man. He came through
transcendently as L.A. won the NBA title BY JOHN PAPANEK

ARVIN (MAGIC) JOHNSON SORT OF WADDLED ONTO THE COURT AT PHILADELPHIA'S SPECTRUM AND SET himself in the center jump circle, fidgeting there for nearly a minute before anyone else was in position, trying to decide how to jump. "I didn't know whether to stand with my right foot forward or my left," he would say later. "Didn't know when I should jump or where I should tap it if I got to it." All the thinking and foot shuffling, the very idea of playing center for the first time since high school, made Magic Johnson giggle.

Caldwell Jones, the 7'1" forward who jumps center for the 76ers, watched as Johnson got ready for the start of the sixth game of the NBA championship series and said to himself, "Hey. Wow! Really?" Magic grinned as they shook hands.

The 76ers knew, of course, that Kareem Abdul-Jabbar, the Lakers' indomitable center, was home in Los Angeles nursing the left ankle he had sprained two nights earlier during the 108–103 Game 5 victory that put L.A. ahead in the series three games to two. But the Sixers never expected to see a 20-year-old, 6'9" rookie point guard lining up to jump center. Giggling.

In fact, it was hard to convince the 76ers that Abdul-Jabbar wouldn't suddenly material-ize like some kind of genie. Just that afternoon their coach, Billy Cunningham, had said, "I'll believe he's not coming when the game ends

and I haven't seen him. They could fly him in at any time by private jet or something." Indeed, all day, Philadelphia basketball fans had watched their highways and skyways in panic, and several Abdul-Jabbar sightings were reported, including one from a cabbie who called a radio station to say he had picked up Kareem at the airport and driven him to the Spectrum. At least one fan was heard to say before the game, "I know he's here. I don't know where, but I know he's here somewhere."

But at that moment, Abdul-Jabbar was home in bed some 3,000 miles away in Bel-Air, his sore ankle propped up on pillows, his companion Cheryl Pistono beside him and Magic Johnson fidgeting on television before him. Kareem had received whirlpool and ultrasound treatment that day and felt he would be ready for Game 7 if necessary. He knew that the Lakers would be hard pressed to come up with anything like the

33.4 points, 13.6 rebounds, 4.6 blocked shots and explosive defense he had been providing in the series. And he also knew that without Spencer Haywood, the power forward who had been suspended for disciplinary reasons after Game 2, the Lakers would have but seven regulars available, only two of whom—Jim Chones and Mark Landsberger—had the kind of muscle needed to combat the 76ers' strong and deep front line of Caldwell Jones, Darryl Dawkins, Julius Erving, Bobby Jones and Steve Mix. Still, Abdul-Jabbar had a premonition.

"It takes time for a team to learn about an opponent," he said. "After five games Philly has done that. Now, all of a sudden I'm not there. Tonight they will see something completely different."

That they did, and so did everyone else who cared to watch.

As Referee Jack Madden threw up the ball for the opening tip, Magic had decided on his course of action. "I looked at Caldwell and realized he's 7'1" and he's got arms that make him around 9'5"," he said. "So I just decided to jump up and down quick, then work on the rest of my game."

Good thing. Caldwell Jones won the tip, but with the score 7–4 Lakers, Magic went to work. Like Bill Walton, Magic threw a scoring pass from the high post to Michael Cooper. Then, like Dave Cowens, he used position to get a rebound, dribbled upcourt and hit a jumper from the foul line. Next, like Moses Malone, he drove by Erving for a bank shot. And then he drove to the hoop again. "That time I wanted to dunk it, like Kareem," he said. "But I saw Dawkins coming and I thought, well, I better change to something a little more…"—he bobbed his head, stroked his fuzzy little goatee, flashed his elfin smile—"…magical." So he did. He hung in the air, double-pumped, made the layup and drew the foul. *Magical.*

The Lakers won the game 123–107, and thus the NBA championship without the most dominant player in basketball. Magic Johnson played 47 minutes, scored 42 points, hitting seven of 12 shots from the field in the first half, seven of 11 in the second, and 14 of 14 from the foul line. He had 15 rebounds, seven assists, three steals and a blocked shot. He was everywhere. He did everything.

"What position did I play?" he said. "Well, I played center, a little forward, some guard. I tried to think up a name for it, but the best I came up with was C-F-G Rover." Which means that a rookie three years out of *high school* played one of the greatest games in NBA playoff history at all five positions—center, point guard, shooting guard, small forward and power forward.

So stunning was Magic's performance that it somewhat eclipsed a brilliant team effort, just as Abdul-Jabbar has eclipsed so many of his teammates—Magic being the latest—over the years. Jamaal Wilkes happened to play *his* best game ever—including any in his championship season at Golden State in 1975—with 37 points and 10 rebounds. Chones had 11 points, added 10 rebounds and held Dawkins to 14 and four. Landsberger picked off 10 rebounds in 19 minutes, Cooper scored 16 points, and Brad Holland, usually a mop-up guy, scored eight very big ones. The Lakers ran Philadelphia near to death and outrebounded the 76ers 52–36—without Kareem, mind you—to finish the series with a devastating rebound advantage of 308–223.

"Before the game," said Wilkes, "I thought our chances of winning were 10% to 15%. But it's gratifying to be able to show the country that this is a great team, even without Kareem."

"It was amazing, just amazing," said Erving, with 27 points the only 76er to play

anything approaching a decent game. "We went over everything they do when Kareem's not there, and still we couldn't do anything about it. They wanted to show us they were not a one-man team and got maximum effort. Magic was outstanding. Unreal." Doug Collins, the 76ers' former All-Pro guard, who missed the playoffs with a knee injury, couldn't get over Magic. "I knew he was good but I never realized he was great," said Collins. "You don't realize it because he gives up so much of himself for Kareem."

In 1977, the year most of these same 76ers lost the NBA championship to Portland, Johnson was leading Lansing's Everett High School to the Michigan Class A championship. A year later he turned Michigan State from a 10–17 doormat to an NCAA regional finalist. And in 1979 as a sophomore he took the Spartans to the national championship and was the tournament MVP. Now, one year

after that, he single-handedly wins the final game of the NBA championship and is voted the Most Valuable Player of the playoffs.

"Magic thinks every season goes like that," said interim Laker Coach Paul Westhead. "You play some games, win the title and get named MVP."

The issue of MVP—decided by seven writers and broadcasters—was a touchy one among the Lakers. Virtually everyone agreed that the rightful recipient should have been Abdul-Jabbar, that the MVP was a bone thrown to Johnson because he will finish second to Boston's Larry Bird as Rookie of the Year—which, in the light of Magic's playoff performance, will forever seem ridiculous—while Abdul-Jabbar will win his sixth regular-season MVP award.

One thing certain is that Johnson wouldn't have had the chance to do what he did in Game 6 were it not for Abdul-Jabbar's

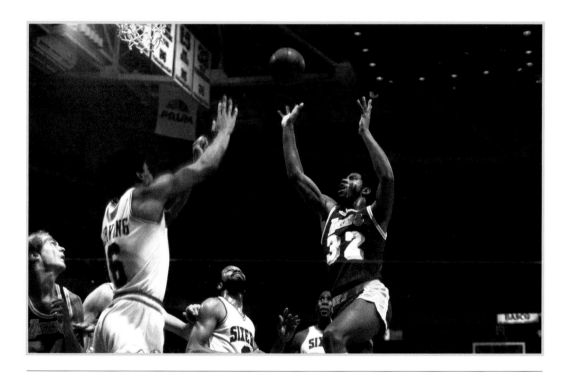

With Abdul-Jabbar limited by injury, the rookie Johnson led the Lakers to victory.

performance—and injury—in Game 5. The Lakers led by two when Kareem wrenched his left ankle with four minutes left in the third quarter and hobbled to the dressing room. Johnson, who had had a desultory game at that point, ignited a Laker blitz, scoring six and assisting for two of the next 12 points to expand the lead to eight. He would finish with 14 points, 15 rebounds and 10 assists. But it was Abdul-Jabbar, hobbling back to a thunderous ovation in the fourth quarter, who won the game, scoring 14 of his 40 points on the bad ankle, including a three-point play with 33 seconds left to break a 103–103 tie.

Despite the victory, the atmosphere in the Forum was grim. Kareem was rushed out for X rays—a fracture was feared. His last words to the team were, "We got three. We only need one more now."

The next morning the newspapers reported that the X rays were negative, so the Lakers were shocked when they arrived at the airport for the flight to Philadelphia and learned that Abdul-Jabbar wouldn't be going with them.

Westhead tried to keep things positive. "It should be interesting," he said, perhaps whistling in the dark. "Pure democracy. The king's on leave. We'll go with the slim line." The slim line meant Magic up front with Wilkes and Chones, with Cooper and Norm Nixon in the backcourt.

Magic, the Lakers' own merry prankster, took it from there. Boarding the first-class section of the plane, he plopped himself down in the first seat in the first row on the left-hand side, the seat everyone on the team knows as Kareem's seat—always. Magic turned around and grinned. He was asked if he was going to shoot Kareem's sky hook, too. "No," he said. "I shoot the magic hook." He said, "Jim Chones, don't you worry if your man gets by you, No. 33 [Kareem's number]

will be there to help." Magic was like a kid all dressed up in his daddy's clothes.

The Lakers needed Magic's laughter, for it had been a difficult week, starting with owner Jerry Buss's surprise announcement that Laker Coach Jack McKinney—injured in a bicycle accident last November and off the bench since—wouldn't be returning next season. So the team headed East without Kareem and wondering if Westhead, suddenly a prime candidate for any NBA coaching vacancy, would be returning next fall.

Magic nevertheless prepared for the game in his usual way: "Hopped in my bed, told the operator to hold the calls, took my box, turned on my tunes and jammed. And dreamed up a little bit of the game.

"In the dream I had the ball. I made the shots. I got the boards. I did what I came here to do."

In his dream he was Kareem for a day.

"Before the game," said Westhead, "I told the team, 'Everybody expects us to be courageous tonight. We're not here to be courageous. We're here to win.' They all looked at each other as if to say, 'That's a good idea.'"

The Lakers jumped out to a 7–0 lead and then to 11–4 before the Sixers got a single point from their front court. Few in the Spectrum thought this would go on for long. In the Sixer victories in Games 2 and 4, Dawkins had gotten 51 points. Without Abdul-Jabbar to menace him, there was no telling what he might do. What he did was choke. He took only nine shots, and scored a measly 14 points. Still, the score was close until midway through the second quarter, when Erving and Mix finally attacked inside for 16 points and the 76ers went ahead 52–44. Westhead called time-out. He wanted more collapsing in the middle on defense, more rebounds and more running.

Two lightning fast breaks and two baskets and two free throws by Holland pumped

L.A. back up and the Lakers left the floor at halftime tied at 60.

"By the second half it really got hard for me," said Abdul-Jabbar. "It was real nervous time. I was sweating badly. Not your classic fan reaction. I had to turn off the sound. I couldn't believe what I was hearing. 'Darryl Dawkins with eight points and two rebounds.' I said, *What?* I wanted the Lakers to win but the way they were doing it was so strange. I mean, they were running all over the place. The 76ers were so slow. It didn't make any sense. I couldn't listen to the explanations. I just had to watch."

The Lakers scored the first 14 points of the second half—Magic, Cooper, Wilkes, Cooper, Wilkes, Magic, Wilkes. Wilkes got 16 in the third quarter. The Sixers were nowhere.

But by the fourth quarter the Sixers, and reality, came creeping back. Erving hit two quick jumpers. Caldwell Jones dunked. Bobby Jones hit a 14-footer, and the Laker lead was 103–101 with 5:12 left. Westhead called another well-placed time-out. He gave a pep talk to Magic and Wilkes, the only Laker who had been in a championship game before. "I was tired," said Magic. "Really tired. But I ran through it." He tapped in a fast-break miss by Cooper, and then Wilkes drove the lane, drew a foul and made a three-point play. The Lakers were up by seven only 1:16 after the time-out.

"After Jamaal's three-point play," said Kareem, "I ran out into my yard and screamed. Then I came back and chewed on a pillow."

From seven points, it went back to five, but then the Lakers won running away, Magic scoring nine points in the last 2:22. The next thing Abdul-Jabbar knew, Magic was talking to him on the television screen. Kareem turned up the volume. "We know you're hurtin', Big Fella, but we want you to get up and do a little dancin' tonight," Magic said.

In Bel-Air, Abdul-Jabbar got up and did "a little hippity-hop step," he said. Was there not even a tinge of regret that the championship he had worked so hard for was won while he was absent?

"Not at all," said Kareem. "In the Islamic culture we call that Kismet. Something that is fate. I was meant to be here, and Earvin was meant to have that game. It reminded me of the kind of game Oscar Robertson used to play in college, when he would score 56, get 18 assists, 15 rebounds, when he used to do it all. Just one man playing against boys. Except that Earvin was just one boy playing against men."

The Laker victory party started in the Spectrum, continued at the hotel and on the plane back to Los Angeles on Saturday morning. Magic, as usual, was the music master. "From center to point guard to E.J. the deejay," said Westhead.

"E.J. the deejay," said Magic in his deep deejay voice. "Goin' to Noo Yawk for the MVP thing, then back home to do some partyin' and play third base for the No. 1 softball team in Lansing—the Magic Johnsons! To be me, just plain Earvin Johnson again. Oh, maybe they'll congratulate me, you know, for one or two days, but then it'll be over. We'll be singing on the street corners again. This season—wow!—97 games. Exciting, crazy and fun. A lot of love for each other. A great experience. I learned a lot and—we're the world champs. Wow!"

The long flight went quickly. No one slept. At the L.A. airport a crowd was gathered on the tarmac. The airplane door opened but before anyone could get off a big man in cowboy duds—denims, a cowboy hat, red bandanna—came aboard. Abdul-Jabbar. Norm Nixon yelled, "It's Billy Jack!"

Kareem silently hugged each one of his happy teammates, then stood straight up in the cabin and yelled at them in mock anger, "You didn't even wait for your boy!" •

Sports Illustrated

JUNE 17, 1985 $1.95

KING OF THE COURT

Kareem Leads Los Angeles To The NBA Championship

QUEEN OF THE COURT:
CHRISSIE WINS IN PARIS

FINALLY, A HAPPY LAKER LANDING

Los Angeles overcame its history of failure against the Celtics and won the NBA championship in Boston BY ALEXANDER WOLFF

TO THE CHAGRIN OF SEVERAL FLIGHT ATTENDANTS, PAT RILEY HAD ESTABLISHED POSITION NEAR THE first-class galley of TWA Flight 846, the widebody that was whisking the Los Angeles Lakers to Boston for Sunday's sixth game of the NBA championship series. He had posted up some reporters, and he wasn't budging one inch. "We're not going to be careful," said Riley, whose Lakers led the Celtics three games to two, and now had two chances to close out the series in Boston Garden. "We're going to be carefree. If they thought we ran last night...."

The stewardi weren't looking. Riley stuck his hand into a nearby ice bucket, dug out a cube and popped it mischievously into his mouth.

"...they're going to see us run some more. Sometime in the course of the game one team is going to crack. And if we push it, it's more likely to be them.

"Hey, if it's meant to be"—and Riley believed it was, having already made much of how the Lakers would atone, after their loss to Boston in Game 7 of last spring's finals—"why not go back to Boston and win it there?"

We now know that Riley spoke a prophecy at 36,000 feet, and the man who made it come true was 38-year-old Kareem Abdul-Jabbar. His skyhook, the supersonic shot with the turboprop pedigree, made the difference in the six-game get-back setback the Lakers dealt the Celtics.

Boston *did* crack, 111–100, right there in its own Garden, losing the final game of a championship series on the parquet for the first time ever. And after the Lakers had banished the demons of their eight straight championship series losses to the Celtics dating back to 1959, only Abdul-Jabbar was old enough to invoke the most felicitous analogy. "It's like the Dodgers beating the Yankees in 1955," he said. "Celtic pride was in this building, but so were we."

The Lakers, if you please, would like to make one thing clear: The Celts didn't just lose, they succumbed to L.A.'s relentless pressure. Take an ice cube, suck on it, clamp your teeth down, and it's only a matter of time before it cracks. "I'd seen that they were tired all over their faces," Magic Johnson said. "Riles kept making that point. 'Hey, Bug, keep pushing it.' Even if we pushed it up and didn't score, my job was still to push it up. To keep pushing it till they'd break."

Charley Eckman, the folksy former coach of the Fort Wayne/Detroit Pistons (1954–58), used to say there are only two great plays: put the ball in the basket and *South Pacific*. And in their only certifiable must-win game of the season, the Celtics shot horribly. They began

"We *made*'em lose it," Magic said.

The Lakers' collective will was the sum of many individual motives. James Worthy, a young star, was motivated by the moment. He provided 28 points in the clincher on an impressive array of splay-legged slams and outside jumpers, scoring from the perimeter more often than Bird did. But if anything spurred the Lakers on, it was the resolve of their written-off and their reviled. "There comes a time when you have to plant your feet firmly, take a stand and kick some butt," Riley said. "That's what we did. They can never mock us, or humiliate us, or disrespect us, which is what they did last year."

L.A. defensive specialist Michael Cooper had taken a muzzled shot at his coach for

> "You wait so long to get back. A whole year, that's the hard part. But that's what makes this game interesting. It's made me stronger. You have to deal with different situations and see if you can come back." —Earvin (Magic) Johnson

the series by shooting a record 60.8% from the field in Game 1. They ended it with a miserable 38.5% effort in Game 6.

Their guards, Danny Ainge and Dennis Johnson, clanged 25 of 31 shots Sunday. Their series studhorse, Kevin McHale, hit 11 of 18 from the field and 10 of 13 from the line for 32 points, but was forced to spend his sixth personal foul with 5:21 to play. And while Abdul-Jabbar was the unanimous choice as the playoffs' Most Valuable Player, Boston's Larry Bird, the regular-season MVP, never did bust loose. "I thought I'd have a great game today," said Bird, for whom 28 points on 12-for-29 shooting isn't great at all. "I can only dream about the shots going in that didn't."

failing to get him in at the end of Game 4, when Dennis Johnson sank a 21-foot jumper at the buzzer to beat the Lakers at the Forum, 107–105. Here in Game 6 he helped to throttle Bird, even returning for the fourth quarter after his day seemed finished late in the third, when he was carried off with a bruised knee.

Mitch Kupchak, the 6'10" reserve, was a longshot to ever play again after ripping his left knee apart 3½ years ago. In an ironic twist, Kupchak embodied the Lakers' commitment to physical fitness. He threw his rebuilt body at McHale all series long, and spelled Abdul-Jabbar for a long stretch of the second quarter Sunday, when fouls forced the captain to the bench. "They really didn't lose nothing," Bird noted.

Kurt Rambis, trashed by Celtics radio man Johnny Most as a creature "from a sewer" who perhaps should be "kicked out of the league," dived routinely into the stands for loose balls. Those scratches on his back, he explained, really weren't from alley fights under the boards—he grabbed 19 rebounds in Games 5 and 6—but from trimming rose bushes.

As for Abdul-Jabbar, he had been humiliated by Riley at a team meeting following his lethargic 12-point, three-rebound performance in L.A.'s 148–114 Game 1 loss. "He stepped forward and said what I was saying was right," Riley said. "And he made a contract with us that it would never happen again, ever. That game was a blessing in disguise. It strengthened the fiber of this team. Ever since then, Kareem had this look, this air about him."

Magic, of course, had nursed a special kind of determination, too, ever since he muffed late free throws, threw away crucial passes and took the rap for the Lakers' '84 loss to Boston. "You wait so long to get back," he said. "A whole year, that's the hard part. But that's what makes this game interesting. It's made me stronger. You have to deal with different situations and see if you can come back."

The Lakers found out they could. They refused to Wilt after that dispiriting loss in Game 4 at the Forum, when D.J., Boston's L.A.-bred guard, took a pass from Bird above the foul circle with two seconds left

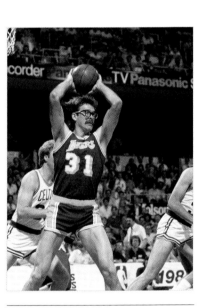

Kurt Rambis's physical play was a hallmark of the Lakers–Celtics rivalry.

and "buried it in his own backyard," as Celtic M.L. Carr put it.

Long before that buzzer-beater, even before the game began, in fact, the Celtics had outfoxed the Lakers. Just hours before tip-off, NBA vice-president for operations Scotty Stirling warned the opposing coaches, Riley and K.C. Jones, that extracurricular horseplay of the sort demonstrated in Games 2 and 3 would be dealt with summarily. Riley dutifully relayed the message to his Lakers but Jones cagily kept it to himself. L.A., which had seemed to profit psychologically in Games 2 and 3 from its newfound aggressiveness, was the consensus loser as Game 4 play turned Etonian. The Lakers had their chances, but couldn't deliver a fatal sting. "It makes you wonder when they win all the games decided by one or two points," Cooper mused. "Those are the games where you see the heart of a good ball team. We've just gotta buckle down and win one of these."

In Game 5, the Lakers were determined to match the Celtics' aggressiveness, and a defensive switch early in the second quarter helped them to break through with a 120–111 win. McHale, who came to full-blooming stardom in this series, had already scored 16 points over and around smaller Lakers, so Riley took Abdul-Jabbar off Robert Parish and assigned him to McHale. The Celtics naturally began feeding Parish, but the Chiefs troubles didn't end when Kareem left him. McHale, meanwhile, was sealed off from the

offensive boards, where he had run down four rebounds before Abdul-Jabbar began guarding him. And he made but three shots the rest of the way.

The 6'8" Rambis was the one left to cope with Parish. Twice Rambis pirouetted around the seven-footer for steals that started Laker breaks. But his single most impressive play came late in the second quarter, with L.A. nursing a 50–48 lead. McHale had entered the lane and launched another one of his heretofore automatic short jumpers, the ones that Most calls "pumpkins."

Worthy poached to his left and sent McHale's shot flying for the sideline, ticketed for out-of-bounds. Rambis pursued the ball to the courtside row of Forum fat cats. It did not matter to Rambo that a long-stemmed lovely in lavender and white, squired by Indy 500 champ Danny Sullivan, sat demurely in his path. Nor did he mind particularly that to keep the ball in play, he had to leave size 12DD treadmarks on her face, which would soon be sullied with tears. "Hey, sorry, lady," Rambis would say later.

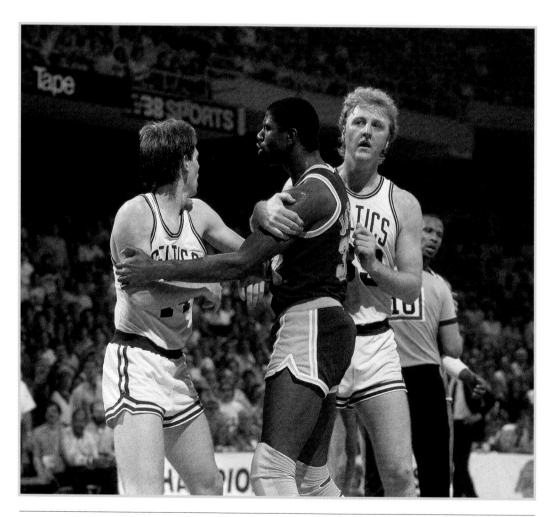

Familiarity bred contempt between the Lakers and Celtics.

Worthy took Rambis's retrieval to the other end, where he sank a free throw. Soon Worthy and Rambis each picked off a D.J. pass, and L.A. put together a 14–3 run to end the half ahead 64–51 and very much in control. When the Celts rallied to trim an 89–72 Laker lead to 101–97 with 6:01 remaining, L.A. ignored the autopsies that blamed the Game 4 loss on heart failure. Magic conjured three hoops, and Abdul-Jabbar threw down three skyhooks, plus a dunk for good measure. "People didn't think we could win close games," Magic said. "But we won one."

When it was close in Game 6 on Sunday—tied, in fact, at 55 at halftime—the Lakers actually felt good about themselves. "They'd only played seven guys," Magic said. "Kareem and me hadn't played much because of foul trouble, and we were running off the long jumpers they'd take." The long jumpers they'd miss.

When fatigue did begin to settle in—Games 5 and 6 were separated by only 38 hours, and 3,000 miles—it bypassed Abdul-Jabbar. He led the Lakers through the stretch, scoring 18 of his 29 points in the second half, seemingly unmindful that more than 14 years had passed since he was last a playoff MVP, as a young Milwaukee Buck named Lew Alcindor. "He defies logic," says Riley. "He's the most unique and durable athlete of our time, the best you'll ever see. You'd better enjoy him while he's here."

He'll be there for one more season, in which the Lakers will try to do what these Celtics came so close to but no team has done since 1969—win back-to-back titles. Riley likes their chances. "This team is going to win again," he says. "It's going to win as long as he's with us."

"The best marathoner in the world is in his 30s," Kareem says. "He pays the price. I live with me all the time. I know what I can do."

Johnson and L.A. won two of their three NBA Finals matchups against Bird's Celtics.

"He amazes me," Magic said. "But then again, he doesn't, because he's Kareem. He was focusing in. Nobody and nothing stops Kareem once his back hits the wall. You know he's coming back."

And Magic?

"I'm back. *Back.*"

To Los Angelenos, flying is "skying." To fly back to their home airport is to "sky to LAX." The word somehow does justice to both how the Lakers won, and what they'll be doing all summer long. Look for contrails of contentment wherever they go. •

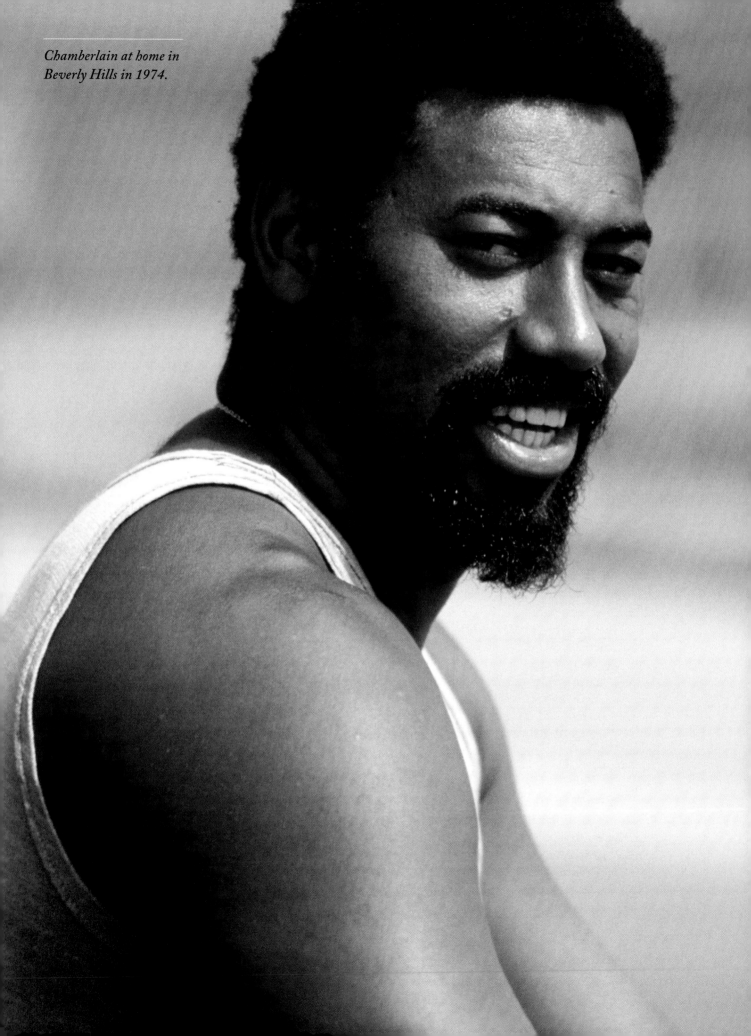

DOING JUST FINE, MY MAN

At 50, Wilt Chamberlain has finally mellowed some; however, he remains, as always, larger than life BY FRANK DEFORD

COME AHEAD, AND WITH ONE BEND IN THE ROAD, IMAGINE YOURSELF IN SEOUL, LATE IN SEPTEMBER OF 1988 *as the U.S. Olympic basketball team takes the court for its opening game against Spain. The starting five for the Spaniards is introduced: Creus and Villacampa at the guards, Sibilio and San Epifanio at the forwards and Martin at center. And then the Americans: Lebo and Rivers at the guards, Ellison and Manning at the forwards and Chamberlain at center. The cheers are so great for the one player, the last man, that the referee, Fiorito of Italy, delays the jump for three minutes, until finally the roar of the crowd dies down. "O.K., my man," the big fellow says, taking his crouch.*

It does not seem possible (except, of course, that time flies when there are no free throws to shoot), but next Thursday, Aug. 21, at the end of Leo, on the cusp of Virgo, the most incredible physical specimen ever to walk the earth will turn 50 years old. Even now, save perhaps for a tiny white fringe in his beard, he doesn't look a day older than the legend. He favors black, revealing garb—usually tank tops and tight-fitting pants—and unfettered feet. Even on the pavement of Manhattan he goes barefoot, donning shower clogs only on the most demanding, formal occasions. The deep, resounding voice (with the curious, contradictory little boy's occasional stutter) has not risen so much as half an octave, and he is even trimmer than when he played, 25 or 30 pounds down; but, more important, as far as he knows, he has not shrunk a whit from the seven feet one and one-sixteenth inches, which he says he is but which no one ever believes. How's the weather up there?

He was, always, the Giant. But he was also the Monster. "Nobody loves Goliath," Alex Hannum, one of Wilt's coaches, once said. Yet the benign irony of Chamberlain's middle-aging is that while he has lost the villain's stigma, he yet retains the giant's stature. Wilt is still the very personification of height, for good or for carica-ture. Even now, 13 years after his career ended, 24 years after he scored 100 points in an NBA game against the Knicks before 18,000 scream-ing fans at Madison Square Garden, grandfathers don't say to tall boys: "My, you're going to be a regular Ralph Sampson." Or "…a regular Manute Bol." They say, "My, you're going to be another Wilt the Stilt." If you have something

to sell involving a point you're trying to make about size or stature—like a car or an airplane seat or a brokerage house—you still call Wilt Chamberlain and have him represent your product because then people get the point right away even if they never saw a basketball game or weren't even born when Wilt Chamberlain was playing.

For all the times that Bill Russell trumped Chamberlain—and while he was at it, almost broke Wilt's heart—for all his championship rings, still, Russell would walk into a coffee shop somewhere and little old ladies would come over and ask "Mister Chamberlain" for his autograph. Years later, at the height of his career, Kareem Abdul-Jabbar would suffer the same fate. But nobody ever mistook Wilt for anybody else until, he reports proudly, the last couple of years when, every now and then, people call him "Magic." Magic Johnson is 23 years his junior.

But the tragedy to Chamberlain was that although he was probably the greatest athletic construction ever formed of flesh and blood, a natural who was big and strong and fast and agile, accomplished in virtually every challenge he accepted—for all that, he was never allowed to win. If, by chance, he did win, it was dismissed because he was the Monster. If he lost, it was his fault. He was a road attraction, the guy to root against. And Wilt, baffled that his bigness and bestness were the very cause of that disaffection, fought back in the worst way, with more bigness and bestness. If the most points would not win him love, then he would grab the most rebounds, tally the most assists; or he would make the most money, eat the most food, go to the most places, drive the fastest cars, sleep with the most women.

As, through the ages, men who could pull off only one or two of these feats found out, it doesn't necessarily assure satisfaction, accumulation doesn't. Al Attles, an old friend and

teammate, now vice-president of the Golden State Warriors, says, "I don't think Wilt would ever admit this, but he would try to do things just to get acceptance from other people. But people would never be happy with what he did, and beneath that veneer, I knew how much it was hurting him. He was so misunderstood. So few people took the time to try and appreciate Wilt. Most everybody just assumed that a great player couldn't possibly also be a great person."

Chamberlain was on holiday on the Adriatic in the summer of '74 when it occurred to him that he would finally hang it up. It wasn't anything dramatic that made him quit. Good Lord, he could sure still play. (Twelve years later, just this past April, the New Jersey Nets reportedly offered him nearly half a million dollars to play out the last couple weeks of the NBA season—and he was 49 by then.) He didn't have any special new career plans back in '74 either. No, there was just one thing: "The more I thought about it, the more I realized that there was always so much more pain to my losing than there ever was to gain by my winning."

And so he walked away. Not long after, he published his autobiography, and in it he unequivocally declared that his happiest year had been the one with the Harlem Globetrotters, the one when nobody asked him to break any records, but just to go out there, put his rubber bands on his wrists like always, have fun and help other people enjoy themselves.

Is that year with the Globies still your happiest? Wilt drew his bare feet across the tiles. Los Angeles stretched out below him, his great house soaring above. "Oh, no, my man," he said with a big smile. "There's been 10 great years since then. There's been 10 *straight* happier years."

No one comprehends better than Wilt himself that he had to lose all those

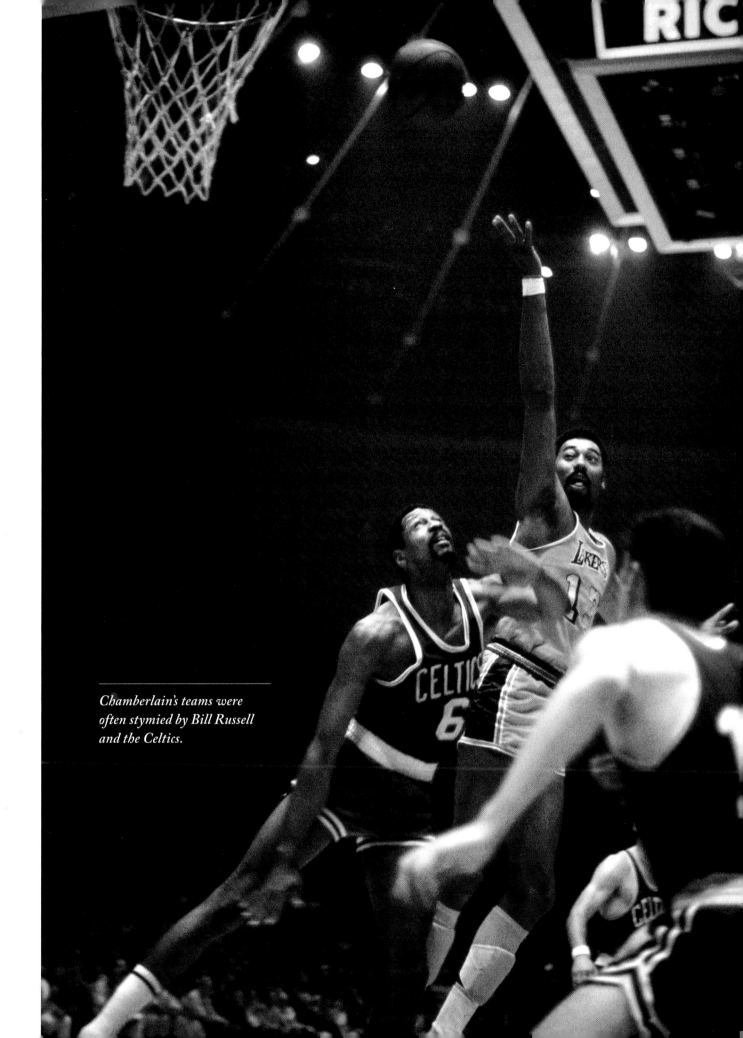

Chamberlain's teams were often stymied by Bill Russell and the Celtics.

many times to satisfy other people, so that then, after basketball, he could live happily ever after.

Wilt is aiming his white Ferrari down the freeway at a considerable speed. "I've never had any bad habits for spending money except on cars," he says. He has a classic Bentley—baby blue—back in the garage, and is involved, in England, in a project to build a $400,000 custom sports car that will be ready soon, known as the Chamberlain Searcher I. Peter Bohanna, an automotive designer who worked on special effects for James Bond films, is personally developing the Chamberlain. There will be a prototype mold so that 20 copies can be run off, should you want to order one.

The white Ferrari is something like 8½ centimeters from road to roof, but Wilt fits in comfortably, a revelation that infuriates littler people. These people hate to think that big people can ever be comfortable, especially in a) cars and b) beds. Little people are always asking Wilt how he sleeps, and they are mightily upset to learn that he sleeps like a baby. Little people forget that everybody starts off their existence sleeping all tucked up, and it's not really all that hard for tall people to revert to that when a bed is too short.

But then, little people no longer aggravate Wilt. After 50 years of this, he just laughs—down—at them. "I know that, subconsciously, little people feel anybody tall has

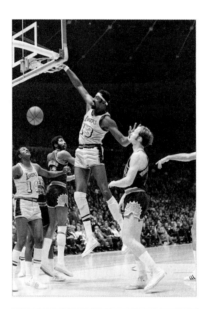

Phoenix's Dick Van Arsdale pays the price of guarding Chamberlain.

enough going for him, and so there's envy and they try to belittle your height," Wilt explains. "People will never come up to a stranger and say, 'Gee, you're small,' or 'How much do you weigh, fatso,' but nobody ever minds asking anybody tall how tall they are. It doesn't make any difference what you tell them, either, because if you're tall, no matter what you answer, little people will say, 'Oh no, you're taller than that.' You think I don't know how tall I am, and they do? But it doesn't matter. I could say, 'Oh, I'm ten-foot-three' and the guy would say, 'Oh, no, you're taller than that.'"

Little people, Wilt says, get it all wrong even when they're trying to be polite. For example, whenever he gets on an airplane, the top of the door is about at his belt level, but the stewardess will always say, "Don't forget to duck." Wilt shakes his head. "What am I going to do?" he asks. "Bump into the door with my stomach?" In a world where doors and doorknobs, mirrors, shower heads and everything else is built for little people, big people learn to duck instinctively all the time. Wilt laughs at the fact that when little friends spend time with him, after a while they all start to duck, subconsciously, just from being around him. Actually, it is little people who bump their heads most, because they're not used to the occasional low-hanging thing. Little people are the ones stewardesses ought to really worry about.

"I wouldn't say it's always been the easiest thing being seven feet and black, but never

once in my life did I ever feel like I was a misfit," Chamberlain explains. "Athletics probably had a lot to do with that." Still, it is not just that he is extremely tall. Wilt's is a phenomenal, overwhelming presence. Tom LaGarde, who tops out at a mere 6 ft. 10 in., was a member of the 1976 U.S. Olympic team. He remembers being on court before a game in Montreal when Wilt strolled into the arena. Several people on the floor were as tall as Wilt, or nearly so. It didn't matter. Everything just stopped. Everyone just stared. Bob Lanier, 6 ft. 10 in., 270, one of the hugest men anywhere, filled out a questionnaire recently that asked him to cite the most memorable moment in his entire athletic career. Lanier wrote: "When

basketball) compete in memory all too much with whatever did happen. Wilt is not averse to embellishing his own legend here and there, either. At the moment, Lynda Huey, an old friend, a travel agent by trade, a track nut by passion, is trying to get Wilt to enter the World Veterans Championships in track and field (50-year-old division) next year in Melbourne. "Wilt will rewrite all the record books," Huey says blithely.

And what event would you enter, Wilt? The discus, the 200, the high jump? "Almost anything," he shrugs. These days, for typical daily amusement he competes (against others or himself) in the following activities: basketball, racquetball, volleyball, tennis, polo (yes, the kind with horses), rowing

No matter how well one knows Wilt and, presumably, gets used to him, no one is ever able to consciously accept his majesty.

Wilt Chamberlain lifted me up and moved me like a coffee cup so he could get a favorable position."

No matter how well one knows Wilt and, presumably, gets used to him, no one is ever able to consciously accept his majesty. Wilt's oldest friend, since third grade, is Vince Miller, a schoolteacher in Philadelphia, a man of better than average height himself. Yet, no matter how many times they play each other in tennis, Miller never fails to lob too short when Chamberlain comes to the net, and as the overhead comes screaming back, there is Miller shouting, "I just never remember how tall you really are."

And how strong was he exactly? How fast? How high could he jump? How long? Who knows? By now, the myths of what Chamberlain did at his leisure (or might have done, if he hadn't been concentrating on

single sculls, swimming, running races, lifting weights, hurling objects, performing the martial arts, aerobics and walking long distances. He still holds his own in scrimmages with current NBA players. The Nets' offer, while obviously of considerable publicity value to a team somewhere out in the suburbs that nobody knows exists, was perfectly legitimate. Wilt finally turned it down only because he was afraid he would disappoint people, afraid that even though he was sure he would acquit himself proudly, playing in the NBA in his 50th year, nothing he could do would be enough to satisfy expectations. He would lose again.

But maybe, Wilt, maybe you could shoot free throws better now? Wilt shakes his head in tolerant chagrin, suffering another fool as best he could. No matter what, he is never going to escape from free throws. He could

always score and rebound and run and jump and arm wrestle and throw shot puts and god knows what all, but he couldn't shoot free throws. It just goes to show you: Everybody really is human. Nobody Can Do It All. In fact, one theory was that deep in his soul, Chamberlain wanted to miss free throws so that people would see, at last, that he had human limitations, too. Certainly it was psychological—"totally, a head trip," he says—because early in his basketball life he did quite well shooting free throws. That night at Madison Square Garden, when 50,000 fans jammed in to see him score his 100, he went 28 for 32 at the line.

Countless suggestions were proffered. He shot underhanded, one-handed, two-handed, from the side of the circle, from well behind

the line. Hannum suggested to Wilt that he shoot his famous fadeaway as a foul shot. Hannum checked the rule book and said he found that you had to be behind the line only *when* you shot, so he proposed that Wilt start near the basket and fade back to the line. Wilt thought the idea had merit, too, but he was just too scared to try the scheme and bring even more attention to his one great failing. And so he never did learn to shoot free throws as well as a man as he did as a boy. It was a very peculiar Achilles' heel.

When Wilt was negotiating to fight Muhammad Ali in 1971, his own father, who was 5 ft. 8¾ in. and a boxing fan, said, "You'd be better off if you gave back those gloves right now and went down to the gym and worked on foul shots."

Chamberlain was the center of attention throughout his career.

For whatever reason, Chamberlain has always been a loner. His favorite sport to this day remains track and field, an individual game—not basketball, with its team clutter. His fondest early recollections in sports are of his going over to a field at the Philadelphia Rapid Transport Company and throwing the shot. It was something he enjoyed the most because he could do it all by himself. Perhaps he became a loner simply because he was so much bigger and stronger than everyone else. It is also true that he sucked his thumb until he was in junior high. But, he says, "you've got to like yourself more to be a loner," and anyway, Wilt never has lacked for friends.

His closest friends—most of whom have always called him Dipper or Dippy—go back 20 years or more; his advisers, as well, have been tight with him for decades. Chamberlain also numbers among his buddies women who were once lovers—whom he always describes, most properly, as "young ladies"—but for all his affairs there has been little real romance, and never once has he come close to getting married.

His reputation precedes him. During a time when Groucho Marx was a neighbor, Groucho would suddenly appear at Wilt's house, cigar in tow, walking in his crouch, the whole bit, come in, smirk, say only, "Where're the girls? Where're the girls?" and then slink away. And, like free throws, the subject of Chamberlain's bachelorhood forever clings to him. "I just don't think I'm the sort of person who could be with one soul," he explains. "I'm too individualistic…and too gregarious with the young ladies. And I'll tell you this, too, my man: I have no need to raise any little Wilties. Not any—especially in a world where overpopulation is our biggest problem."

In many respects, Wilt, even at 50, looms as the perpetual adolescent—playing games by day, chasing women by night, no family responsibilities, plenty of money. One could even say he is narcissistic. But it is not quite as simple as that. All along, as his old teammate and friend Tom Meschery says, "what Wilt was on the outside identified him as a person. It's that way with many athletes, but it's all the more so with Wilt because there was more on the outside of him than anybody else."

The well-adjusted athlete can, in effect, grow beyond his body when the time for games is over. The weak ones have trouble. "Many athletes hang on because they're afraid of the real world," Wilt says. "They miss the limelight, the young ladies on the road. So maybe I was lucky. The fans were so fickle with me. I *had* to learn that self-acclaim is more important than what anybody else says." In all his years in the NBA, he never once gave a young lady a ticket to one of his games.

Still, unlike other athletes who could retire from sports, Chamberlain could not retire from his body. It's not unlike the famous story told of Winston Churchill, when the lady next to him at dinner said, "Why, Mr. Churchill, you're drunk." And he replied, "Yes, madam, but when I awake tomorrow I will no longer be drunk, but you will still be ugly." A lot of athletes will wake up some tomorrow, and they won't be athletes anymore; they'll be insurance salesmen or restaurant owners or TV color men. But it didn't matter when Chamberlain gave up basketball—that was nearly coincidental—for he would forever be one of the most imposing creatures in the world, never able to retire from his body.

Not that he minds. "I have to exercise three, four hours a day," he says. "If I miss just one day, my body tells me. I don't sleep as well. I get irritable. But then, maybe it's not so bad for me to depend on something. Most people depend on some*one*. Besides, I work hard at keeping my body in shape, because

that's been my money-maker, you understand. Most of the commercials that I still get wouldn't have been mine if I had gotten fat. You see, my man, it's still important that I look like I could do it."

And, just as he turned down the Nets' six-figure offer for a few weeks' work, so does Wilt pick and choose his jobs around the globe. He remains very much a worldwide phenomenon, and, indeed, almost wherever Wilt goes he is sure to meet someone who tells him how he was personally there in the Garden, along with 475,000 others, SRO, the night Chamberlain went for his 100. When Wilt does agree to work, he is most often involved with the movies—as a budding producer or as an actor of sorts in the latest of the *Conan* films—or in commercials, for the variegated likes of Drexel Burnham, Foot Locker and Le Tigre. He can be most discriminating, for few other athletes ever invested so wisely. Chamberlain made money in traditional areas, such as stocks and real estate, but also at his famous Harlem nightclub, Smalls Paradise, and in something as risky as broodmares. His house and the Bel Air hilltop it stands on may be worth eight figures. He remains in demand. "I'm still something of a yardstick," he says. "They say, 'When you're hot, you're hot.' But I've always been hot."

In his spare time, he works with young amateur athletes, often as a patron. He has sponsored volleyball teams, the Big Dippers (men) and the Little Dippers (women), and track clubs, Wilt's Wonder Women and Wilt's A.C. (WHERE THERE'S A WILT, THERE'S A WAY, reads the slogan on the team bus.) Currently, mid-Olympiad, he is concentrating his support on a few individual comers, and dreaming dreams of 1988 in Seoul for himself, too.

It's amazing what it will do for a man when, suddenly, his size is only an object of awe, and not an instrument of might. The worst thing in sports is to be expected to win, and then to lose. The second worst thing is to be expected to win, and then to win.

Nothing, of course, in all Wilt's life so affected him, so undid him, as his rivalry with Russell. "Wilt always played his best against Russell," says Meschery, now a teacher living in Truckee, Calif., "but then it wasn't just that Russell's team always beat Wilt's team. It was that somewhere along the way, Russell became the intellectual, the sensitive man, the more human, the more humane. And Wilt wasn't supposed to be any of those things. Well, that was a bad rap. Wilt was every bit as good a person as Bill, and you could tell how much he was hurt by the way he was perceived."

The argument about who was more valuable, Chamberlain or Russell, will never be resolved. The variables of team, the subtleties of contribution, temperament, achievement and synthesis, are all too complex—even contradictory—ever to satisfy truly dispassionate observers. But whatever, Russell clearly enjoyed much the better press and public image. Also, it seems, he got the best of Wilt personally. When Russell quit, Chamberlain was shocked at the criticism Russell suddenly unleashed about him.

"Friends had told me that Bill had been conning me," Chamberlain says now. "I didn't want to believe them. You want to believe that somebody likes you for yourself. But now, I'm afraid that they were more right than I was."

For all the criticism he suffered, though, Wilt remains remarkably charitable about the past. "All that stuff is beyond me," he says. "Besides, I think it's even better for a person to change his attitudes. That's a bigger thing to do than to be born with all the right ideas." Only Russell's old coach and mentor, Red Auerbach, still draws Chamberlain's ire.

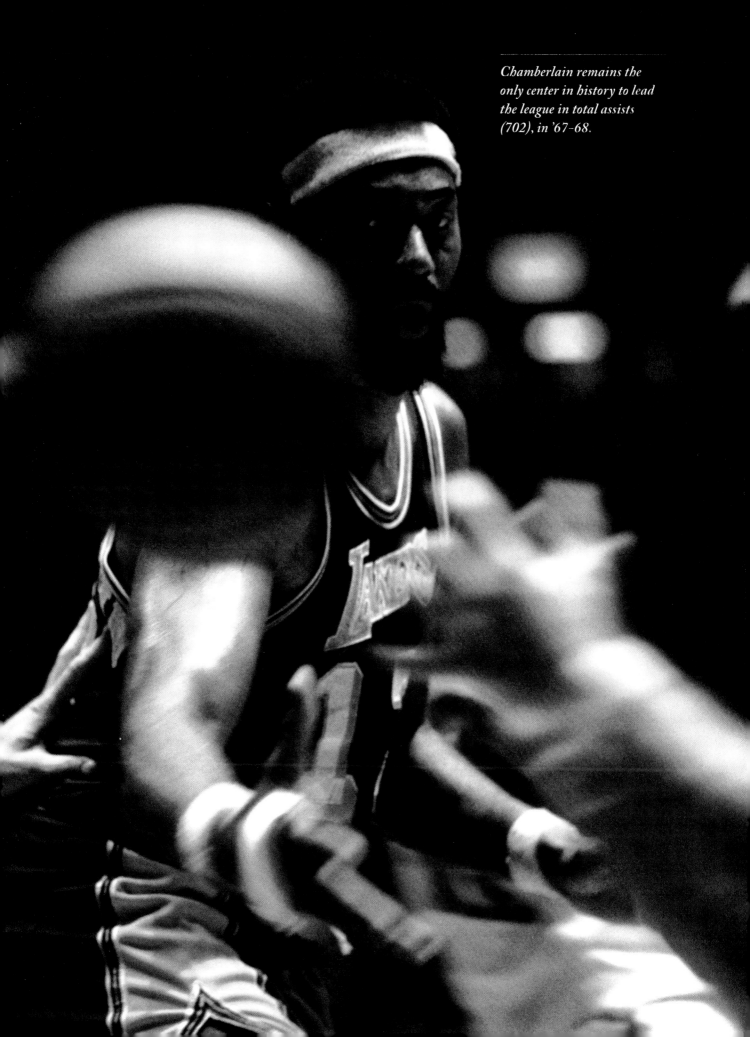

Chamberlain remains the only center in history to lead the league in total assists (702), in '67–68.

He refers to Auerbach not by name, but as "that man I don't like"—but even then, he goes on to credit Auerbach for his professional successes.

"Looking back, maybe I was luckier than Russell," Wilt says. "Working with so many coaches was probably more character-building for me, as opposed to Russell, who had only one coach, that man I don't like.

"I know this, my man: It took a lot for me to go out there year after year, being blamed for the loss. I'd be in a crowd somewhere in the middle of the summer, and someone would holler, 'Hey, Wilt the Stilt, where's Bill Russell?' But after the Celtics would beat us, I'd always make it a point to go into their locker room—and maybe those losses were good for my life. Everybody would like to have a few more rings, but I wouldn't trade the experiences I had. If you win like that, like the Celtics did, year after year, if you win everything when you're a young man, then you expect to win everything for the rest of your life."

Curiously, while everything about the physical Chamberlain is in the extreme, he is a man of moderate instincts. He even chose to support Richard Nixon instead of liberal Democrats. His upbringing in Philadelphia was stable and middle class. He was raised in a large family by two southern parents who "never stressed anybody's race or religion." His neighborhood in west Philly was mixed, his closest neighbor a white numbers banker. Overbrook High was largely Jewish at the time, and then he went to the University of Kansas, which put him in touch with middle America, and the Globies, which introduced him to the world. Wilt possesses a perspective that is more global than that of most Americans, let alone most Americans who grew up in the parochial world of locker rooms.

"Look, my man, I'm proud to be black, but I'm even more proud of being an American, and I'm proudest of all of being a member of the human race," Wilt says. "I know some of my brothers in the 'to [the ghetto] won't appreciate me saying this, but, all things considered, I think America's dealt with the racial situation as well as we could have. You have to look at it in comparison with similar problems in the rest of the world—in Ireland or India, wherever. I've never allowed bigotry to make me bitter, you understand, and I've seen an incredible change for good in my lifetime.

"I feel so strongly about here, about California being the Mecca, the melting pot of today, the hope. It all works so well here, all types of people. But I also know I can be naive, because I want it to work so much. And I always know the Birchers and the KKK are never far away. But we're getting there, you understand.

"And then we get hung up on the wrong things. I don't find it shocking that if 90 percent of the people are white, then more of the kids identify with Larry Bird than some black player. So what? Physiologically, it's apparent that blacks are better built to handle the game of basketball. We're quicker. We can jump. Whatever the reason: genes, environmental conditioning—who knows? It's like the little black kid who says, 'Mommy, why do I have curly hair?' And she says, 'Well, son, you have kinky hair to keep the tropical sun from baking your brain.' And the kid says, 'But, Mommy, I live in Cleveland and it's 22 degrees out.' 'I'm not the Maker. I don't know why.'

"But these kids today, they've got no concept of history. They're always coming up to me and saying, hey, Wilt, aren't the Celtics racist? And I say, look, that man I don't like is still running that team, but he was the first coach to play a black, and the first to start five blacks, and the first man to hire a black coach. Now all of a sudden he's a racist?

"Or these kids, they're trying to tell me the players today are better. Let me tell you, my man, that I played in the golden age of basketball. They say, look at the shooting percentages today. Are you telling me any of these guys today can shoot better than Jerry West or Bill Sharman? Well, they can't. One game I saw on my dish this year, and I counted, and the two teams shot 57 layups. In one game. I guarantee you, nobody *ever* shot 57 layups in a *week* of games I played in. It's a good game now, you understand, but it's a different game. They're flashier. They have more flair, but they're not necessarily any better. And hell, Elgin was doing all that stuff 30 years ago."

Wilt leaned back in his chair then, stretching out to his full 7 ft.1 1/16 in.(although he is, of course, much taller than that) and he spoke about his own game. While with the Lakers in 1969, he tore a tendon in his right knee, and while he was recuperating, running on the beach, he discovered volleyball. Periodically since then there has been talk that Chamberlain wanted to play on a U.S. Olympic volleyball team, and while he still entertains such thoughts, now he is also thinking seriously about trying out in '88, when he would be a growing boy of 52, for the discus or the U.S. basketball team.

His past professionalism might well not be an obstacle. Pro soccer and ice hockey players participated in the 1984 Games, and the International Olympic Committee is now considering a revision of the rule governing eligibility, which could open the door for any athlete to compete.

Wilt would dearly love the opportunity. "Of course, maybe I'd get thrown out of the Hall of Fame if I messed up," he says. Or maybe they would build a new wing for him if he sank a couple of clutch free throws against the Soviets. He chuckled at that thought, and scratched at the patio with his bare feet. The young lady he was with looked at him with even more fascination. One minute, he was talking about playing games in the deep past before she was even born, and in the next, he was talking about playing games in the years ahead, with people even younger than she.

———————————

One of the reasons Chamberlain likes to travel the world is that it allows him to be even more content when he gets back to his castle on the hill. It is totally his domain. Time does not operate here as it does outside the gates, for Wilt remains the most nocturnal of men; often, he will not call it a day before the sun comes up. Apart from the hours he sets aside for his exercise, there is no pattern to his existence. He does not even live a diurnal life as we know it. He will, for example, go on a complete fast, eat nothing at all for three days, and then suddenly, at 4:30 in the morning, devour five greasy pork chops. He has driven across the country— the whole United States—on the spur of the moment. He is as independent as anyone in the world.

His house is as unique as he is, like a great cloak that surrounds him. Wilt conceived the house and helped design it—and it was completed in 1971, during the time he was leading the Lakers to their record 33 straight wins. At its highest point, the mansion reaches 58 feet. The ceilings are cathedral, and much of the glass is stained. "Everywhere I've been in the world, the prettiest things are the churches," Wilt says. There is not a right angle in the place. The front door is a 2,200-pound pivot. There is a huge round table, a Jacuzzi and sauna, a weight room, a pool room, a room that is entirely a bed, and so forth. And a moat surrounds much of the house. On the next rise over, but down from Wilt's mansion, lives Farrah Fawcett. The rest of the City of Angels is below that.

All the doors are high so that he never has to duck, but there are only two other concessions to Chamberlain's height: one large chair downstairs, and a master bathroom with the toilet and shower head set high. From his bed, Wilt can push a button and fill a sunken bath at the other end of the room. He can push another button and roll the roof back, "so I can get my tan in bed." Except for the young ladies who pass through, and friends who stay over, he is alone, save for two jet-black cats, whose names are Zip and Zap. "At last," Al Attles says, "he is so secure, so at peace with himself."

An eclectic collection of mostly modern art decorates the halls, but in all the house there are only two trophies. One is a huge eight-foot carving that the late Eddie Gottlieb, the Mogul, Wilt's friend and first NBA owner in Philadelphia, presented to him once for something or other that Wilt can't recall anymore; the other, on his bureau, is his citation of membership in the Hall of Fame. "I gave all the other stuff away," he says. "It makes other people happier." Attles, who was Philadelphia's second-leading scorer with 17 points the night Wilt tossed in his 100 before 1,872,000 paid at Madison Square Garden, has the ball from that game.

Downstairs, in the kitchen, lies a copy of *The New York Times* of Aug. 21, 1936, the day Chamberlain was born. An old friend had just sent it to him as an early birthday present. The Spanish civil war was the lead story; Alf Landon's campaign was in high gear in Omaha; Trotsky was on the run from Stalin's Russia. And Jesse Owens was on his way back to America, to triumph and segregation, after starring in the Olympic Games of Berlin.

Fifty years, someone mused.

"Well, it takes awhile, you understand," Wilt replied. "The first time I was in Russia, they'd give me the best caviar, and I'd dump it and ask, 'Hey, where're the hot dogs?' Basketball inhibited me. It took me awhile to find out it's not all bouncy, bouncy, bouncy." By now, he just thanks the people who tell him how proud they were to have been there in Madison Square Garden the night he got his 100.

Curiously, Wilt Chamberlain himself was in Hershey, Pa., that evening, because that's where the Knicks and Warriors played before 4,124 fans when he got his 100.

He laughs and strides across the sunken living room. There he is: black on black, the beard, the tank top, the skin-tight pants, the bare feet, this great human edifice that hardly seems touched by the years. But something seems to be missing. What is it? What's wrong with this picture?

Suddenly—yes. The rubber bands. Or rather: There aren't any rubber bands. Chamberlain always wore rubber bands around his wrists. It was his signature as a player, something he had started as a kid, to make sure he always had extras to hold up his socks on his long, skinny legs. And then when his legs got fuller and stronger, he kept wearing the rubber bands, just for effect. And even when he finished playing basketball, he still wore rubber bands. Where are the rubber bands, Wilt?

"I kept wearing them because it reminded me of who I was, where I came from," he says. "Then suddenly, about two years ago, I felt that I just didn't need that reminder anymore. So I took off the rubber bands." He hasn't worn any since that day.

Wilt is strictly on his own now. The Giant is 50 years old, but the Monster didn't live that long. •

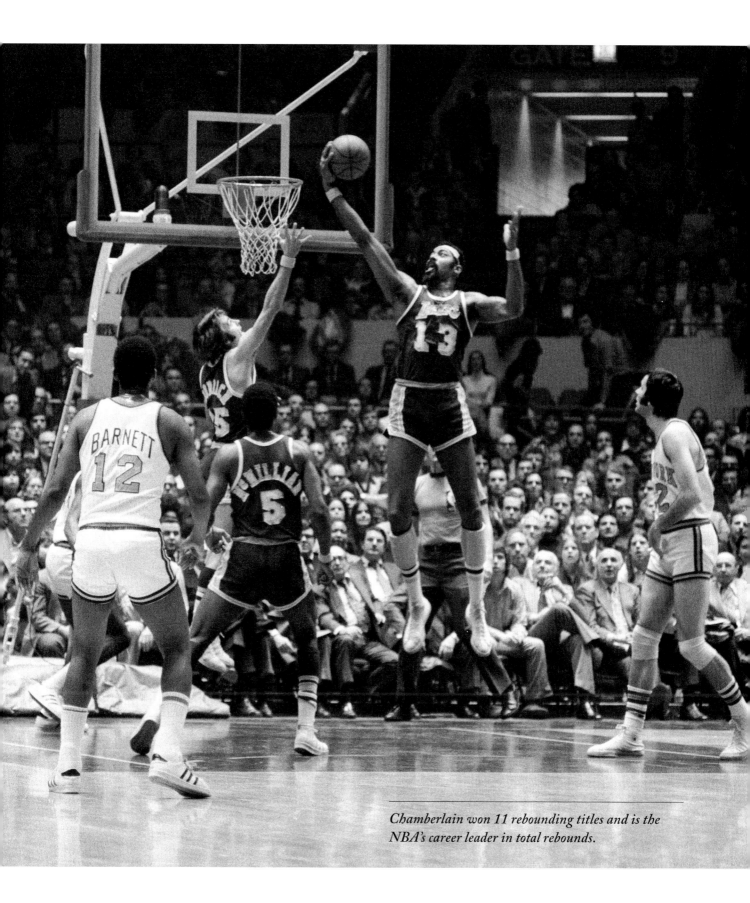

Chamberlain won 11 rebounding titles and is the NBA's career leader in total rebounds.

FANTASTIC FINISHES
TIGER AND THE TITANS

The Redskins Rediscover Defense

Sports Illustrated

Coming Through!

Why Shaq and the Lakers are steamrolling the NBA

LAKERS

SPALDING

BIG TIME

Elevated by the outsized play of Shaquille O'Neal, the Lakers are looking down on the rest of the NBA BY PHIL TAYLOR

T IS APPARENTLY TIME TO MAKE A NEW ENTRY IN THE DICTIONARY OF SPORTS NICKNAMES, RIGHT AFTER Big Country and Big Daddy and just before Big Unit. Los Angeles Lakers center Shaquille O'Neal sauntered through the locker room at the Staples Center last week and declared that he had dubbed himself Big Stock Exchange. When someone asked the inevitable question—why?—a broad smile spread across his face. "Numbers, baby," he said. "Numbers."

The moniker may not stick, which won't bother O'Neal, who gives himself a new one almost daily.

Thanks to Big Stock Exchange and a new dedication to defense inspired by coach Phil Jackson, the market is Bullish on the Lakers, who are flourishing the way Jordan & Co. once did. Through Sunday, Los Angeles had ridden a 14-game winning streak—capped by a comeback from a 19-point deficit for a 110–100 victory over the SuperSonics in Seattle—to a league-best 29–5 record, and O'Neal was laying waste to any unfortunate center who wandered into his path. His scoring average of 27.8 was tied for second in the league, he was shooting a second-best 57.6% from the floor, he led the NBA with 14.5 rebounds per game, and, most significant, he was averaging 3.18 blocks, his most since he was a rookie. "I definitely think they're the favorites to win the championship," says Philadelphia 76ers coach Larry Brown. "Kobe Bryant is playing at a high level, Glen Rice is playing at a high level, and Shaq is playing off the charts."

But talk of a title in January is especially premature when it involves the Lakers, who have made a habit of sizzling in the regular season and then flaming out in the playoffs. In 1997–98 they opened with 11 straight victories and went on to win the Pacific Division with a record of 61–21, only to be swept by the Utah Jazz in the Western Conference finals. Last season they were wiped out in four straight in the second round by the San Antonio Spurs. "With our history we can put up all the numbers we want, and no one is going to take us seriously until we do it in the playoffs," says forward Rick Fox.

There's no denying, however, that the Lakers' success is built on a firmer foundation than in previous years. Even the sometimes shaky relationship between O'Neal and Bryant, the spectacular shooting guard, has never been better. The two were watching television in the locker room before a game last week when Bryant commented on how silly the commercial they

had just seen was. "That was almost as bad as you and Hakeem on those little bikes," Bryant told O'Neal, referring to a fast-food commercial Shaq made with Hakeem Olajuwon a few years ago.

"Hey, that won awards," O'Neal said, laughing. "It wasn't as bad as you in that one where you wore that cook's uniform." Bryant donned an apron in a recent soft-drink ad. "'If I was a cook, would you care what I drink?'" O'Neal said, mimicking Bryant in the commercial. On they went, two stars good-naturedly needling each other about their thespian turns.

With the notable exception of his abysmal free throw shooting—44.9% at week's end—there is nothing about O'Neal's primary career to poke fun at these days. He is almost unanimously thought to be playing his best basketball since he entered the league. The only dissenting opinion comes from Shaq himself. "I played better my second year," he says, referring to 1993–94, when he averaged 29.3 points, 13.2 rebounds and 2.8 blocks and finished fourth in the MVP balloting. "After that year I got my first taste of being injured, and I was a couple of steps slow. The last couple of years I've had stomach injuries that kept me from doing a lot of things defensively that I used to do. Now I'm 100 percent, and I'm getting back to where I was early in my career."

O'Neal might have been better then, but so was the competition, which leads to a frightening thought: Even though he has been abusing backboards and opponents for seven years, even though he has career averages of 27.1 points and 12.2 rebounds, the era of O'Neal's true dominance might just be starting. When he and Alonzo Mourning broke into the league, the centers who were at or near the top of their games included Olajuwon, Patrick Ewing, David Robinson, Dikembe Mutombo, Rik Smits and

Brad Daugherty. Today Daugherty is retired and Olajuwon, Ewing, Robinson and Smits are in varying stages of decline. The number of traditional back-to-the-basket pivotmen is dwindling as more teams turn, by necessity, to glorified power forwards to man the middle, which is like offering bite-sized snacks to the 7'1" O'Neal. After watching him rack up 22 points and 24 rebounds against 6'9", 206-pound Jerome Williams of the Detroit Pistons on Dec. 12, Pistons coach Alvin Gentry said, "That's not fair. Shaq eats more for lunch than Jerome weighs."

You could argue that O'Neal has to face only four topflight pivots who are in their prime: the Spurs' Tim Duncan, the Atlanta Hawks' Mutombo, the Miami Heat's Mourning and the Sacramento Kings' Vlade Divac. More often he has his way with centers who lack either the bulk or the quickness—or both—to offer much more than token resistance. No player in the NBA is so often hacked as a last resort, and not just because of his free throw woes. In a 118–101 win over the Los Angeles Clippers on Jan. 5, O'Neal was the main reason that the lead-footed Michael Olowokandi fouled out in just 18 minutes. O'Neal treated Olowokandi's matchstick-thin backup, 7'3", 212-pound Keith Closs, the way a wrecking ball treats a window pane. He bulled his way through Closs for prime post-up position and then turned and dropped the ball in the net as casually as if he were placing a book on a shelf, finishing with 40 points and 19 rebounds.

It is that apparent ease that has caused O'Neal's superiority to be taken for granted. While acrobatic slashers such as Bryant and the Toronto Raptors' Vince Carter seem to create a new move every time they take to the air, there is a repetitiveness to O'Neal's dominance that is almost numbing. Amid the aerial spectacle presented each night by the

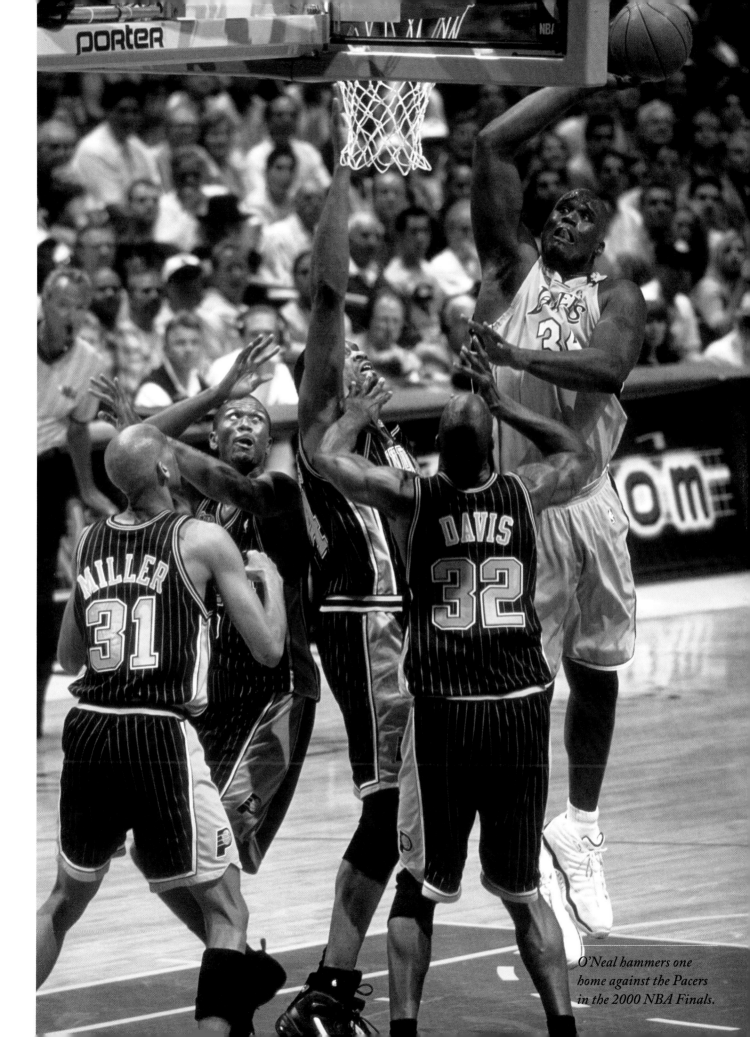

O'Neal hammers one home against the Pacers in the 2000 NBA Finals.

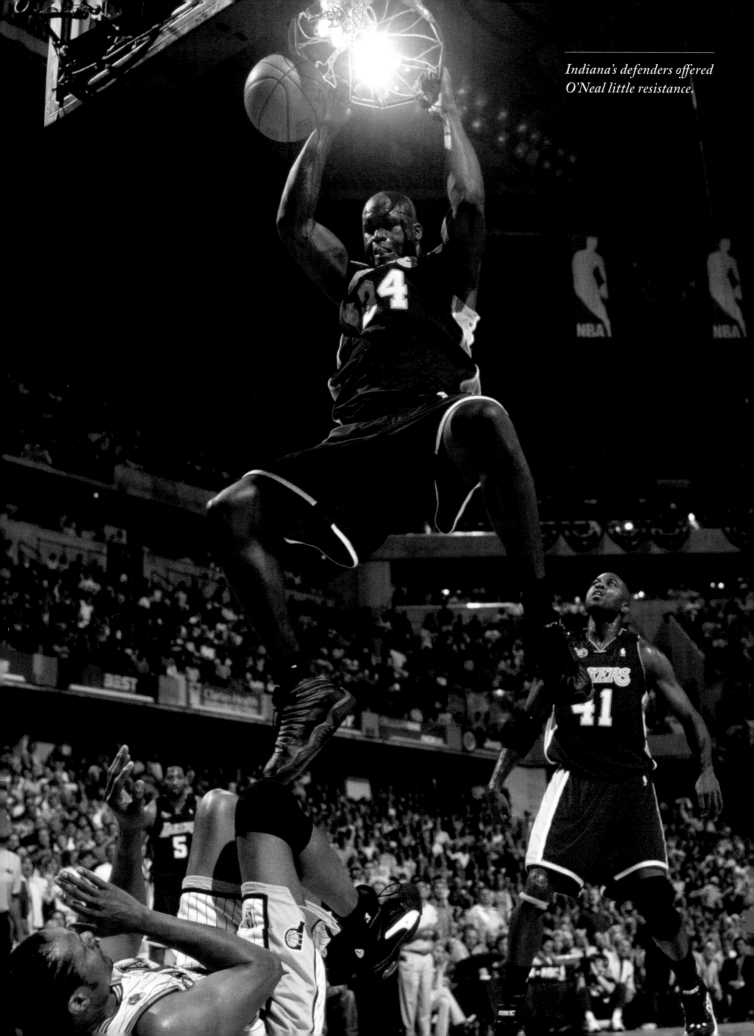

league's young stars, it's easy to forget that dumping the ball inside to Shaq is as sure an offensive play as there is in the league.

O'Neal has proved this year that his game is also adaptable, readily adjusting to the triangle offense installed by Jackson and assistant Tex Winter. The system calls for Shaq to find cutters with his passes, which accounts for the modest rise in his assists. (He's averaging more than three for only the second time in his career.) The triangle's spacing and ball movement also have allowed O'Neal to get even better low-post position because it is harder for defenses to sag on him. "This is an offense that should enhance the abilities of a dominant center, not take away from them," says Winter.

But the most pronounced difference in O'Neal's—and L.A.'s—game this season is on defense. Until this year O'Neal hadn't averaged more than three blocks since his rookie season, having swatted a career-low 1.67 a game in 1998–99. His renewed propensity for rejecting shots has helped make his teammates better defenders. The Lakers gave up 96.0 points per game last year, which ranked them 25th in the league. This season, even as rules changes have increased scoring, they're allowing 90.4—fifth best. "We can really be aggressive knowing Shaq's back there to clean up anything that gets by us," says Rice, L.A.'s sharpshooting small forward. "We can take things from teams on the perimeter and force them to go into the lane knowing the big fella will be there for us."

There are three reasons for O'Neal's surge in swats: His nagging injuries have fully healed, he has trimmed down (to close to his listed weight of 315), and Jackson has demanded it of him. Jackson has an air of authority that his predecessors with the Lakers, Del Harris and Kurt Rambis, didn't; it's apparent that O'Neal is playing for the first coach who has commanded his complete

respect. He has said that Jackson reminds him of his stepfather, Phil Harrison, a retired Army sergeant, in the discipline he imposes. Jackson's six championships with the Bulls don't hurt, either. "I went out to see him in Montana before the season, and I saw the sun hitting all those trophies," says O'Neal. "It was like, bling, bling, bling, bling, bling, bling. When a man with his track record asks you to do something, you do it."

In a way, the Lakers' defensive improvement leaves no doubt that they didn't come close to getting the most out of their talent in the past. There is no equivalent to the triangle on defense, no new system or philosophy. Jackson realizes he doesn't have the kind of athletes to apply the perimeter pressure that his Bulls could. In fact, the Lakers don't have great individual defenders—they traded their only exceptional one, forward Eddie Jones, to get Rice from the Charlotte Hornets last season—though adding the savvy of forward A.C. Green and guard Ron Harper has helped their team D. "There's no big secret to how we've done it," says Bryant. "We're just working harder. We're quicker to rotate when someone gets beat. We fight through screens a little harder."

Jackson hasn't used any of his favorite stratagems for manipulating players that he employed in his days with the Bulls. "He hasn't handed out books for the players to read or spliced scenes from movies into the game films," says Bryant. Jackson doesn't need those tricks, at least not yet, because he can motivate his team by just walking into the locker room. On Jan. 4, after the Lakers allowed the Clippers to score 61 points in the first half, Jackson gave his team a brief but stern address. "I told them I was looking for players interested in investing the game with some emotion and energy," he says. Left unsaid, but understood, was that he would be willing to sit the starters if they didn't prove

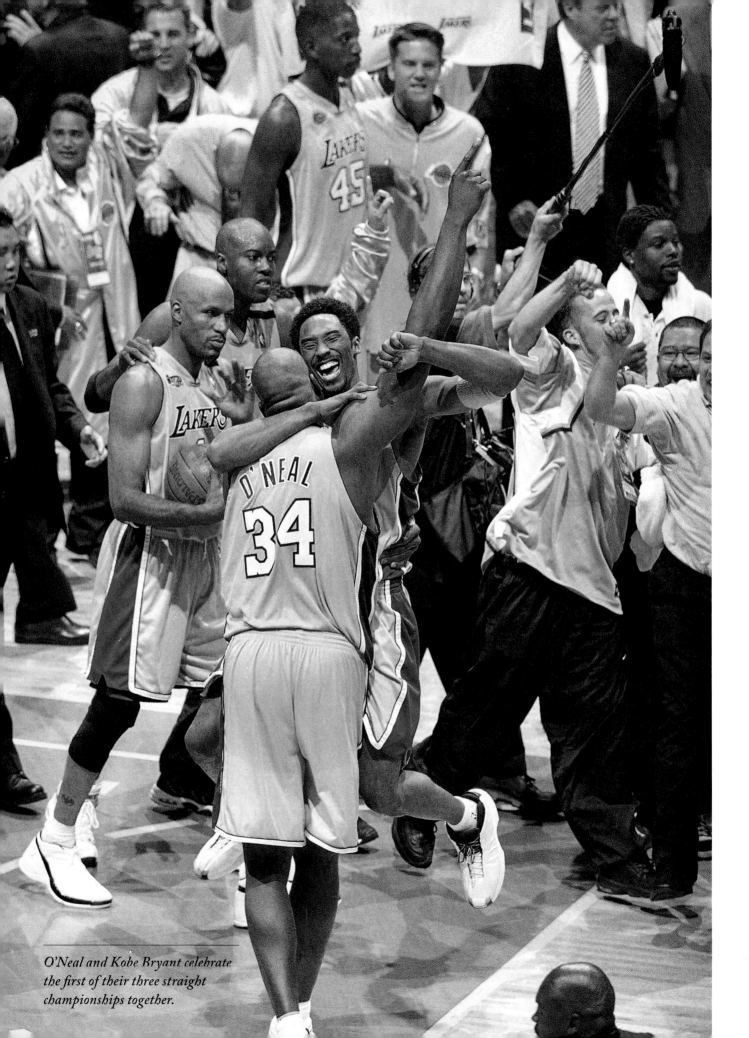

O'Neal and Kobe Bryant celebrate
the first of their three straight
championships together.

to be those players. The Lakers responded by limiting the Clippers to 37 second-half points and winning 122–98.

"When Phil Jackson tells you to defend the pick-and-roll a certain way, you do it because he's proven he knows what he's talking about, and you know you'll be sitting next to him if you don't do it that way," says O'Neal. "Guys know that listening to him could get us over the hump. If we don't win now, we won't have any excuses."

The prime objective for Jackson has been to run a tighter ship. He set the tone early by saying that O'Neal, who reported to camp a good 15 pounds over his listed

$14 million per for a player with his years of service. Sources close to Rice say they would not be surprised to see a trade before the Feb. 24 deadline, and Jackson refuses to rule one out. Rumors abound involving forwards P.J. Brown of the Heat, Juwan Howard of the Washington Wizards and Tracy McGrady of the Toronto Raptors. Rice, who has only sporadically looked comfortable in the triangle offense, politely declines to discuss his future, but the Lakers have to decide to take one of two risks: Either tinker with a successful lineup and trade Rice, or keep him for the rest of the season and hope his performance isn't affected by the

> "When Phil Jackson tells you to defend the pick-and-roll a certain way, you do it because he's proven he knows what he's talking about, and you know you'll be sitting next to him if you don't do it that way. Guys know that listening to him could get us over the hump. If we don't win now, we won't have any excuses." —Shaquille O'Neal

weight, needed to be lighter and in better condition. Jackson has soft-pedaled the issue since, but it is probably no coincidence that he has been giving O'Neal heavy minutes (39.1 a game) to help him shed pounds. That approach has paid off, though the added playing time for O'Neal also points up one of the Lakers' weaknesses—they lack a genuine power forward or backup center to help him shoulder the burden on the boards. Green and Robert Horry have done their best, but Green is 36, and Horry is a small forward playing out of position.

An even bigger trouble spot may be the unresolved status of Rice. He can become a free agent at the end of the season, and Lakers management has shown no willingness to give him the maximum contract, which starts at

knowledge that the team doesn't want to re-sign him.

Maybe O'Neal, whose largesse is legendary, can come up with a little bauble to keep Rice's spirits up. He did, after all, give backup point guard Derek Fisher a $5,000 Rolex watch as his secret Santa gift last month, and when O'Neal found out that equipment manager Rudy Garciduenas was driving an old pickup truck last season, he bought him a new one, which Garciduenas adorned with the vanity license plate THNX SHAQ. The best news for the Lakers is that they have three months to pave over potential potholes before the playoffs start. "May and June are the only months that matter," says O'Neal.

Everything else is just numbers, baby.

121

Stanley Cup Countdown

Sports Illustrated

IRON MIKE GOES SOFT
BY RICK REILLY

THE BIG MAN

JUNE 17, 2002 www.cnnsi.com
AOL Keyword: Sports Illustrated

SHAQUILLE O'NEAL

THE SHAQ FACTOR

How have Shaquille O'Neal and his size 22s led the Lakers' march to a third straight title? Let us count the ways BY JACK McCALLUM

THE GLEAMING WHITE SNEAKERS IN SHAQUILLE O'NEAL'S LOCKER LOOK LACQUERED, WHICH THEY ARE NOT, and massive, which they are. First-time visitors to the Los Angeles Lakers' locker room at the Staples Center gaze at them in wonder, and a brave few, casting nervous glances to make sure the big man is not in view, lift up their puny dogs to compare them with O'Neal's size 22s. Last week one Japanese reporter reached up and discreetly turned around a can of roll-on deodorant so that the label faced outward. "Ban," she announced.

It's not often that we have the chance to measure ourselves against giants, not to mention inspect their personal toilette. O'Neal affords us that opportunity because, unlike most giants, he walks among us—though, through Sunday, the NBA Finals had been more coronation than competition for O'Neal and his Lakers. He has conjured up comparisons to the recent master of the postseason while distinguishing himself from Michael Jordan in the following ways: His Airness never mooned fans from the team bus; nor did he offer his intestinal insights before an overflow press gathering. With noble carriage and sublime charisma, Jordan was Henry V; O'Neal, big, bold and bawdy, is pure Falstaff.

On Sunday, after a 106–103 victory over the Nets in New Jersey, the Lakers were one win away from a three-peat, and O'Neal was on the verge of winning a third straight Finals MVP award.

Trying to avoid the label of Worst Team Ever to Play for the Title, the Nets were even more hapless than expected in trying to stop the 7'1", 345-pound force of nature who in those three Lakers wins had averaged 37.0 points, 13.0 rebounds, 3.0 blocked shots and even 3.7 assists. Should L.A. win Game 4 on Wednesday at Continental Airlines Arena, it would be the first Finals sweep since the '95 Houston Rockets obliterated the Orlando Magic, whose 23-year-old version of O'Neal was much less complete than the current Lakers pivotman.

"It's a big stage," says Lakers forward Rick Fox, "and this is his time." Indeed, Shaq has so dominated the series, both on and off the court, that other purple-and-gold mainstays have been reduced to bit parts. Cataloging Kobe Bryant's various off-court jerseys has been a pleasant diversion (Hank Aaron, Wayne Gretzky,

Derek Jeter, Joe Montana, Joe Namath, Mariano Rivera and Jackie Robinson over the past few weeks), but the best all-around player in the world hasn't had to extend himself in this series because of O'Neal's preeminence. Watching Lakers coach Phil Jackson try to tie Red Auerbach's record of nine NBA titles has been interesting, but during games the Zenmeister has remained seated to a greater degree than usual because his message to the offense is so clear and simple: Get the ball to Shaq.

Then, too, on those occasions when the Lakers were stressed, it was Shaq who talked

The younger version of O'Neal was not the complete player who would win three titles in L.A.

them off the ledge. Trailing for most of Game 3, the Nets rallied behind a zone defense that collapsed two, three and sometimes four men on O'Neal, disrupting the Lakers' triangle offense and helping New Jersey take a 94–87 lead with 6:44 left. But back came Los Angeles, wrapped in the Big Security Blanket. "It's at those times that Shaquille becomes the most influential player in the game," said Jackson. "He has the ability to calm the effect of the crowd and get things to happen positively." Shaq talked softly during timeouts, told his teammates they've been together far too long to fold, encouraged them to keep sniping at the Nets. They did, regaining control of the game and getting closer to title number 3.

Because Shaq's influence on his team is so profound, because he has worked so hard at becoming a complete player and because he has played through so much pain, he bristles whenever it is suggested that his oversized body is the primary reason for his success—a suggestion that is made every night of the season. "The truth is, I was created by you guys," O'Neal told the media last week. "When I was a young player having fun, doing movies and doing albums, you criticized me all the time. I'd hear, 'Shaq O'Neal is a great player, but he doesn't have a championship. But he's not hitting free throws.' So, after taking criticism all my life, I know how to turn it into positive energy." Then he broke out into a huge smile. "So this is what you created, and I'm glad you did. Thank you, and I love you all."

He got up and left with everybody feeling happy. It was vintage Shaq, which can also be said about these Finals. While Bryant, Jackson and the rest did their bit, the series was really all about Shaq. And what's Shaq all about? Why, bull's-eyes, bare butts, nipple studs and other 100% true...

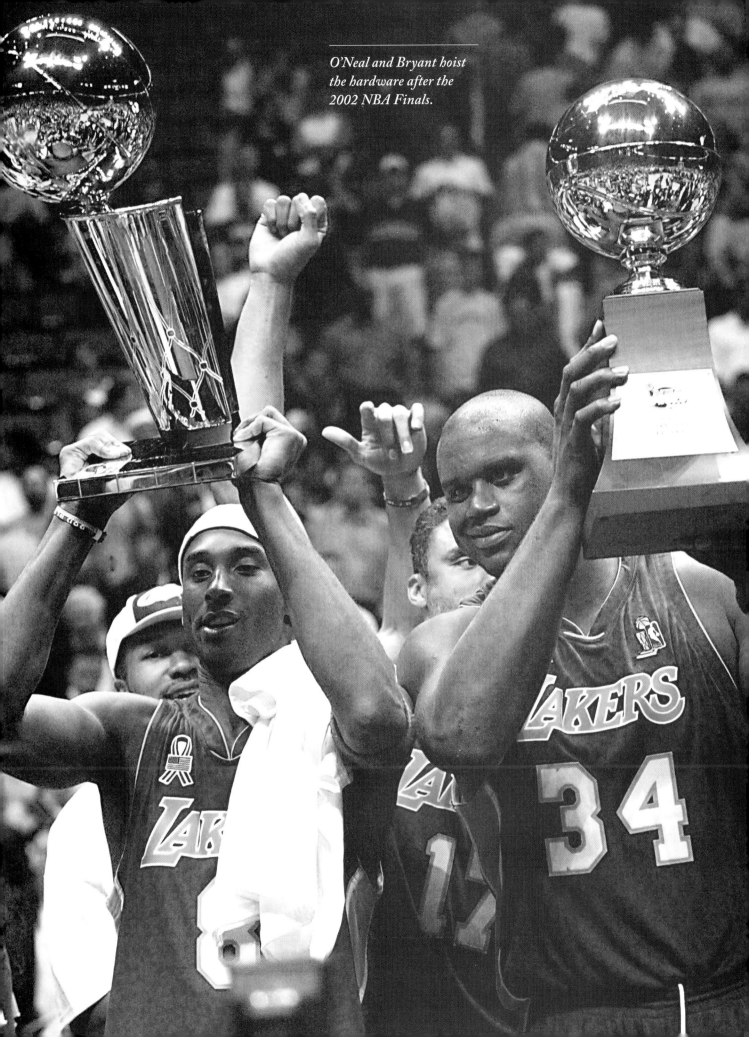

...SHAQ FACTS

TOP COP Shaq still plans to enter law enforcement when he's done playing. "I want my book to be different from most retired players'," says O'Neal, 30, who is under contract, at $21.4 million per year, through 2005–06. "I want people to say, 'Great high school player, great college player, great NBA player. And that sumbitch is a *sheriff* now!' I don't want them saying, 'Great player. That sumbitch is doing TNT now.'"

AMONG THE LILLIPUTIANS When he was taken out of Game 2 with 1:07 left, O'Neal stopped and said to Nets reserve forward Brian Scalabrine, "Mark's gonna bust your ass." He was referring to Lakers backup Mark Madsen, who rarely plays. Shaq said it straight-faced, but Scalabrine knew he was joshing, and it made him feel good.

One of the best things about O'Neal is that he takes the time to talk to everyone and generally sits or stoops to make his partner in conversation comfortable.

EARLY-BIRD SPECIAL? Shaq snagged about 80 Game 3 tickets for relatives who live in and around Newark, his birthplace. With a mansion in Beverly Hills and a 40,000-square-foot palace in Isleworth, Fla., near Orlando, Shaq

still claims, "I'm a Jersey guy all the way." Having said that, he's already decided that he will retire in Florida.

LOVE SHAQ Shaq is pondering marriage to Shaunie Nelson, his girlfriend of several years, but don't start shopping for wedding gifts. "I want to do it when I can focus on nothing but my marriage," he says. "Right now I'm trying to focus on my NBA career and my police career." Shaq and Shaunie live with a brood. Taahirah, 5, is Shaq's daughter from a previous relationship; Myles, 4, is Shaunie's son from a previous relationship; and Shareef, 2, and Amirah Sanaa, seven months, are the progeny of Shaq and Shaunie. "Amirah won't go to sleep until she hears my voice," says Shaq, who on many nights dozes off with her lying on his chest.

ROYAL FLUSH Shaq has drawn inspiration from Sacramento Kings coach Rick Adelman, who has continued to complain that Shaq was allowed to step over the line prematurely on his free throws during the hotly contested Western Conference final. Before Game 3, O'Neal sent a rhymed message to Adelman: "Don't cry/Dry your eyes/Here comes Shaq/With those four little guys." Then O'Neal went out and made 12 of 14 foul shots in a 106–83 victory, after which he described the exact moment when he heard Adelman's latest gripes, on a late-night sports broadcast.

Shaquille O'Neal

"I'm in the bathroom…sitting there, flipping through the channels, and he's complaining," O'Neal said. In Game 2, O'Neal even vogued after successful free throws, leaving an extended right arm in the air for several seconds to accentuate the purity of his stroke. "Another message to Adelman," he said.

ROYAL FLASH After a heated Game 7 victory in Sacramento, O'Neal delivered a different message to Kings fans who were hooting at the Lakers' bus as it pulled away from Arco Arena: He lowered his pants and showed them his rear end.

ACTION SHAQ-SON Shaq's questionable thespian talents (*Kazaam*, *Blue Chips*, *Steel*) notwithstanding, he says he would consider a return to the big screen, "if I can get me an action role where I can be jumping out windows with some *Matrix*-type effects." His career as a rap artist, however, appears to be over. "I did six albums: one platinum, two gold, three wood."

HOG HEAVEN Shaq began riding motorcycles six years ago. Although he is reluctant to ride in L.A.—"It's too hilly and curvy, and the people are crazy," he says—he will tool along level Ventura Boulevard. "You let the wind hit your face," he says. "You feel free, you get away from everything and you get to think."

BREAST BEATING Before the Finals, Shaq says, he removed the diamond studs that are in both of his nipples "for no particular reason."

GETTING RELIGION Shaq heard Louis Farrakhan speak at a Nation of Islam meeting several months ago. During the Sacramento series he greeted Kings forward Hedo Turkoglu with an embrace "because you greet a Muslim man with honor." And he plans to take a pilgrimage to Mecca one day with his

stepfather, Phil Harrison, a Muslim. Still, Shaq says he has no plans to convert to Islam. "My mother [Lucille Harrison] is a Baptist, so I understand both religions," says O'Neal. "Right now I'd just call myself a man who believes in God."

PISTOL PAQIN' Shaq, usually accompanied by Jerome Crawford, his bodyguard and close friend, likes to take pistol practice at a range in Van Nuys. Out of 300 shots from between 25 and 50 yards he says he routinely scores 265 to 270 bull's-eyes.

KING OF PAIN For all his playfulness, Shaq isn't always the easiest guy to be around—the *Los Angeles Times* disclosed last month that the Big Moody is one of his teammates' out-of-earshot nicknames. But all the Lakers praise his fortitude in playing with an arthritic big right toe and a left little toe that was operated on last year. Shaq puts the pain in his right toe at eight on a scale of 10. "Your toe is supposed to bend when you walk," says Shaq, "but mine doesn't at all. I walk flat-footed, I run flat-footed. The worst time is the morning after games, when I wake up and can't even move it. I lie there and think, I gotta play basketball on this? But I suck it up. Some people who think I'm not hurting should walk a mile in my shoes." •

TRAINING CAMPS OPEN
HERE COMES THE NFL
CAN THE BENGALS' CARSON PALMER EARN HIS STRIPES? ▸▸

PLUS: Big questions for the Cowboys, Bucs, Eagles, Chiefs and Patriots

Sports Illustrated

IT'S OVER
The Fall of the Lakers and The Resetting of the NBA
by JACK McCALLUM

TODD HAMILTON WINS THE BRITISH OPEN

Maria Sharapova's Fast Lane

JULY 26, 2004 www.si.com
AOL Keyword: Sports Illustrated

THE END

*By trading Shaquille O'Neal and keeping Kobe Bryant, the Lakers
dropped the curtain on the NBA's most riveting soap opera. (Can you
hear the applause all over the West?)* BY JACK MCCALLUM

THEY ARE AT LAST EMANCIPATED FROM EACH OTHER AFTER BEING BOUND (HOWEVER TENUOUSLY) FOR EIGHT
years, with a continent between them, free to snipe away with impunity. The trading of
Shaquille O'Neal to the Heat of Miami (which becomes a new "media mecca," according to
Shaq) and the re-signing of free agent Kobe Bryant by the Lakers of Los Angeles (soon to
be a lesser media mecca, at least by NBA standards) dominated a momentous off-season in a
league that not so long ago didn't even own a hot stove.

But when all the stories about Shaq were
written (for local scene, SHAQ IS BIGGEST
BIG NAME YET proclaimed the front page
of *The Miami Herald* on July 14, followed by a
$HAQING UP headline in the business section)
and all the denials from Bryant were in ("If
[Phil Jackson's] departure had something to do
with me, I had no idea" and "People assume I
didn't want [Shaq] around. That's not true"),
the clear winners after the breakup of this
As the World Turns team were…the champion
Detroit Pistons and the Western Conference
(except, of course, the Lakers).

There's no denying the impact O'Neal will
have in Miami. Some 400 number 32 jerseys
were ordered from the Heat's website in the first
two hours they were available. Team president
Pat Riley likened the ticket-selling scene at
AmericanAirlines Arena last week to the floor
of the New York Stock Exchange. Revelers at
South Beach were already salivating over the

prospect of the Big Buzz making the scene.
But having dealt its starting frontcourt
(Lamar Odom, Brian Grant, and Caron Butler)
plus a No. 1 pick, Miami is far from the favorite
in the East. The Heat still needs a frontline player
or two, and two-thirds of its payroll now belongs
to a 32-year-old podiatric puzzle who will make
$58.3 million over the next two years.

As for the Lakers, look for the triangle
offense to be replaced by Bryant's "my angle"
offense. (Hey, you need to take a lot of shots to
earn the maximum, $136.4 million over seven
years.) But even if Bryant averages 30 points, the
Lakers are no better than the fifth-best team in
the West. Take O'Neal out of the conference and
every other team gets better—it's that simple.

If Karl Malone returns to L.A., it won't be to
the soap opera in which he played a supporting
role this past season; then again, it might not be
much of anything. Even in this realm of over-
sized men brazenly pursuing their own agendas,

it's hard to fathom the Lakers' implosion. "In the history of the game," said one GM, "there's never been that much turmoil after that much success." Anyone with any sense knows that a team with Shaq and Kobe on the same page (or at least in the same book) and Jackson ruling sagaciously from the sideline should have been practically unbeatable. On some level O'Neal and Bryant knew that as well.

Yet they all went their separate ways: Shaq demanded a trade and Jackson reached a mutual decision with owner Jerry Buss that he would not be offered another contract. Jackson had conceded, publicly at times and much more strongly in private, that his relationship with Bryant was troubled. "They wanted to make some moves to accommodate signing Kobe," he said last week. "We knew they probably wouldn't work if I was coaching the team." Shaq, who has always slyly gotten his point across about Bryant without blasting him directly, said last week, "If you look at all the pieces of the puzzle that are thrown out there and you understand the game and understand the politics, you can put it all together and draw your own conclusions."

Bryant with daughter Natalia before a game in 2005.

Disingenuous doesn't even begin to describe Bryant's reaction to the destruction of what could have been a dynasty. He denied urging Buss to get rid of Shaq and Jackson, denied lobbying for the hiring of Duke coach Mike Krzyzewski, and said he was hurt by the accusations that his Machiavellian dealings had broken up the team. Then he admitted that he had called Krzyzewski—Coach K spurned L.A.'s five-year, $40 million offer—and that he did not recommend retaining Jackson to Buss.

But it's not all Bryant's fault. O'Neal's aversion to conditioning (he has missed 15 games in each of the last three seasons) contributed to Bryant's not wanting to play with him, a fact confirmed by multiple Lakers sources. Shaq was also demanding a huge extension that Buss had no desire to grant. And perhaps Jackson realized the time had come to recharge his batteries at his home in Montana, probably to return as a coach (in New York?) or a team president.

The only thing clear about the NBA earthquake that hit L.A. last week is that the fortunes of the purple and gold have declined—even with the return of center Vlade Divac, 36, who on Monday reportedly agreed to a free-agent deal with the Lakers. "It's going to be a struggle for us, an uphill battle," Bryant said last week. And provided he is still plying his chosen trade after the conclusion of his sexual assault trial which begins in Eagle, Colo., on Aug. 27, it will be his struggle, his uphill battle.

The mood in Miami is immeasurably lighter, festive even, befitting the arrival of a supersized celeb in a party-hearty town. As Shaq got prodded and probed and MRI'd in Coral Gables last Thursday, passersby

stared into the windows at Doctors Hospital, photographers hid in bushes, and a news helicopter hovered overhead. Before heading to L.A. for the weekend, O'Neal did give South Florida a dose of Shaq-yak. He said that he wants to finish his career in Miami; that he had been thinking about buying a house near there anyway because he likes to take his kids on boat rides in the Atlantic; that facing the Eastern Conference centers, "outside of [Indiana's] Jermaine O'Neal, is not going to be that difficult for me"; and that he sees himself being competitive for five or six more years. "Buy tickets," he told a group of fans, "and be ready to roll."

Yes, it's the summer of Shaq, and the living is easy. But not for Bryant. Between these two superstars, who perhaps flew too high too fast to enjoy the ride, right now it is assuredly less trying to be O'Neal. But judgment day between the lines will come for the Diesel, too, because the Heat didn't acquire him just to sell jerseys or jazz up the scene at Liquid. Together, O'Neal and Bryant prospered, but their partnership could not endure. Will they ever prosper apart? •

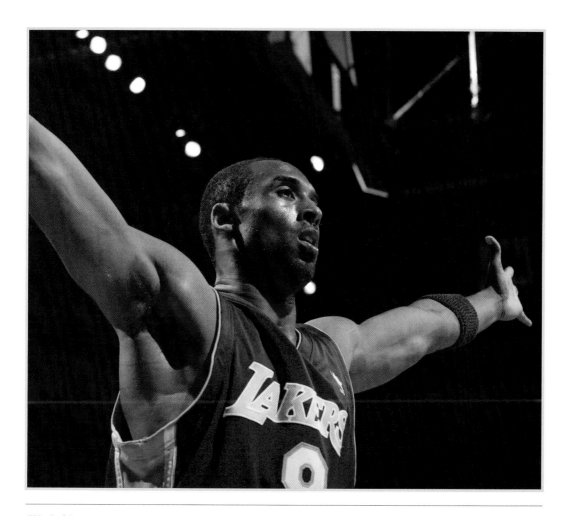

With O'Neal in Miami, the Lakers were unquestionably Kobe Bryant's team.

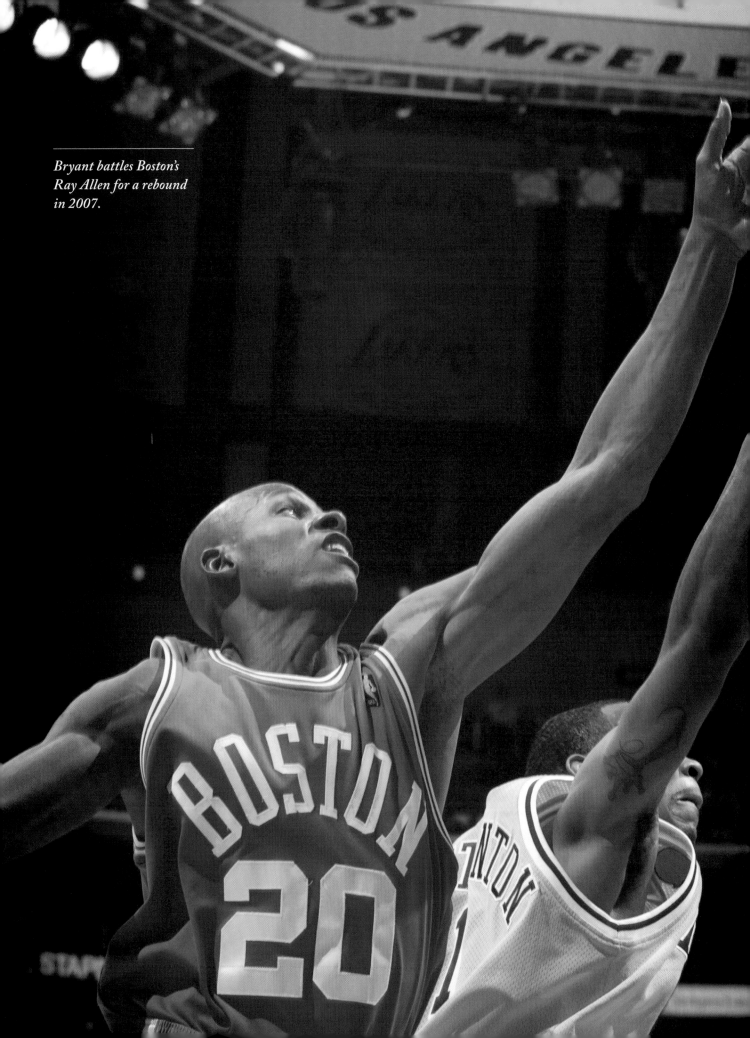

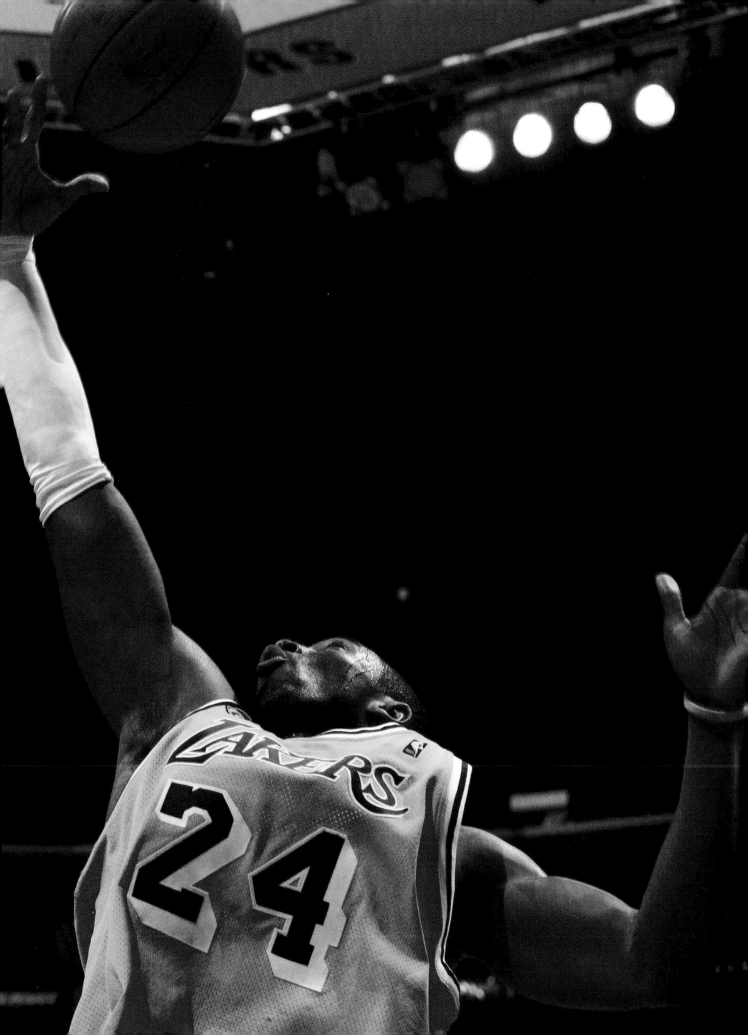

HAPPY FATHER'S DAY
FROM REX AND BUDDY
BY TIM LAYDEN P. 46

Sports Illustrated

JUNE 22, 2009 | SI.COM

NBA CHAMPIONS

Kobe's Moment

P. 36

BY CHRIS BALLARD

SATISFACTION

The Lakers are NBA champions again, and it's because they have a star who would settle for nothing less. BY CHRIS BALLARD

IT IS 2 A.M. ON THURSDAY DURING THE SECOND WEEK OF THE NBA FINALS, AND KOBE BRYANT CANNOT SLEEP. In less than 24 hours the Lakers will make an unlikely comeback to win Game 4 in overtime, and three days later after a masterly 30-point performance in Game 5, Bryant will again be a champion.

He will raise the Larry O'Brien trophy in his long arms, and he will laugh and hug his teammates long and deep and, yes, even tear up a little. The mask of intensity he has worn for months will finally fall.

But for now it remains. For now the Lakers lead the Magic 2–1 but are recovering from a painful loss in which Bryant missed late-game free throws. So he sits in a high-backed leather chair in the lobby of the Ritz-Carlton in Orlando, surrounded by chandeliers and white orchids and gleaming white floors, in the company of friends—a group including his security guy, team employees, and trainers—but alone. He says little, the hood of his sweatshirt pulled over his scalp, his eyes staring into the inky night, past the windows and the palm trees. He holds a Corona but rarely brings it to his lips. He looks like a man so tired he cannot sleep, a man nearing the end of a long journey. It is one that began well before November, when this season started, or even last June, when the Lakers fell to the Celtics in the Finals. As he will later explain in a quiet moment, he divides his career into two bodies of work: "the Shaquille era and the post-Shaquille era." Since the post-Shaq era

began in 2004, when the Lakers traded O'Neal to Miami, many have doubted, again and again, that Bryant would ever earn a ring on his own. And while he has dismissed those who classify his legacy as Shaq-dependent, calling them "idiotic," he also knows how close he is to banishing that perception.

Minutes pass. Bryant stares and says nothing. He has waited this long. He can wait a little longer.

Thirteen years into an exceptional NBA career, this is finally Kobe Bryant's moment. Sure, these Finals were about Phil Jackson attaining his 10th ring as a coach (surpassing Red Auerbach's record) and guard Derek Fisher's nerveless performance in Game 4 (hitting a pair of clutch three-pointers to swing the series in Los Angeles' direction) and the emergence of 23-year-old Dwight Howard (proving, as he took the Magic to the Finals, that a big man need not scowl to be dominant). But let's be honest: this has been about Kobe all along.

So what do we make of him now? As polarizing a figure as there is in the league, he is deified in L.A. and often detested elsewhere, yet not even his detractors can deny his talent or accomplishments. At 30, Bryant has four championship rings (one more than Michael Jordan at the same age), two scoring titles, an MVP award, and now a Finals MVP award. He has won for six coaches and as part of starting lineups that included Travis Knight and Smush Parker, suffering but one losing season (and when it comes to Bryant, suffering really is the right term). He has accomplished all this while playing for one team, showing the single-town loyalty fans cherish in their sports heroes. Those who would claim that he is a poor teammate or a poor leader would seem to be finally out of ammunition.

can't do it by sheer force of personality, is by winning.

So he gave himself over to this one goal as never before—which is saying a lot for Kobe. He shut down communication during the Finals, ignoring most phone calls and cutting off email. He became so ornery that his two young daughters took to calling him Grumpy, from Snow White. And he sought nothing less than a similar commitment from his teammates. When 21-year-old center Andrew Bynum came out lackluster in Game 3, Bryant lit into him during a timeout, loud enough that a sideline reporter could overhear, "Get your head in the f— game." This was not the soft, cuddly Bryant we were served up last month in ESPN's Spike Lee documentary

He dominated not only with baskets but with passes—he had nearly twice as many assists as any other player in the Finals.

His performance in these Finals was memorable not necessarily for the bursts of scoring (though of course there were those) but for the moments that revealed both his evolution as a player and his near-desperate desire to win. The way he wrestled with Orlando's Rashard Lewis, elbowing and hooking and kneeing when he had to switch onto the 6'10" forward; the way he bared his teeth after big plays, like a feral animal; the way he dominated not only with baskets but also with passes—Bryant had nearly twice as many assists as any other player in the Finals. Though he would never admit it, his willingness to play whatever role his team needed may have reflected Bryant's awareness that the era of LeBron James and Dwight Howard is at hand, and that the best way for him to stay relevant, since he

Kobe Doin' Work. Rather, this was Kobe actually doing work. And it was far more compelling.

Thus, to see the man as he was during these Finals, not as Nike or Lee or Bryant might prefer, is to see a portrait of him at his competitive best, a man intent on controlling his own legacy.

It's late in the first half of Game 1 at Staples Center, and Bryant is on one of those rolls. He sticks one jumper, then another. At times like these, he says, he can sense the fear in his opponent, in this case 6'6" swingman Mickael Pietrus. "They get kind of nervous and are scared to touch you," Bryant explains. "It's no fun playing against players like that." He prefers a confident opponent. "It becomes more fun for you," he says, "because it becomes a challenge."

This desire for challenges—and isn't it remarkable that in the Finals he craves added obstacles—is what Bryant has spent the last decade trying to both feed off and harness. In recent years, at Jackson's suggestion, he's turned to meditation. He's also coming to terms with the fact that it isn't that his teammates don't want to win as much he does (though this is true), it's that they don't have the capacity to want to win as much as he does. Says Gregg Downer, Bryant's coach at Lower Merion (Pa.) High and a good friend, "As difficult as Kobe can be, as demanding as he is, I think [he and his teammates] all found some middle ground, a center."

That center is this: give as much as you can, and you can play on his team. "I'm going to continue to push and push, and if my teammates can keep up, they will," Bryant says. "If they can't, then they probably won't be here."

Now it is Game 2, and Bryant is backing out of a double team, then passing to the weak side. He is trying to be a facilitator, trying to override his instincts, the ones that tell him to take over, to win this thing right here. And it's working: at the half he has the same number of shots (five) as assists.

It's a lesson he learned in the Western Conference finals against the Nuggets. Bryant was averaging 36.8 points, yet the series was tied 2–2 and L.A. was struggling, reliant on an increasingly exhausted Bryant to carry them.

Watching film, Bryant and Jackson noticed the same thing: Denver's double teams were creating avenues to the rim. The next game, Kobe made the adjustment. Doubled on the perimeter, he retreated, pulling the defense with him, then found open men who found open men. As Bynum said after that game, "When he's calm and he's moving the ball, nobody can beat us."

Bryant finished Game 5 against Denver with eight assists, then had 10 in a clinching Game 6 and was instrumental in dozens of other plays. It was, put simply, the Good Kobe. For L.A.'s coaching staff, getting Bryant to play like this has been an ongoing challenge. "He likes to make the pass for the assist of the score," says assistant Brian Shaw. "We would like him to make the pass that would lead to the pass."

Even though Bryant doesn't do this all the time, it's hard for coaches to get too upset. "There's a trust that we have because we know that he's trying to win the game," Shaw says. "There are a lot of times when Phil will call a play, but [Kobe] will have a feel for what's going on out on the floor and say, 'No, no, no. I already got something going.' Phil trusts that."

Now it is 5:30 in the morning after Game 4, and Bryant is headed to the gym. Only hours earlier the Lakers pulled out a dramatic 99–91 win to take a 3–1 series lead, and with three more chances to finish the series, the players could finally relax. There are two nights off before Game 5, and it was time to celebrate a bit, and Kobe did. For all of four hours. Now, before he goes to sleep, it is time to get in some work.

At the urging of his trainer, Tim Grover, Bryant heads to the fitness center at the Ritz-Carlton, where a couple of early-bird businessmen are shocked to share their treadmill time with an 11-time All-Star. For an hour and a half Grover takes Bryant through a series of exercises: weights, stretching, muscle-activation routines. Grover's logic is that if Bryant gets his work in now, he can have a block of uninterrupted sleep and not disturb his rest pattern.

Bryant's work ethic is renowned, but this season he became even more obsessive. Unhappy with his physical stamina during the Finals a year ago, he asked Grover, with whom he'd worked during the off-season, to become, in essence, his personal trainer: travel

with him, monitor his workouts. For Grover, who runs his business out of Chicago, and whose clients include Dwyane Wade (and, for many years, Michael Jordan), it was asking a lot. "There are only about three guys in the league I would have even considered doing this for," says Grover. "With Kobe, I knew he'd take it very seriously."

Grover's modifications were small but important. Bryant had never been an advocate of cold tubs; Grover had him taking ice baths frequently for muscle recovery. He focused on strengthening Bryant's ankles, wrists, hips— "areas that don't make you look better in your jersey but can become nagging injuries," Grover says. The result is that, despite having played for nearly three years straight due to his Olympic commitments, Bryant came into these Finals free of ankle braces, shoulder wraps, and sleeves—although his right ring finger, dislocated earlier in the season, remained taped. He even wore low-top shoes.

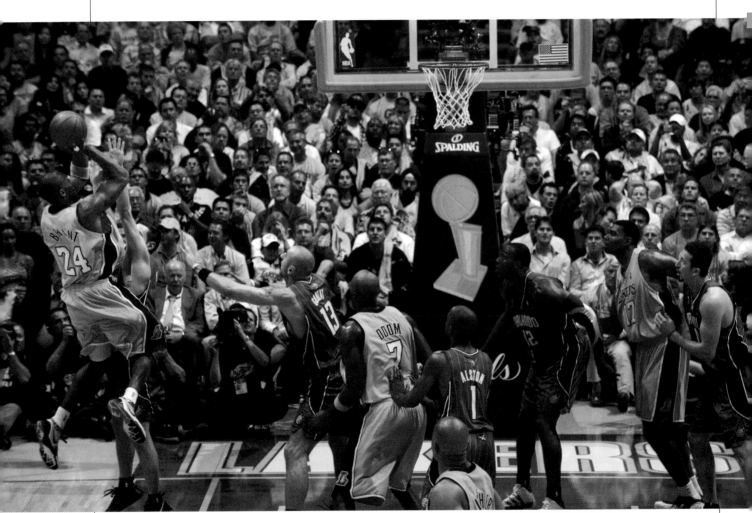

Bryant shoots in Game 1 of the NBA Finals in 2009 against Orlando. He was named the Finals MVP after the Lakers won the series in five games.

(Bryant believes they give him a greater range of motion, and Grover concurs.) When Bryant missed those free throws in Game 3, finishing 5-of-10 from the line, Grover had him show up early the next day and spend 40 minutes just shooting foul shots. "The superstars aren't superstars just by accident," says Grover. "Michael was Michael because of what he did on and off the court; it didn't just happen. Same with Kobe. It's because of the time and effort and the knowledge that he gains and his willingness to listen to people."

It is an interesting concept, that a man long criticized for not listening to people is succeeding now because he does.

Now it is before Game 5, and it seems as if every camera in Amway Arena is trained on Bryant. His eyes are hooded, his jaw is set. This is what he came for. When Bynum says of Bryant, "Only he knows what motivates him," well, that's not really true at all. Don't we all know what motivates Bryant? As Fisher says, "He wants to be the best player to have ever played this game. That's what he works at every day."

While it is often easy to question Bryant's sincerity, it is hard to do so when the subject is his drive. "I push and push and push—that's the only way I know," Bryant says. A day earlier I had asked him about the future, when he's in his mid-30s, and whether he could ever see himself being a third option on a team. "Third option?" he said, and then he paused. He frowned slightly, rolling the idea around in his head, entertaining an existence where he orbits others, not the other way around. He wrinkled his nose at the thought, then finally answered. "I don't know; that's tough to see," he said. "One thing I've always been great at is scoring the ball. Even when I'm 35, I think I'll be a bad mother—." And with this, Bryant laughed. It must feel good to tell the truth.

Finally, the moment—his moment—is here. There is 1:12 left in Game 5, and the Lakers have both the ball and a 95–84 lead. Once again, Bryant has been superb. He has hit big shots, including an acrobatic runner across the lane, coming right to left, switching hands in midair, eluding the 6'11" Howard's reach and then hitting a soft banker before crashing onto his back; it called to mind Jordan's iconic levitating, right-to-left midair layup against the Lakers in the 1991 Finals. Again, however, it was the rest of Kobe's game that stood out. He had two steals, four blocks, six rebounds, five assists, and untold hockey assists—the passes that lead to the passes that lead to the scores that make Brian Shaw so happy.

Now, during this final Lakers timeout, Bryant heads back to the bench. He tries to lean back in his chair but cannot sit still. He attempts to control his breathing, which is quick and shallow. He bites his nails, shifts his eyes; he looks nervous, like a teenager about to ask a girl out on a first date. Then, finally, shyly, he smiles. It is a genuine smile, oddly naked. It is a Bryant we rarely see.

Soon, he will accept the MVP trophy and bring Natalia, 6, and Gianna, 3, onstage. Then he will run back to the locker room, slithering through the hallway crowd, shouting, "Oh! My! God!" and he will make sure to drench Jackson in champagne, and then he will sit before the media at a podium and grin goofily and talk about getting "a big old monkey off my back" and rest his cheeks in between his hands and say how it feels as if he's dreaming and how he "can't believe this moment is here." And then he will head to the Ritz to celebrate, still wearing his champagne-soaked T-shirt and shorts, a cigar protruding from his mouth, punch-drunk and pleased to take photos with all comers, no longer the child prodigy, no longer the petulant sidekick, no longer the selfish ball hog, no longer the Michael Jordan wannabe, but just Kobe Bryant, champion. •

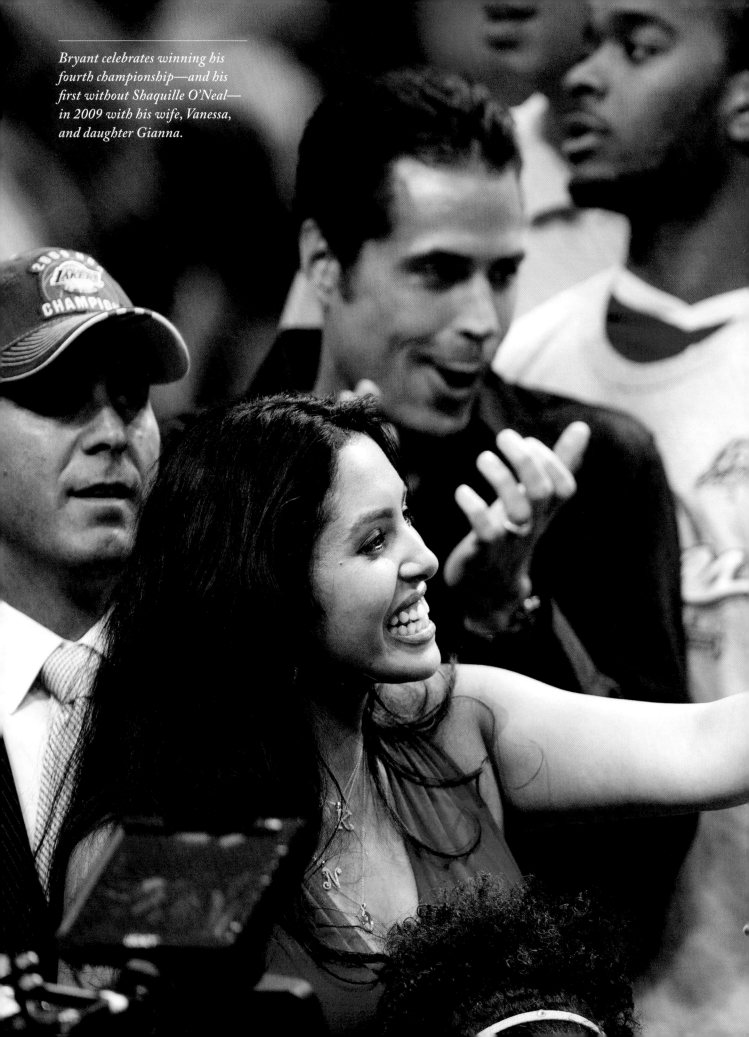

Bryant celebrates winning his fourth championship—and his first without Shaquille O'Neal—in 2009 with his wife, Vanessa, and daughter Gianna.

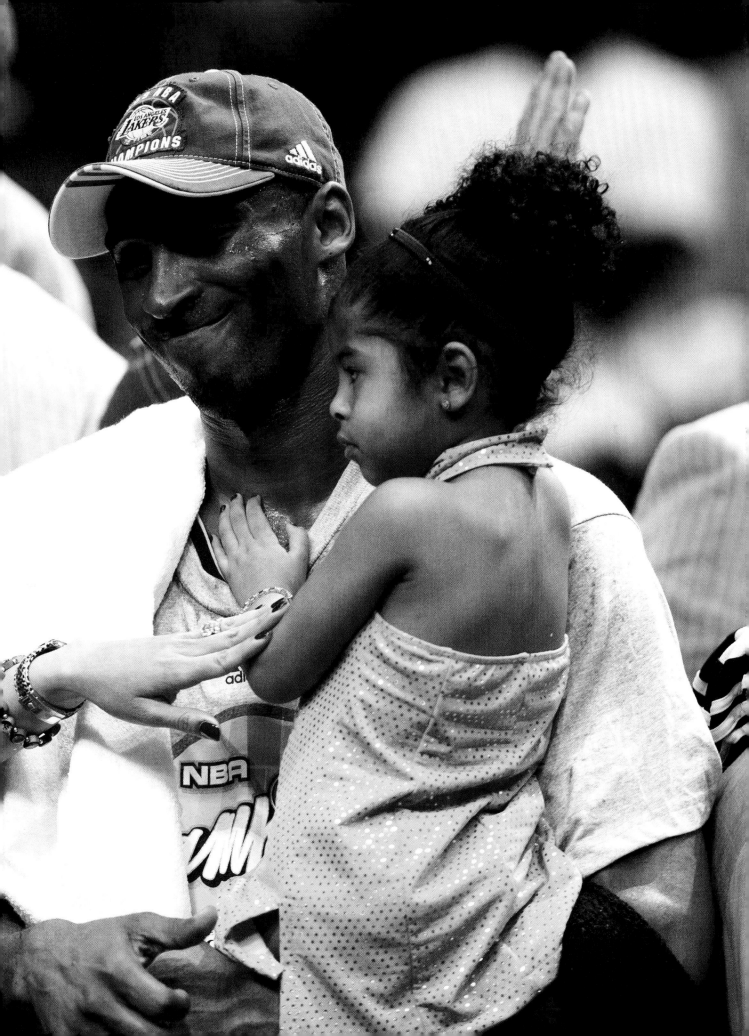

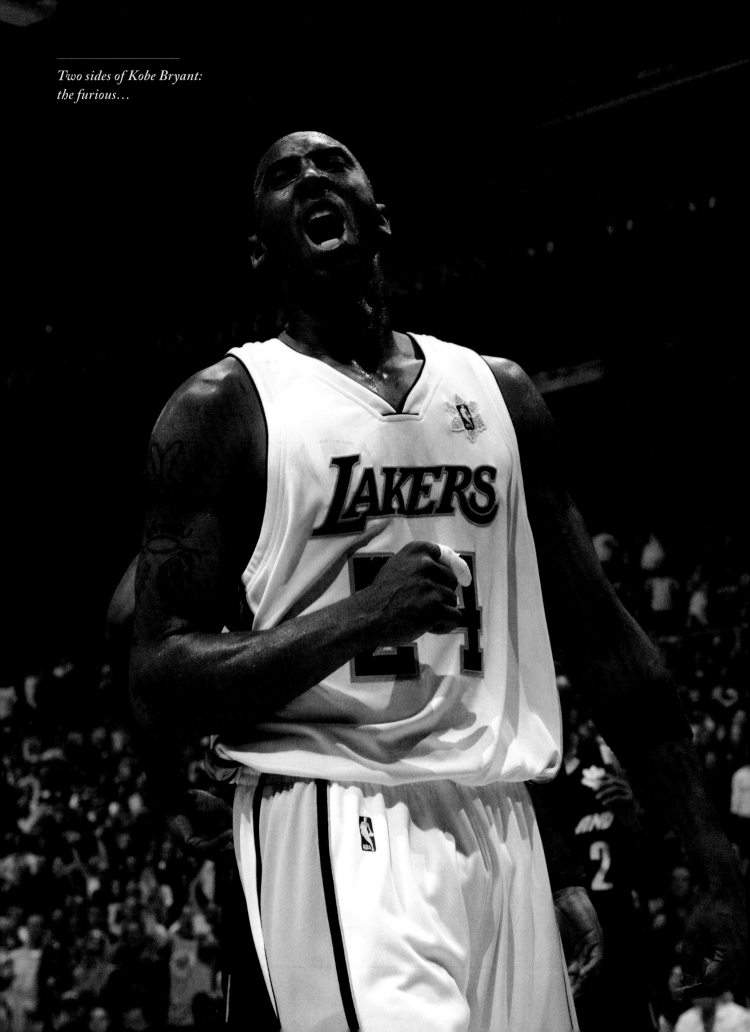

Two sides of Kobe Bryant: the furious…

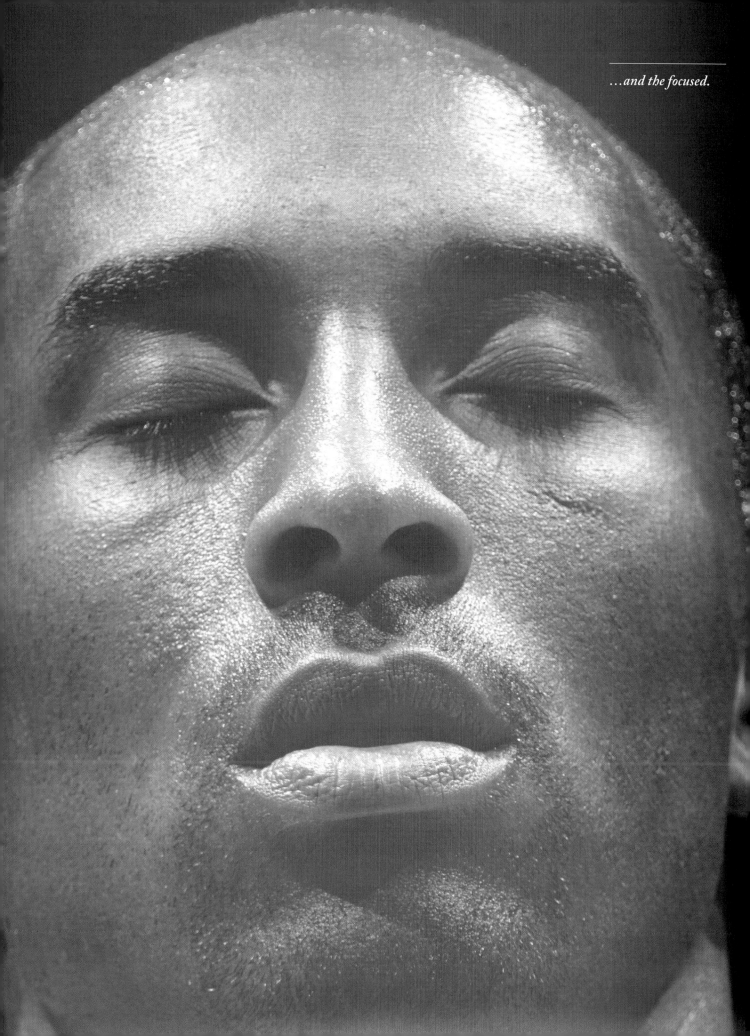

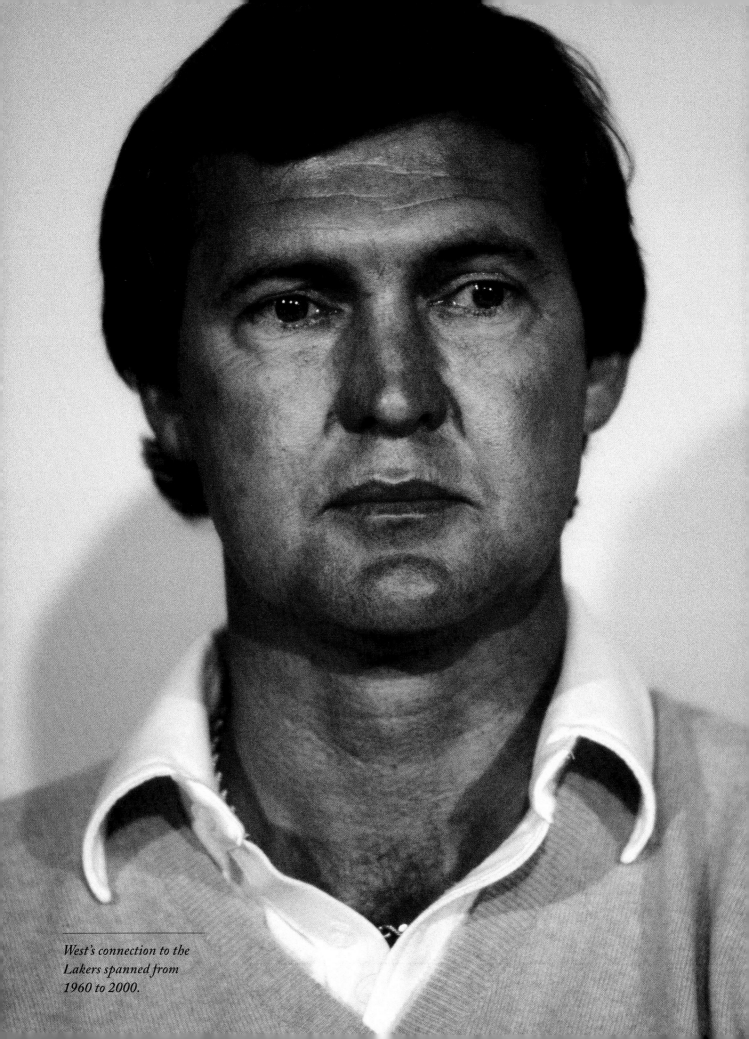

West's connection to the Lakers spanned from 1960 to 2000.

BASKETBALL WAS THE EASY PART

Hall of Famer Jerry West reveals the sources of the drive that led him to succeed both on the court and in the Lakers' front office, and of the depression that haunted him every step of the way BY GARY SMITH

H**ERE'S THE TROUBLE WITH THE GODS: THEY DON'T COME CLEAN. NOT EVEN TO FELLOW GODS. SO MAYBE IT** *wouldn't work.*

Maybe Jerry West couldn't do what he would love to do: gather them in a room—Michael and Kobe and Magic and Larry and Tiger and Ali—and begin digging to the bottom of what separated them from the mortals.

"But they just don't talk about these things," he says. Maybe they don't know, or want to know, what's at the bottom. Maybe they're afraid knowing might diminish their power. Maybe they've not stared down there as many nights as he has, waiting for light to find its way to his window.

Prometheus stole fire from the gods. He scaled Mount Olympus, snatched a glowing ember from their sacred hearth, hid it in a hollow fennel stalk and slipped away, pretending the stalk was a walking stick. He passed it on to men, freeing them from the misery of darkness, cold and ignorance.

This enraged Zeus. Fire had been a critical advantage the gods held over men. Prometheus was chained to a boulder on Mount Caucasus, where each day an eagle tore open his flesh and feasted upon his liver.

Who could doubt that Jerry West was one of the gods? He levitated West Virginia to the NCAA title game in 1959, tying a tournament record with 160 points in five games. He co-captained the U.S. to the Olympic gold medal in Rome a year later. Among retired NBA players, only three—Michael Jordan, Wilt Chamberlain and Elgin Baylor—averaged more than his 27.0 points a game, and only one, Jordan, surpassed his 29.1 playoff scoring average; just imagine

those numbers if there had been the three-point shot. Jerry produced perhaps the most statistically stunning game the NBA has ever seen, a quadruple double before such a thing existed: 44 points on 16-for-17 shooting from the field and 12 for 12 from the foul line, 12 rebounds, 12 assists and 10 unofficially counted blocked shots. And he was a *shooting guard*. He was an All-Star in each of his 14 Lakers seasons and remains tied for second, after Karl Malone, with 10 selections to the All-NBA first team. He's the logo, for God's sake. That white-silhouetted figure dribbling on the NBA brand—that's *him*.

Then, unlike the other gods, he retired and became something *greater*: the architect of Lakers teams that went to eight NBA Finals and won four of them, the general manager whom many consider the best in NBA history.

It would have been so easy, at 73, to tally it all up in a memoir like the books of the other gods, one that bounces from exploit to exploit in a double career containing more seminal moments than that of any other man in the history of his sport. From his epic six NBA Finals wars with the Celtics in the 1960s to the 63-foot shot he nailed in the '70 Finals to the NBA-record 33-game winning streak he spearheaded in '71–72 to the triple-title Showtime Lakers he helped build as G.M. in the '80s to his lightning-strike acquisitions of Shaquille O'Neal and Kobe Bryant in the summer of '96, setting off another title run.

Instead….

Instead he anguished for more than three years co-writing a book with Jonathan Coleman—*West by West: My Charmed, Tormented Life*—that's choking with the truth about the fire that made him a god.

———————

Why shouldn't Jerry tell mortals the truth about fire? He needn't fear Prometheus's fate—he's been devouring himself all his life.

Like that night in Honolulu during training camp, recounted in the book, when, as G.M., Jerry took 15 members of the Lakers' front office and scouting department to dinner at Ruth's Chris Steak House and returned his steak to the kitchen twice because it wasn't cooked as he'd requested. He insisted on eating it when the cook got it wrong a third time, insisted on paying for it even when the manager told him there would be no charge, insisted that he would never come back again if he were not charged…but then was so incensed when he was charged that he walked out of the restaurant, leaving his 15 guests in awkward silence, and returned with four cheesecakes from a nearby restaurant for everyone to eat right in front of the bewildered manager. He'd go back to his hotel room or his home after nights like that and lie awake, feeding kindling to the glowing embers, turning slights into flaming grudges. Blazes too magnificent for any steak-house manager but just right to roast an opposing guard or general manager.

One thousand one hundred seventy-eight days and nights sitting in his socks and jock and shorts in pregame locker rooms, sweat pouring from his skin, stomach about to heave up the small meal he'd risked 6½ hours earlier, hearing nothing his coaches ever said, burning so much energy that he'd feel lifeless by the opening tip, then waiting, watching as the game began. "Just hoping someone on the other team would say something, anything, even something small and stupid, to piss you off," he says, moving to the edge of a couch in the house in White Sulphur Springs, W.Va., where he lives three months of each year as a break from L.A. "You'd want to embarrass that person. You'd turn from a player who was competing to a person who was a monster. That anger was like having mental steroids. Driven to the point of being crazy. I'm not sure I loved the game. I loved the

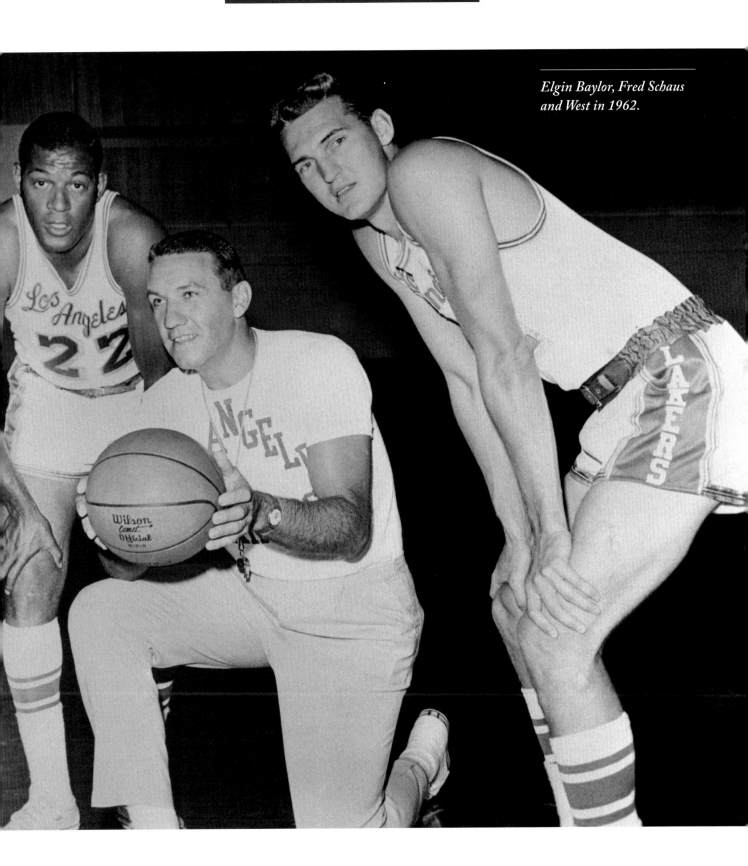

*Elgin Baylor, Fred Schaus
and West in 1962.*

competition. I'd think, I've got to get it out, but how can I take this out on someone who's an equal, someone of equal size, so it's fair?"

Another gifted athletic jerk? Oh, no: Most of the players beside and beneath him during his five decades of combat loved his humility and authentic interest in them and his bottomless respect for the game, cherished him just as much as they were mystified by him. Odd, what Magic Johnson said to the man who was his general manager, not his coach, when the Lakers unveiled a 14-foot bronze statue of Jerry outside the Staples Center last February: "Everything we did as a team, we did because of you."

Odd, what a man with his own 14-foot bronze statue says in his new book: *People will ask, "When does the healing begin?" and I say it never begins.*

Or maybe not so odd. Another fine question for the roomful of gods.

———

But selfhood itself was born in an act of defiance—if Jerry allowed that to flicker out now, why then….

He can't show you his last childhood home in that little mining town in that little hollow in the Alleghenies. Fire took it all away. A frying pan that was spitting oil set a kitchen curtain ablaze while his mother and sister watched *American Bandstand* one day in 1962, during Jerry's second season with the Lakers, and the Wests' home went up in flames, incinerating all his memorabilia except his gold medal and Olympic uniform: good, better that way. Many of his later keepsakes and awards, he would leave behind when he moved out of a house in L.A. that he had rented from Pat Riley, telling Riley to do with them whatever the hell he wished. They're in a Miami storage bin today.

It was never about rewards or memories or fame or, hell, the game itself. Why, he wasn't even *practicing*, he says of the hour

upon hour he spent on a beat-down dirt yard shooting at a hoop a neighbor had nailed to a storage shed in Chelyan, W.Va. Shooting alone, from every conceivable angle, even when the dirt went to mud. Shooting till his hands cracked and bled in the cold. Shooting with a higher and higher release point so the imaginary defender covering him couldn't possibly deflect his shot as he ticked down the final 3-2-1 of a game in his head. Shooting alone at a netless wire basket that he later attached to a bridge, shooting with perfect backspin to make sure the ball would swish and rotate back toward him rather than roll down an embankment, shooting by sighting on the two hooks farthest away from him on the rim, a visual cue he'd use the rest of his life—"How did I figure that out on my own?" he wonders. Shooting clean through his mother's cries that she'd whip him if he didn't come home for dinner…but don't dare call it *practicing*: "I was just afraid to go home." Afraid not of Cecile's whippings, even though she was big, broad-shouldered, man-strong; no, those were a lark. Afraid of *his*.

Father's. Howard West would come home to his wife and six children from Pure Oil in nearby Cabin Creek, where he was a machine operator and union activist, so head-to-toe black that Cecile would make him remove his clothes before he stepped inside. Then he'd sink into his chair, barely speaking to her—Jerry can't remember their ever showing affection for each other—and sink into sleep. But when he roused….

Suddenly the boy might find himself pinned beneath the man, whippings turning into beatings. There was plenty in the world to be angry at. Howard was locked in a marriage to a depressed woman whom he had betrayed, reeling into poverty after being fired as a result of his union activities at Pure Oil and spinning in grief over the death of his third child, 21-year-old David, in 1951.

Jerry's eyes, 60 years later, still grow wet at the utterance of his brother's name. *It was as if he had an aura about him*, Jerry writes. David, nine years older, was so calm, kind, devout and mature…the shine in his perfectionist mother's eye, the boy who lifted everyone's spirits and lowered everyone's guard and made Jerry keep thinking that if only he could be like David, maybe he too could feel his parents' love, maybe he could stop feeling there was something wrong with him.

David's effect upon his infantry mates in Korea was no different. The Preacher, they called him, staying near him when they came under fire, convinced that God wouldn't take that godly a man—until He did. Mortar shell. Amputation. Raging infection.

Jerry, a 13-year-old coming home just after the telegram arrived, heard the pounding as he approached the front door. It was the fists of his mother as she beat the walls. When they didn't collapse, she staggered outside to pound the earth.

Schaus and West in 1962.

For six months the family awaited David's body. Weeks of Jerry running to the post office in Cabin Creek to fetch the mail and freezing at the sight of another late-to-arrive loving letter from David. Months of Jerry's mother plunging deeper into depression, pulling Jerry in her wake as he watched her recede from him and from life. "I turned my back on my family," he says. "For me, it went from anger to futility. I didn't understand why *I* didn't get killed. The thing I used to say to myself all the time was, What did I do wrong for this to happen?…I'd think, I bet they wish David lived and I died."

He stopped eating, spiraling into a depression that no one identified. He kept shooting right through dinner, dreading the man at the head of the table and recoiling from the food his mother scraped together. His skin took on the texture of a plucked chicken's. Once, after six straight days of the same soup, he told his mother he couldn't bear it anymore, and his father beat him so long and hard that Jerry drew a line. He had to take everything miserable in his childhood, all the grief and rage he couldn't talk about with anyone, and turn it into a weapon, one that would require so much vigilance to wield that he would never be able to relax and would rarely feel joy for the rest of his life. If his father ever laid a hand on him again, Jerry told him, he would take the Remington .410 Single Shot shotgun from under his bed and turn it on him. In that instant, on that lonely ledge, the lost boy found some sort of footing.

"I became defiant," he says. "You couldn't get in trouble where I grew up, but if I'd lived in a big city, I've always wondered if I'd have ended up in prison." Now the work on the beat-down dirt court grew deadly serious, the construction of another home, a *perfect* one, hinging it on a jump shot more classic and clean than a Roman arch and furnishing it with all manner of moves and fakes and spins, a structure so airtight that not even the bleak

fatalism of his poor mining community could enter it, so impeccable that not even his father could defile it…a place where the wrong son didn't die. When he wasn't *in there*, he ran everywhere he went, roaming the mountain woods alone or fishing the Kanawha, the last silhouette on the bank of the river, refusing to give up even as darkness fell and the catfish circled around his solitude.

He began sprouting by his junior year of high school. Long arms, big ears, high-pitched voice, ill-fitting clothes, quick-to-burn cheeks. The gangly kid on whom other kids' mothers smelled desperation for a hug. Flushing with envy and shame on all those frozen nights when he had to thumb rides for the five-mile trip home from practices at East Bank High. But here they came, flashes of basketball instincts forged—no, not in the crucible of asphalt courts and white-hot competition that produced the peers he'd one day meet at the game's highest levels, but in the smithy of his imagination, alone with those netless rims and those mountains and woods and the river.

He made all-conference that junior year, got more votes than anyone else despite playing on a 13–13 team, but somehow was left on the honorable-mention heap for the all-state team, looking up at all-staters who'd gotten fewer votes than he for the all-conference team. He was bewildered, crushed, but never said a word, licking his lips when he was selected to the Boys State program a few months later and saw those all-staters there, feeling his heart thump when two of them picked teams for a game and he was one of the last chosen. Here it came, all that anger he'd been warehousing at a father and a brother's death and a grimly silent home. Here it came, the first significant use of fire. He torched those all-staters that day. He went home knowing that he was the best player in

West Virginia. He went home seeing, for the first time, his way out.

He carried East Bank to the state title his senior year, averaging 41 in the semifinal and final. The town, in his honor, decreed that for one day its name would change to *West* Bank. His father came to one game to see his suddenly golden child, got into an altercation with a fan and so embarrassed Jerry that he ordered his mother to never let him come again.

Which is very different from being done with him.

―――――――――――

Close your eyes at the end of this paragraph. What happened next, the wind shear when in 1960 Jerry went from the hollows to Hollywood…picture if it had occurred today, a half-century later. Picture Oscar Robertson and Jerry emerging from college as co-captains of the Olympic gold medal team, the Nos. 1 and 2 picks in the draft, the black city kid and the white country boy, the Big O and Zeke from Cabin Creek, the two best perimeter players in the NBA almost from Day One: the Magic and Larry of their time. Picture the cameras and microphones trailing Jerry, as they now trail Kobe and LeBron, everywhere he went, because of where he nearly always went: to the NBA Finals, six times in his first nine years, each time against the dynasty Celtics. Picture the withdrawn country kid who'd built and holed up in that second home, that perfect place, having to face today's 24-hour multimedia spin cycle leading into and out of all those Finals…when he lost every one of them. Oh, the hounding and mockery, the sneering nicknames…

Jerry West's nickname was Mr. Clutch.

Such simpler and gentler times, those were, for everyone—everyone but Jerry. The paradoxes piled higher and higher. The blushing introvert as sudden hero, hitting impossible shots late in games again and

again. The social outcast who hated being singled out or hoisted up, ending up there over and over…till the ultimate last moment, the postseason's final game. Coming early for practices and morning shootarounds to rehearse that moment, still the lonely kid clicking off 3-2-1 in his head, perfecting three different release points to cover every contingency or dropping his head and driving and replicating the pool-table spins that he'd watched his Hall of Fame teammate Elgin Baylor create with ball and glass. *For someone as anxious as I am*, he writes in his book, *how calm I would get near the end of a game. Everything would become quieter and slower…* until it all became louder and faster, a train in the tunnel of his head as soon as 3-2-1 struck 0. After road games he'd duct-tape the blinds

prove him wrong by dropping another 40 or 45 the next time it counted. Or, hell, Jerry's own in-laws, who had the gall to give the impression that their daughter, Jane, whom he'd met at college, had married beneath their social status. Or, hell, a *city*: To this day, since he retired as a player, he has never set foot in Boston. Someone once described Jerry as a man who forgets everything—except a grudge. A man who needed someone, anyone, to play fill-in, to replace the original source of fire, especially after a heart attack took away his father in '67. Something, anything to keep him on the court through nine broken noses, through a groin tear so severe that he barely slept for three months, through a hamstring pull that turned him into a one-legged man in Game 7 of the '69 Finals—a uniped with

He carried East Bank to the state title his senior year, averaging 41 in the semifinal and final.

The town, in his honor, decreed that for one day its name would change to West Bank.

of his hotel windows, desperate for sleep that wouldn't come. After home games he'd drive till 4 a.m., anywhere, nowhere, the beaten kid beating himself up—if he forgave himself, what would happen to the flame that had given him life?

Here was the shadow side of fire, the risk that came when identity and game were built upon grudge. He *had* to keep producing new ones, had to take everything personally. When Jerry's opponents failed to provide them, there was always…hell, his own coach: Fred Schaus, who had the gall to *humiliate* him in front of Lakers teammates and fine him $100 for violating a no-golf-on-game-day rule when word got in the papers in 1965 that Jerry had nailed a hole in one. Jerry had to show up Schaus when the squad scrimmaged the next day, refusing to take a single shot, had to

13 rebounds, 12 assists and 42 points—and through so many pain-numbing pregame and halftime injections that pioneer sports doctor Robert Kerlan called Jerry the "craziest competitor" he'd ever seen.

Never mind the atrial fibrillation: all those times the stress sent his heart into crazy drumbeats that could last for days or weeks, his breath cascading into rapid, shallow gulps that left him ventilating into paper bags at halftime to keep from fainting, his thoughts stampeding until it was impossible for him to sit still and concentrate, his depression so dark he wouldn't speak to his wife for a week, wouldn't utter hello or goodbye to anyone, wouldn't desire anything except for a sleep from which he'd never awake. "You feel like you're in a forest at midnight," he says. "There have been a number of moments when I

haven't wanted to live, when I felt so hopeless. Nights I went to bed and hoped I wouldn't wake up. Suicide? It isn't a coward's way out, like people say. It would take enormous courage. I'm not looking for sympathy. I'm just telling the truth. You'd probably never know I was in it, I mask it so well."

His depression nearly annihilated him after that sixth straight NBA Finals loss, in 1969, that monster one-legged game that the Celts won by two, Bill Russell's swan song. *I wanted to quit basketball in the worst way, West writes. I honestly didn't think I could endure any more pain. Every night I went to bed I thought about it. Every night. Every goddamn night. It was the most helpless feeling because I was sure I was going to be labeled a loser forever.*

He was named the MVP of the Finals anyway—the only losing player ever accorded that honor—and flew to New York City to receive the Dodge Charger that came with it. An idea crept into his mind that he couldn't shake. He wanted to place a stick of dynamite in the car, right there in mid-Manhattan, and blow it to pieces.

———

Here's where Tiger and Magic could speak to the roomful of gods. About sex. About forgetting. About the need for the 10, 20, 30 minutes of oblivion that a woman could provide, the silencing of the mind's din, the furnace's shutdown switch. It was the summer of '69 in L.A., for God's sake…but isn't it always for the gods? Even ones with a wife and three sons? *That is when I started to get out of control, began doing whatever I could to ease the pain. It became a sickness and it became my way of coping…. I would lose myself in women, a lot of women.*

And yet, for the seventh time, he took his team to the Finals in 1970, this time against the Knicks. For the seventh time he lost. O.K., eighth if you count the NCAA Finals loss to Cal—and he *did*. What was going on

here? It was as if his father, every spring, were being proved right. As if Jerry really *did* carry some hidden defect.

A strange thing happened in May 1972. Jerry played the worst NBA Finals of his life. The Lakers beat the Knicks in five. Jerry was a champion! Hooray…? "I never felt the fulfillment when we won," he says. "All I thought about was all the times we'd lost. It'll haunt me till I die."

One for the road—an eighth Finals loss in 1973, again against the Knicks—and the fire had finally reduced everything inside him to ashes. He took off his uniform after a preseason game in the autumn of '74, at age 36, and handed it to trainer Frank O'Neill. He was done.

His eyes lit on another woman two months later, a Pepperdine cheerleader named Karen Bua, at her school's basketball banquet, where Jerry had been invited to speak. She was gorgeous and had empathetic eyes, and he was free-falling through the void of life without games, weary of the flesh carnival and his all-but-disintegrated marriage, and he had to get this out, this thing in him, before it devoured him. Her eyes widened as this stranger sat beside her and told her everything. He was the saddest man she'd ever met, she says, and within a few years they were married.

———

The logo, created in 1969 and modeled on a photo of Jerry, was apt in a way that the NBA couldn't have dreamed: a white ghostlike figure, frozen forever on the run. But a Buddhist artist would've sketched that phantom a different way. The Hungry Ghosts of Buddhism have pinhole mouths, long necks so thin that they can't swallow and absurdly bloated bellies—forever starving but unable to eat, forever seeking gratification from old needs never met. The fate of most of the gods.

They often try coaching when they're done playing, just as Jerry did, but that never works. No one on their teams is ever as gifted as they; that, they can bear, their egos permit it. But no one's as insatiable as they; that, they can't bear.

Jerry coached the Lakers from 1976 to '79, getting them into the playoffs all three seasons. Insufficient. His angst only grew now that he couldn't inflict it physically on an opponent. In *West by West*, Pat Riley, who joined the Lakers' broadcast team in '77, remembers seeing the look on Jerry's face as he stood on a 15th-floor hotel balcony after a loss to the Kings, and saying three words to him: "Don't do it."

So why, in that other realm ill-suited to gods—as general manager—was he a master? His game, far more than the other gods', had been born of solitude and imagination; his mind's eye saw things that theirs couldn't. It was like working on the intricate jigsaw puzzles that his family always had going on a table near the fireplace in his childhood, puzzles he'd make sure to "win" by keeping a few pieces hidden under the rug or in his pocket. He could picture how the players he was evaluating fit into the larger scheme, the subtle aspects of their games that might flower in the Lakers' system and who they would be three years down the road. He understood something about fire, sensed

After the firing of Paul Westhead in 1981, Pat Riley and West were named co-head coaches by Lakers owner Jerry Buss.

that greatness usually grew from pain, so he wanted to see the player he was scouting *in* pain, playing his *worst* game: Did he want to *kill*? What was in his eyes and in his body language if he were removed from the game? Could he will his way to the foul line during such misery, rediscover his shooting rhythm there? If his skills were ordinary, did he do something seemingly small—like grab the ball coming through the net, jab one foot out-of-bounds and inbound it swiftly—the way Kurt Rambis did, turning a teammate's defensive failure into another Lakers fast break? Manacled with lower picks by the Lakers' success, Jerry found A.C. Green and Vlade Divac under the draft rug and pulled Bob McAdoo, Mychal Thompson and Robert Horry out of his trading pocket to keep the powerhouse humming. "It's like seeing a pretty woman," he says. "Someone else might not see she's pretty because of how she's dressed or wearing her hair. Maybe she'd be pretty in a different position or situation. Maybe she's pretty in ways that aren't obvious at first. Maybe she's beautiful inside."

His humility was as critical as his eagle eye. He could stand quietly on the edges and observe his players, figure out what their egos needed, and supply it. He could keep Kareem Abdul-Jabbar from checking out when Kareem felt Riley grew overbearing and too much spotlight swung to Magic Johnson, defuse Shaq's and Kobe's squabbles when they were about to detonate the franchise, take James Worthy aside to remind him that his five-year contract allowed him to be traded at any time. The G.M. who could vanish right in front of his wife's and children's eyes was the first one to ask his players how their families were doing, the first one at their homes if a loved one were sick or dying, all with a caring and vulnerability in his eyes that was so unusual in a god and that dissolved into tears when it came time to release or trade them. "I

have never seen anybody so passionate and who cares so much," Worthy, one of the stars on the Showtime Lakers, says in *West by West*. "He internalizes his thoughts so much, it looks like pain." When the Lakers won, Jerry deferred all the credit to his players and coaches and was nowhere to be found at the championship parades. At banquets where praise and pedestals lurked, he paid valets to keep his car nearest to the door so he could vanish.

Showtime ended. Five years went by without a trip to the Finals. The heartbeats got crazier, the breathing shallower in the summer of '96 as Jerry sunk hooks into the two biggest fish he'd ever attempted to reel in: Shaq in Orlando and Kobe coming out of high school. He drove himself to the brink with all the behind-the-scenes baiting and luring of agents and players, finally hauling in the catch…and landed in a hospital. He lay there for three days as doctors tried to stop the cascade of palpitation, plummeting blood pressure, exhaustion and clinical depression. He tried psychotherapy briefly, three times, but he didn't really believe in it, couldn't risk a script change in the narrative he'd been telling himself all his life.

It took four years for Kobe to ripen. By then Jerry couldn't bear to watch meaningful games, spending them adrift on freeways, in the darkness of movie theaters or in the stadium tunnel talking to black security guards—the outcast had always felt an instinctive bond with African-Americans. Nothing broke the darkness, not the generous checks that Jerry wrote to help people get their kids through college, not the two or three books a week that he buried himself in. His second marriage nearly shredded.

He resigned at age 62 amid the euphoria of the Lakers' 2000 championship, convinced that coach Phil Jackson and owner Jerry Buss didn't need him around. "I was like a drug

addict who overdosed," he says. "I couldn't function. I couldn't relate to people close to me. Winning was a sickness. It's an attempt to create your own perfect world."

Do not serve coffee to the roomful of gods. "Coffee makes me nervous," Jerry says. "Everything makes me nervous. My head is way too busy. It's amazing what's going through my head as I talk to you. I'm trying to answer a question, and entering my mind are all these things I shouldn't be aware of. I could not sleep last night…."

What becomes of a god when his hair turns white and the games recede? He fishes with friends, wishing to God he didn't *have* to catch the biggest fish—yearning, in fact, to write the winner's check to someone else because he loves seeing someone else *enjoy*—but usually catching it anyway. He returns to the NBA in 2002 and takes a punch-line franchise, the Grizzlies, to three playoff appearances, gets named Executive of the Year again and then pulls away when the blowback scorches him again in '07. He plays gin with friends. He takes a blood thinner, Xanax and Prozac each day. He wolfs down dinner in about eight minutes—that meal still carries too much cargo—and then becomes either the most vibrant of conversationalists, eager to share and add to his vast knowledge of the world, or the remote man whom Karen and their two adult sons steer a circle around. He golfs, but not as much as he used to back when he broke the Bel-Air Country Club record with a 28 on the back nine, and broke the Bel-Air record for broken clubs. He accepts an offer from the Golden State Warriors in May 2011 to join their executive board as an adviser, to see if there's any way to do this from a safer distance, so he can go back to searching for those rare players who have… what, exactly?

I have always believed in the notion of gold dust, he writes, of there being something so innate in a person that it can't easily be defined, something that propels you onward and keeps you fighting, no matter what, until the bitter end.

There it is. The gods' contradiction. Their refusal to connect the dots. The gold dust *is* the sickness. The fire is the hurt and the anger stuck to their flypaper skin. And so on they roam, turning it all outward to the end, seeking release over blackjack tables or $10,000 putts or female bodies…all except for one of them, uneasy with the summit where the gods live, returning ever inward, to the bottom of the hollows. Driven to say what no one else in that room would.

"Most people just want to write a book about their exploits," he says. "I wanted none of that. I did it to show people I'm not who they think I am. I'm a very flawed person. I'm hopeful it can be an inspiration, to show that you don't need support or encouragement, that you can find a way. I'm more at peace with myself now. Getting out the things I've kept inside for so many years.

"And yet I'm fighting the same battles inside. I see people who are calm, I see people laughing and happy, and I think, Oh, my God, I wish I could be like that. If I knew how, I'd be the happiest person in the world, because everything else has fallen in place for me. This should be a time of freedom. I've led a charmed life externally but not internally.

"If there'd just been love in my house growing up. But I'd rather have had the career I did than have the peace of mind. I couldn't have had both. I'll take the trade. At times I felt special."

Two things happened not long ago. Jerry pulled the cord to undrape that bronze 14-foot statue, and he immediately turned his head away. A friend sent him a book about how to forgive your father, and he turned away once more. •

155

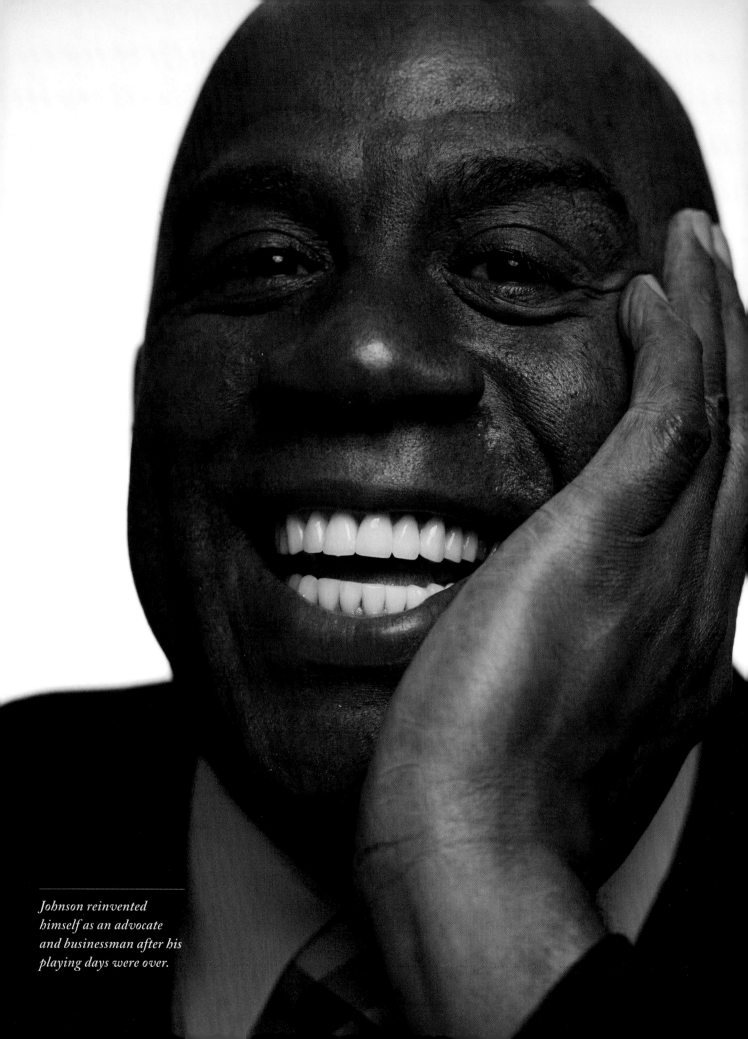

WE BELIEVE IN MAGIC

Earvin Johnson has tirelessly invested in African-American communities and advocated for those affected by HIV/AIDS—and, despite his own diagnosis, the smile has never left his face BY JACK McCALLUM

HEN HE AROSE ON THE MORNING OF OCT. 25, 1991, WHICH WOULD TURN OUT TO BE THE WORST DAY OF Earvin (Magic) Johnson's life, a glorious path stretched out before him. "I knew exactly where I was going," says Johnson, whose vision on the basketball court was never questioned. A few more seasons—he was only four months removed from a ninth trip to the NBA Finals with the Lakers—an Olympic gold medal trip to Barcelona and the expansion of his nascent business empire lay ahead.

But on a visit to his family physician that day, the 32-year-old Johnson received the news that he had contracted HIV, which at that time was widely considered tantamount to full-blown AIDS and death. Dying young was not part of his plan. "That kind of put everything on hold for a while," Johnson says, epically understating what was really going through his mind. For even this most wide-eyed of optimists was devastated, uncertain how long he was going to be drawing breath, let alone whether Magic Johnson Enterprises (MJE), a company he had formed in 1987, would ever produce more than T-shirts or Pepsi (two of his early ventures).

Here's more epic understatement: It's 23 years after the worst day of his life, and Magic is back on his path. MJE, a multitentacled conglomerate

that focuses on products and services for minority communities, has an asset value of $1 billion. The Magic Johnson Foundation, which he started soon after he discovered he was infected, backs a host of initiatives, including minority scholarships, community empowerment centers and, most prominent, HIV/AIDS education, to which Johnson, through his business and foundation, has given about $15 million. As for Magic Johnson himself, he is happy (albeit horrendously overscheduled) and by all accounts, including his doctor's, healthy. He gives freely from his own pocket, bestowing millions upon, among others, his church and Michigan State, his alma mater.

He is the father of three, grandfather of two and husband of one—Cookie, who was his bride

of nine weeks when he announced that he was HIV positive.

In fact, the worst day of Magic's life turned out to be a most fortuitous day in the global fight against HIV/AIDS. In the weeks that followed his Nov. 7, 1991, press conference in Los Angeles—10 riveting minutes that will endure as a where-were-you-when-you-heard? touchstone—HIV testing spiked all around the country. In New York City it rose by 60%, according to *New Yorker* writer Michael Specter, who covered the epidemic for *The Washington Post* and *The New York Times*.

Dr. David Ho, who had been in the trenches of AIDS research and treatment since 1981, witnessed Johnson's influence. "When Earvin got his diagnosis, he became the poster boy for the disease," says Ho, who has been Johnson's doctor since '91. "And as he remained healthy and in the public eye, Earvin became a symbol of hope that this disease is not a death sentence. As much as anyone in the world, he remains that today."

And so for contributions personal and professional, for turning personal tragedy into global triumph, for staying a course that at first seemed fatal and was never felicitous—his ever-present beaming countenance notwithstanding—SI presents Earvin Magic Johnson with its second Sportsman of the Year Legacy Award. He is linked to the first recipient (2008), the late Eunice Kennedy Shriver, by the focus of his work: the unrecognized and the underserved. Shriver championed the intellectually handicapped; Johnson, the ostracized HIV/AIDS community and the minority consumer.

Like Shriver, who as the founder of the Special Olympics crusaded for special-needs children when much of the world wanted to warehouse them, Magic does not hear the word *no*. He weaves his way around and through challenges, as he once did quarterbacking some of the NBA's greatest teams, and he represents a refreshing deviation from the normal life course of America's Retired Athlete. He does not make his millions (and, to be clear, he does make millions) by merely showing up, shaking hands and shanking 5-irons. "I only played golf once," said Magic, "and I'm glad I'm over it. Think how much time I would've wasted."

He is, as was Shriver before him, opinionated, blind to obstacles and self-believing to the point of arrogance. Oh, how happy it made him when he even got the best of his good buddy/old rival in a game that His Airness tried first.

In 1994, Michael Jordan played Double A baseball and hit .202.

In 2012, Johnson bought the Dodgers and hit a home run.

———————

Only once did the subject of death enter his mind. "I didn't really believe I would die," he says, "but I wanted to get some things in order. I wanted to talk about it once and get it over with."

By early 1992 the magic in Magic had been rekindled. Commissioner David Stern had given the retired icon an exemption to play in the All-Star Game—"As much as anything, that turned it around for Earvin," says Lon Rosen, his longtime friend and adviser and now a Dodgers executive—and he was determined to join the Dream Team in Barcelona. He began to work out and watch his diet. In short, he turned down the role of Dead Man Walking. It was full speed ahead on his life plan.

So he presented himself in the office of Hollywood exec Peter Guber, who was running Columbia Pictures Entertainment. "Earvin comes in and says, 'I'm going to tell you a story,'" remembers Guber, who has green-lit films like *A Few Good Men* and *Philadelphia* and now co-owns the Warriors.

"Earvin was very animated, very sure of himself. He says, 'What if I told you there's a giant untapped territory, an enormous entertainment-seeking audience that speaks English, loves movies and is not being served by the movie community?'

"I said, 'I'm listening.' And Magic says, 'It's 20 blocks from here. Baldwin Hills. Minority community. They have movies but not multiplexes. The theaters are broken down, and they have inferior concessions. We can give them what they want *and* demonstrate good business sense.'"

Guber, who is now one of Johnson's Dodgers' partners, was hooked. The result of their joint venture was a string of Magic Johnson Loews Theatres in L.A. Johnson's next big sit-down was with Starbucks CEO Howard Schultz, to whom he gave a similar spiel. That resulted in a partnership with Starbucks and an offshoot company called Urban Coffee Opportunities.

And with those two deals, the world's most famous HIV-positive citizen stepped into the major leagues of Big Business.

Johnson was unafraid to plunge into the deep waters of stereotype without fear of drowning. He told Guber: African-American moviegoers like to yell at the screen and drink sweet beverages. So at Magic Johnson Theaters shushing is taboo and grape soda is on tap. His Starbucks served up sweet potato pie and played more Marvin Gaye than classic rock. The minority community made up the clientele as well as the workforce. And along with newspapers and neighborhood announcements, customers could pick up brochures about HIV/AIDS.

Understand that Magic is no Mother Teresa. He's almost always made money, and lots of it. He bought 4.5% of the Lakers in 1994 for a reported $10 million, and that had nothing to do with altruism. When he sold his piece of the team and his Starbucks holdings in 2010, he made a combined $100 million. The value of the Dodgers increased by 24% last year. His net worth is an estimated $500 million.

But his focus on the minority community, which has driven many of his ventures, has created a different paradigm in the business world. The MJE conglomerate includes holdings in ASPiRE, a television network targeting African-Americans; Magic Johnson

Johnson in his office on Wilshire Boulevard in 2014.

Bridgescape Academies, a program aimed at helping high school dropouts get their diplomas; and Clear Health Alliance, a health-care provider with a special emphasis on HIV/AIDS patients, gay men of color being the fastest-growing population in the U.S. to contract HIV and AIDS.

"I get asked if I'm trying to help minorities or make money," says Johnson. "My answer is, I'm trying to do both."

Johnson says that even in the early days of his ventures he was accepted without question. "Nobody ever 'forgot' to shake my hand in a boardroom," he says. Still, at least two companies with which he had major endorsement deals, Pepsi and Nestlé, scaled back their partnerships after his HIV announcement.

And though the smile rarely left his face, things didn't go smoothly for him in the basketball world.

In 1984 a 13-year-old hemophiliac from Kokomo, Ind., named Ryan White became infected with HIV from a blood transfusion. Over the next two years there was national debate about whether Ryan should be allowed to attend public school. He died in 1990, at 18, having been admitted to his school but forced to move with his family from Kokomo when the threats got so bad.

In 1986 columnist William F. Buckley proposed the following: "Everyone detected with AIDS should be tattooed in the upper forearm, to protect common-needle users, and on the buttocks, to prevent the victimization of other homosexuals."

In 1991, when Johnson announced he had HIV, AIDS had claimed celebrities such as actor Rock Hudson, Broadway director Michael Bennett and entertainer Liberace. About 10 million people worldwide—mostly men, though the disease was beginning to spread to women—were infected with HIV, and most of them were expected to die.

"Patients were dying left and right," says Dr. Ho, "and very few people paid attention, including the government, which considered it a gay men's disease."

This was the environment into which Johnson stepped.

There is no doubt that Magic's fame made him less stigmatized after his disclosure. He was never told, as Ryan White was, that he couldn't enter a public building. But after Stern gave him the O.K. to play in the '92 All-Star Game, many players decried the decision, including some who would be on the court with him that day. (All of them, however, came forward to shake his hand when he had been voted the game's MVP.)

The Australian team doctor called on his team to boycott the Olympics because of Magic's participation. (It never happened.) In Barcelona the Dream Team was revered, but, still, a foreign journalist asked Magic, "How does it feel knowing you won't watch your children grow up?"

Johnson, co-owner of the Dodgers, with broadcaster Vin Scully in 2014.

When Johnson got back to the States from Barcelona, several NBA players, most notably his Olympic teammate Karl Malone, expressed reservations about playing against Magic. He walked around knowing that his perspiration was an international issue, every droplet, as some saw it, a potential time bomb. And when a photo of a gloveless L.A. trainer Gary Vitti tending to a cut on Magic's arm went viral—or what passed for viral in 1992—even Magic got discouraged. He left the Lakers, made an ill-advised return and finally retired for good in 1996.

As the years rolled on, it became clear, if it hadn't already, that Magic had made a significant mark on HIV/AIDS awareness. He was the most famous designee of a new medical genus: long-term nonprogressor. But then a curious thing happened that put Johnson back in the critical crosshairs. His healthy profile was seen as a deterrent to people getting tested. While fewer were dying of the disease, more were actually getting it, a twisted good-news, bad-news scenario that researchers are still pondering. Ho, who is the scientific director and CEO of the Aaron Diamond AIDS Research Center in New York City, estimates that 35 million people worldwide are now living with HIV or AIDS, roughly the same number who have died of the disease since the dawn of the epidemic.

"I realize that people look at me and say, 'Magic's doing O.K., so why do I have to worry about it?'" says Johnson. "People think, I'm going back to the same lifestyle. I'm going to be like Magic Johnson and live a long time. So they're not getting tested and not practicing safe sex. I try to get out the message that early detection saved my life. But a lot of people aren't hearing it. So I got credit for spreading awareness, and then I got criticized when people started living."

It's difficult to understand how Johnson could be blamed for staying alive. And here's the larger point: Magic has never publicly expressed despair about his condition or rancor toward his critics. He showed the world a smile and talked only of hope, his equanimity much needed in what was—lest we forget—a desperate time when the disease was winning almost every battle.

"Instead of retreating, Earvin engaged and changed the global debate on HIV and AIDS with the force of his personality, his courage in fighting and through the efforts of his foundation," says Stern, who retired earlier this year after a 30-year run. "Magic has set the standard for postcareer social responsibility."

That Johnson handled the disease so well did not surprise a certain teacher back in his hometown of East Lansing, Mich.

"I was lucky enough to have Earvin in my first year of teaching fifth grade," says Greta Dart, now retired, "and he made life easy and wonderful for me. He was charismatic and popular, and he kept the other kids in line. But what I remember the most is that on the playground, when he was a captain, which was most of the time, he never picked the best kids for his team. He picked the underdogs. Then he went out and tried to win."

And so we have reached this point without speaking of championships, fast breaks, no-look passes and baby hooks, all those things that first got the smiling kid from Michigan noticed. More and more Magic Johnson has morphed into Citizen Johnson, a man driven by—yes—a bottom line, but also a good heart and big dreams. His has been an extraordinary life, busy, noisy, complicated and—best of all—much longer than many once thought it would be. "I'm just getting started," says Johnson. "There's lots to do."

"Earvin became a symbol of hope," says his doctor, David Ho, "that this disease is not a death sentence." •

FASHIONABLE 50 ⤶

SPECIAL FLIP COVER
Odell Beckham Jr.
Must Be Seen

Sports Illustrated

LEBRON + L.A.

JAMES
23

WHY THE
MOVE WAS
MEANT TO BE
BY LEE JENKINS

PLUS
Going (Jerry) West:
On the Lure of the Lakers
BY JACK McCALLUM

Kobe's Kinder,
Gentler Mission
BY LEE JENKINS

Photo Illustration by
BRYCE WOOD

FIT FOR THE KING

It's Hollywood's ultimate celebrity marriage: the best and brightest star joining the league's glitziest franchise. With his latest seismic signing as a free agent, LeBron James gives the Lakers new life. But will he ever get the help he'll need to raise their 17th banner? BY LEE JENKINS

RICH PAUL IDLED OUTSIDE OF LAKERS HEADQUARTERS LAST FRIDAY MORNING, WATCHING *THE GODFATHER* in his car while waiting for shooting guard Kentavious Caldwell-Pope to emerge from the team's practice facility. It was one of the hottest days in the history of Los Angeles, pushing 110º, and Paul cranked up both the air conditioning and the volume. "I'm on the scene where Tom Hagen goes to L.A. to help get Johnny Fontane the part in the movie," Paul reported. "You remember that? Fontane was beautiful—slick hair, expensive suit.

But Jack Woltz was the film producer, this older wealthy guy, and he wouldn't cast Fontane because he never forgave him for messing with one of his actresses. That's why Woltz woke up with the horsehead in his bed."

Paul represents Caldwell-Pope, who signed a one-year contract worth $12 million with the Lakers early Friday, but he is also agent and consigliere to longtime friend LeBron James. On the night of June 30, Paul, James and Lakers president Magic Johnson gathered in the great room of James's Brentwood home for a summit that will live in L.A. lore, particularly if it yields a 17th gold banner in the rafters at Staples Center.

There was no food or wine, no video montage or Power Point presentation.

"Magic was Magic, but he was also Earvin," Paul recalls. "It wasn't a pitch. It was just a conversation: 'Here's who I am. Here's what we do. Here's the culture we stand for. Here's what we're trying to accomplish. Here's how we look at you. Here's how we value you.'"

Paul was 21 when he met James at Akron-Canton Airport before a flight to Atlanta. Paul was selling throwback jerseys from the trunk of his car and James was starring at nearby St. Vincent–St. Mary High. In the terminal James noticed the Warren Moon throwback Paul

was wearing and asked how he found it. Just like that, Paul stumbled upon a client. But as close as Paul has grown to the world's best basketball player since their chance encounter, on some levels he cannot relate. He listened to James and Johnson go back and forth, drawing parallels in the way they approach their games and lives.

"It was like watching two fish in a fish tank that speak a language the rest of the world can't understand," says Paul. "Magic understands what it's like to be LeBron. He was a 6'9" point guard. He was an MVP. But he was also Tragic Johnson." His stumbles in the 1984 Finals against Boston were every bit as severe as James's in 2011 against Dallas.

Paul is reluctant to overstate the significance of the sit-down because no single exchange delivered James to Los Angeles. Even pinpointing a primary motive behind James's third free-agent decision is difficult. "In 2010, when he went to Miami, it was about championships," Paul continues. "In 2014, when he went back to Cleveland, it was about delivering on a promise. In 2018, it was just about doing what he wants to do."

James was leaning toward L.A. for days, and according to those outside his direct orbit, for months. But Paul rejects the commonly held explanations that James was driven either to expand his Hollywood empire or spark an overnight superteam. In the hours after his commitment, the Lakers reached

Rich Paul and Klutch Sports have become NBA power brokers.

agreements with guard Lance Stephenson and center JaVale McGee—not exactly Kawhi Leonard and Paul George. Any hope of the Lakers building an instant rebuttal to the Warriors was dashed.

During James's last days with the Cavaliers, as he fell to Golden State for the third time in four Finals, he repeatedly espoused the importance of intellect on the court. "In order to win, you've got to have talent, but you've got to be very cerebral," he said. "Listen, we're all NBA players. Everybody knows how to put the ball in the hoop. But who can think throughout the course of the game?" Once, he mentioned Rajon Rondo by name, in underlining the collective IQ of the 2008 Celtics.

The day after James announced he would sign a four-year, $153.3 million contract, L.A. added Rondo on a one-year, $9 million deal, and he will have to keep James from breaking his hand against any more grease boards this season. The Lakers' starting point guard, Lonzo Ball, is 20. Their wings, Brandon Ingram and Kyle Kuzma, are 20 and 22. McGee and Stephenson are older, but age does not always produce acumen, as James discovered when 14-year veteran guard J.R. Smith forgot the score in Game 1 of the Finals, prompting the scrap with the whiteboard.

The acquisitions of Rondo, Stephenson and McGee suggest a sea change for L.A.,

and for James. A year ago the Lakers supplied their prospects much freedom, careful to ensure that veterans would not threaten confidence or playing time. Now, they've installed Rondo as competition for Ball and Stephenson for the wings, in hopes their pups are pushed. Coach Luke Walton may have the toughest job in the league. Fourth quarter, tie game, two minutes left, do you go with Ball at the point or Rondo? If it's Ball, how does that

sit with Rondo? If it's Rondo, how does that sit with Ball's father?

Stylistically, the Lakers should be much the same. They finished third in pace last season and don't want to slow down, even though James's squads are typically more deliberate, with spot-up shooters scattered around the arc to provide space for his headlong drives. L.A. shot 34.5% from three, 29th in the NBA, and the additions of Rondo (33.3% last year) and

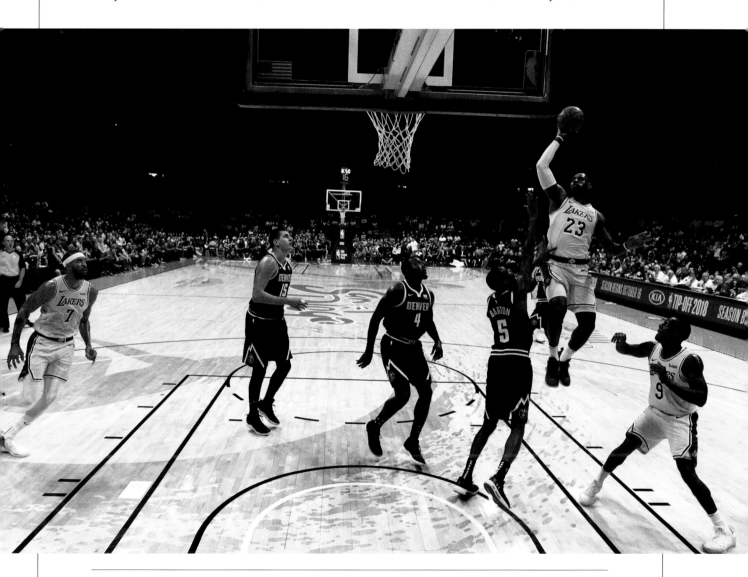

LeBron James glides toward the hoop against Denver in 2018.

Stephenson (28.9%) won't help. James will be surrounded by more playmaking and defense than he was in Cleveland, with far less marksmanship. "We might have a roster where there are five ballhandlers on the court at one time," Rondo says. "Obviously a lot of teams are shooting the three ball, but I think it's kind of crazy to think you're going to outshoot Golden State. There are other ways you have to try to beat those guys. We're going to try to crack that code."

At the moment L.A. appears nowhere close, especially with center DeMarcus Cousins joining the Warriors as a fifth All-Star starter. But the Lakers' immediate outlook could change with one phone call to San Antonio. James did not go to L.A. because he believed

nucleus, beyond James and Johnson. The Lakers love Kuzma, remain loath to trade Ingram and have invested heavily in Ball. But nobody signs James to be part of a protracted youth movement. His patience rarely extends past February.

James is coming off a standard season—27.5 points, 9.1 assists, 8.6 rebounds—and a superlative playoff run. Eight times he scored more than 40 points. Four times he posted triple doubles. Twice he sank buzzer-beaters. But when he left Quicken Loans Arena on June 8, the Warriors celebrating again outside his locker room, he looked like a man who had kept banging his head into the same wall. There is no guarantee the noise will abate now that he is in L.A. He could have

> **"You put any group of players around LeBron James, he's been to the Finals [eight] straight times. My expectations are the exact same thing. I expect to win." — Rajon Rondo**

Leonard, the Spurs' All-Star forward, would follow him. But he safely assumes that the Lakers, with their young talent, bedazzled front office and inherent recruiting advantages, will eventually find or develop another headliner or two. He is in no rush, those close to him maintain, but at 33 he also does not have prime years to waste.

"You put any group of players around LeBron James, he's been to the Finals [eight] straight times. My expectations are the exact same thing," Rondo says. "I expect to win." James can appreciate Rondo's guile, McGee's length and Stephenson's grit, even though he has clashed with each of them in the past. Their presence, like Boogie's in Golden State, could be fleeting. Rondo, McGee and Stephenson are all on one-year contracts, part of the cast but not the core. At this point it's hard to even identify the

surely improved his odds in Philadelphia or Houston. And if losing is inevitable, which it may be in the Golden State age, he could have at least assured himself eternal love in Cleveland.

But James, like any aspiring Hollywood producer, thinks big. A juggernaut on South Beach. A homecoming to Northeast Ohio. And now, a celebrity marriage in Los Angeles, the union of the NBA's signature player and its signature franchise. LeBron and the Lakers, a match made in commercial heaven. Together, as all sorts of A-list couples could attest, their wattage does not simply double. It multiplies exponentially.

James's championship in Cleveland is forever, but the charm of his return is gone, replaced by new expectation in L.A. Basketball's biggest fish has entered the aquarium. •

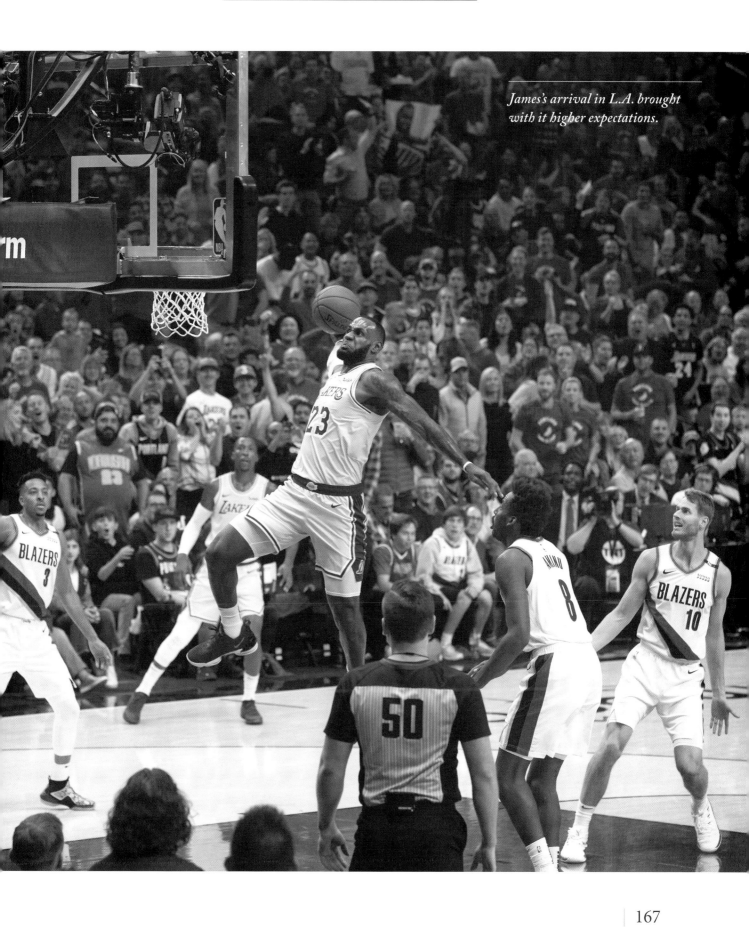

James's arrival in L.A. brought with it higher expectations.

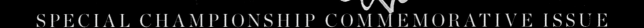

Sports Illustrated

PRESENTS

UNPRECEDENTED
SEASON

———

UNSURPASSED
GREATNESS

BUBBLE-ICIOUS

A unique NBA season
had a familiar end: •
LeBron James won
his fourth Finals MVP,
and the Lakers took
their 17th title.

#WholeNew

BUBBLE-ICIOUS

In the longest, most uniquely grueling season in NBA history, the focus displayed by LeBron James, Anthony Davis and the rest of the Lakers through various tragic events separated them from the rest of the league BY MICHAEL ROSENBERG

AKE BUENA VISTA, FLA.—ON THE NIGHT WHEN THE NBA'S MOST GLAMOROUS FRANCHISE WON THE league's least glamorous championship, the sport's biggest star did the grunt work. LeBron James had given self-care his best shot in the bubble. He had one of the two big suites on the Lakers' floor at the Gran Destino, two doors down from Anthony Davis. He had a wine fridge in there and a hyperbaric sleep chamber for his daily naps. But he did all of it so he would be ready for a night like this.

He guarded Heat star Jimmy Butler for long stretches of Game 6. He took hits to his midsection and his face; he tried to draw a charge, failed, ran down the court, got the ball after a missed shot, turned around, thought he got fouled, didn't get the call and kept going. He scored 28 points, had eight assists, and grabbed 14 rebounds, including one where he simply rose above muscular Heat power forward Bam Adebayo and ripped the ball away. During his rare moments of rest, he sat on a gray Fit by Jake stability ball on the end of the Lakers bench, watching intently. He dove after a basketball with under 6 minutes left and a 23-point lead. It was one of his easiest game nights in weeks.

James knew this was his 95th day in the bubble—"I had a little calendar I was checking off," he said with a laugh afterward—and he finished it with his fourth title, for his third franchise. He also won his fourth Finals MVP award. He does this so routinely that when he returned to the Lakers' locker room Sunday, he stopped before anybody could spray champagne on him and said, "Where's the goggles?"

James has so much success individually, and the Lakers have had so much historically, that it is easy to see James winning a title with L.A. as an inevitability. It was not.

The Clippers, not the Lakers, were the preseason favorite for oddsmakers. The numbers geeks at FiveThirtyEight gave the Lakers a 13% chance of winning the title. SPORTS ILLUSTRATED had the Lakers as the fifth-best team in the league, with an anonymous scout saying, "They'll be in the top half of the West, but I can see them winning a championship or taking an early playoff exit." The Lakers were the fourth choice of an ESPN panel of experts.

They made a lot of choices that were fair to question at the time. The Lakers hired agent Rob Pelinka, with no executive experience, to be their general manager. James chose to join

a nonplayoff team at age 33. Pelinka traded two former No. 2 draft picks (Lonzo Ball and Brandon Ingram), the No. 4 pick in 2019, and two future first-round picks for Pelicans star Anthony Davis when Davis was just one year from free agency. The last time the Lakers acquired a star center a year from free agency, Dwight Howard in 2012, proved disastrous. As if to throw a middle finger at history, Pelinka followed the Davis trade by signing the aging Howard in free agency.

Pelinka settled on Frank Vogel to coach after failing to reach an agreement with Tyronn Lue, who won a title with James in Cleveland. The Lakers hired Hall of Famer and former head coach Jason Kidd to be Vogel's lead assistant, sparking immediate speculation that Kidd would angle for Vogel's job.

This was a season that nobody could have anticipated. The Lakers won, in part, because the choices they made for a happier world turned out to be right for this one.

In December 2019, Lakers owner Jeanie Buss's mother, JoAnn, died. As she grieved, Jeanie received a voicemail that was so thoughtful, she still has it on her phone. It came from Kobe Bryant.

Two weeks later, Buss ran into Kobe and his daughter Gigi at a Lakers-Mavericks game (Gigi loved watching Dallas star Luka Dončić) and Jeanie told him how much his message meant to her. Three days after that, longtime NBA commissioner David Stern died after a brain hemorrhage. Jeanie considered Stern "a very influential person in my life," and she flew to New York in mid-January for his funeral service, at the end of a miserable few weeks, with no idea how much misery awaited.

On Jan. 26, the day after James passed Bryant on the all-time scoring list in Bryant's hometown of Philadelphia, the Lakers were

doing something they rarely do: sleeping on the team plane. Usually, somebody is playing music or cards or both. When they awoke, Kobe and Gigi Bryant were dead.

The tragedy was the Bryant family's primarily, but it was not theirs alone. Pelinka was Bryant's former agent and best friend. Almost everybody in the organization, from security guards to media-relations personnel, had a personal relationship with Kobe, except for some of the players—but he had an outsize influence on them. Jeanie worried the players were so devastated and distracted that one would get in a car accident on the way to the arena. She asked the league to postpone the Lakers' next game.

Public mourning and private pain do not always mix, and the Lakers had to find ways to honor the Bryants without looking exploitative in any way. They wore Kobe-designed Mamba jerseys for every Game 2 after the first round, because 2 was Gigi's number. The salutes were all genuine, and people *knew* they were genuine, because of how close Bryant was to Pelinka. Pelinka says, "I still hear his voice in most of the decisions I make." Sometimes he speaks of Bryant in the present tense: "He is not a micromanager, or a 'Let me tell you what you should do' friend at all. He's more of, 'I'm going to empower you to be great.'"

Pelinka still talks to Vanessa all the time. If something bothered her, he would be one of the first to know. He says of the team's various tributes: "They happen organically and kind of at a spiritual level. I don't think you can really architect anything around a tragedy like that. There's no master plan, or 'Let's write thoughts down on a piece of paper and go with that.' That's not what this is about."

Buss says, "I don't know if we've done things the right way. We have only done things that felt right in our heart."

While Kobe's family and friends coped with the loss of a loved one and the public mourned the death of an icon, James dealt with a third kind of grief. LeBron and Kobe were longtime rivals, for both championships and the public's affection, and they were far from close when they were both in the league. The Mamba Mentality does not call for hugging the enemy. But in recent years, the relationship improved. After Bryant played in Cleveland for the last time, he had signed his jersey and gave it to James's agent, Rich Paul. Sometimes Bryant would sit next to Paul at Lakers games.

James started to see Bryant as one of the few people in the world who could understand what it was like to be him. In sports, heated personal rivalries don't stay heated forever. Bryant had mended his relationship with Shaquille O'Neal, and James had returned to Cleveland four years after owner Dan Gilbert's infamous letter trashing him. Kobe was gone before a true friendship with James could fully form.

"It was trending that way, for sure," Paul says. "And that's what sucked about it. [LeBron] was just distraught.… It took a while to come out of that funk. A long time. Honestly, I don't even know if he's still out of it. I don't know for sure."

James honored Bryant with a tattoo and a promise: He would lead the franchise, the way

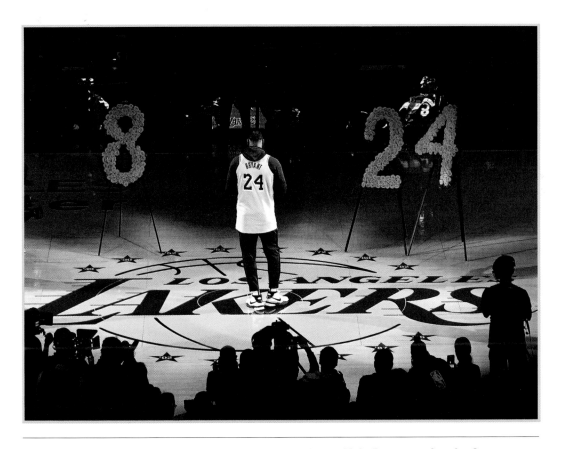

LeBron James speaks during a pregame ceremony to honor Kobe Bryant at Staples Center on January 31, 2020.

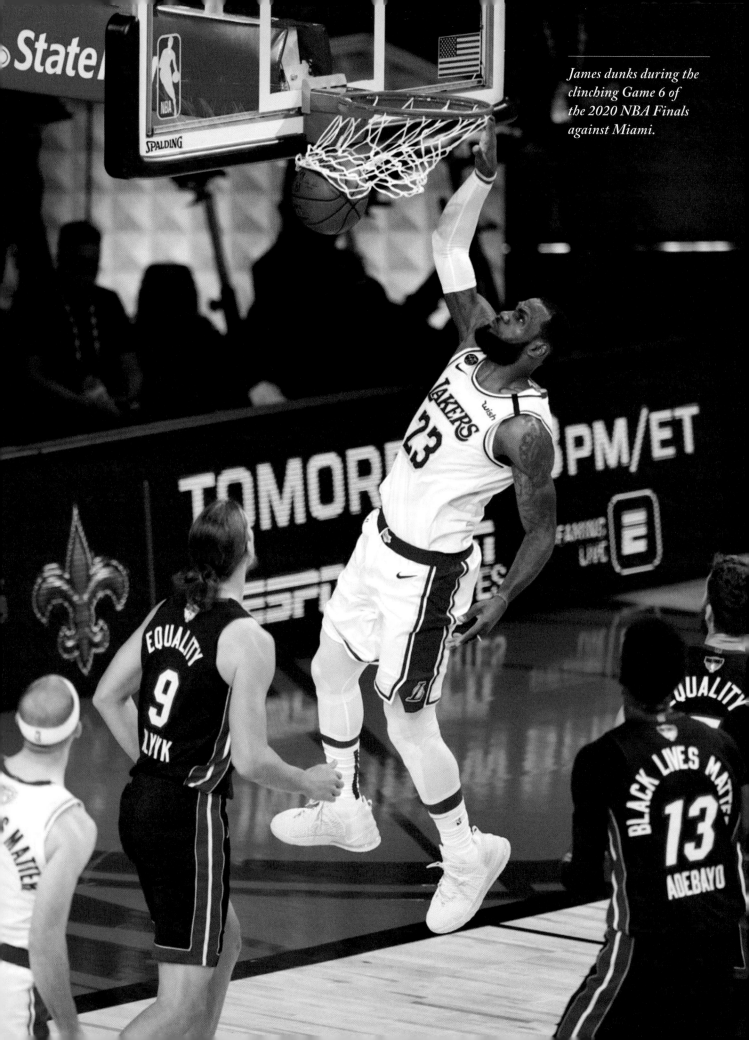

James dunks during the clinching Game 6 of the 2020 NBA Finals against Miami.

Bryant did. But he barely had time to do it. Sixteen days after a service for the Bryants at Staples Center, the NBA suspended its season because of the pandemic.

———————

Pelinka was in the Lakers' practice facility in El Segundo, Calif., when he heard the news. He immediately told his executive assistant, Sam Usher, "I don't think there's gonna be a path to finish the season."

The NBA paved a path, of course, but two Lakers never got on it. Defensive stopper Avery Bradley, who had started 44 of the 49 games he played, opted out of the restart to be with his family. Assistant coach Lionel Hollins stayed home because he was deemed high-risk. Hollins's departure left Vogel with one former NBA head coach on his bench: Jason Kidd.

The Lakers arrived in Orlando with a 49–14 record, best in the West, driven by the most top-heavy roster of any contender. James and Davis each made first-team All-NBA, but the rest of the team was mostly composed of role players or stars past their prime. For this to work, the pieces had to fit.

Davis had arrived in L.A. after firing his agent, hiring James's agent (Paul), requesting a trade and allowing Paul to say publicly that he would not sign an extension, scaring off potential suitors. It was obvious that he wanted to join James on the Lakers. But the Lakers still had to make the deal.

As a former agent, Pelinka has decades of experience pleasing stars, and he does not shy away from James's influence on the roster: "It's definitely a collaborative approach, because I mean, he's the basketball savant. When I process decisions, I like to do a lot of listening at the front end. And of course he's a primary voice. But then you've got to make the decision and you got to own it."

Pelinka was sure he wanted to make the deal: "I think that when you have a chance to get the unicorns in the game, you have to go for it. That's why we all do what we do. It's really hard to get to the end and win a championship unless you have unicorns on your team. There was really no hesitation on my part."

Buss was warier. She gets nervous during practices just because she doesn't want anybody to get hurt, and she says, "I'm not that cutthroat person that's all about 'Win, win, win, me, me, me, whatever it takes, I don't care who is crushed in the process.' One of the hardest things for me to do is to trade away a player. I adore Brandon Ingram and Josh Hart and Lonzo Ball."

Buss's late father, Jerry, had urged her to learn to play poker, one of his passions, because of what the game would teach her. He said most poker players get too aggressive, trying to create what isn't there, but "when you do get the cards," Jeanie says, "you have to go from zero to 100 in a snap of the fingers." She never got very good at poker. But she knew this was a chance to go from zero to 100.

With Davis in the fold, Vogel maximized the team's strengths: its stars and its defensive versatility. He created substitution patterns so either James or Davis was on the floor almost all the time. He had James play primarily at point guard for the first time in his career, to allow everybody else to play off of him, and allowed James to steer the offense.

And Vogel, like Pelinka, welcomed James's influence instead of resisting it. When James was hurt, Vogel invited him into coaches' meetings. Vogel did not try to over-impose his authority. He just coached the team.

———————

The Lakers lost four of their first six games after the restart, as everybody felt their way around. Bubble games were played in small arenas, with only a few spectators, no road games and simpler shooting

backgrounds. As one might expect, field goal and free throw percentages were a little higher than before the restart. More telling, though: Teams fouled more often, as defenders often do when they are a step slow. Teams stole and deflected fewer balls, and yet turnovers went up slightly. That tells a story: Players struggled to summon the energy for the game's grunt work or the concentration for crisp basketball.

The teams that advanced would not just play the best basketball; they would play the best *bubble* basketball. Three months together in one hotel can make a group of people want to strangle each other, or it can make them grow closer. It is no coincidence that the two teams that grew closest were the last two

standing. The Heat has some young players (with more natural energy and fewer people at home to miss) and a culture made for any grind. The Lakers had their own advantages.

Because James likes to help build his teams instead of just star for them, he takes a leadership role that goes beyond just exhorting guys to play hard. Teammates marvel at how he remembers everybody's name, their kids' names, what's going on in their families' lives. (At the first timeout of Game 1 of the Finals, James walked back to the huddle and told his teammates, "We got the president in the house." He had noticed Barack Obama in the virtual stands.) He would not allow them to lose their competitive edge like the Bucks and Clippers did.

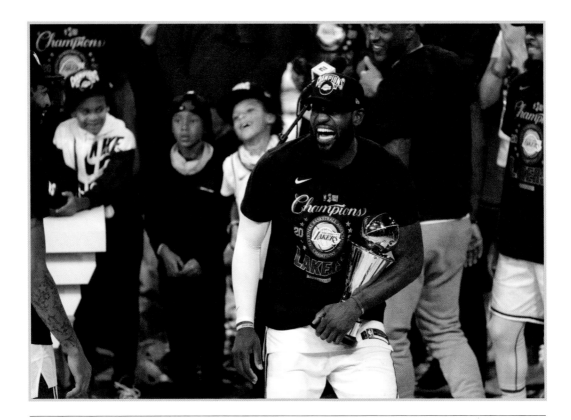

James became the first player in NBA history to be named Finals MVP with three different teams.

In the bubble, James was part superstar, part concierge. Most players in the bubble hung out in a lounge at the hotel, but L.A. reserve Jared Dudley says, "You didn't see Laker players (there) … maybe one or two players, for the most of it. We do our own lounge."

The first sign that the Lakers were made for the bubble came after their first exhibition game of the restart, against the Mavericks. They went to Anthony Davis's suite and watched the Snoop Dogg vs. DMX *Verzuz* battle together. It was not an organized team-building exercise; it just happened. They started holding pool barbecues, trivia night and *Monday Night Football* and UFC viewing parties—often in James's and Davis's suites, but sometimes in the team's meal room and film room.

Everybody wanted to get away, but nobody wanted to get away from each other. Lakers guard Rajon Rondo broke his thumb in July and left the bubble; when he returned and had to quarantine, his teammates kept talking to him through his hotel-room door, to make him feel connected. When he got out, they drank wine with him in the hallway. It was a long way from bottle service at the club, but it was all they could do. The Lakers were not the only team that hung out together, of course, but they did so in unusually large clusters: eight to 10 players together, instead of four or five.

The Lakers started most days by walking across a pedestrian bridge to eat breakfast at Three Bridges Bar and Grill. After games, they would grab a bite to eat … at Three Bridges Bar and Grill. They got through the slog in part because James wanted four rings, Davis wanted his first, and they were as productive together as any pair of teammates since Kobe and Shaq.

The NBA did a marvelous job of erecting the bubble, but those inside were constantly conscious of the fact they could never leave. Enough players mentioned "exhaustion" in interviews that Buss finally asked a psychologist: With no travel, and limited activities, why were professional athletes speaking of exhaustion? She was told that the lack of stimulation could leave people exhausted.

Exhaustion and anger are a combustible combination, and NBA players stopped their season again in late August, in the wake of the Jacob Blake police shooting in Wisconsin. That night, players had heated conversations about social justice and the purpose of basketball, centering on the question: *Why are we even here?*

Prominent players spoke. So did Kidd.

The Lakers were lucky to have him after all. As a Hall of Fame player and one of the smartest point guards in history, Kidd garnered a different kind of respect that night than a white career coach like Vogel could. Kidd told the players to weigh the options. He said if their hearts were not in it, maybe they shouldn't play. James asked his teammates to think about what they were standing for and why. The Lakers took an informal vote, which was reported as a vote to end the season, but that wasn't quite right. It was more of a vote that they were *willing* to end the season if that's what most players in the bubble wanted to do.

The next morning, Pelinka met Kidd for coffee. Pelinka said he had been up until 2 or 3 a.m. Kidd said he did not get back to his own room until 5. Neither man knew whether the season would resume.

Years ago, Jeanie Buss would tease former Bulls and Lakers coach Phil Jackson by asking the same question everybody else asked: Who was better—Michael Jordan or Kobe Bryant? Jackson told her he thought the kid in Cleveland might end up being the best ever, because of his uncommon strength and

extremely high basketball IQ. All he needed, Jackson said, was the right coach to get him there. James found that coach in Miami, when he played for Erik Spoelstra.

The LeBron James who beat Spoelstra in the 2020 Finals was everything Jackson could have dreamed he would become. Most players saw the bubble as a necessary evil, an annoyance or a science experiment. James saw it first and foremost as a place where he could win a championship. "Once I got inside here, I said, 'OK, this is my mission,'" he said Sunday night. "It was hard for me to focus on other teams and what other players were feeling. I didn't engage in that. I didn't look for it. I wanted to keep my energy in the right space."

James has danced with the legacy question for years. In his first year in Miami, he said he was keeping track of everybody who ripped him for leaving Cleveland. After winning his second championship with the Heat, he struck a gentler tone, telling the media, with a cigar in his mouth, "I will see you guys when I see you guys. And please continue to motivate me. I need you guys. Thank you." In 2016 he said, knowing an SI writer was within earshot: "My motivation is this ghost I'm chasing. The ghost played in Chicago."

James talked Sunday night about "little rumblings of doubt" that fuel him, but they don't seem to consume him. Paul says, "Once he won the championship in 2016, I think he really settled.... I mean, he didn't stop wanting to compete and win, which was a narrative that was put out there that was totally false. But I think he stopped worrying about what critics had to say, because it didn't matter at that point."

This was arguably James's most difficult title run, but it was also the one that came most naturally to him. He connected with Davis better than any costar except

Dwyane Wade. He saw the value in former G Leaguer Alex Caruso and supposedly washed-up Dwight Howard and Rajon Rondo. When Vogel subbed Caruso in for Howard in Game 6, there was no chance of Howard complaining, because that's not how LeBron James teams operate these days. The move worked brilliantly, spurring a Game 6 blowout.

In the final minute of Game 6, Vogel hugged Pelinka and Kidd simultaneously. When commissioner Adam Silver handed James the Finals MVP award, the first person to hug James was Davis. The Lakers were ready for their celebration … at Three Bridges, of course.

Artistry courses through history: From Leonardo da Vinci's studying how hummingbirds moved and breathed before painting them … to Kobe Bryant's learning that about da Vinci and speaking passionately about the importance of details to anybody who would listen … to Bryant's best friend, Rob Pelinka, deciding that with teams limited to traveling parties of 35 people in the bubble, he would personally stick a hand in the face of Danny Green and Kentavious Caldwell-Pope when they practiced shooting, to prepare them for the contested shots in games. Pelinka says: "It goes back to mastering the details, but also just serving the guys."

On one late possession Sunday, wearing Michael Jordan's number for Kobe Bryant's team, LeBron James set a screen, looked to set another, then grabbed a pass for an easy dunk, which he punctuated by slamming his free hand against the glass. He was called for a technical. He thought that was silly. Moments later, he hit a long jumper, yelled in celebration to the family and friends in the stands and then turned and barked at Caldwell-Pope to play defense. The game was long decided. Nobody *had* to play defense. That was the point. •

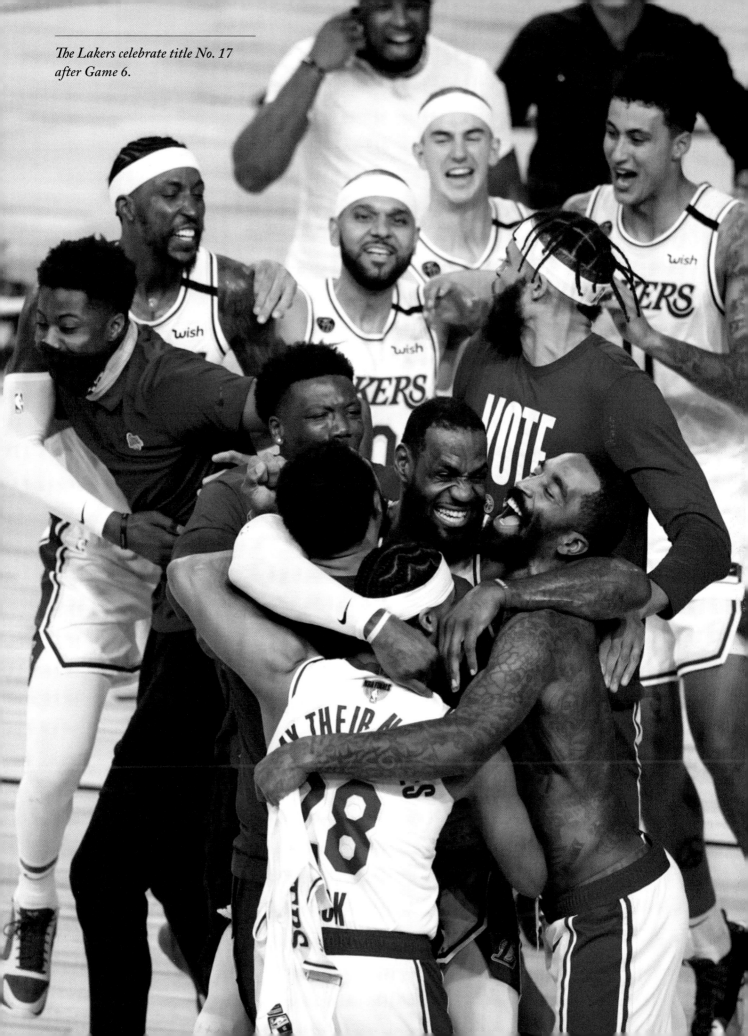

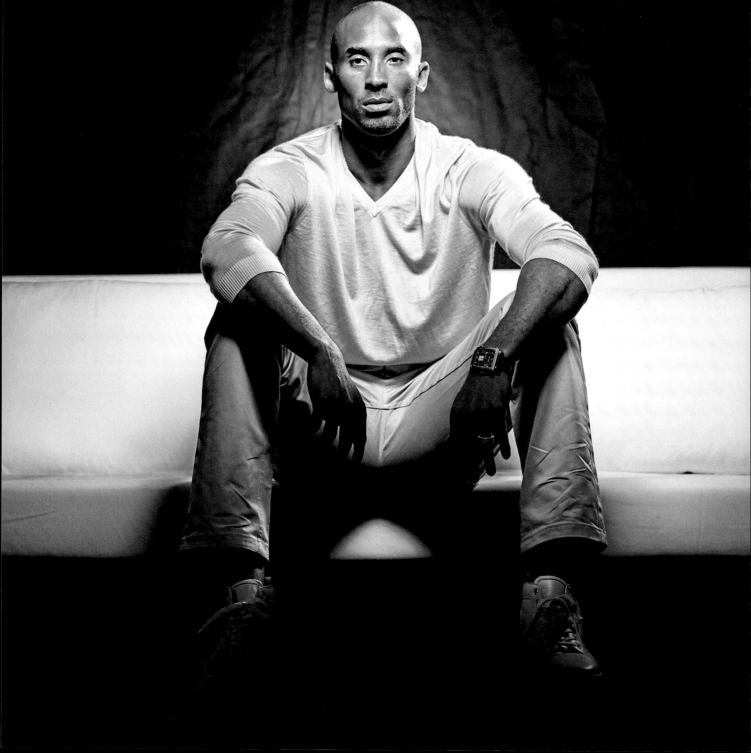

KOBE IS GONE— BUT IN TODAY'S NBA HE IS EVERYWHERE

*Bryant was an icon, a role model, and, to many, a valued mentor. In today's
NBA you don't have to look far to find hints of him.* BY HOWARD BECK

CHRISTIAN WOOD WAS A TODDLER, A LITTLE GIDDY AND A LITTLE MESMERIZED, WHEN HE FIRST SAW Kobe Bryant soar across his family's television screen in Long Beach, Calif. At age four, he watched Bryant claim his first NBA championship. The next year, another. And another the year after that—his fandom accelerating with every dunk, crossover and fadeaway. Whatever the Lakers' superstar did, young Christian tried to emulate.

"My childhood hero," Wood says. "I wanted to *be* Kobe."

At age 10, he watched Bryant score a mind-blowing 81 points against the Raptors.

At age 20, Wood got to meet his idol, for just long enough to absorb a few words of wisdom. And at age 25, Wood—an NBA journeyman suddenly flirting with stardom—got a rare honor: the live, postgame interview on TNT's *Inside the NBA*. The first question was about mindset, to which Wood, the starting center for the Houston Rockets, replied with a two-word phrase.

"Mamba mentality," he said on the Jan. 14 broadcast, alluding to Bryant's alter ego (the Black Mamba) and his ethos.

Wood would invoke the mantra three times in two minutes—a poignant reminder that Kobe Bryant, in ways both subtle and profound, is still inspiring and influencing today's players— prodding, motivating, setting standards, shaping careers.

It's been one year since a helicopter crash claimed Bryant, his daughter Gianna and seven others, sending shock and sorrow through the basketball world. To NBA veterans, Bryant was an admired, respected and feared rival. To younger players, he was an icon, a role model and, to many, a valued mentor.

"It's still so hard for me to talk about, because it's still very raw—and it's raw for a lot of other people," Nets star Kyrie Irving, who counted Bryant as a confidant, said in a recent interview. "And I know I'm not the only person feeling like this, because it's just every single day is just thinking about him."

Indeed, he could have been speaking for so many others. Jayson Tatum, the Celtics' brilliant young star, considered Bryant a trusted adviser and friend. So did Kawhi Leonard and Damian Lillard and DeMar DeRozan and Devin Booker and Kevin Durant and Russell Westbrook and Carmelo Anthony and Trae Young and Giannis Antetokounmpo, and countless others.

Gaze across the league, and you will find Bryant's imprint everywhere.

Norman Powell wears No. 24 in Bryant's honor. So do Lauri Markkanen, Buddy Hield, Dillon Brooks, Pat Connaughton, Marques Bolden, Khem Birch and Devin Vassell. (Three others wear 24 for different reasons.)

Twenty-three players wear No. 8, Bryant's original number, including 10 who chose it specifically because of him: Zach LaVine, Marcus Morris, Maurice Harkless, Wayne Ellington, Naji Marshall, Josh Green, Shaq Harrison, Dwayne Bacon, Jae'Sean Tate and Malachi Flynn.

Cleveland's Lamar Stevens chose No. 8 for other reasons—but he has a "24" tattoo near his left calf in honor of Bryant.

Stephen Curry and Kobe Bryant speak during Bryant's final NBA season in 2015.

Then there's Utah's Miye Oni, who chose No. 81 in part because of his home area code (818) and in part as a nod to Bryant's 81-point masterpiece in January 2006.

Around 90 players wear "Kobes," Bryant's signature shoe, on a regular basis.

The admiration runs deep in this league, from the brightest stars to the fringe guys on two-way contracts. It's not just the points Kobe scored, or the championships he won, or the sheer beauty in his game. It's his spark, his drive, his ethos, his ferocity, his attention to detail, his obsessive dedication to the game. His *Mamba*ness.

"I would say about 70 to 80% [of players] are living through what Kobe has put out," says Wood, "and that's just his mentality, it's his approach to the game and just, you know, his winning mindset."

"It was just his determination," Wood says, "his determination to take the last shot, his determination to be the best on the floor and just the way he approached and was a leader at the same time."

Look a little deeper, and you'll find Kobe's spirit still permeates the league, his best and boldest traits embodied by today's stars.

That uncanny ability to get any shot, any time? You see it in Tatum.

The clutch-time bravado? You see it in Lillard.

The thunderous, soul-stealing dunks? That's Westbrook.

The passionate advocacy for women's hoops? Stephen Curry carries the torch.

The all-consuming work ethic? Jimmy Butler.

The say-anything candor? Draymond Green.

The obsessive film study? LeBron James.

The ultrasmooth midrange game? You see reflections in Booker, DeRozan, LaVine and Leonard.

And if you want to see the Mamba mentality personified, look no further than Wood, an undrafted prospect who was cut four times before blossoming into a star in this, his fifth season.

Bryant saw the potential. The two crossed paths in Philadelphia, in December 2015, when Wood was a 76ers rookie and Bryant was beginning his farewell tour. They chatted briefly in an arena tunnel while walking to the court before tip-off.

"He actually knew who I was as a rookie, which was surprising to me," Wood says. "He told me I had a lot of talent, to keep going."

Wood would be waived and re-signed twice by the Sixers that season, then bounce from Charlotte to Milwaukee to New Orleans to Detroit over the next four years. Now, his place in the league is secure, thanks to a renewed dedication, resiliency and work ethic—or as Wood puts it, "My whole approach to the game is Mamba mentality."

No single player can replicate what Bryant did, or what he meant to the game. But here are five who best represent the best of Kobe.

As J.R. Smith wrote on Instagram: "The game misses your avatar but we all know your soul is all around it."

The clutch performer: Damian Lillard

Lillard hit his first game-winner, a buzzer beater, in his 23rd NBA game. He hit three more game-winners over the next 12 months. He clinched his first career playoff series with a buzzer beater that knocked out the Rockets.

From day one, Lillard has thrived in the biggest moments—a hallmark of Bryant's career.

"What makes a great clutch shooter is confidence and fearlessness," Lillard says. "I think everybody knows the work ethic of Kobe Bryant.... When you know you've put the work in and you've put the time in, you go into certain situations with a different level of confidence. Because you feel like you've got the right to be that confident."

Lillard says he's always been fearless, going back to his AAU days. He's never lacked confidence, or a willingness to work. But it was Bryant who gave him a critical early lesson about preparation.

As an Oakland native, Lillard grew up a Warriors fan—but he idolized Bryant and rooted for the Lakers each spring, when his hometown team was nowhere to be found. He vividly recalls Bryant's seizing control in overtime of Game 4 in the 2000 Finals, after Shaquille O'Neal had fouled out. He can still picture Bryant's game-winner from the right elbow to beat the Suns in the 2006 playoffs.

"I had a Kobe jersey. I had the Kobe shoes," Lillard says. "We all idolize Kobe."

They struck up a friendship soon after Lillard arrived in the league, in 2012. After his fourth season, Lillard reached out with a critical question: *What does it take to be a champion?* As always, Bryant was generous with his advice.

"A lot of it had to do with film," Lillard says. "He watched a lot of film on the best defenders and how they defended him. He watched full games. And he would always say, *You will be surprised how often people do the same things.… And if you can learn people's patterns, and you can learn their tendencies and habits, by watching them game after game, you'll see that they do the same things, and you can take advantage of it. And you can manipulate that.* Then I started to do that. That really helped me."

No current star has assembled more dramatic, clutch-time shots than Lillard. His 37-foot buzzer beater to knock out Oklahoma City in 2019 is one of the most iconic shots of all time.

Even in a league bursting with talent and bravado, Lillard's fearlessness and skill in the biggest moments set him apart—just as Bryant's did in his time.

"I think it is rare," Lillard says. "I think there's guys in the NBA who have it, who

truly have it, but I don't believe everybody that the public might say has it. I don't believe everybody has it. I think guys are talented and good enough to have moments. But I think the guys that you see do it time and time and time again are the ones who truly have it."

The WNBA advocate: Stephen Curry

It's worth remembering where Kobe, Gigi and the others were heading last January: to the Mamba Academy, for a girls' basketball game. With Kobe as their coach.

Over the years, Bryant had become a fierce advocate for girls' and women's hoops, and the WNBA in particular. He wasn't the only NBA star to champion the women's game, but he was surely the most influential of his time.

That responsibility now falls to another generation of stars, with Stephen Curry among those leading the charge.

Curry sponsors a free camp for 200 girls and young women. He's worked with Under Armour to bring some of the top girls to his annual SC30 Select Camp. He's written passionately about the need for pay equity and equal opportunities for women and girls.

"The fact that you have a guy like Kob, that was lending his platform, his voice, resources, his time to champion the women's game, that obviously is a huge encouragement to continue that mission," says Curry, who says his efforts were partially inspired by Bryant's. "A lot of people really appreciate it more because of how Kobe celebrated and supported the game while he was here."

Like Bryant, Curry is a proud "girl dad" who wants the best for his own daughters, eight-year-old Riley and five-year-old Ryan. He's thought a lot about what their experiences will be like, whether they pursue basketball or other passions.

"There's a huge opportunity to raise awareness around the women's game, and

involvement in youth sports, that can make a difference in somebody's life," Curry says.

The WNBA recognized Bryant's efforts last year by creating the Kobe and Gigi Bryant WNBA Advocacy Award to honor those who make significant contributions to girls' and women's basketball.

Curry's passion for the WNBA was stoked as a child, attending Charlotte Sting games with his father, Dell (then playing for the Hornets), cheering for Andrea Stinson and Dawn Staley. "It was a pretty dope environment there at the old Hornet Coliseum," he says.

Curry's involvement today includes mentoring Liberty star Sabrina Ionescu, who had also been closely tutored by Bryant.

"The way that she emulated Kob, in terms of how she approached the game, and her killer instinct and attitude, and just how he resonated with her, and obviously her growing up out here in the Bay and watching me play, there's definitely a connection there," Curry says. "It's pretty awesome to know that, obviously, after his tragic death, that that connection grew even stronger with me and her, just in terms of the opportunity to take what Kob was doing and what his legacy will continue to do in the women's game and carry that torch."

The vengeful dunker: Russell Westbrook

Bryant dunked with ill intent. He made that clear throughout his career, and made it explicit in his 2018 book, *The Mamba Mentality*.

"Dunking," he wrote, "is about domination."

It's about a mentality, Bryant asserted. About setting a tone. About letting the opponent know, "You're there to humiliate them."

Those sentiments could have just as easily come from Russell Westbrook.

"Their intent feels the same," says Jamal Crawford, who had to check both stars over his 20-year career. "The passion [Westbrook] shows after the dunk is almost exactly the same. It's almost like he's imposing his will as well with that."

Antetokounmpo dunks forcefully and often. James slams with style and power. Joel Embiid relishes the timely jam. But no current player dunks to destroy like Westbrook does.

"Russell had the ability to intimidate the opponent with his aggressive tenacity towards the rim," says Scott Brooks, who coached Westbrook through his first seven years. "And he treated the rim like an opponent."

Westbrook will always be remembered for his 2016–17 MVP campaign, his triple doubles and his dizzying assault on the record books. But it's the assaults on the basket, and anyone standing nearby, that will be forever seared in our memories.

Crawford immediately recalls a moment early in that MVP season, when Westbrook—rendered a solo act in Oklahoma City by Kevin Durant's departure—viciously threw down a left-handed dunk on Houston's Clint Capela to seal a victory.

"It's demoralizing," Crawford says, "and he's *trying* to demoralize you."

That was Bryant's enduring mission, whether he was slamming an impossible reverse dunk against the Knicks at age 24, or demolishing the Nets' frontcourt at age 34.

Every Westbrook drive is a potential highlight clip, every dunk worth the price of admission—and every one of them a statement, a show of superiority. A timely slam on the home court electrifies the whole arena. On the road, it can crush 20,000 spirits at once.

"Like he's just punking the whole gym," Crawford says. "It's an unbelievable weapon to have."

The aftermath of a Westbrook dunk can be just as potent: the stomping, screaming, chest-beating, glowering, snarling. And

though the physical histrionics might rub some the wrong way, you can bet Westbrook does not care about anyone's feelings.

"He's one of the few guys, like Kobe Bryant, he wasn't out there to make friends," Brooks says. "And that was part of the Mamba mentality."

The voice of candor: Draymond Green

Green has opinions on NBA policies and rules, media coverage, referees, teammates, coaches, opponents, league relations with China, police reform, the Capitol insurrection and, well, too many other topics to list here.

And he's willing to speak candidly on all of it, no matter how touchy the subject or how uncomfortable it might make anyone else.

"I have always been outspoken," Green says. "I've always been comfortable using my voice."

That's a rare trait in this NBA era, where players are hyperconscious of their personal brand, and an army of PR people and image consultants are constantly advising them to play it safe.

But Green rarely worries about backlash or controversy, which is a very Mambaesque quality. Candor and bluntness were prime features of Bryant's press gaggles, especially in his later years.

"That was something that always struck me, that Kob was going to say however he felt, whenever he felt that," Green says. "And he wasn't gonna bite his tongue for anyone."

Outspoken players are often mischaracterized as controversial, as if their sole aim is to cultivate conflict. But Green, like Bryant, is just brutally honest, thoughtful and unafraid to express himself, whether on basketball or anything else.

"I refuse to be held hostage to the public's opinion," Green says. "Regardless of what someone thinks, if I feel a certain way, I'm going to express that. And I don't really care what the response to what I say is."

That same bluntness comes into play on the court, whether Green is confronting a teammate about a blown play or teaching them in real time. That tough-love leadership also echoes Bryant's approach.

"My mom was very adamant that we use our voices," Green says. "If there was ever anything that we had to say, she would encourage us to say it, and regardless to who it was to…. If you're telling the truth, you're just telling the truth."

The workout fiend: Jimmy Butler

Every player who's achieved a measure of NBA stardom worked hard to reach these lofty heights. But not everyone's definition of "work ethic" is the same.

There's work. And then there's maniacal, all-consuming, eat-breathe-sleep, all-hours-of-the-day-and-night work.

"My midnight workouts have become a thing of legend," Bryant wrote in *The Mamba Mentality*. "They were always purposeful. They were born from a mix of obsession and real-world responsibilities. I always felt like if I started my day early, I could train more each day."

Jimmy Butler lives a similar credo, even in the offseason, even when he's purportedly on vacation, even when that vacation is on one of the world's most gorgeous beaches.

A few years ago, Butler took a trip to Mykonos, Greece, accompanied by his friend (and NFL star) Demaryius Thomas; his cousin Marqueese Grayson; his trainer, James Scott; and his agent, Bernie Lee.

They landed around 10 p.m., had a late dinner and stayed up all night playing cards and dominoes. Around 7:30 in the morning, Lee decided to get some sleep. Butler had other ideas: "Meet us in front in 10 minutes. We're going to work out."

Ten minutes later, the entire traveling party was on the beach to get in a 90-minute session before it got too hot.

"It was the hardest hour and a half of my life," Lee says. "It had to have been 120 degrees on this stupid beach. The sand was like the size of like salt grains, like you couldn't run on it. And we went through a workout as if we were like Navy SEALs, or like the world was ending the next day."

Only Butler and Thomas made it all the way through, and Thomas "looked like he was going to die," Lee says. "And I remember when we got done, Jimmy walked back to the car is if nothing had happened, as if we did like a Peloton class or something."

Butler, who rose from the 30th pick in the 2011 draft to an NBA superstar through sheer will, clearly needed no outside prodding to develop his work ethic. He never spent much time in Bryant's direct orbit. But he heard the stories of Bryant's legendary, almost mythical approach while playing for USA Basketball. It had an impact.

"If you competed against him, you realized there was truth behind the myth," Lee says. "It seems like a very simplistic thing from a work ethic standpoint to aspire to. And then once you start doing it, you do realize how difficult what he did actually is." •

Bryant lends a hand to Damian Lillard in 2015.

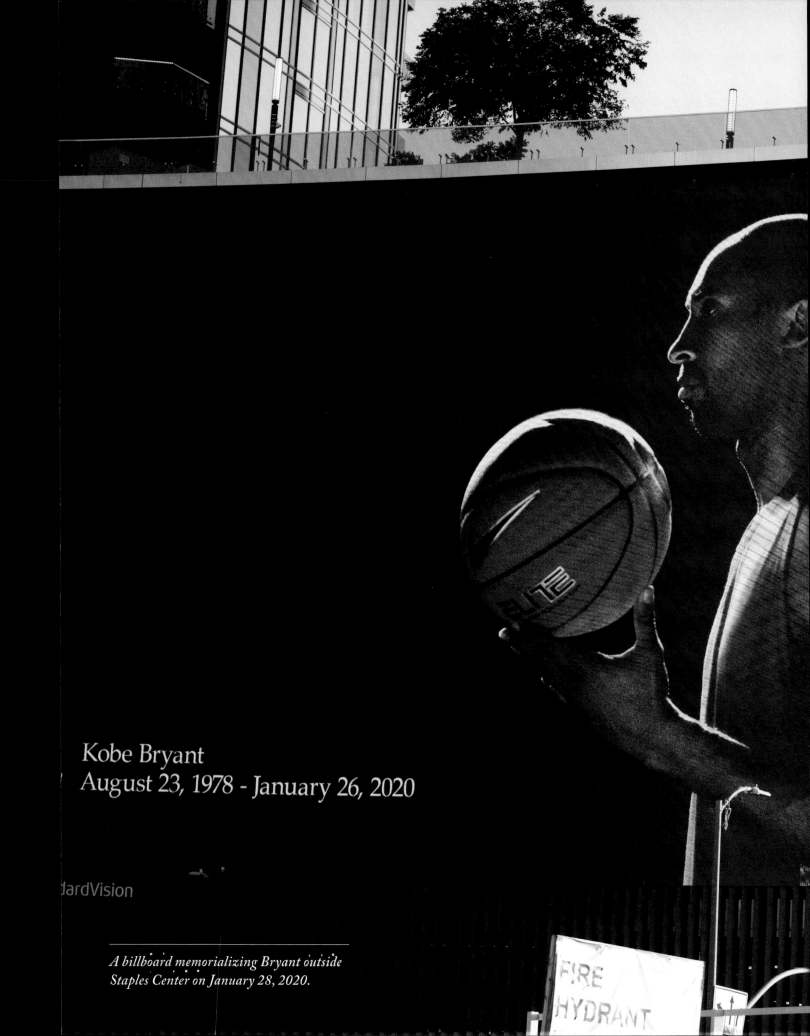

Kobe Bryant
August 23, 1978 - January 26, 2020

*A billboard memorializing Bryant outside
Staples Center on January 28, 2020.*

Mamba Forever

RIGHT LANE
BUSES
RIGHT TURNS
ONLY

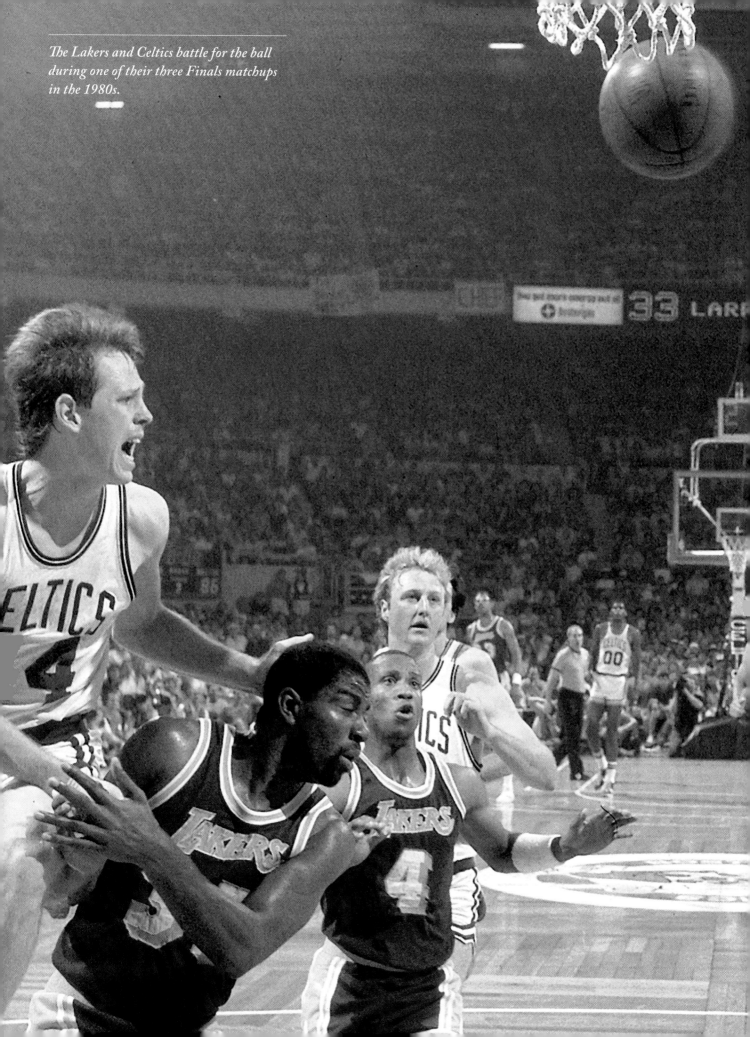

The Lakers and Celtics battle for the ball during one of their three Finals matchups in the 1980s.

THE CHAMPIONSHIPS

No team has won more NBA titles than the Lakers' 17. Those championship runs have been full of memorable moments

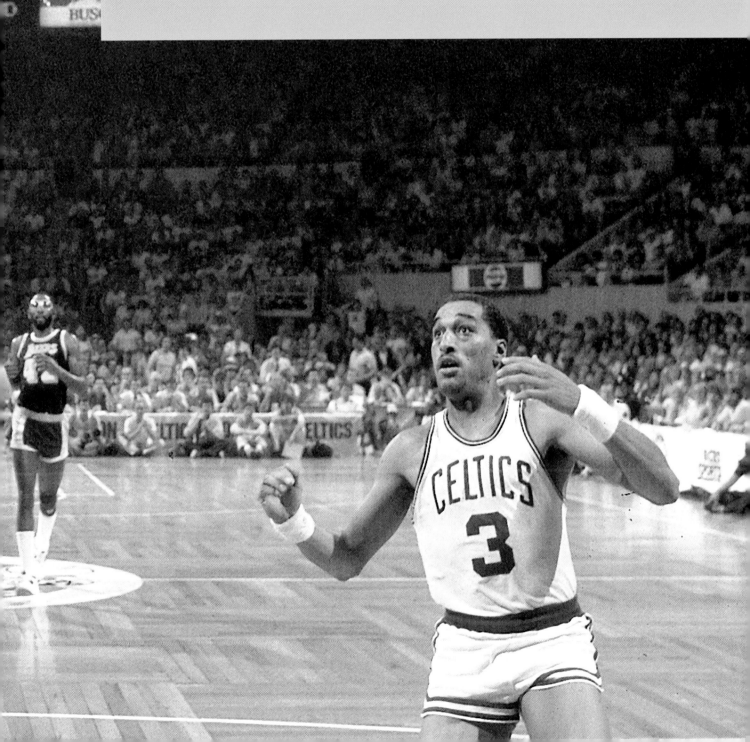

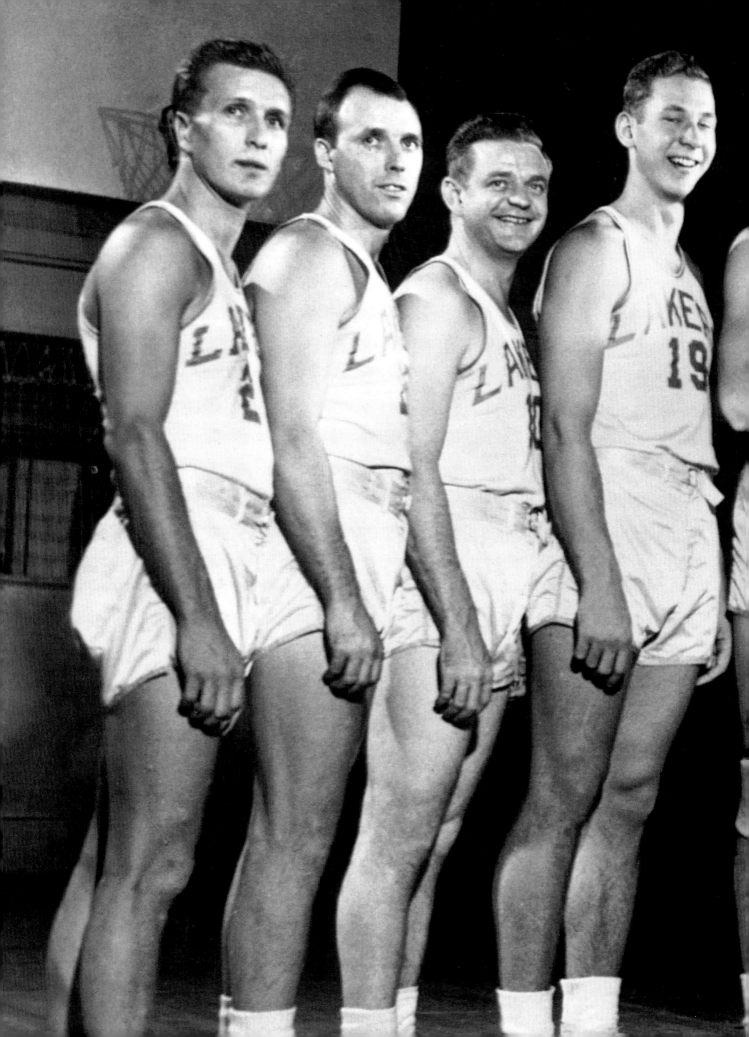

1949 BAA Finals, 1950/1952/1953/1954 NBA World Championship Series

After being founded in Minnesota in 1947, the Lakers found near immediate success thanks to the presence of basketball's first superstar, center George Mikan. In 1948-49, their first season in the Basketball Association of America, the Lakers defeated Red Auerbach's Washington Capitols to win the league's championship. The following year, the BAA merged with the National Basketball League to form the National Basketball Association, and the Lakers repeated as champions. After falling short of their goal in 1951, the team won the next three titles, making it five triumphs in seven years. Mikan retired in 1956, and in 1960, the franchise relocated to Los Angeles.

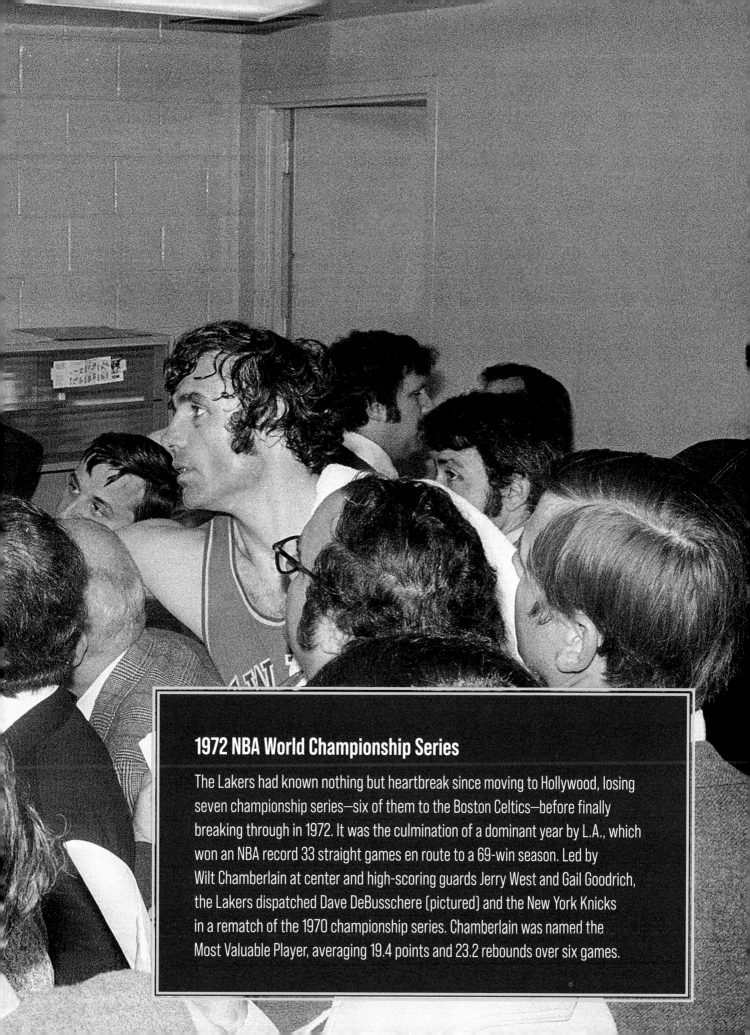

1972 NBA World Championship Series

The Lakers had known nothing but heartbreak since moving to Hollywood, losing seven championship series—six of them to the Boston Celtics—before finally breaking through in 1972. It was the culmination of a dominant year by L.A., which won an NBA record 33 straight games en route to a 69-win season. Led by Wilt Chamberlain at center and high-scoring guards Jerry West and Gail Goodrich, the Lakers dispatched Dave DeBusschere (pictured) and the New York Knicks in a rematch of the 1970 championship series. Chamberlain was named the Most Valuable Player, averaging 19.4 points and 23.2 rebounds over six games.

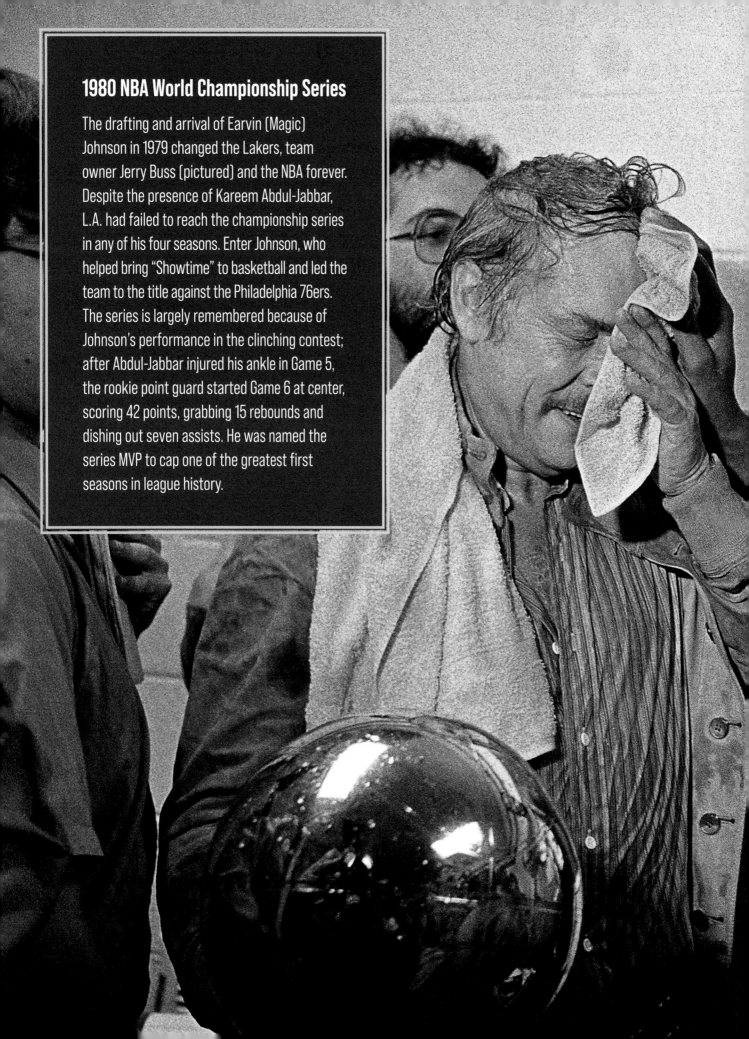

1980 NBA World Championship Series

The drafting and arrival of Earvin (Magic) Johnson in 1979 changed the Lakers, team owner Jerry Buss (pictured) and the NBA forever. Despite the presence of Kareem Abdul-Jabbar, L.A. had failed to reach the championship series in any of his four seasons. Enter Johnson, who helped bring "Showtime" to basketball and led the team to the title against the Philadelphia 76ers. The series is largely remembered because of Johnson's performance in the clinching contest; after Abdul-Jabbar injured his ankle in Game 5, the rookie point guard started Game 6 at center, scoring 42 points, grabbing 15 rebounds and dishing out seven assists. He was named the series MVP to cap one of the greatest first seasons in league history.

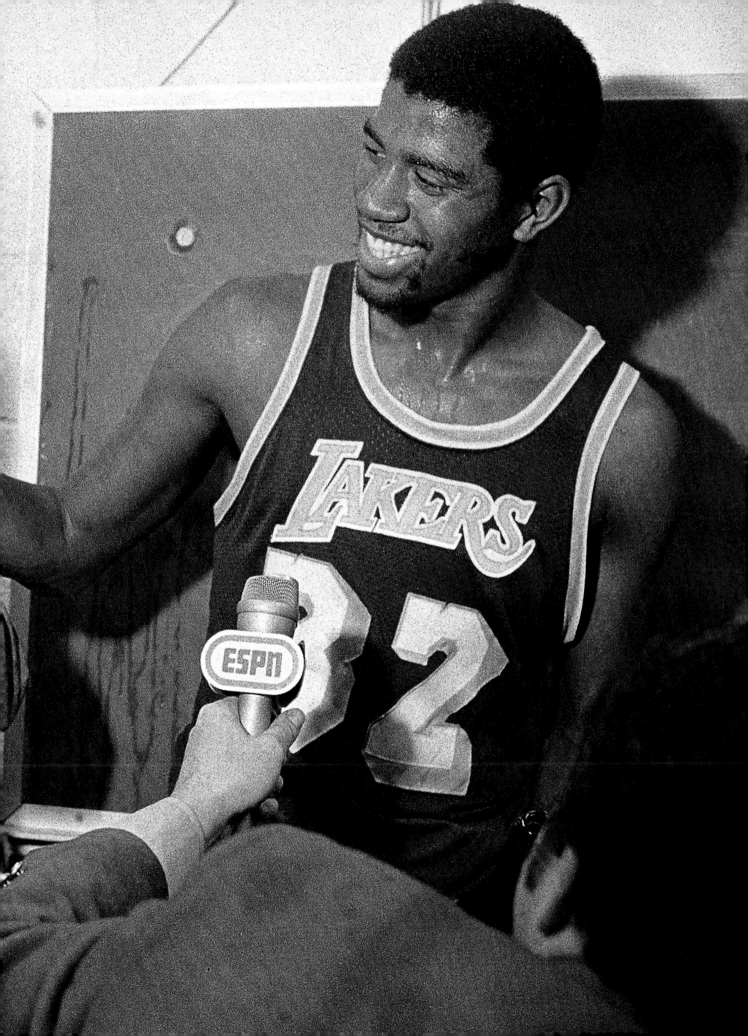

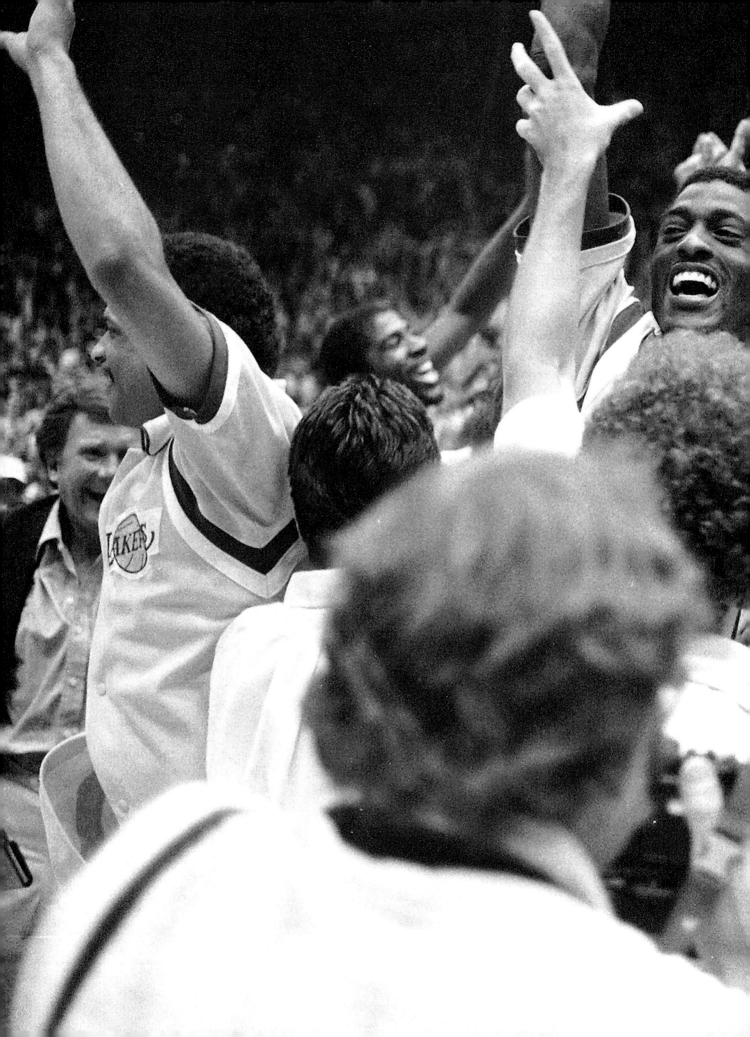

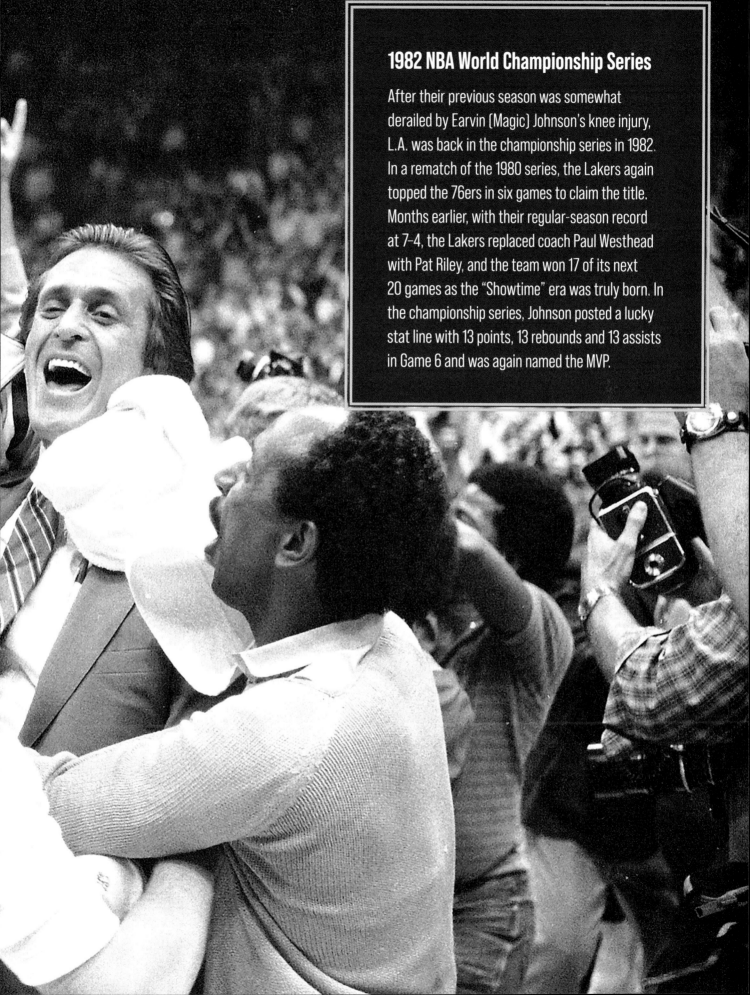

1982 NBA World Championship Series

After their previous season was somewhat derailed by Earvin (Magic) Johnson's knee injury, L.A. was back in the championship series in 1982. In a rematch of the 1980 series, the Lakers again topped the 76ers in six games to claim the title. Months earlier, with their regular-season record at 7–4, the Lakers replaced coach Paul Westhead with Pat Riley, and the team won 17 of its next 20 games as the "Showtime" era was truly born. In the championship series, Johnson posted a lucky stat line with 13 points, 13 rebounds and 13 assists in Game 6 and was again named the MVP.

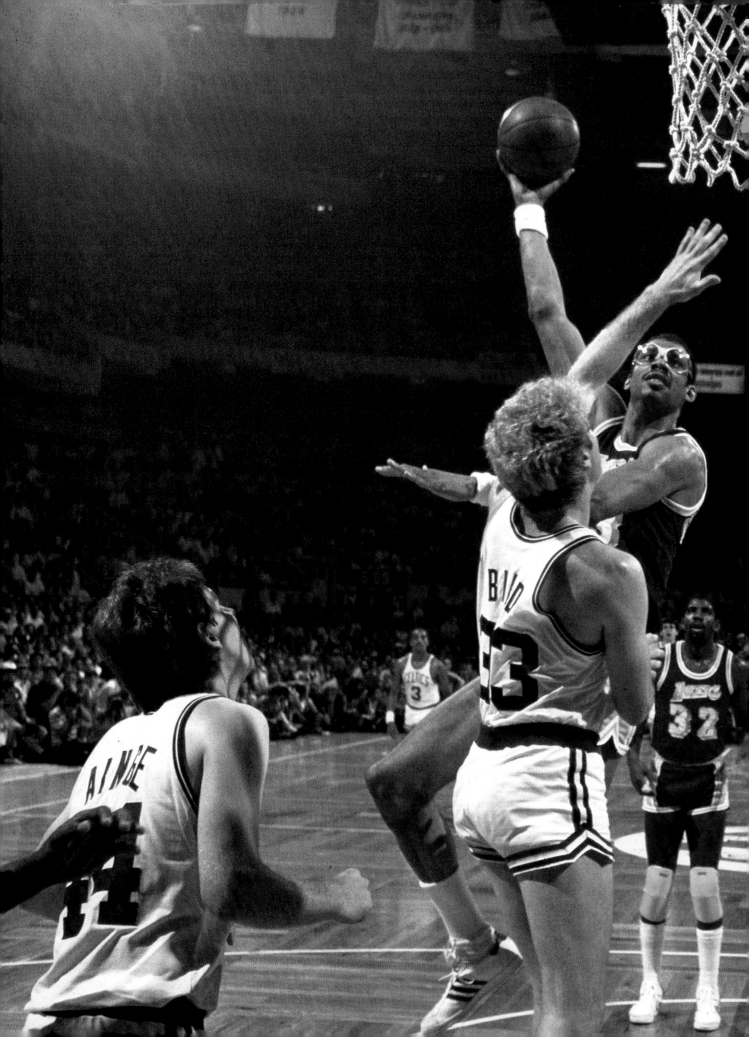

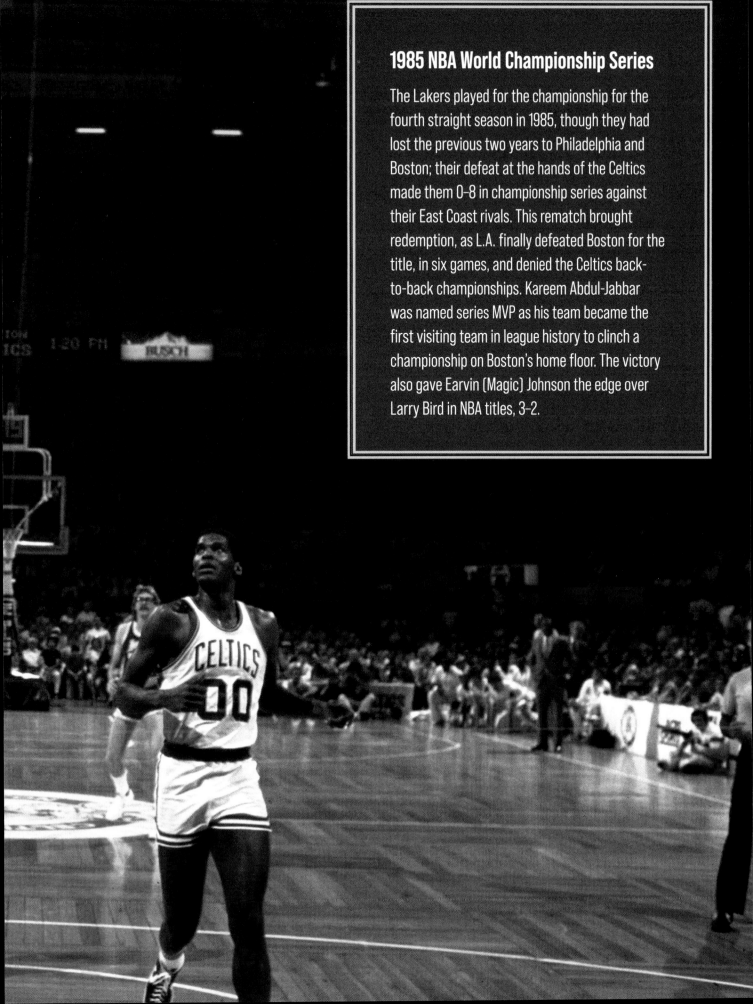

1985 NBA World Championship Series

The Lakers played for the championship for the fourth straight season in 1985, though they had lost the previous two years to Philadelphia and Boston; their defeat at the hands of the Celtics made them 0–8 in championship series against their East Coast rivals. This rematch brought redemption, as L.A. finally defeated Boston for the title, in six games, and denied the Celtics back-to-back championships. Kareem Abdul-Jabbar was named series MVP as his team became the first visiting team in league history to clinch a championship on Boston's home floor. The victory also gave Earvin (Magic) Johnson the edge over Larry Bird in NBA titles, 3–2.

1987 NBA Finals

The Lakers and Celtics met in the championship series, now named the NBA Finals, for the third time in four years, and for the second time, L.A. prevailed in six games. With Kareem Abdul-Jabbar turning 40, the Lakers were now unquestionably Earvin (Magic) Johnson's team, and he won the league's MVP award while leading them to a league-best 65-17 regular-season record. He memorably converted on a "baby sky hook" to win Game 4 and was named MVP of the Finals. After the series, coach Pat Riley guaranteed the Lakers would win again the following year to become the first back-to-back champions since 1969. The Celtics, meanwhile, wouldn't return to the Finals until 2008.

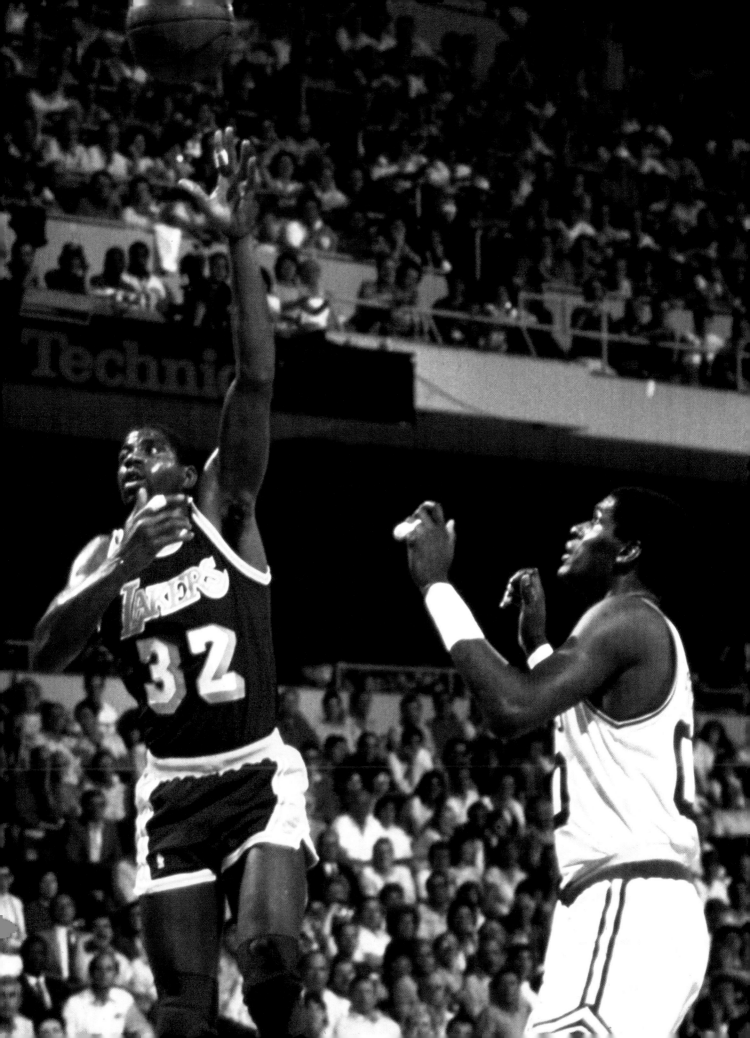

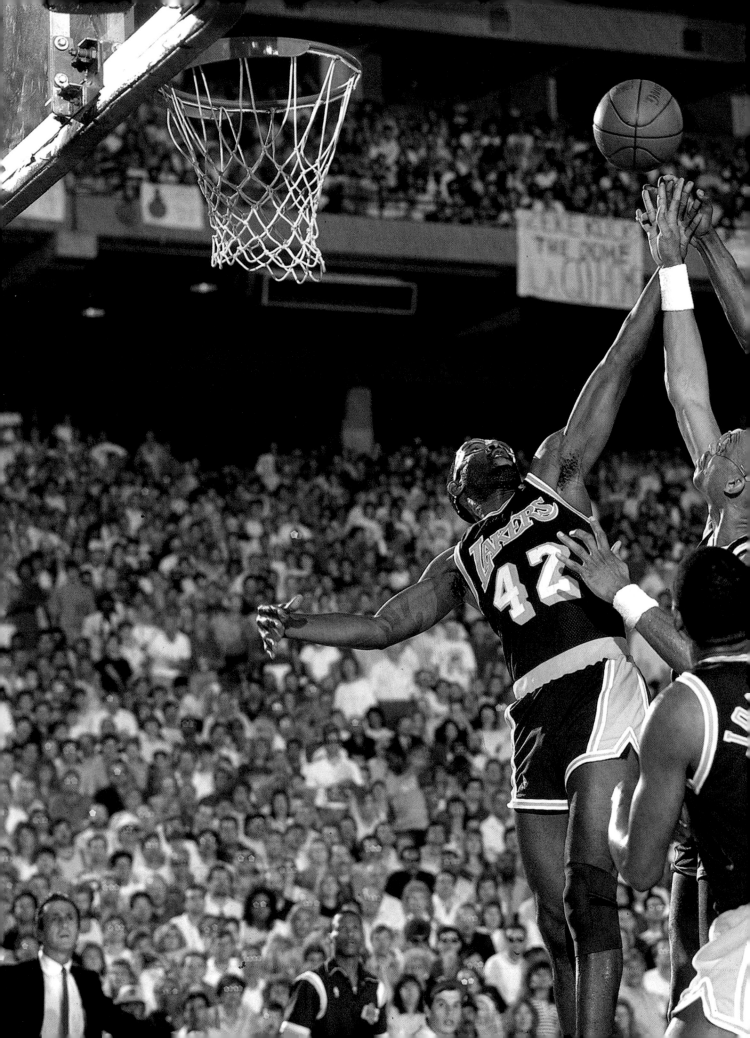

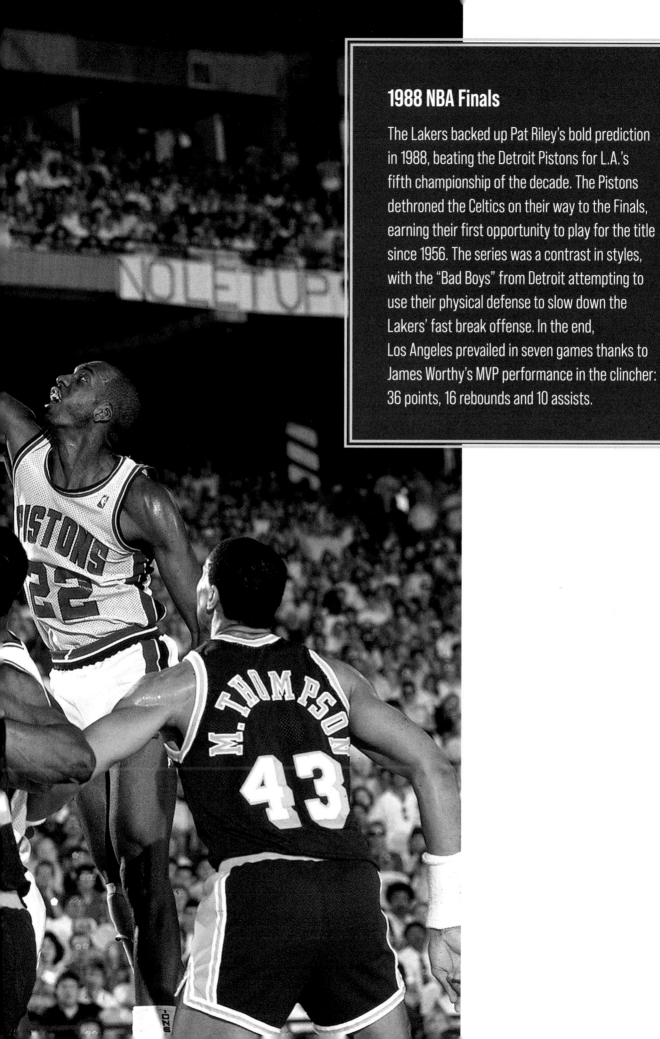

1988 NBA Finals

The Lakers backed up Pat Riley's bold prediction in 1988, beating the Detroit Pistons for L.A.'s fifth championship of the decade. The Pistons dethroned the Celtics on their way to the Finals, earning their first opportunity to play for the title since 1956. The series was a contrast in styles, with the "Bad Boys" from Detroit attempting to use their physical defense to slow down the Lakers' fast break offense. In the end, Los Angeles prevailed in seven games thanks to James Worthy's MVP performance in the clincher: 36 points, 16 rebounds and 10 assists.

2000 NBA Finals

After 12 years, the Lakers returned to the top of the NBA mountain in 2000, winning their first of three consecutive championships. Though blessed with All-NBA talents Shaquille O'Neal and Kobe Bryant, L.A. had failed to get back to the Finals until hiring coach Phil Jackson, who brought his triangle offense and six previous championship rings with him. Despite the combustible mix of personalities, the Lakers rampaged through the Western Conference, winning 67 games during the regular season. In the Finals, the Pacers proved to be no match for O'Neal, who was the overwhelming choice for MVP, averaging 38 points and 16 rebounds in the six games.

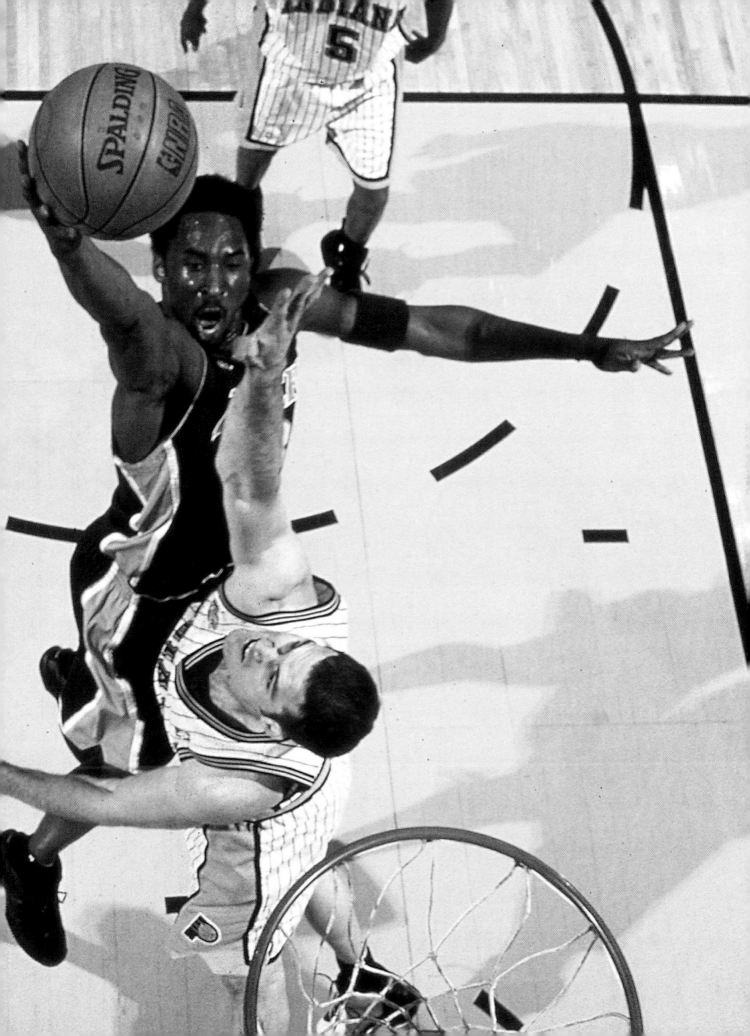

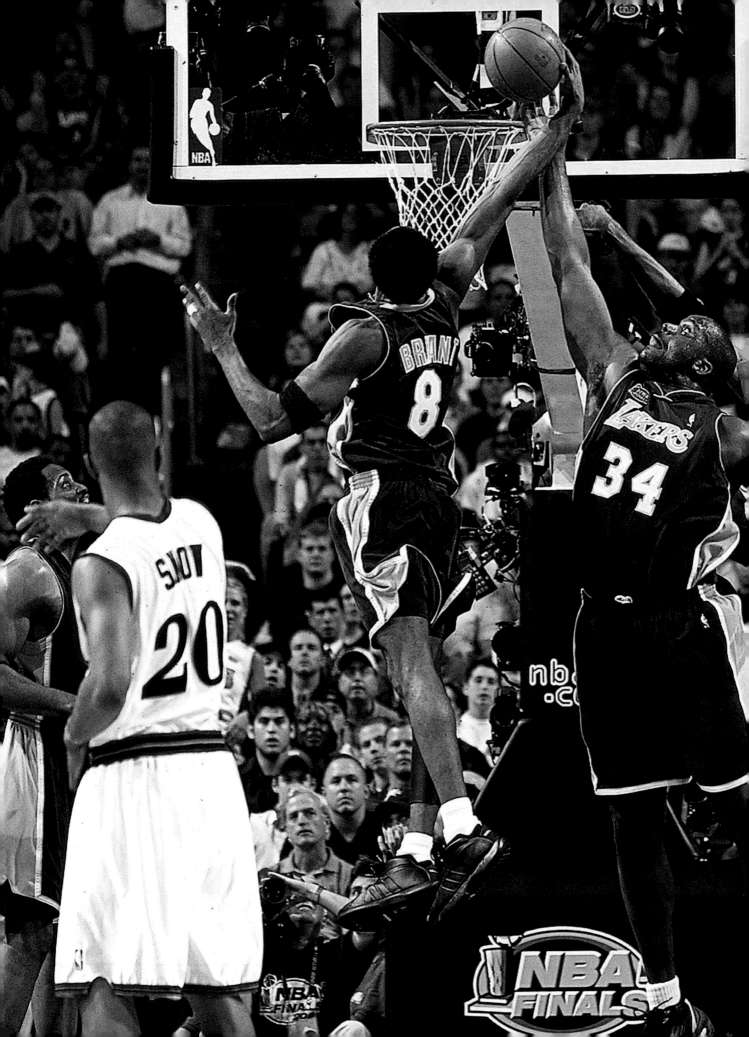

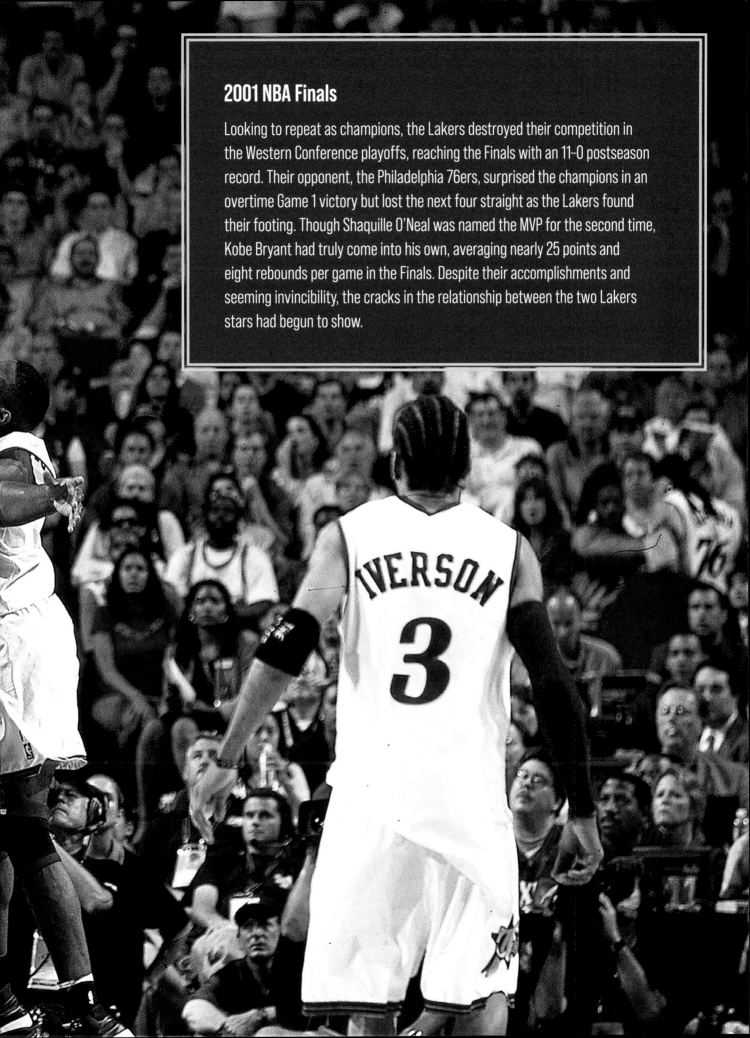

2001 NBA Finals

Looking to repeat as champions, the Lakers destroyed their competition in the Western Conference playoffs, reaching the Finals with an 11-0 postseason record. Their opponent, the Philadelphia 76ers, surprised the champions in an overtime Game 1 victory but lost the next four straight as the Lakers found their footing. Though Shaquille O'Neal was named the MVP for the second time, Kobe Bryant had truly come into his own, averaging nearly 25 points and eight rebounds per game in the Finals. Despite their accomplishments and seeming invincibility, the cracks in the relationship between the two Lakers stars had begun to show.

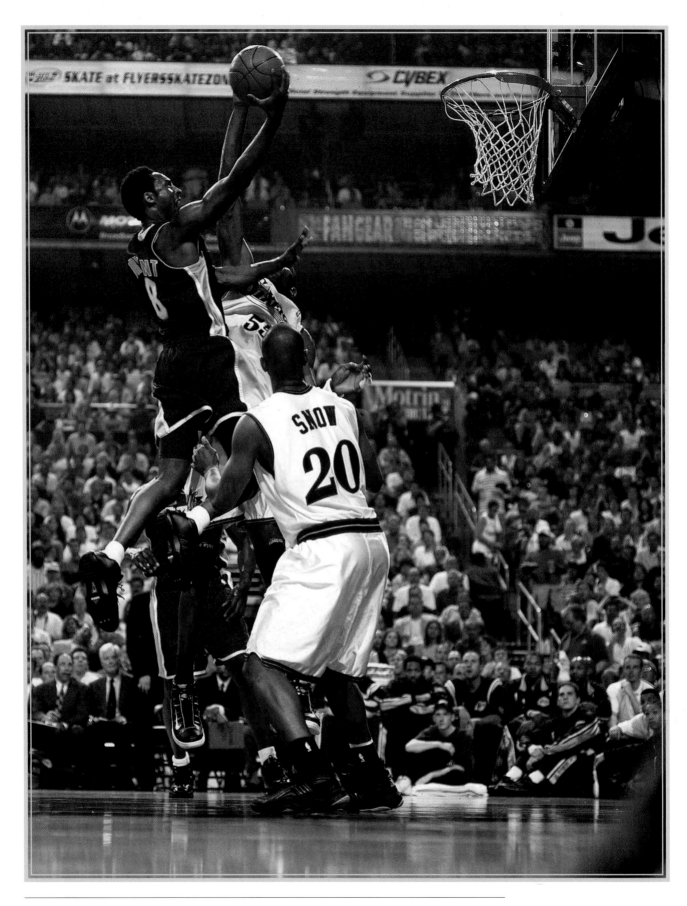

Opposite: Shaquille O'Neal declared Bryant the best player in the league as the Lakers won their second title in a row. Above: During the 2000–01 playoffs, Bryant averaged 29.4 points, 7.3 rebounds and 6.1 assists per game.

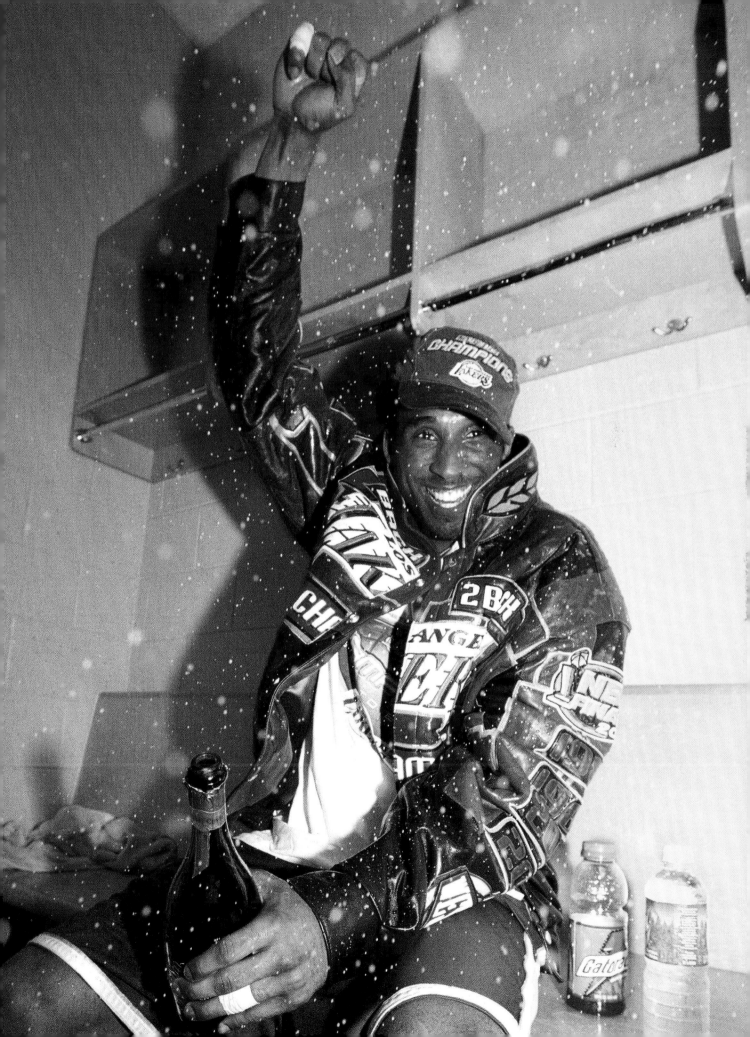

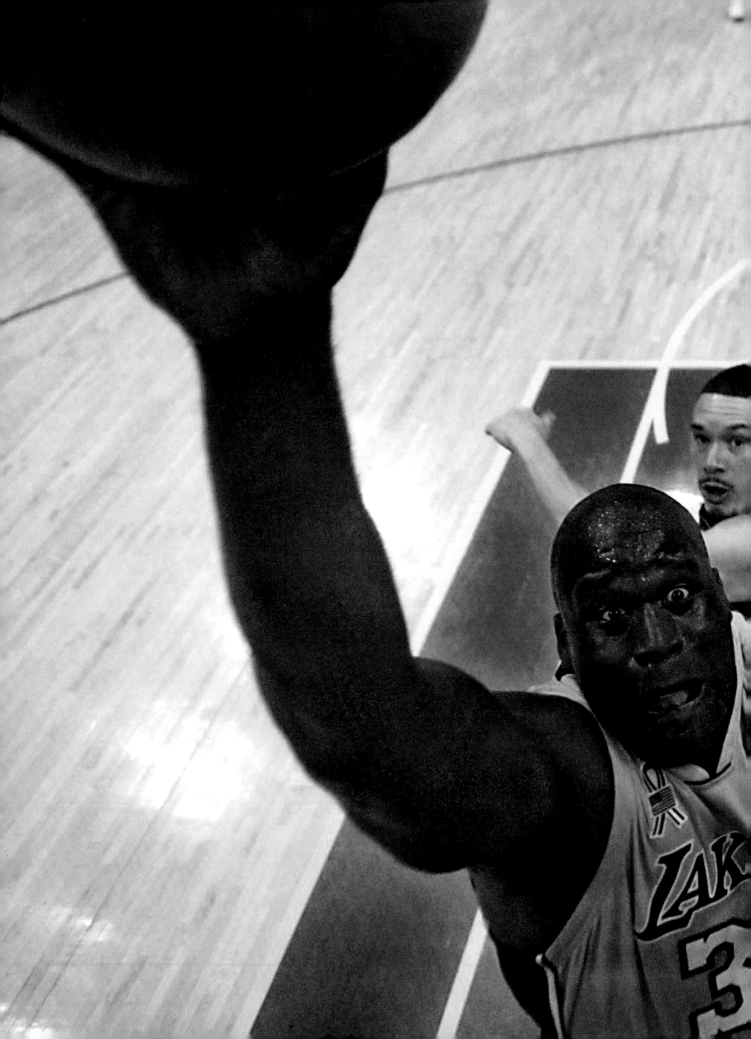

2002 NBA Finals

Looking to become only the second franchise to three-peat since the 1960s, the Lakers faced the biggest threat to their dynasty in the Western Conference Finals, against the Sacramento Kings, where some late-game heroics and curious officiating calls were enough to earn them a spot in the Finals against New Jersey . Los Angeles then overpowered the Nets in a four-game sweep, winning their third straight NBA title, a feat no team has duplicated since. Shaquille O'Neal took home another Finals MVP trophy after playing what turned out to be his crowning achievement as a Laker; he was traded to Miami in 2004 to end the long-simmering feud between the center and Kobe Bryant.

2009 NBA Finals

With Shaquille O'Neal gone, Kobe Bryant became the undisputed leader of the Lakers but had been unable to lead them to another championship, reaching the Finals in 2008 but falling in six games to the Boston Celtics. But with help from big man Pau Gasol, Bryant and the Lakers got over the hump against Orlando in 2009. Bryant won his first Finals MVP trophy, averaging more than 32 points and seven assists in the five-game series. Los Angeles would look to make it three straight Finals appearances in 2010.

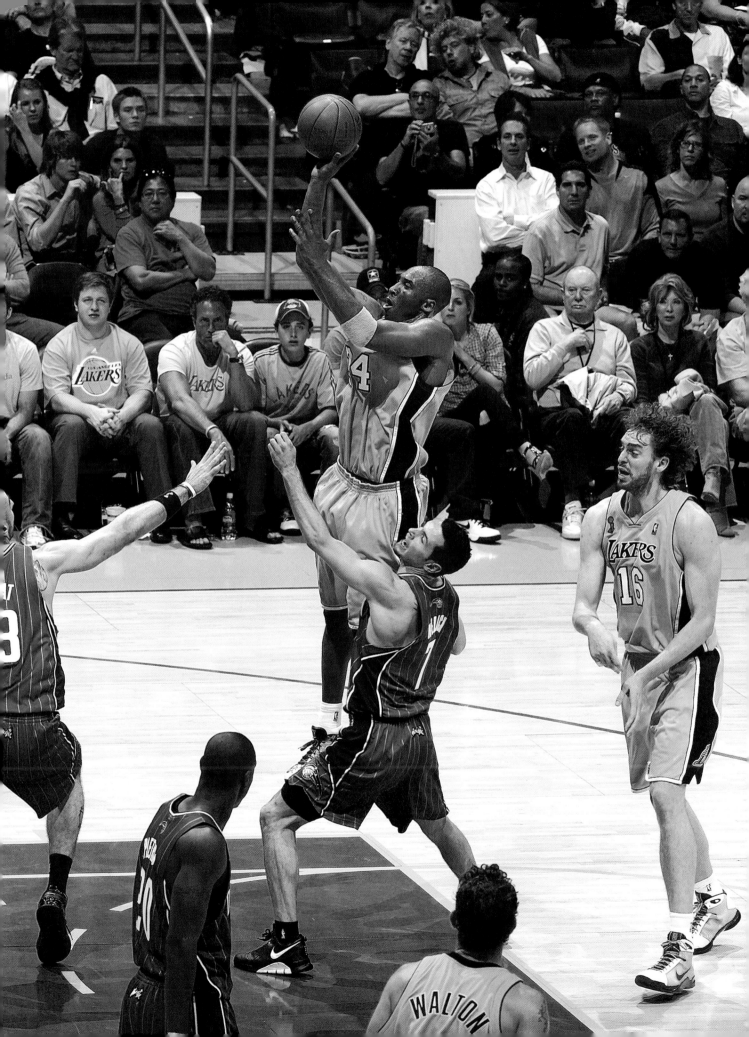

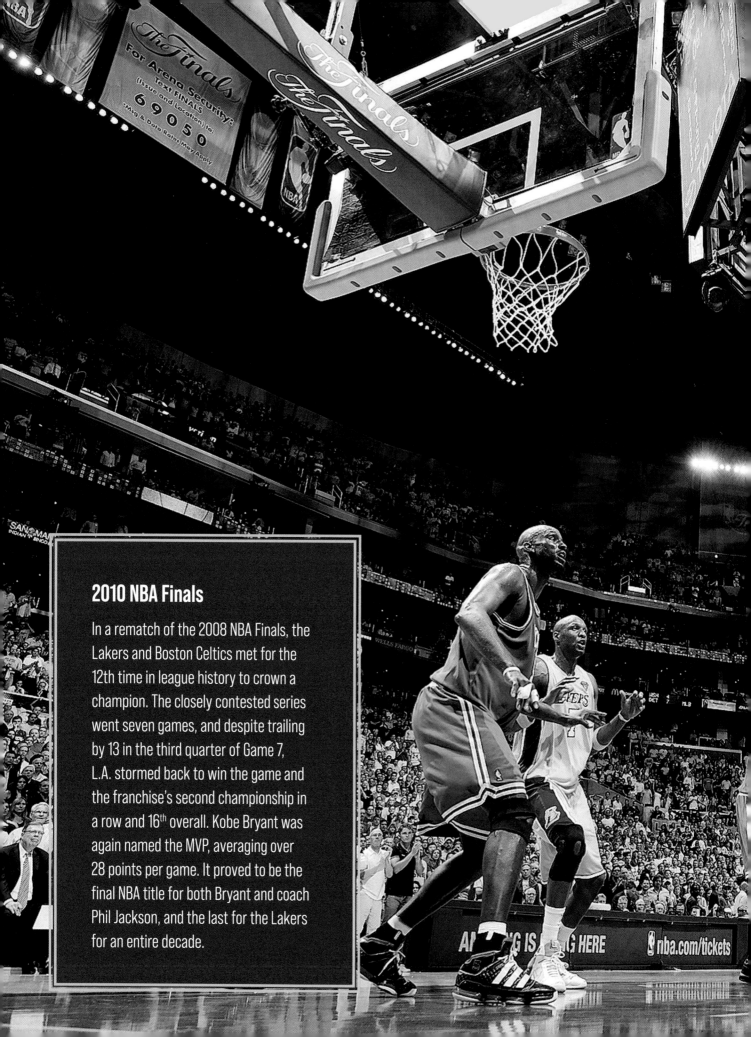

2010 NBA Finals

In a rematch of the 2008 NBA Finals, the Lakers and Boston Celtics met for the 12th time in league history to crown a champion. The closely contested series went seven games, and despite trailing by 13 in the third quarter of Game 7, L.A. stormed back to win the game and the franchise's second championship in a row and 16th overall. Kobe Bryant was again named the MVP, averaging over 28 points per game. It proved to be the final NBA title for both Bryant and coach Phil Jackson, and the last for the Lakers for an entire decade.

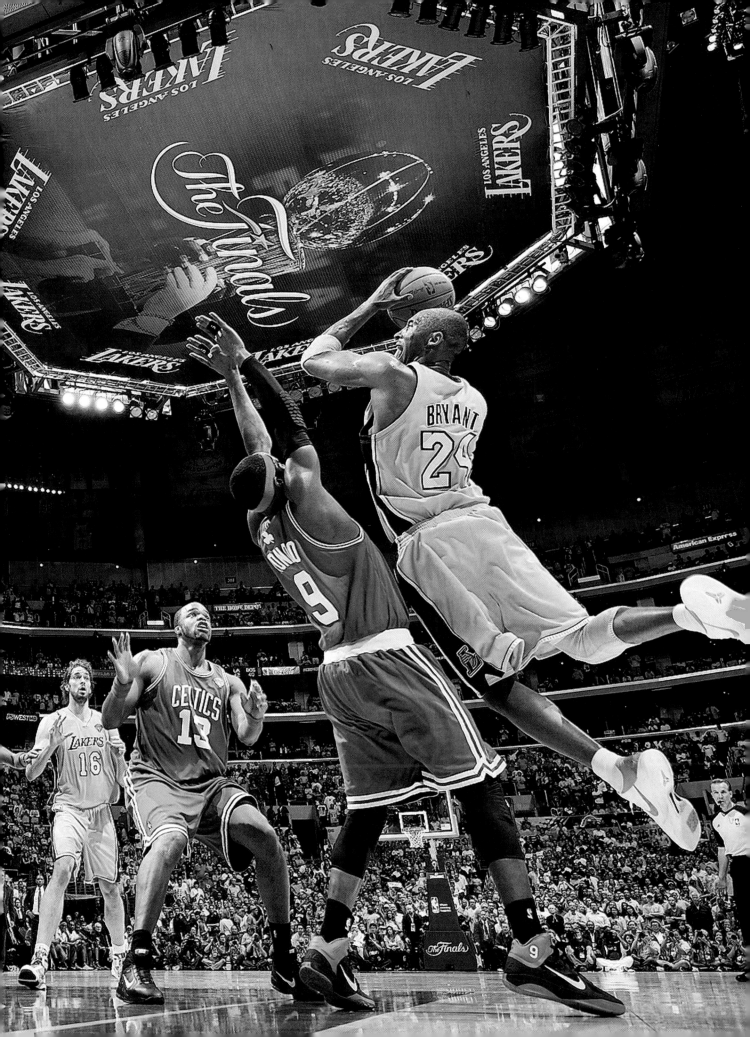

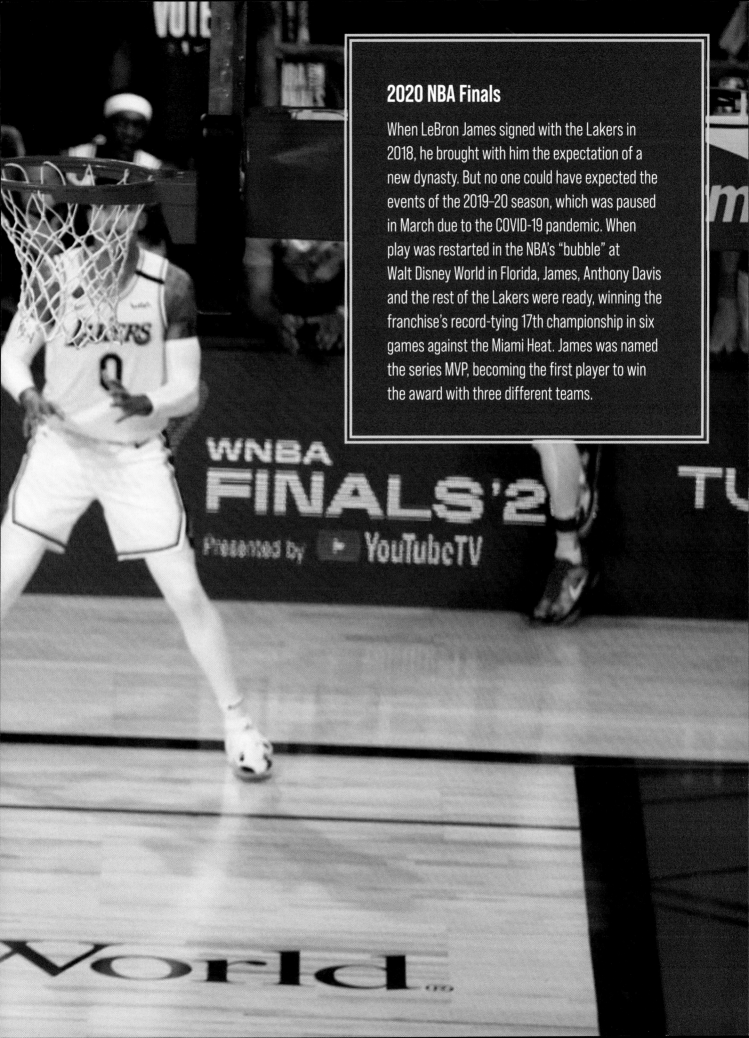

2020 NBA Finals

When LeBron James signed with the Lakers in 2018, he brought with him the expectation of a new dynasty. But no one could have expected the events of the 2019–20 season, which was paused in March due to the COVID-19 pandemic. When play was restarted in the NBA's "bubble" at Walt Disney World in Florida, James, Anthony Davis and the rest of the Lakers were ready, winning the franchise's record-tying 17th championship in six games against the Miami Heat. James was named the series MVP, becoming the first player to win the award with three different teams.

LAKERS BY THE NUMBERS

HEAD-TO-HEAD RECORD

Rk	Franchise	Games	Wins	Losses	W/L%
1	Sacramento Kings	441	280	161	.635
2	Golden State Warriors	430	258	172	.600
3	Detroit Pistons	344	210	134	.610
4	Atlanta Hawks	336	194	142	.577
5	Boston Celtics	296	133	163	.449
6	New York Knicks	295	171	124	.580
7	Philadelphia 76ers	287	146	141	.509
8	Oklahoma City Thunder	260	151	109	.581
9	Phoenix Suns	259	146	113	.564
10	Portland Trail Blazers	237	125	112	.527

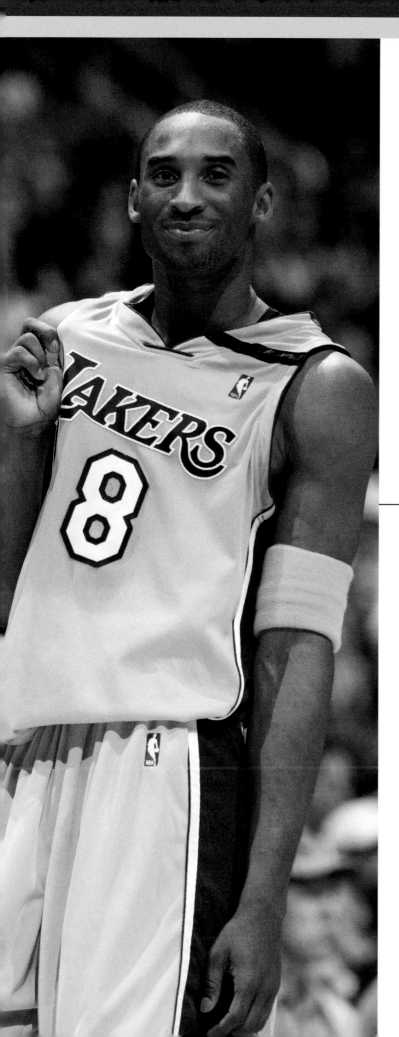

CAREER GAMES

1. Kobe Bryant **1,346**
2. Kareem Abdul-Jabbar **1,093**
3. Jerry West **932**
4. James Worthy **926**
5. Derek Fisher **915**
6. Earvin (Magic) Johnson **906**
7. Michael Cooper **873**
8. Elgin Baylor **846**

 Byron Scott **846**
10. A.C. Green **735**

CAREER POINTS

1. Kobe Bryant **33,643**
2. Jerry West **25,192**
3. Kareem Abdul-Jabbar **24,176**
4. Elgin Baylor **23,149**
5. Earvin (Magic) Johnson **17,707**
6. James Worthy **16,320**
7. Shaquille O'Neal **13,895**
8. Gail Goodrich **13,044**
9. Byron Scott **12,780**
10. Jamaal Wilkes **10,601**

CAREER ASSISTS

1. Earvin (Magic) Johnson **10,141**
2. Kobe Bryant **6,306**
3. Jerry West **6,238**
4. Norm Nixon **3,846**
5. Michael Cooper **3,666**
6. Kareem Abdul-Jabbar **3,652**
7. Elgin Baylor **3,650**
8. Gail Goodrich **2,863**
9. James Worthy **2,791**
10. Nick Van Exel **2,749**

CAREER STEALS

1. Kobe Bryant **1,944**
2. Earvin (Magic) Johnson **1,724**
3. James Worthy **1,041**
4. Byron Scott **1,038**
5. Michael Cooper **1,033**
6. Kareem Abdul-Jabbar **983**
7. Derek Fisher **968**
8. Norm Nixon **868**
9. Jamaal Wilkes **706**
10. A.C. Green **657**

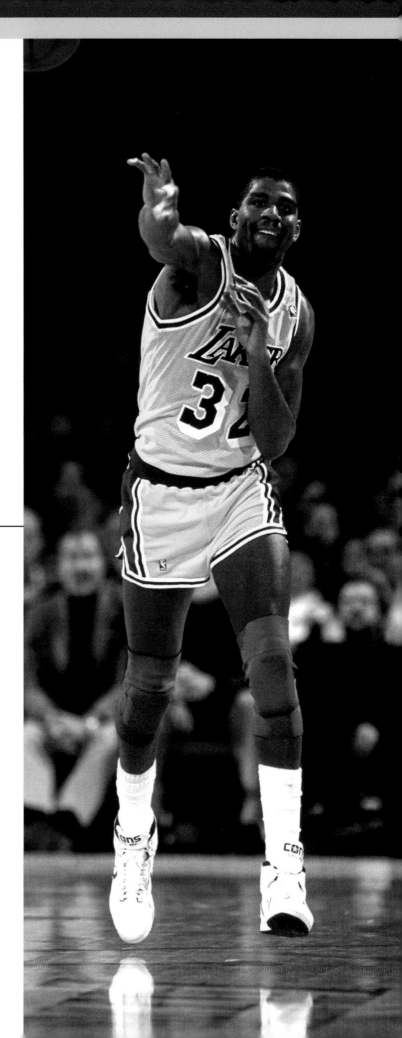

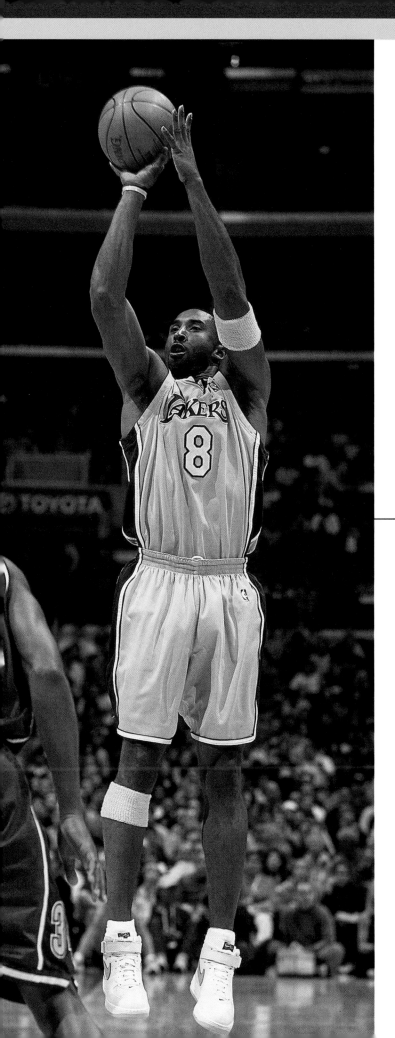

CAREER THREE-POINTERS

1. Kobe Bryant **1,827**
2. Derek Fisher **846**
3. Nick Van Exel **750**
4. Byron Scott **595**
5. LeBron James **524**
6. Kentavious Caldwell-Pope **522**
7. Kyle Kuzma **510**
8. Eddie Jones **489**
9. Rick Fox **480**
10. Nick Young **465**

CAREER REBOUNDS

1. Elgin Baylor **11,463**
2. Kareem Abdul-Jabbar **10,279**
3. Kobe Bryant **7,047**
4. Earvin (Magic) Johnson **6,559**
5. Wilt Chamberlain **6,524**
6. Shaquille O'Neal **6,090**
7. Vern Mikkelsen **5,940**
8. A.C. Green **5,632**
9. Rudy LaRusso **5,571**
10. Jerry West **5,366**

CAREER BLOCKS

1. Kareem Abdul-Jabbar **2,694**
2. Shaquille O'Neal **1,278**
3. Elden Campbell **1,022**
4. Vlade Divac **834**
5. Kobe Bryant **640**
6. Andrew Bynum **628**
7. James Worthy **624**
8. Elmore Smith **609**
9. Pau Gasol **607**
10. Michael Cooper **523**

CAREER TRIPLE-DOUBLES

1. Earvin (Magic) Johnson **138**
2. LeBron James **32**
3. Elgin Baylor **26**
4. Kobe Bryant **21**
5. Jerry West **16**
6. Kareem Abdul-Jabbar **13**
7. Russell Westbrook **10**
8. Wilt Chamberlain **8**
9. Elmore Smith **6**
10. Pau Gasol **5**
 Julius Randle **5**

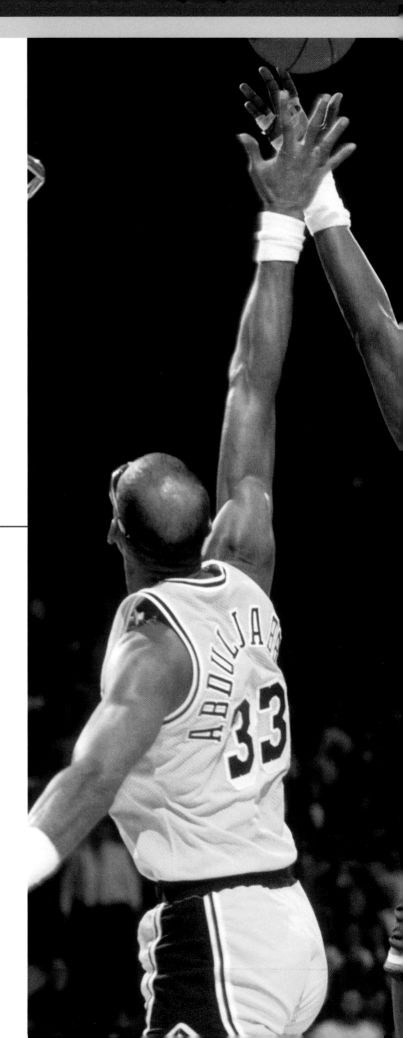

CAREER COACHING VICTORIES

1. Phil Jackson **610**
2. Pat Riley **533**
3. John Kundla **423**
4. Fred Schaus **315**
5. Bill Sharman **246**
6. Del Harris **224**
7. Jerry West **145**
8. Frank Vogel **127**
9. Paul Westhead **111**
10. Butch van Breda Kolff **107**

MOST NBA CHAMPIONSHIPS

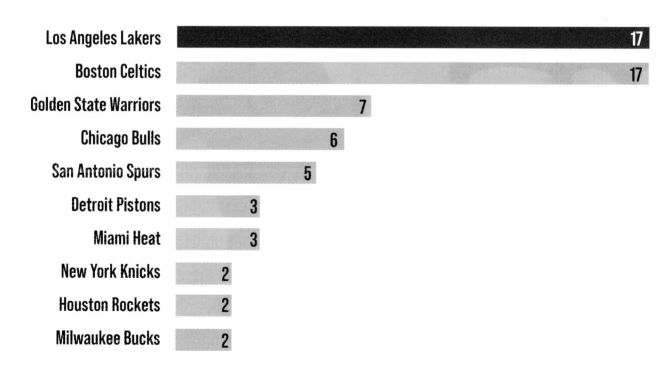

Team	Championships
Los Angeles Lakers	17
Boston Celtics	17
Golden State Warriors	7
Chicago Bulls	6
San Antonio Spurs	5
Detroit Pistons	3
Miami Heat	3
New York Knicks	2
Houston Rockets	2
Milwaukee Bucks	2

THE COVERS

April 29, 1968

December 13, 1971

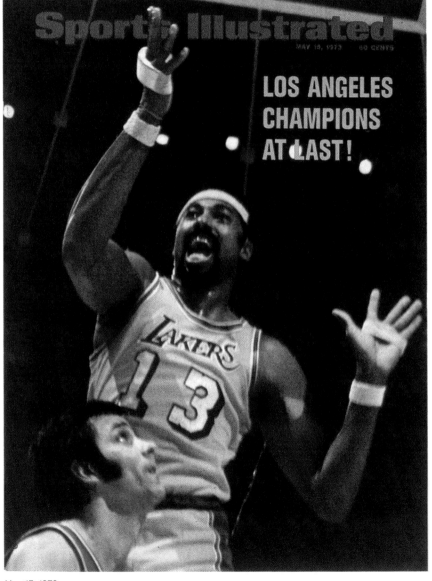

May 15, 1972

October 16, 1972

May 7, 1973

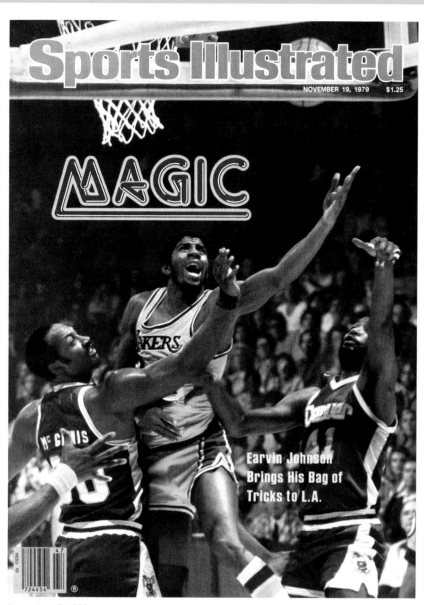

November 19, 1979

May 24, 1982

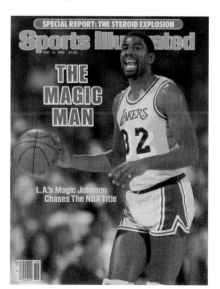

May 13, 1985

December 23–30, 1985

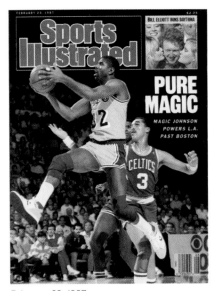

February 23, 1987

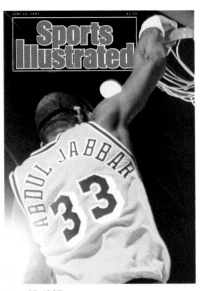

June 22, 1987

April 18, 1988

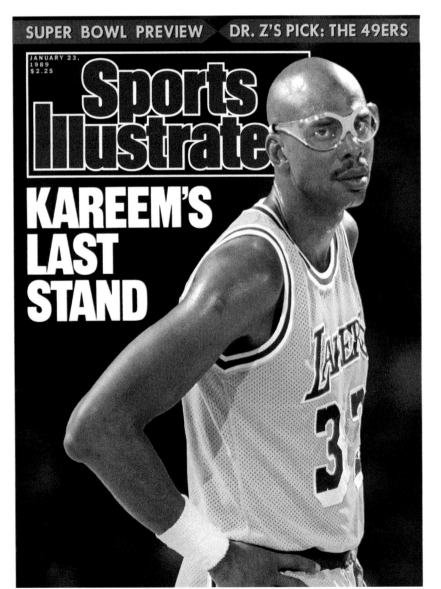

January 23, 1989

June 5, 1989

December 3, 1990

June 10, 1991

February 12, 1996

November 11, 1996

April 27, 1998

March 8, 1999

November 1, 1999

June 12, 2000

June 4, 2001

June 25, 2001

August 20, 2001

June 10, 2002

Sports Illustrated

BEYOND LEBRON
The Next Sports Prodigies

FREDDY ADU
Soccer
JOSÉ REYES
Baseball
DARKO MILICIC
Basketball

Kobe's Run
13 GAMES, 551 POINTS

PLUS
"KOBE IS BETTER THAN MICHAEL"
HERESY FROM RICK REILLY

MARCH 3, 2003 www.si.com
AOL Keyword: Sports Illustrated

March 3, 2003

April 21, 2008

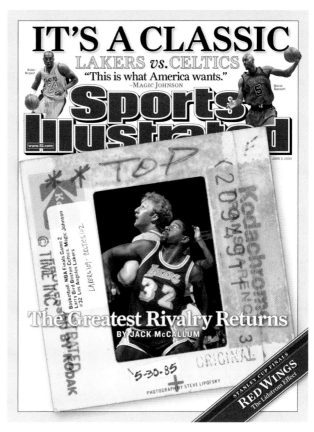

June 9, 2008

October 27, 2008

June 28, 2010

October 21, 2013

October 22–29, 2018

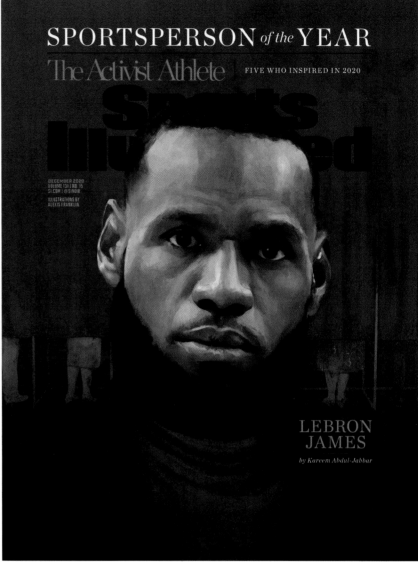

December 2020

Photo Credits

Andy Hayt: Pages 36, 37, 54-55, 86, 87, 220, 222; Bob Rosato: Pages 138, 140-41, 204-05, 219; David E. Klutho: Pages 12, 120, 172, 174, 177, 216-17; John Biever: Pages 40, 131, 206-07, 210-11; John D. Hanlon: Pages 28, 68; John G. Zimmerman: Page 149; John Iacono: Pages 2, 200-01; John W. McDonough: Pages 4, 8-9, 13, 14, 15, 38, 41, 42-43, 117, 118, 126, 127, 130, 132-33, 142, 143, 185-86, 214-15, 218; Jonathan Ferrey: Page 167; Manny Millan: Pages 1, 7, 31, 32, 33, 35, 51, 52, 54-55, 74, 78, 88, 97, 98, 99, 153, 188-89, 198-99, 202-03, 208-09; Neil Leifer: Pages 19, 23, 29, 66, 71, 84, 109, 124; Robert Beck: Pages 11, 156, 159, 160, 164, 178, 221; Tony Triolo: Pages 20-21, 100.

Additional photography: Adrees Latif/AFP via Getty Images: Pages 212-13; AP Photos: Pages 44, 60, 185, 192, 193, 196-97; Bettmann: Pages 16, 24, 25, 26, 46, 48, 63, 72, 73, 104, 106, 113, 147, 194-95; Focus on Sport: Pages 18, 47, 57, 103, 144; Kevork Djansezian/Getty Images: Pages 171, 223; Matt Campbell/AFP: Page 125; Minnesota Historical Society via Getty Images: Pages 190-91; Paul Natkin/WireImage: Page 50; Thearon W. Henderson/Getty Images: Page 180.